Courbet Reconsidered

Courbet Reconsidered

Courbet Reconsidered

SARAH FAUNCE AND LINDA NOCHLIN

THE BROOKLYN MUSEUM / 1988

This publication has been made possible with the generous
support of the B. Gerald Cantor Art Foundation
and The Andrew W. Mellon Foundation.

This exhibition has been organized by The Brooklyn Museum
and is made possible by a grant from the IBM Corporation, with
additional support from the National Endowment for the Arts,
and an indemnity from the Federal Council for the Arts and
Humanities.

The Brooklyn Museum: November 4, 1988–January 16, 1989
The Minneapolis Institute of Arts: February 18–April 30, 1989

Library of Congress Cataloging-in-Publication Data

Faunce, Sarah.
 Courbet reconsidered.
 Issued on the occasion of an exhibition to open at the
Brooklyn Museum in November 1988.
 Bibliography: p.
 Includes index.
 1. Courbet, Gustave, 1819–1877—Exhibitions.
2. Realism in art—France—Exhibitions. I. Nochlin,
Linda. II. Brooklyn Museum. III. Title.
N6853.C737A4 1988 759.4 87–37510
ISBN 0–300–04298–1 (alk. paper)
ISBN 0–300–04358–9 (pbk: alk. paper)

Cover image: Gustave Courbet. *The Trellis,* or *Young Woman
Arranging Flowers,* 1862. The Toledo Museum of Art, Gift of
Edward Drummond Libbey.

Produced and distributed by Yale University Press,
New Haven and London.
The paper in this book meets the guidelines for permanence
and durability of the Committee on Production Guidelines
for Book Longevity of the Council on Library Resources.

10 9 8 7 6 5 4 3 2 1

Contents

Director's Foreword

The centenary exhibition of Courbet's works organized by the Louvre in 1977 and *Courbet in Deutschland,* organized by the Kunsthalle in Hamburg in 1978, were major European events that led to increased scholarly scrutiny of the artist and increased awareness of the range of issues raised by his work and his career. Meanwhile, in the United States there had been no full-scale exhibition of Courbet's paintings since the one presented at Philadelphia and Boston in 1959–60, almost thirty years ago. Because of its reputation for serious exhibitions in the field of nineteenth-century painting, The Brooklyn Museum is the appropriate place to provide an American audience with the opportunity to focus on the paintings of this figure who is so central to the development of painting in the nineteenth century, and who continues to stimulate controversy and a wide diversity of interpretations. It was this kind of visual enthusiasm and conviction of Courbet's seminal position that led me to initiate the project shortly after arriving at Brooklyn in 1983. Sarah Faunce, Curator of European Paintings at The Brooklyn Museum, and especially qualified as the organizer of significant nineteenth-century exhibitions at the Museum, undertook the project with the collaboration of Linda Nochlin, Distinguished Professor of Art History at the Graduate Center of the City University of New York and our leading scholar in Courbet studies.

Any contemporary effort to construct a Courbet exhibition must confront the fact that there will be major omissions; it is not only the great and massive canvases of *A Burial at Ornans* and the *Painter's Studio* that can no longer travel for reasons of fragility, but such other important figure paintings of the early 1850s as the *Grain Sifters,* and now the *Meeting,* have sadly joined the list of monuments that cannot safely be moved. These works of course play a significant role in this book; and I hope it will be agreed that the range and power of Courbet's art as a whole is such that it would be wrong to allow these restrictions to prevent the possibility of providing for Courbet the kind of critical focus that only an exhibition of original works of art can permit. Owing to the generosity of a large number of lenders here and abroad, we have been able to present a selection of works that go a considerable way toward revealing the complex nature of Courbet's realism; the way in which his painting

unites a concrete visuality with a powerful, and essentially moral, subjectivity. The exhibition, together with this publication, should make clear the extent to which Courbet's art invites reconsideration; provocative and controversial in its own time, it retains the power to arouse intense feeling and equally intense differences of viewpoint.

Initial support from the National Endowment for the Arts made it possible for the Museum to approach the IBM Corporation for the necessary funding. We are deeply indebted to the IBM Corporation not only for their indispensable financial support of this major project, but for the thoughtfulness and understanding that they have demonstrated in all their dealings with the Museum.

Robert T. Buck

Acknowledgments

We have been very fortunate in having as our informal adviser on the exhibition Mme. Hélène Toussaint, formerly of the Department of Paintings at the Louvre. It was the energy and scholarship of Mme. Toussaint and her colleagues that made the catalogue of the centenary exhibition of 1977–78 the most reliable reference work we have on Courbet's paintings. Although we have not agreed with every point of her interpretation, we have relied on her knowledge and profited greatly from her encouragement and advice. At The Brooklyn Museum, our thanks go in particular to Ann Dumas, who as Assistant Curator helped in all aspects of producing the exhibition and catalogue; to Caroline Mortimer, who prepared the U.S. Government Indemnity Application; to Rena Zurofsky, who managed the liaison with Yale University Press; and to Elaine Koss for editorial assistance. We are also grateful for the support and assistance of the following people: Lynne Ambrosini (The Minneapolis Institute of Arts); Kenneth Aptekar (New York City); Katharine Baetjer (The Metropolitan Museum of Art); Lyn Borg (Washington, D.C.); Aline Brandauer (New York City); Benjamin Buchloh (New York City); Judith Calvert (Yale University Press); Peter Chametsky (New York City); Jean-Jacques Fernier (Musée Courbet, Ornans); Pierre Georgel (Picasso Museum, Paris); Stephen Hahn (New York City); Klaus Herding (University of Hamburg); Denis Hollier (Yale University); John House (The Courtauld Institute); Rosalind Kraus (Hunter College of the City University of New York); Michel Laclotte (Musée du Louvre); Eunice Lipton (SUNY, Binghamton); Caroline Mathieu (Musée d'Orsay); Judy Metro (Yale University Press); M. and Mme. Jacques-Alain Miller (Paris); Marc Perrin de Brichambaut (French Cultural Services, New York); Edouard Pommier (Direction des Musées de France); Joseph Richel (Philadelphia Museum of Art); George Shackleford (Houston Museum of Art); Carl Strehlke (Philadelphia Museum of Art); Patrick Talbot (French Cultural Services, New York); Ann Townsend (Washington, D.C.); Eugene Thaw (New York City); Gary Tinterow (The Metropolitan Museum of Art); Alice Whelan (U.S. Government Indemnity); Tom Wolf (Bard College). Finally, an immense debt of gratitude is owed to all the lenders to the exhibition, whose generosity has made the project possible; their names are listed on pages 243–45.

Sarah Faunce, Linda Nochlin

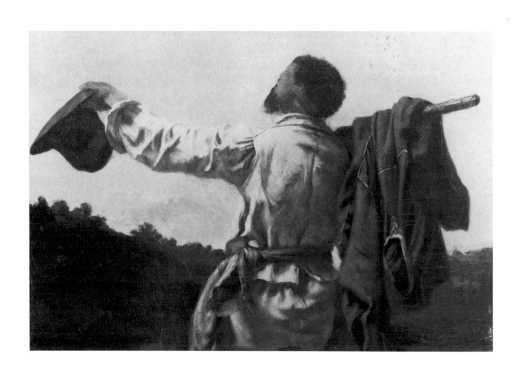

Reconsidering Courbet

Courbet has never been a neglected artist, but he has been an intractable one. He looms large, if uneasily, in the early history of modern painting. Until recent years the history of modernism was seen, in developmental terms, as a quasi-biological evolution toward the goal of "pure painting." Such a reading necessitated the suppression of the subject in favor of purely formal qualities; the very real break with the language, or narrative orientation, of traditional art seemed to require an exclusive focus on the visual properties belonging to painting itself. From this formalist perspective Courbet was something of an embarrassment. He built his paintings up from dark grounds like the Old Masters from whose works he learned to paint; his subjects, whether human figures or animals or fruit, possess an insistent physicality that is essential to their power as works of art; the landscapes, devoid though they are of human, let alone literary, reference, nonetheless assert a specificity of place that cannot be ignored or subsumed into matters of facture or of the materiality of paint. From a formalist point of view, in fact, the very word attached to his work—realism—seemed a contradiction in terms.

One way out of the dilemma was to skirt the issue of Courbet's modernity, or rather to recast it in purely sociopolitical terms. The most thoroughgoing exponent of this view has been T. J. Clark.[1] His contribution to the understanding of the historical context of Courbet's work of the late 1840s and early 1850s—his documentation of Courbet's *situation*—has been essential, as is his insistence that we take a more complex, ironical view of Courbet's persona, that we neither leave him to the clichés and caricatures of his own period nor sanitize him into an artist whose political concerns have become irrelevant. But we are left with a Courbet who, however complex and fascinating in Clark's terms, is allowed little meaning other than political, and whose work loses significance after the period of intense controversy leading from the Revolution of 1848 to the coup d'état of 1851 and the earliest years of the Empire. And by holding to a strictly formalist definition of modernism, despite the fact that in the 1970s, when he was writing about Courbet, that model was steadily losing ground, Clark deprives Courbet of any formative role beyond the sociological. If however, modernism is given a more complex interpretation—as has been the case in recent years—if it is seen not as a hermetic concentration on the means and properties of painting as such, but rather as a series of ideas and attitudes that are filtered through pictorial sensibilities into works of art, then Courbet's place can be seen more clearly.

Since December 1986 it has been possible to witness not only Courbet's stature (that could be seen before) but his essential modernity. In the Musée d' Orsay we are able to compare in one building the paintings of Courbet with those of the Academy against which he set himself; of the contemporaries with whom he shared only a little more than the term *realist* conferred by the critics; and of Manet, Monet, Renoir, Bazille of the 1860s, his true heirs. (We can also see a painting that celebrates the latter connection, the central panel of Monet's *Déjeuner* of 1865–66 [fig. 1.1], in which both Courbet and Bazille are models for Monet's group of picnicking figures.)[2] In these installations we can see the rhetoric of the Academy in full force, with all the power of its leading talents; we can see the grip of theatricality, even in modest genre paintings; we can see

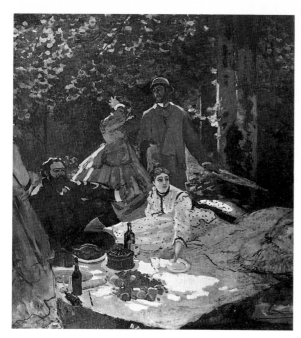

1.1. Claude Monet (1840–1926). *Le Déjeuner sur l'herbe*, central portion, 1865–66. Oil on canvas. Paris, Musée d'Orsay.

that Courbet, in breaking violently with both rhetoric and theatricality and in destroying for good the whole notion of "genre," really did transform not only the art of painting, but the relation of the artist to his own experience. His successors took from him the modernist demand for authenticity, and the exhilarating but dangerous realization that they were, so to speak, alone with their own experience, to make of it what they could—and to find the audience that knew the same of themselves.

It was at the Salon of 1851 (to which Courbet sent nine paintings, chief among them *The Stonebreakers* [fig. 1.2], *The Peasants of Flagey Returning from the Fair* [pl. IV], and *A Burial at Ornans* [pl. I] that the radical nature of his work became fully apparent, as did the weight and intensity of the resistance to it. The Salon was really that of 1850, but its opening was delayed until December 30 because of political unrest and the uncertainties of the divided government of the Second Republic. In the wake of the uprisings of February 1848 and the bloody repressions of June, the country was in an unprecedented state of division, hostility, and instability. Louis-Napoleon, elected President of the Second Republic in December 1848, would just two years later bring the Republic to an end in a coup d'état that was justified as the only means to ensure stability and order. From the point of view of the Legitimists, the Orleanists, and the growing party of supporters of Louis-Napoleon, the very existence of the Republic, with its pressures toward popular representation and free expression, was in itself a threat. Repression and

disenfranchisement by the right divided and weakened the Republicans and led to greater radicalism on the left—a classic case, including a classic fear of the left that made of "socialism" an angry epithet, carelessly applied.

Courbet himself was a Republican, a staunch believer in the principles for which his beloved grandfather Oudot fought in the first Revolution. In 1848 he did not fight on the barricades, but his sympathies were with those who did. His best friend, the poet Max Buchon, was imprisoned for seditious activities in 1849 (he would later be exiled under the Empire). In 1850, at the age of thirty-one, Courbet had been in Paris for about ten years, living the marginal life of the obscure and developing artist, the Bohemian life that, as he wrote to his friend Francis Wey in the spring of that year, he had deliberately chosen.[3] He admired the eccentric Jean Journet, itinerant exponent of the Utopian socialist ideas of Fourier, and he would become a lifelong admirer of the socialist philosopher P.-J. Proudhon; his friends in Paris were Baudelaire (who did go to the barricades), Pierre Dupont, the worker-poet, and other intellectuals of the left. He himself was emphatically a man of the left and was consciously and consistently so throughout his life. (There has been a traditional tendency to make an equation between his beliefs and his supposed social class—the earlier criticism often refers to him as a "peasant"—but recent research has established quite clearly that the Courbet family, as a result of the changing pattern of landholding during and after the Revolution, belonged to the rural bourgeoisie of the Franche-Comté.)[4] Ironically, the few elements in *A Burial at Ornans* that we now can read as specific references to the artist's Republican allegiances—the presence at the far left of Grandfather Oudot, who had died in 1848, and the two men in the center dressed in the style of the "men of '93"—would have been illegible as such to the Salon critics, who in any case were ignorant of the young artist's actual background and political beliefs. In the tense atmosphere of 1850 such specific information was hardly necessary in order to produce a political response to Courbet's work. A challenge to the established cultural norms, in the form of imagery drawn from the life of ordinary people, was instantly equated with political dissent.

Of the three large, ambitious works depicting rural themes, it was *A Burial at Ornans*, all twenty feet wide of it, that caused the most intense anxiety and vituperation. Courbet's effrontery in claiming the size and status of a history painting for a subject that would normally be considered genre had something to do with it, but this

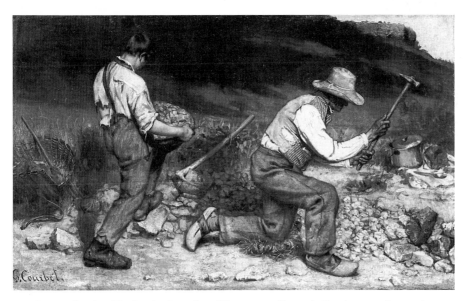

1.2. Gustave Courbet. *The Stonebreakers*, 1850. Oil on canvas. Formerly Dresden, now destroyed.

was only the beginning of the difficulty. In the previous year the artist had shown *The After Dinner at Ornans* (fig. 1.3), which might fairly be described as a life-size genre painting, and its purchase by the state had marked him as a coming artist; it later went to the museum in Lille. The *Burial* was seen in a different way. Three years later, in a letter to his patron Alfred Bruyas, Courbet would refer to the *Burial* as "my *début* and my statement [*exposé*] of principles."[5] This, of course, is a retrospective judgment on the artist's part, reflecting to some extent his awareness of how much importance had been given to the painting by the very intensity and range of hostile criticism. But he had made a definite claim at the time for the importance of the painting, in its size, in the immense effort required to complete it, and in the title he gave to it: "Tableau de figures humaines, historique d'un Enterrement à Ornans." This was to be not just a traditional genre subject on a large scale, it was to be a challenge to the whole idea of the *peinture d'histoire* and the rigid categories of the Academy.

The power and scale of the painting led many critics to feel it their duty to warn not only the public but the young artist himself away from his dangerous ways. As Claude Vignon put it, "We perhaps would not have spoken of these distressing productions of M. Courbet, if he had not been announced as destined to lead a school, and if we ourselves had not perceived in him, beneath all the eccentricities, an artist of talent who has strayed into a false road . . ."[6] And the noted critic E.-J. Delécluze could write of the *Burial* that "this work embodies qualities that are too solid, and certain parts are

too well painted, for one to be able to believe in the savagery and ignorance that are affected by this artist."[7] Already Courbet is known by his mask, part untutored Franche-Comté peasant, part rowdy Bohemian of Paris, but the critic is too smart to be taken in by it. He dislikes the work wholeheartedly, but he sees that its character, which he and the others find offensive, comes about deliberately and not through any weakness or failure on the part of the artist.

What, then, were the causes of offense? To put it at its most general, the painting transgressed by breaking the code of aesthetic perception.[8] First, in its subject matter: the spectacle of the massed, black-clad bourgeoisie of a small provincial town did not, as Clark has so eloquently shown, conform at all to the convention considered appropriate by Parisian critics to the treatment of the countryside and the village.[9] Conservatives were willing, if reluctant, to admit that rural genre themes had their place, albeit a minor one, in art; the more liberal critics welcomed such themes, but both camps shared the same convention, the same expectation that such subjects must conform to recognizable types. That is, the figures and the situation must be clearly identifiable as those of the peasantry, whether serious and noble like Millet's *Sower* (shown in the same Salon), or—preferably—pretty and jolly like the Italian peasants of Léopold Robert, the artist whom Gautier held up as a model for Courbet. After all, if an artist is sympathetic to the people, why should he not make them attractive?[10] But quite the contrary, it was the nearly unanimous opinion of the Salon reviewers, no

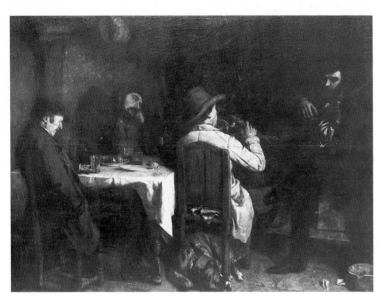

1.3. Gustave Courbet. *After Dinner at Ornans*, 1849. Oil on canvas. Lille, Musée des Beaux-Arts.

matter what their political persuasion, that not only had Courbet failed to make his figures attractive, he had gone out of his way to make them ugly. The term "ugly"—*laid*—was then as now notoriously easy to use and difficult to pin down. In these texts it is a term that conveys the writers' sense of anger and bewilderment at the fact that there is nothing they can get hold of in the work that they expect and recognize in a painting; they cannot find the "art." For in the terms of their aesthetic code, "art" must contain poetry, the ideal, nobility of feeling, charm, grandeur—any one or a combination of these concepts must be seen to be present in a work of art. But these were concepts whose meanings were determined for them by the visual conventions of the Academy, and faced with such a radically different visual experience it was impossible to perceive them. The *Burial* appeared to lack or, worse, to refuse meaning.

One way in which the sense of ugliness is formulated in these texts is in the attack on Courbet for merely copying nature, for just lazily reproducing what is in front of his eyes, when it is obvious that "art is not the indifferent reproduction of the first thing that comes along, but a delicate choice made by an intelligence refined through study . . ."[11] Delécluze compares the *Burial* to the "result of a badly done daguerreotype,"[12] an up-to-date remark that puts a finger on the troublesome lack of easily recognizable sentiment in this painting of a subject that might have been expected to have had dramatic, even edifying overtones. Another painting in the same Salon, *The Death of a Sister of Charity* by Isidore Pils (fig. 1.4), presented a related subject

also drawn from actual life, but it was correctly perceived as being very different from the *Burial*. One critic opposed the "Christian spirituality" and "moral beauty" of the Pils painting to Courbet's "cold image of nothingness."[13] Today, the visitor to the Musée d'Orsay can once again, like the viewers of 1851, look at both works in adjacent spaces and make that same comparison. To modern eyes the Pils painting, though by subject grouped together with paintings of the Realist school, is imbued with the rhetoric of the Academy: the highly focused composition, the dignity of the dying nun and her nobly calm attendant, the pathos of the poor mother with her young children, the reverence of the girls kneeling behind her. *The Death of a Sister of Charity* was well received at the Salon, as were other works concerned with the sorrows of life, such as Hébert's *Malaria* or Tassaert's *An Unhappy Family* (fig. 1.5). To compare these paintings with the *Burial* is to see that Courbet's work inhabits a different aesthetic and moral universe.

The painting, with its friezelike arrangement of massed figures, apparently arbitrarily cut at either side, appears almost uncomposed. There is a total absence of rhetoric, a total lack of direction as to what the viewer should feel. Whatever tears are there are hidden; there are no noble sufferers, no upturned, glistening eyes. The viewer is not present at a theatrical spectacle, as he is in the conventional paintings of the period, whether academic or realist in subject matter. There is no obvious clue to the artist's own attitude toward this scene, and lacking conventional signs for emotional response in what after all is a scene of death, the viewer might feel unsafe, in danger from the possibility of irony and from having to face the world without self-deception. The massed figures bear ordinary human features, mostly plain, marked in the usual way by time and work. These were faces done from the life of Courbet's fellow citizens of Ornans, and when the painting was first shown in the fall of 1850 in Besançon, the local audience had no difficulty in recognizing and accepting this representation of people they knew either individually or by type. But in Paris they became ugly caricatures, willful distortions. In Paris the *Burial* was judged as a work that had thrust itself into the grand tradition of history painting, like an upstart in dirty boots crashing a genteel party, and in terms of that tradition it was of course found wanting. Had there been any of the conventional clues to response such as those found in the Realist painters of genre—in Bonvin, or Breton, or Antigna, others who were favorably mentioned by the more liberal critics in 1851—the upstart might have been forgiven. As it was,

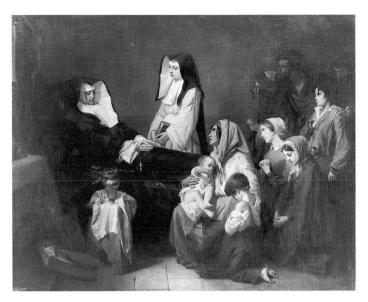

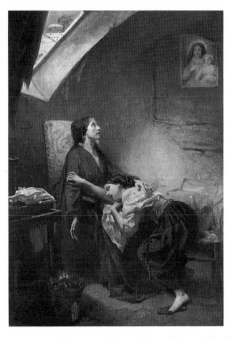

1.4. Isidore Pils (1813–75). *The Death of a Sister of Charity*, 1850. Oil on canvas. Paris, Musée d'Orsay.

1.5. Octave Taessaert (1800–74). *An Unhappy Family*, 1850. Oil on canvas. Paris, Musée d'Orsay.

out of the dozens and dozens of commentaries on his work by people unknown to him (his friends Buchon and Champfleury were, of course, sympathetic collaborators), only three were admiring, and of these only one showed a genuine understanding of his work.

Méry, an amusing writer for a publication called *La Mode*, far from objecting to the depiction of "ugliness," praises Courbet genuinely, if ironically, for having so successfully rendered the true ugliness of the bourgeoisie, a class the writer clearly despises.[14] From the opposite perspective Paul Mantz, writing in *L'Evénement*, hailed the *Burial* as "les colonnes d'Hercule du réalisme."[15] But the basis for his praise was solely that Courbet, in this and the other pictures of rural subjects, was advancing the cause of such subjects; and he liked the *Burial* mostly because it depicted a funeral and showed the hard life of the poor (as he interpreted it; he was not alone in failing to perceive that these mourners were not poor peasants at all, but citizens of a small provincial town). In 1853, when Courbet's Salon entries were on themes that could not be construed as related to rural poverty, Mantz would express regret that the artist had betrayed his earlier promise of becoming the painter of the miseries of the poor and had shown himself to be "nothing but a painter."[16]

The one person who proved able to grasp and articulate a sense of the character and quality of Courbet's work was a man whom he would later come to know through his patron Alfred Bruyas, and who in fact was very likely to have been instrumental in leading Bruyas to Courbet's work: François Sabatier. Like many of his critical colleagues, Sabatier wrote a series of newspaper articles on the Salon of 1851.

M. Courbet has made a place for himself in the current French School in the manner of a cannon ball which lodges itself in a wall . . .[17] *Despite the recriminations, the disdain, and the insults which have assailed it, despite even its flaws,* A Burial at Ornans *will be classed, I have no doubt at all, among the most remarkable works of our time. I look in vain in the Salon for anything which can be compared to it. Since the shipwreck of the* Medusa, *nothing as strong in substance and in effect, especially nothing as original, has been made among us . . .*[18]

These articles were soon afterwards revised and published as a book under the name François Sabatier-Ungher, which incorporated the name of his wife, the opera singer Caroline Ungher. Both the newspaper, the short-lived *La Démocratie pacifique,* and the publisher, the Librairie phalanstérienne, were Fourierist in philosophy, as was Sabatier. A contemporary of Courbet, he was a landowner in the Hérault near Montpellier and was not only a theorist of democracy but may also have been active in the dangerous politics of the Second Republic as a socialist candidate in the highly polarized Assembly elections of May 1849.[19] Persona non grata under the Empire, he spent much of his time in Florence, where his wife owned a house that he had decorated with Fourierist allegories.[20]

Sabatier writes about art from a clearly formulated philosophy of social harmony. For a follower of Fourier, art is not a luxury, not the pleasure or the accomplish-

ment of a cultivated aristocracy. "We Phalanstériens" know that art and pleasure are necessities for all people, because nothing is more serious than happiness—*bonheur.* "Art is the highest and most complete expression of the human microcosm, the most sublime creation of social man." Plato is called to witness: "Beauty is the splendor of truth."[21] Elevated vocabulary and references such as this were commonly used by conservative critics as weapons with which to attack the realist school in the name of the "ideal form" taught by the Academy, but for Sabatier there are very different conclusions to be drawn. For him the truth from which the splendor of beauty may emerge is the truth of living human experience, the stuff of life as it is lived in each generation. The gods and heroes of the past, however much they may have meant to past generations, do not speak to the people of today. The hero of today is "man . . . the people, that is to say humanity."[22] The Salon of 1851, with its high proportion of landscapes and genre paintings, represents a victory of modern painting over "the painting of imitation," by which he means all those subjects so common at the time, drawn from Antiquity, from the Middle Ages, from the eighteenth century: that is, scholastic painting, which has nothing to do with the experience of either the artist or the public. History itself is an immensely important source of knowledge, but *history painting* is only rhetorical. David's Horatii and his Brutus had meaning when the Republic was being created, when Antiquity was a living model; to follow him in the present is to work not from life but from books. Sabatier is not above a bit of rhetoric himself: "The grand style (*le beau style*) is wrong, not that it is not very grand, but because it is Greek, and in France, in the nineteenth century, Frenchmen are alive and the Greeks are dead."[23]

Sabatier praises Courbet, not only for making ordinary people the subjects of what he correctly perceives to be a *peinture d'histoire,* but for doing it so well.

The clothes, the heads, have a solidity, a variety of tone and a firmness of drawing that is half Venetian, half Spanish; it is close to Zurbarán and to Titian . . . It was not an easy thing to give dignity and style to all these modern clothes . . . I maintain . . . that far from having fallen into vulgarity and materialism, M. Courbet has idealized and stylized his subject as much as it was possible to do, and still remain moving and true.[24]

Among the various interesting predictions to be found in this text, such as the coming age of aerial navigation and the probable invention of the architecture of the future by railway engineers, is the equally correct predic-

tion that the *Burial* will one day be in a museum and will be considered a classic. Sabatier's text has, amid the surrounding gloom and irritation of his critical colleagues, the freshness of a new vision of life, the flavor of modernity at its inception. That Sabatier should be the one observer outside Courbet's own circle who could grasp the importance of his work in 1851 makes sense, because the painter was breathing this air as well:

I have studied, outside of any system and without prejudice, the art of the ancients and the art of the moderns. I no more wanted to imitate the one than to copy the other; nor, furthermore, was it my intention to attain the trivial goal of art for art's sake. No! I simply wanted to draw forth from a complete acquaintance with tradition the reasoned and independent consciousness of my own individuality.

To know in order to be able to create, that was my idea. To be in a position to translate the customs, the ideas, the appearance of my epoch, according to my own estimation; to be not only a painter, but a man as well; in short, to create living art—this is my goal.[25]

This text represents about three quarters of the short introduction Courbet wrote to the catalogue of the exhibition of his own work that he produced—in a specially built structure that came to be known as the *Pavillon du réalisme*—as an adjunct to the *Exposition Universelle* of 1855. It is interesting, in the light of the long tradition of considering Courbet as somehow incapable of articulating his own thoughts and requiring Champfleury or some other writer to organize his texts, that the ideas expressed in this text, and the very phrasing, are close to what Courbet wrote in a letter to his newfound patron Bruyas in October of 1853. This is the long, feisty, and amusing letter in which he relates the story of how Nieuwerkerke, Superintendent of Fine Arts under Napoleon III, had tried to persuade him to accept a government commission.

I continued, telling him that I was the sole judge of my painting, that I was not only a painter but also a man, that I had become a painter, not to make art for art's sake but to achieve my own intellectual liberty, and that by the study of tradition I had succeeded in freeing myself and that I alone, of all the French artists who are my contemporaries, had the power to depict and to translate in an original way both my personality and my society.[26]

To the latter part of these remarks Nieuwerkerke responded, not surprisingly, "M. Courbet, you are indeed proud!" And the artist replied that he was indeed "the proudest and most boastful man in France." It was re-

marks like these, taken at their face value and gleefully passed along the chain of recorded gossip, that gained for Courbet the reputation of vanity pure and simple. And Courbet was not one to disarm people with polished manners or an affectation of modesty. A glimpse of his attitude can be found in the letters that he wrote from Ornans to his friend Francis Wey in Paris during the winter and spring of 1849–50, when he was working on the *Stonebreakers* and the *Burial.* Apologizing to Wey for a failure to write a letter of condolence, he wrote, "Decidedly, the qualities of savoir vivre, of propriety, of French politeness will always be lacking in me." Later that spring, in a long reflective letter about the completion of the *Burial,* he wrote, "Yes, my dear friend, in our so very civilized society it is necessary for me to live the life of a savage. I must be free even of governments. The people have my sympathies, I must address myself to them directly." And later on in the same letter: "It is a serious responsibility, first to provide the example of liberty and personality in art, and then afterwards to provide publicity to the art which I have undertaken."[27]

"A reasoned and independent consciousness of my own individuality"; "the achievement of my intellectual liberty"; "the example of liberty and personality in art"—these phrases seem tame enough today, but for the early 1850s the reality they attempt to express is large and difficult and new. What Courbet was trying to do was not simply to work in a new way, in complete independence of the Academy, or to extend the range of subjects considered appropriate for painting, or to be an artist "of his own time," a "painter of modern life." He was doing all these things, but in doing them he was also asserting the claim that the experience of the individual self in the world is the only valid source of art. Surrounded by a world of professional artists whose skills were developed to enable them to render episodes from classical legend and from all the most picturesque periods of history, he asserted that "the artists of one century [are] basically incapable of reproducing the aspect of a past or future century . . ."[28] This idea was naturally misunderstood at the time, even by his friends; Courbet was accused of failing to understand the great masters, the creators of history painting, and of denying the importance of imagination.[29] But of course his remark was not directed at the Renaissance and Baroque masters who conceived the biblical and classical narratives in terms of pictorial conventions that had nothing to do with historical actuality. He perceived that in his own time painting was in the process of becoming a handmaiden to a new kind of historical imagination, one that had a new sense of the reality of the past and a new

1.6. Honoré Daumier (1808–79). *Combat des écoles,* 1855. Lithograph from *Charivari.*

concern for factual detail. What he grasped was that there had to be a divorce between the visual imagination and this new sense of history if painting were not to become a mere instrument, a technique by which to illustrate concepts and create convincing decors. Painting, to be authentic, must come directly from the artist's own experience.

This idea of authenticity was at the root of Courbet's realism; its implication of subjective autonomy was at the opposite pole from the conception of the artist held by most cultivated people and enshrined in the procedures and the hard-won careers of the academicians. The term *realism,* at midcentury, was very much a battle cry: the seventeenth-century battle of the Ancients and the Moderns updated in a sense, but in a form much more threatening to established institutions and therefore ripe for Daumier's satirical pen (fig. 1.6). Another aspect of the battle, having more to do with the issues of social snobbery embedded in the controversy, is seized upon by Thomas Couture, an artist who himself followed a successful path of compromise (fig. 1.7). Couture's Realist painter has reversed the natural order of things: degrading what should be his proper model, a piece of classical sculpture, by sitting upon it, he takes as his subject of study the head of a pig, the lowest animal on the social and moral scale. The peasant clothing, the wine, the boots, and the beer steins hanging on the wall all refer to the Realist painter as the standard-bearer of the uncouth. The notion that in order to be painted by a Realist (certainly by M. Courbet) one had to appear in dirty clothes with a muddy face was good

stuff for the art of caricature, then flourishing in the popular journals, and even for theatrical entertainment.[30] What underlay the caricatural idea was the social fact that the intricate references of the classical and historical subjects favored by the academicians were perceived as attributes of the cultivated classes; to attack this subject matter was to attack not only the Academy but the whole distinction between those who had acquired this culture and those who had not. Hence the equation between Realists and the lower orders; not only did they paint peasants, they partook of the peasants' nature.

Courbet himself did not care for the term *realism* particularly, though of course he used it. As for the battle itself, he might complain of the epithets and insults, but he knew that it was inevitable, because what he wanted to do constituted such an enormous challenge to the existing system. He would also come to realize that such controversy was, despite the hostility, not altogether to his disadvantage. Controversy, after all, meant publicity, and as we have seen in the remark to Francis Wey quoted above, he was concerned early on with the question of publicity, of getting his work seen. For these purposes it worked to his advantage to have a persona, a public image, however crude or insulting. Courbet's boyhood friend Urbain Cuenot wrote to Courbet's sister Juliette from Paris at the time of the 1851 Salon:

Gustave is still the subject of all conversation in the art world. The most contradictory rumors and the most amusing stories are going around . . . There are salons where they claim that Courbet was a woodworker or a mason who one fine day, pushed by his genius, began to make paintings and made masterpieces right off the bat. In others, they maintain that he is a terrible socialist, that he is at the head of a band of conspirators. That can be seen in his painting, they say. That man is a savage . . .[31]

The public image of Courbet as a peasant, a ruffian, a self-satisfied primitive, was created by the many voices of early 1851 and began a long career of visual and verbal caricature. Courbet did nothing to contradict the image; if anything he fed it by refusing to follow the classic path, so common to the arrivistes of the Second Empire, whereby the rough-edged provincial comes to Paris, not only to make his fortune but also to rise in society through taking on the polish of the established classes. He kept his country accent and his country manners, and he maintained the stubborn, even defiant independence of the man of the Franche-Comté vis-à-vis the superiorities of Paris. By thus contradicting and implicitly condemning the accepted model for the be-

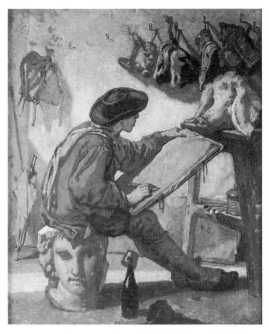

1.7. Thomas Couture (1815–79). *The Realist*, 1865. Oil on canvas. Study for a painting in the Municpal School of Art, Cork.

havior of the provincial in Paris—the model that was being established in his lifetime and that is so brilliantly elucidated in Zola's saga of the Rougon-Macquart family—he managed to offend that considerable part of the Parisian public that was actively conforming to the model. As time went on, certain more perceptive critics began to see a little more clearly into the truth of the matter: Edmond About, in his *Salon de 1866*, wrote that the "rustic of Ornans is a peasant of the Doubs the way that Metternich was a peasant of the Danube. His naiveté is composed of all the secrets, all the malice and all the delicacies of art."[32] But by that time the caricatural public image had a life of its own and was not receptive to modification. That there was plenty of venom fueling it Courbet discovered to his despair when he was caught in the toils of official revenge against the Commune.

The idea of the artist's overweening vanity was, of course, very much a part of this image. The fact that he was rather justifiably proud of his good looks as a young man really had very little to do with this, though the caricaturists had fun with the so-called Assyrian profile (fig. 1.8), taking off from the artist's self-portrait in the *Meeting* (pl. 19) and the *Painter's Studio* (pl. 11). What rankled was a much deeper matter: Courbet's claim to have studied tradition—that is, the paintings, particularly of the Spanish and northern schools, that he was able to see in Paris and the Low Countries—in order to free himself; his claim to have arrived at a valid point of creation without having submitted himself to the

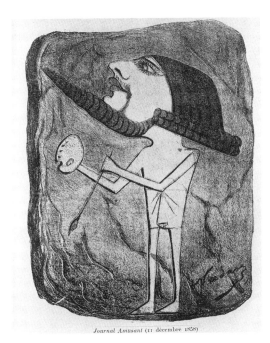

1.8. Nadar (Gaspard Félix Tournachon) (1820–1910). "Les contemporains de Nadar: Courbet," in *Journal Amusant*, December 11, 1858. Lithograph.

rigorous system of training of the Academy; his sense—from his point of view, a beleaguered sense, but from the outside an arrogant one—that indeed he was, as he told Nieuwerkerke, the only artist of his time to take on this immense role of making the art of painting something that would reveal the truth about himself and about the actual world in which he lived. This was of course an extravagant claim, and one can understand why About might write (this is eleven years earlier, in 1855, at the time of Courbet's unprecedented Pavillon du réalisme) that the artist had made his reputation in 1851 on scandal and celebrity, and that his head had been turned by it. "He proclaimed that he had no master, and that he was issued from himself, like the Phoenix. The phoenix is of all birds the one that loves himself the most: as son, he reveres the venerable father in himself; as father, he cherishes in himself the tenderest of sons."[33] The term *narcissism* was not current in these pre-Freudian days, but About has produced an apt image for the phenomenon; and of course the original classical image was readily available. Théophile Silvestre, an ostensible supporter, wrote about the artist in 1856 that he "has nothing violent about him except his love for himself; the soul of Narcissus has descended into him in its latest reincarnation."[34] This notion of Courbet's narcissism is a theme that has been kept alive through the twentieth century.[35] But when we examine it in its original context—that of the year 1855 in which Courbet reexhibited his notorious *Burial*, as well as the *Stonebreakers* and the *Young Ladies of the Village*, and ex-

hibited for the first time the *Meeting*, the *Grain Sifters*, and above all the *Painter's Studio;* the year in which he showed eleven paintings at the Exposition Universelle and forty at his own specially built structure near the Exposition grounds, advertised by the statement of his ambitions as an artist and as a man—we can begin to see the notion for what it is: a way of dealing, self-protectively, with a kind of force and ambition, with a "courage and impertinence" as Benedict Nicolson said in relation to the *Painter's Studio,*[36] that was deeply disturbing. One can sympathize with this disturbance, with the difficulty observers had in responding to the assertiveness of Courbet's paintings and the apparently overweening character of his ambition; it is natural to resist such claims out of the fear that they may be false. But there is no reason, with the perspective of time, to take on their weapons as our own.

"Breaking new ground" is such a cliché in our own day that it is difficult to imagine the original reality of it in a resistant culture. Courbet set out to paint his own life, and thereby not only opened himself to accusations of vanity and narcissicism but put himself into a very isolated position, a position lacking in cultural supports. It was bad enough to take on the Academy and the whole government-managed artistic system, particularly after 1852 when the hopes for the Second Republic had died and the Academy was linked with the Empire. Delacroix, twenty years Courbet's senior, had struggled with the system, too, and despised many of its products. But the older artist accepted its existence and its validating role, and he considered that the membership finally conferred upon him six years before his death was the proper, if belated, recognition of his talents and achievements. Furthermore, his was a mind still imbued with the classical culture, still able to work naturally with its signs and conventions; his solitude was tempered by his sense of intimacy with the great tradition in which the literary and the visual imagination were not divorced. Finally, as Castagnary noted, despite his uneasy relation with the Academy and the Salon, he did have important connections and support within the government during the years when he was establishing himself, while Courbet had no such support at all.[37] In 1868 Courbet wrote to Castagnary about the ridiculous rumor circulating, to the effect that he, Courbet, had presented himself for membership in the Academy on the death of M. Picot, a history painter who had been active in refusing his early submissions to the Salon.

Can you imagine that, because M. Picot was stupid toward me, I should then carry out reprisals against the poor begin-

ners in art? What they made me suffer of despair in my youth, must I now make others suffer? The idea is senseless . . . No, someone at last must have the courage to be straightforward and to say that the Academy is a body which is detrimental, consuming, incapable of accomplishing the object of its pretended mission.[38]

Courbet, of course, had been saying this for twenty years or more. The isolation caused by his refusal to admit the validity, the right to exist, of these institutions is evident enough, as is the power of self-confidence required to persist in opposition. A more subtle sort of isolation, and one calling for an equal force of self-belief, arose from the very novelty of his conception of painting. When he said that his ambition was to translate his own personality and his own society, he meant it in a way too literal for it to be taken seriously—or readily understood. To contemporary observers, the important thing was how well or ill his paintings conformed to existing standards of certain established, graded, types of painting: portrait, self-portrait, landscape, rustic genre. But Courbet's aim was not to succeed in these terms but in terms of his own making, where the standard of judgment would be the degree of authenticity and conformity to the painter's experience, the degree to which that experience is given convincing life. In May 1854 he wrote to Bruyas, speaking of his self-portrait *The Man with a Pipe* (pl. 8), which was to enter Bruyas's collection:

It is the portrait of a fanatic, of an ascetic; it's the portrait of a man disillusioned with the stupidities that serve as his education, and who seeks to establish himself in his principles. I have made in my life quite a few portraits of myself, in proportion as I changed my mental situation; in a word, I have written my life.[39]

And as his art matured beyond the youthful, self-exploratory self-portraits, he continued, in a different sense, to write his life, turning for his large, ambitious figure compositions to the people, the activities, and the setting of his native country town. These did not constitute a preordained genre of painting, but rather were the deepest elements of his existence, to which he turned in order to "achieve his own intellectual liberty." Among the freedoms his work announced was that of approaching a subject directly, of dispensing with the filter of narrative or dramatic intent. There are no stories to be told about the *Young Ladies of the Village* or the *Grain Sifters*, though many critics indulged in making them up. And although there is in a sense a "story" behind the *Meeting*, it is far from being conceived in the anecdotal mode common to the conventional painting of the period.

The painting celebrates what I take to be the most important relationship of Courbet's life, that with Alfred Bruyas, the art patron of Montpellier. Philippe Bordes, in the catalogue of the 1985 exhibition at the Musée Fabre, Montpellier, has given us a study of the man: complex, dreamy, eccentric, quite misunderstood by the family that controlled his funds, but determined to act on his belief in the art of his own time, filled with a kind of reverence for artists in whom he recognized a kindred spirit and for whom he would have liked to provide the independence necessary to their work. From the Salon of 1853 he bought the *Bathers* (pl. 17), the most controversial of the three paintings Courbet showed that year, as well as the *Sleeping Spinner* (pl. 16). A portrait of Bruyas—the *Tableau-Solution* (pl. 18) was also commissioned then. Seven more paintings were bought or commissioned the following year and four others acquired in later years. Courbet went to stay with Bruyas from the end of May through the end of September in 1854. After his return home he was extremely productive, even by his own high standards. By December of that year the *Meeting* was completed, and work had begun on the artist's masterwork, the *Painter's Studio*. Courbet called this painting a "real allegory"; the *Meeting*, in a more circumscribed way, partakes of the same character. Although Silvestre, once again an unreliable witness, maintained that it commemorated Courbet's arrival in Montpellier from Ornans, in fact he traveled by the new railroad; in the painting he represents himself as returning from a session of painting by the sea.[40] Thus the meaning of the painting centers not on anecdote but on the essentials of the relationship between Courbet and Bruyas, between the artist-producer and his supporter, the man whose desire it is to make the art possible. As Courbet wrote, shortly before setting off for Montpellier, "It is not we who have met one another, it is our solutions."[41]

Courbet's letters to Bruyas—published together in the proper chronological order and with full documentation in the 1985 Musée Fabre catalogue—reveal from the start how much of a stimulant Bruyas's patronage was to Courbet. For a time he was able to dream of making a living from his art without any threat to his principles or his conscience, and without having to make any compromises, any "paintings the size of a hand," in order to sell. He may have found it difficult to follow with any exactness the train of Bruyas's somewhat mystical thought, but he had no trouble responding to his encouragement, both moral and financial.

The two were in continuous correspondence during the months in which the *Painter's Studio* was being painted and in which Courbet was arranging to have built his own Pavillon du réalisme—an achievement that would have been impossible without the income from Bruyas's purchases and commissions. And though it is true that in the *Painter's Studio* Bruyas is only one of several figures who play significant roles in the artist's intellectual life—and that it was doubtless for that reason that the patron took a much greater interest in the *Meeting* than in the large manifesto-painting—nonetheless it is possible to suppose that Courbet's relation to Bruyas, given expression in the *Meeting,* also helped to generate the conception of the larger painting. Bruyas's support, coming when it did, had the effect of validating Courbet's convictions and confirming the role he was following; without him, it is possible though of course not demonstrable that even Courbet's powerful artistic ego might not have risen to the ambitious physical and conceptual scale of the *Painter's Studio.*

A measure of the importance of Bruyas to Courbet, even after the first enthusiasm was over, can perhaps be found in the sequence of events of 1857–58. In May of 1857, having weathered the storm of antagonism greeting his *Young Ladies on the Banks of the Seine* (pl. 32) at the Salon, Courbet made a return visit to Montpellier. This time he was accompanied by Champfleury, still a companion though not the enthusiast that he had been earlier in the decade. It was not the same kind of intimate visit that the earlier one had been, though Courbet wrote warmly enough upon his return to Paris in June. But in the August 15 issue of the *Revue des deux mondes* there appeared a piece called "Histoire de M. T." by Champfleury, in which the writer held up to ridicule in great detail a character that was readily recognized as that of his recent host.[42] As soon as he was told of it, Courbet wrote affirming his ignorance of the article, his anger with Champfleury, and his devotion to Bruyas; but Silvestre was again on hand to discredit his protests.[43] Not long afterward Courbet departed for Brussels, a city he liked, where his paintings were admired, he was well received, and the beer was very good. He stayed for many months (nearly a year), reportedly drank a lot, and produced very little. Although perhaps not a breakdown, it was certainly a significant break in the pattern of a life that had been consistently productive until that time. The episode reveals a vulnerability, a sense of losing the track, that could very well be related to the fact that in the same year there occurred not only a further rift with Champfleury, the rather disaffected champion of his early career, but also the rup-

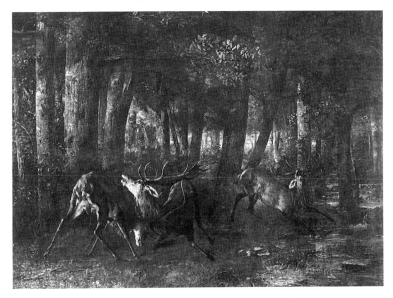

1.9. Gustave Courbet. *The Battle of the Stags*, 1860. Oil on canvas. Paris, Musée d'Orsay.

ture (not permanent, though the relationship was permanently changed) with Bruyas, his first and most important patron and the only one specifically to validate his own faith in himself.

What got him out of this slump in 1858 was an invitation to Frankfurt, where he found admirers, buyers, and hosts who introduced him to stag hunting in the grand style (see pl. VII). He had of course hunted since youth in his own countryside, where hunting was part of the ordinary subsistence of life, and had begun to draw upon this experience already in 1856, in the *Quarry* and *Doe Trapped in the Snow.* In Germany he would hunt on a more princely scale, and he would become enthralled with the magnificence of the great deer that became the protagonists of the *Battle of the Stags* (fig. 1.9) and the *Stag Taking to the Water* (pl. 35), both shown at the Salon of 1861. In April of that year he wrote to Francis Wey about his hunting in Germany, and about the experiences and detailed observations that went into the paintings. His enthusiasm was such that he considered the *Battle of the Stags* to have, in a different way, the importance of *A Burial at Ornans.*[44] It is hard not to sense a certain extravagance in this claim, masking the wish to recall a time of greater certainties, when his work was the center of fierce controversy and he could relish not only the attention but the sense of fighting on the right side. But there was nothing false in his feeling for the hunt or in his admiration for the great stags. He enjoyed the excitement of the chase, of pitting himself against the power of noble animals, but it was not this that he made the theme of his paintings.

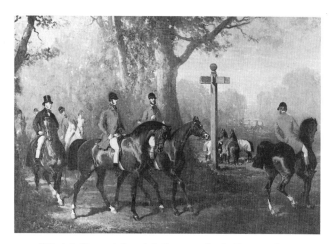

1.10. Alfred de Dreux (1810–60). *Departure for the Hunt*, c. 1850. Oil on canvas. Paris, Musée de la chasse et de la nature.

The Quarry (pl. VI), for example, has within it the minimal elements required for its ostensible subject: a huntsman, a hornsman to announce the event, hunting dogs, and a deer. The French title, *La Curée*, is a word with no adequate English equivalent. It refers to the moment of the hunt when, the deer having been surrounded and killed, the hunting dogs—strictly trained not to act on their instincts until this moment—are allowed to have their share of the quarry. In actual fact it is a scene filled with the violence of unleashed appetite, such that "la Curée" was used by Zola for the ruling image of the second novel in his series, the Rougon-Macquart, in which he explores the greed and passions of the rising profiteers in Second Empire Paris. But Courbet's painting, silent and dreamy, is as remote from this later implication as it is from the literal facts of the hunt. The fact that the central figure of the huntsman bears Courbet's features announces the importance, to the artist, not only of this particular painting but of the hunting theme itself. The deer, hanging to drain its blood, is as lithe and beautiful, and with as silky a coat, in death as in life. The dogs, the same pair as that in the Metropolitan Museum's painting (see chapter 5, fig. 5.5), where they are in dispute over a dead hare, here fill no role but are seen for their own sake. The same can be said of the great stags fighting in springtime, or the forest deer in the Minneapolis painting (pl. 73). The artist identifies as much, if not more, with the animals as with the hunters. But again it is not a sentimental identification, even though a deliberate element of Landseerian drama can be found in the Marseille *Stag Taking to the Water* (pl. 35). Courbet's animals are normally no more theatricalized than are his human figures. His paintings of the hunt and of forest creatures are, as were his figure paintings of the early 1850s, altogether differ-

ent from the typical paintings being produced for the Salon on similar subjects. The popular painter of hunting pictures of the day was Alfred de Dreux, whose fashionable hunting scenes (fig. 1.10) are remote from Courbet's conception of the theme. Yet, unlike his figure paintings, his paintings of the hunt and of deer *sous-bois* were successful at the Salon and with buyers. Observers and critics did not have to deal with the massiveness, the overwhelming close-up presence of his unidealized human figures in their often equivocal settings; they did not experience unsettling challenges to their social and political self-esteem; they did not feel so cheated of sentiment where animals were concerned.

None of these factors, of course, had anything to do with the seriousness or the authenticity of the paintings themselves. Yet at the time Champfleury, Thoré-Burger, and others saw them as a concession to the audience, a descent into the second-rate;[45] also an idea that lives on in the twentieth century, even to the quite extraordinary extent of seeing Courbet's work from the mid-1850s onward as a form of "official realism" deliberately amenable to the Empire.[46] More considered though equally severe versions of this view tend to dismiss his painting after the mid-fifties as lacking in political implication, subsiding into conventional genres, and generally submitting to the taste of the market. It is true that from the late 1850s Courbet's work can be described in terms of the established genres. It is also true that it was in this same period that he realized, after the cooling off with Bruyas and his 1855 exhibition's lack of financial success, that he could not dispense with the Salon, however odious its jury, and that he had to sell regularly in order to survive. It is in the decade of the 1860s that we find him being importuned by his dealers, such as M. Olin of Brussels, who was eager for him to finish and ship a group of marines and landscapes but upon their arrival in March of 1868 was sadly disappointed to find that one of the landscapes lacked the deer the artist had promised to include.[47] There is no doubt that, conditioned by a lifetime of embattlement and the need for self-justification, he overreacted to the pressures of the market. He sometimes worked carelessly, treating the familiar landscape and marine motifs by rote, as it were. His innovative use of the palette knife, so effective in articulating his response to the flaky, chalky walls of the cliffs of his native region, became on occasion a device for easy "effect." But it should also be kept in mind that Courbet belonged to the first generation that had to work for the market in just this way: sending paintings to foreign exhibitions, traveling to the cities—Brussels, Vienna, Munich—where the work was shown and there becoming some-

thing of a local celebrity; shipping pictures to dealers to be sold to anonymous buyers who did not respond to individual works of art but who wanted a "name" and a type of image. This was as much a part of "modern life" as were the contemporary subjects engaged by Courbet and his young successors, the Impressionists, and Courbet was by no means the only one to show signs of the pressure.

There is no warrant for dismissing Courbet's work of the 1860s as consumer goods or evidences of compromise with the regime. As to the latter, Courbet was only confirmed in his contempt for Napoleon III when, after the Salon of 1861, the emperor personally refused to follow his director's recommendation that the state buy the two widely admired paintings, *Battle of the Stags* and the *Stag Taking to the Water*.[48] Indeed, one could argue that it was during these years that, on at least two occasions, his unpopular political ideas got the better of his artistic judgment; in both the *Return from the Conference* of 1863 (now lost), an anticlerical satire, and the *Beggar's Alms* of 1868 (Glasgow Museum), a direct social criticism, the artist falls, via political propaganda, into a kind of theatricalized caricature that is far removed from his genuine figurative style.

When he continues, as he does in this decade, to draw upon his own authentic experience, he continues to produce powerful paintings. One cannot look with an unbiased eye at the *Rest During the Harvest Season* (pl. 74), to take but one example, without realizing how profoundly Courbet has transformed a conventional nineteenth-century theme in the light of his own experience and emotions. Like his human subjects, these animals reveal the artist's capacity to achieve a kind of identification with the objects he paints that is hard not to call love. In this painting Courbet incorporates the livestock of his home countryside into one of the most personal and pervasive themes of his art, that of the sleeping woman. The culminating treatment of this theme, and the masterwork of the decade, is the *Sleepers* (pl. 65), a painting made on commission for a man called Khalil Bey and sometimes thought on that account to represent a kind of pandering to a quasi-pornographic oriental taste. But in fact Khalil Bey, a Turkish diplomat, was a very sophisticated member of Parisian society who had one of the best collections of painting in Paris. It included Ingres's *Turkish Bath,* a challenge to Courbet to create an equally masterful image of a lesbian theme, in contemporary rather than oriental-fantasy terms.[49] The theme was as unsettling then as now, despite the sexual sophistication of both periods; in this painting Courbet both confronted it and transcended it. As for the conception of the nude, any

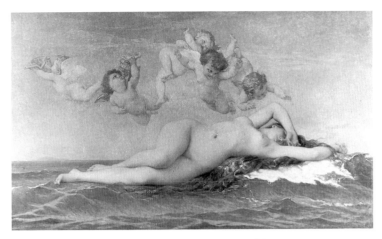

1.11. Alexandre Cabanel (1823–89). *The Birth of Venus*, 1863. Oil on canvas. Paris, Musée d'Orsay.

attempt to assimilate Courbet's work to Second Empire taste would have to deal with the profound differences between the *Sleepers* and, for example, Cabanel's *Birth of Venus* (fig. 1.11).

It is interesting to note that the unsuccessful anticlerical satire mentioned above was made during Courbet's long sojourn in the Saintonge in the west of France, where he stayed, with two short breaks, for almost a year from May of 1862. This was a productive time, during which he painted landscapes (see pl. 37), portraits (see pls. 39–40), and—a new theme for him, in terms of concentration—flowers. The masterpiece of the period, and one of the artist's most beautiful paintings, is Toledo's *Trellis* (pl. 41), in which the remarkably (for Courbet) lissome young woman plays the role of handmaiden to the central presence, that of a cascade of summer flowers. In this painting, there is no mistaking the quality of the artist's passionate observation of the colors and shapes of these products of nature's bounty. As he had found in Germany a new sense of the majesty of the hunt and its quarry, so in the Saintonge, as the guest of Etienne Baudry, he found a new sense of the glory of flowers.[50] Baudry was the friend of Jules Antoine Castagnary, the young critic who had become, in 1861, Courbet's astute and faithful supporter. It was he who took Courbet to stay with Baudry, a well-to-do landowner with a great interest in botany. Baudry became a patron, and though it was not on the same scale as the support of Bruyas, the relationship must have affected Courbet in an analogous way. Baudry's hospitality and Baudry's gardens and greenhouses made possible a series of freshly observed and beautifully painted flower compositions. That the passion did not outlive the setting only indicates the degree to which Courbet's art depended on direct personal experience.

That the experience had to be authentic, both emotionally and visually, and that ideology was pictorially inadequate, can be suggested by comparing the *Trellis* with what we know of the *Return from the Conference* (see chapter 5, fig. 5.1).

The serial character of the flower paintings does outlive the time at Saintonge. It is from the mid-1860s that we have the series of paintings of a new theme in the regional landscapes: the paintings of the river sources, those openings in the massive rock from which emerge the tumbling underground waters that will become the peaceful valley streams (see cats. 47–48). The sexual resonance of these natal images is undeniable and intensifies the power of the paintings. The series adds another chapter to Courbet's exploration of his own native landscape, in particular to his study of its characteristic cliffs and rock formations (see chapter 4). He loved these rocks and would keep an eye out for any similar formations when he traveled. In 1869 he wrote to his parents from Etretat on the Channel coast, where he would paint his last great seascapes (see cat. 77): "I'm doing fine at Etretat. It's a charming little corner. There are rocks bigger than at Ornans, it's very curious."[51] Perhaps it was the very size and impressiveness of the famous *falaise* that prompted Courbet to make the painting on a much larger scale than his previous Channel coast paintings.

These sea paintings were another new theme of the 1860s, and they were structured also in a serial manner, arising out of the experience of a new place. Courbet's first stay in Trouville was in the late summer and fall of 1865; the following summer he returned to the neighboring town—separated only by a narrow tidal river—of Deauville. His stay at Deauville was at the invitation of the young comte de Choiseul, who admired Courbet's work and would try to use his influence to persuade Nieuwerkerke to acquire a painting for the state. A letter of September 27, 1866, to Juliette tells her with a charming naiveté of the wonders of the count's house, where the manner of life is simple, but the appointments and service are luxurious. Each morning he is given a bathrobe and a pair of bathing-drawers, and he goes for a swim, just a few steps from the house. Amid the luxury, the young count's manners are simple and direct, "exactly like my own."[52] (The tone of this letter, and the way in which the artist responds to the count's unpretentious courtesy, is very much at odds with the view of Courbet as *narcisse paysan*.) He also tells Juliette that he has made a lot of paintings, particularly of the beach at Trouville. It is these coastal studies that can be seen in terms of series: the single wave, the stormy sea,

the empty beach at ebb tide. These paintings are studies in solitude; unlike Boudin or Monet, whom he knew in Trouville, Courbet goes no farther than the occasional presence of a drawn-up boat or two to imply human habitation. Like his landscapes of Ornans, his seacoasts are empty, apparently untamed, arenas of personal freedom, remote from the conflicts and restraints of life in Second Empire society.

That society came to its crisis in the summer of 1870, with the defeat of Napoleon III by the Prussian army; and in the bitter aftermath Courbet was crushed. Not right away—he was able, while recovering from prison, to paint a remarkable series of still lifes (see pls. 79–83) that embody his passion for reality and nature in the wake of the experience of interrogation and imprisonment—but finally, after the government's revenge and the exile. The story of Courbet's direct involvement in political life, from September 4, 1870, when the Republic was declared after the Empire's defeat, to June 8, 1871, when he was arrested as a Communard by the forces that had successfully suppressed the Commune during the "bloody week" of May 22, is not easy to summarize. There are masses of documents, including trial records and a substantial police archive dating from 1868, when he was first put under surveillance as a political dissident for having attended the anniversary celebration of Proudhon's funeral.[53] I think it important to try to summarize that history here because the whole issue is often dismissed as irrelevant to Courbet's art; and some very intelligent people, beginning with Zola, while admiring the art, have ridiculed the artist's naiveté and vanity in getting politically involved.[54] Courbet doubtless was naive in his Fourierist political optimism; but by staying in Paris throughout the Siege and joining the Commune in order to take part in what he saw as the liberalization of life and art in Paris, he acted bravely, and consistently, with his long-held beliefs. Although the result was ultimately destructive to him both as a man and as an artist, the action was one of moral authenticity, not unrelated to his sense of authenticity in art.

The central symbolic issue, which in the end destroyed him, was the charge of responsibility for the toppling of the Vendôme column on May 16, 1871. The irony of this, which would certainly have fueled the malice of his accusers, was that his chief role not only in the Commune but in the previous Government of National Defense had been the protection of the monuments and works of art of the city of Paris. Initially, Paris was being protected from the German Army; it was not until March 1871, when the Republic was perceived as hav-

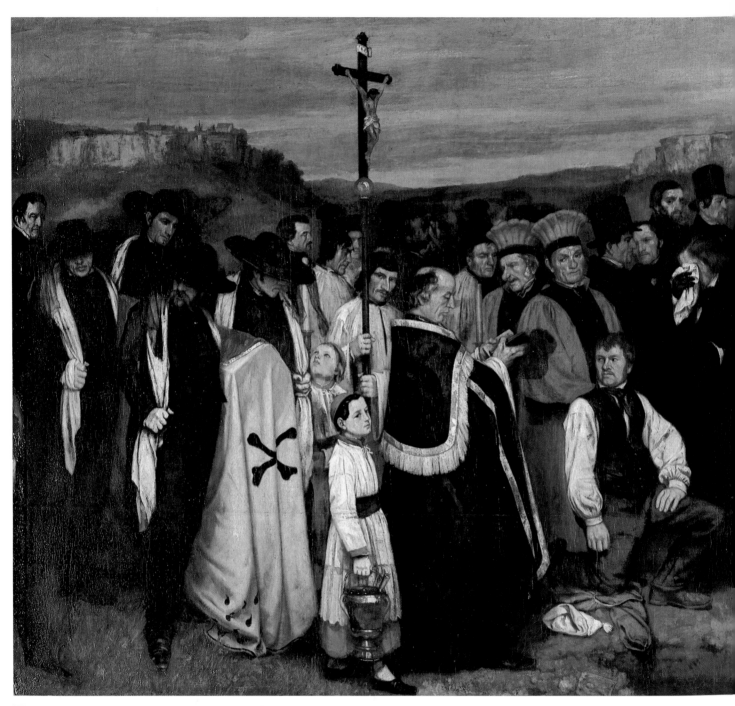

□ I. *A Burial at Ornans* (*Un Enterrement à Ornans*), 1850. Oil on canvas,
124 1/2 × 263 3/4 in. (315 × 668 cm). Paris, Musée d'Orsay.

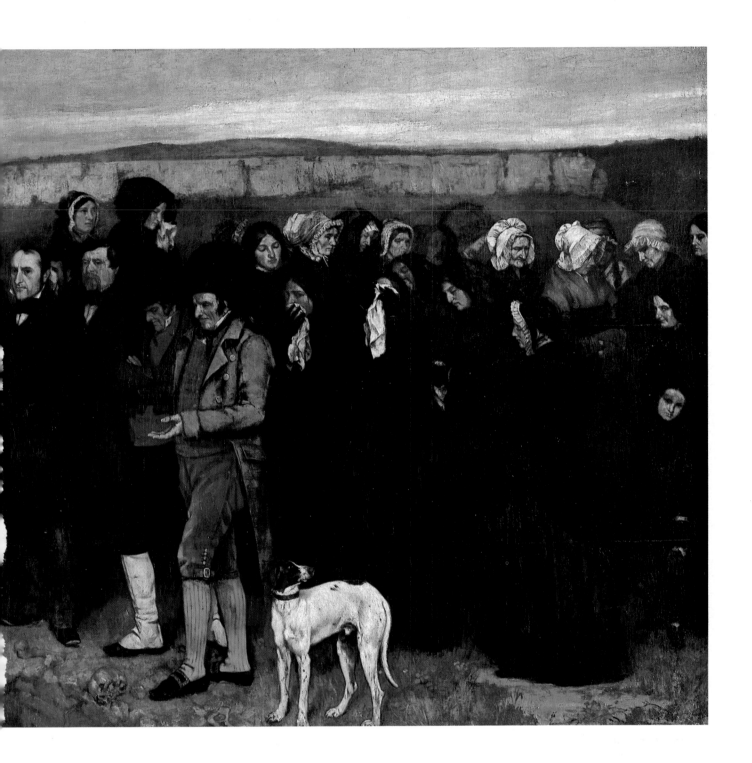

ing capitulated to German force, that the Commune was established. The enemy had changed—the struggle was now a civil war—but the problem of protecting works of art against the destruction of war remained.

There is ample evidence that Courbet was very active in this role.[55] It is also true that in October, as president of the arts commission, he had called for the removal of the Vendôme column from its place; the reliefs depicting the victories of the first Napoleon as well as the statue of Napoleon could, he thought, be removed to the Invalides or to a historical museum. In making this suggestion Courbet was speaking for a considerable body of opinion that viewed the column not as an important work of art—which indeed it was not—but as a political symbol, which it had been since its construction under the first Napoleon. In 1814 the returning Bourbons saw this quite clearly and substituted a flag for the toga-clad statue of Napoleon on top of the column.[56] Louis-Philippe, in a political gesture, put back another statue of Napoleon, this time in provocative military gear; Napoleon III, having established the empire once again, intensified the imperialistic symbolism of the column by having celebratory festivals around it each year. With its glorification of empire and military exploits it was a natural target for those who, like Courbet, believed that the defeat of empire meant not the defeat, but the rebirth, of a France devoted to peace and the well-being of its people. (Courbet had expressed this vision of the future in an open letter to the soldiers and artists of Germany, published in October 1870; its radical vision of a possible brotherhood between peaceloving Frenchmen and Germans, of the disappearance of frontiers and a united states of Europe,[57] would in itself have done much to infuriate the majority, for whom patriotism was defined as nationalism.)

In the end, the decision to take down the column was made much later, in April 1871, at a time before Courbet had been elected as a representative to the Commune government; he had nothing to do with the actual arrangements, which ignored his plan to remove the reliefs and the statue. The column was simply toppled, and popular opinion lost no time in associating Courbet with the deed (fig. 1.12). A week later the troops of the Versailles government were in Paris. Regardless of the column, Courbet would have been arrested as a participant in the Commune. But the symbolism of the column and its association with Courbet in the popular press gave it an exaggerated importance at the trial. Despite the people who either wrote or came to the trial on behalf of Courbet—including Barbet de Jouy, the director of the Louvre who had no love for the Commune but

1.12. H. Monreal. *Courbet Toppling All the Columns of Paris*, 1871. Ink drawing. New York, Private collection.

who respected Courbet's efforts on behalf of the collections[58]—he was fined and sentenced to six months of further imprisonment. This was an ordeal, but worse was to come. In May 1873, the new government of *l'ordre moral* voted a uniquely vindictive measure: the Vendôme column was to be reconstructed, with all expenses charged to Courbet. The amount was impossibly high; the government was already beginning to seize his paintings; after making arrangements to save as much property as he could, he went to Switzerland in July. While the imposed debt remained unpaid he could not return to France without an official pardon; it never came.

Despite a warm reception in Switzerland, Courbet was never able in the four years remaining to him to establish the kind of relation to experience essential to his art. He was ill; he was without his chosen environment and audience; he resorted to collaborators to get the work out and bring the money in. Not surprisingly, the one theme that became an obsession in these years was the Château de Chillon, on the lake not far from where he lived at La Tour-de-Peilz, a structure that was already a tourist attraction, to be sure, but more importantly a building known primarily as a prison. The prison and the mountains that barred him from France: these were the two subjects that he could engage with something of the kind of authenticity that was his hard-won, equivocal—one might even say, with suitable irony, Promethean—gift to the future.

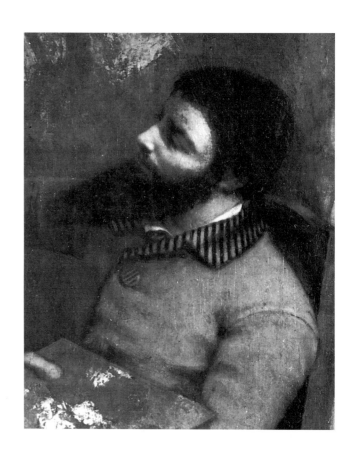

Courbet's Real Allegory: Rereading "The Painter's Studio"

Je fais penser les pierres
GUSTAVE COURBET

Allegories are, in the realm of thoughts, what ruins are in the realm of things.
WALTER BENJAMIN

One can effectively undo authority only from the position of authority, in a way that exposes the illusions of that position without renouncing it, *so as to permeate the position itself with the connotations of its illusoriness, so as to show that* everyone, *including the "subject presumed to know," is* castrated.
JANE GALLOP

Beginning from the Beginning: Wrestling with the Meaning

"It's pretty mysterious. Good luck to anyone who can make it out! (*Devinera qui pourra!*)," Courbet wrote to a friend about the big picture he was working on for the Paris Exposition Universelle in 1855.[1] The painting in question is entitled *The Painter's Studio: A Real Allegory Summing Up Seven Years of My Artistic Life* (pl. II). It represents, in a format reminiscent of the tripartite divisions of the traditional triptych, an oddly assorted group of people in an artist's studio, assembled around the central focus of the figure of Courbet, who is shown working on a landscape, in the company of a nude model, a ragged little boy, and a sumptuous white cat. To the left are those whom Courbet described in a cru-

cial letter to his friend and supporter, Champfleury, as "the world of commonplace life"; to the right is a less anonymous group, including such recognizable figures as Champfleury himself, the poet Baudelaire, and the philosopher P.-J. Proudhon, a group that Courbet refers to in the letter as "his friends, fellow workers, and art lovers."[2] People have been struggling to figure out the meaning of the painting ever since Courbet issued his challenge. The title is almost as enigmatic as the painting it glosses, but it does provide an invaluable key to the interpretative strategy most suitable for unlocking the iconographic code of the *Painter's Studio:* in it, the painting is specified as an allegory.

According to Littré's *Dictionnaire*, the highest authority on French definitions, the term *allégorie* means: "Saying something other than one appears to say. A kind of continuous metaphor, a species of discourse presenting a literal sense but intended, by way of comparison, to convey another sense which is not expressed."[3] "In the simplest terms," says Angus Fletcher in the introduction to his magisterial study, *Allegory: The Theory of a Symbolic Mode,* "allegory says one thing and means another."[4]

Even without the title, however, the visual evidence alone might lead us to suspect that Courbet was working in the allegorical mode in the *Painter's Studio.* The confluence of this oddly assorted group—which includes a rabbinical looking figure, a clown, a beggar woman, an elegantly dressed couple, a ragged child, a famous poet, a naked model, and, in the center, the artist himself, natty in a bottle green jacket and horizontally striped trousers—cannot be accounted for in terms of any sort

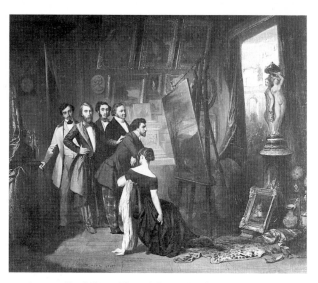

2.1. Auguste Barthélémy Glaize (1807–93). *The Interior of the Cabinet of Alfred Bruyas*, 1848. Oil on canvas. Montpellier, Musée Fabre.

of internal logic: clearly, this crew is not meant to represent a group of actual visitors to the painter's studio, such as is the case in a nearly contemporary work, no doubt known to Courbet, by the Montpellier painter, Glaize (fig. 2.1). Only allegory, it would seem, could account for the strangely muted, isolated, fragmentary, and, indeed, alienated, effect produced by Courbet's painting. *The Painter's Studio* seems bathed in a palpable atmosphere of melancholy, the melancholy of lost presence. Unlike the normal narrative painting of the time, and in contradistinction to the rules of academic composition generally, the *Painter's Studio* offers the viewer no meaningful interaction among the figures, no story-producing give-and-take of gesture or attention. Poses are, with rare exceptions, apparently unmotivated: each figure seems frozen into place the way children "freeze" into odd or haphazard postures in the game of "Statues"; no figure is made to seem aware of or to pay attention to any other. It is precisely this strange, dead, frozen quality marking the composition of the *Painter's Studio* that tells us that the key to its significance lies somewhere outside the perimeters of the painting itself; that there is information to which we, the viewers, are not immediately privy controlling the system of meaning here. Faced with the striking absence of "natural" relationships within the framework of the pictorial given in an allegorical painting like the *Painter's Studio*, the viewer is forced to conceive of its significance as problematic.

Courbet, the artist, plays a dual role in relation to the allegorical meaning of the *Painter's Studio:* he is figured within it as one of its personifications—indeed, as its leading character—but at the same time, he has also chosen to play a role outside it in relation to its meaning. That is to say, in his customary provocative way, he provided his friends, and the present-day viewer, with some confusing hints about his general intentions in the *Painter's Studio,* as well as a deceptively generous amount of data about the surface identities of the individual figures within it. At the same time, in the same document, a long letter to his friend and supporter Champfleury (like Courbet himself, a character in this charade), the artist deliberately withholds information about the arcane, hidden meaning of the allegory, although he constantly drops broad hints about its existence, teasing the reader-viewer like a naughty child with a tantalizing secret. "I have explained all this very badly, the wrong way round," he concludes lamely after his unrevealing enumeration of almost every item in the picture to Champfleury, "I ought to have begun with Baudelaire, but it would take too long to start again. Make it out as best you can. People will have their work cut out to judge the picture—they must do their best."[5]

Although many of Courbet's contemporaries rejected the artist's attempt to suggest that his work hid profound meaning as characteristic pretentiousness and obscurantism,[6] more recent art historians have certainly taken Courbet at his word. Responding to his challenge, they have attempted to subdue the recalcitrant hidden meaning of the *Painter's Studio* like wrestlers—Courbet's own painting by that name provides a suitable painted equivalent of the situation (fig. 2.2)—in hand-to-hand combat. Ever since the painting first appeared in the Louvre, in 1920, they have been attempting to decipher the meaning of Courbet's allegory, both as a general program and in terms of the individual elements within it. Such attempts have included the objective documentary approach of Huyghe; the imaginative, wide-ranging interpretation of Werner Hoffman; the more empirical analyses of the late Benedict Nicolson, and of Alan Bowness; my own reading of the work as a Fourierist allegory; and James Rubin's interpretation of it as a Proudhonian one.[7] All of these interpretations, however, were based on a more or less literal acceptance of the identity of the figures in the left-hand group, the "world of commonplace life," as Courbet had described them in the crucial letter to Champfleury: the Jew was a figure he had seen once in England; the curé was simply a curé, the huntsman a huntsman, the old-clothes man just that. Their allegorical function, it was believed, was simply to represent different aspects of the social order, to create an anonymous opposition to the world of

2.2. Gustave Courbet. *The Wrestlers*, 1853. Oil on canvas. Budapest, Museum of Fine Arts.

"shareholders," constituted by the concrete portraits of Courbet's friends on the right.[8]

Then in 1977, on the occasion of the great exhibition celebrating the centenary of Courbet's death, Hélène Toussaint of the Louvre made an interpretative breakthrough. Starting from a hint given by Courbet himself within the letter to Champfleury about the identity of the "weather-beaten old man" next to the curé,[9] she discovered that most of the figures on the left-hand side of the painting had specific if well-hidden identities. Far from constituting mere general references to the poor and downtrodden masses, each one referred to a specific, generally contemporary, public figure.[10] The adjective *real* describing the allegory in Courbet's title could now be understood not merely as a paradoxical allusion to the putative realism of the artist's style, but rather as a reference to the work's status as a commentary on real-life political events and positions. Its "real" meaning rescued from obscurity, the *Painter's Studio* could now be read once again—as it originally must have been, if only by a relatively small group of initiates—as a kind of political cartoon writ large.[11] The "weather-beaten old man" was now revealed to be a portrait of Lazare Carnot, once a member of the Convention, who had had a checkered career under subsequent governments;[12] the Jew was apparently a disguised representation of the contemporary financier and statesman, Achille Fould, a warm supporter of Emperor Napoleon III who had been Minister of Finance from 1849 to 1852. The "curé" was actually the reactionary Catholic journalist, Louis Veuillot; the figure identified in the letter to Champfleury as an "undertaker's mute" was in fact the editor Emile de Girardin, who had initiated popular journalism in France in the 1830s.[13] The "old-clothes man" (*marchand d'habits-galons*) could be identified with Louis Napoleon's close associate, Persigny, who was nicknamed the "hawker" of the *Idées napoléoniennes,* a tract written by the emperor; and the huntsman behind him to the left regarded as the representative of the Italian Risorgimento in the form of Garibaldi.[14] The man in the cap, in Toussaint's reading, would be Kossuth, representing insurgent Hungary, a figure not, in fact, mentioned by Courbet in the important letter to Champfleury but inserted later; the man with the scythe is now to be read as a portrait of Kościuszko, standing for the Polish freedom movement; and the laborer with folded arms next to him a portrait of Bakunin, representing Russian socialism.[15]

Most startling of all, given Courbet's supposed animosity to the Second Empire and all that it stood for, as well as the fact that direct representation of the Imperial person in cartoons or caricatures was forbidden by the régime, was Toussaint's convincing identification of the booted and mustachioed figure with the hunting dogs who dominates the left foreground as a covert representation of Emperor Napoleon III himself.[16]

Having made these crucial discoveries about the hidden, and manifestly contradictory, agenda of the *Painter's Studio,* Toussaint was understandably reluctant to draw any sweeping conclusions from them. Instead, she ended her decoding of Courbet's real allegory with a series of questions about the implications of this oddly assorted assemblage on the left-hand side of Courbet's painting. "Was Courbet," she asks, "being pessimistic or cynical when he assembled the 'betrayers of the Republic' on the left-hand side of his picture, as if to show that the best way of achieving dictatorial power is to use democracy as a stalking-horse? Is his work a testament of hope or disillusionment, an Inferno or a Paradiso, a farce or a tragedy? Is its message one of total forgiveness or total skepticism?"[17]

Shortly thereafter, a young German scholar, Klaus Herding, responding to the challenge of Courbet's allegorical conundrum, now rendered even more complicated by the presumed political identity of the figures on the left, wrested a complex and convincing solution to the meaning of the *Painter's Studio* from Toussaint's discoveries. In addition, Herding provided convincing answers to the more general questions of interpretation raised by the *Painter's Studio.* In an article entitled "The Studio of the Painter: Meeting Point of the World and Site of Reconciliation,"[18] Herding responded to Courbet's challenging "*devinera qui pourra!*" with an interpretation of the *Painter's Studio* that was at once analytically incisive and synthetically inclusive. Basing his reading of Courbet's real allegory on the long but still viable tradition of the *adhortatio ad principem,* or exhortation to the ruler, Herding interpreted the painting as a complex pictorial lesson designed for the instruction and edification of Emperor Napoleon III. Herding correctly and convincingly reads, and makes sense of, Courbet's hidden intentions in this work: to teach the emperor, on the propitious occasion of the great Exposition Universelle of 1855, a lesson of rulership. In Herding's view, Courbet in the *Painter's Studio* set out to construct a vast didactic panorama of reconciliation, of peaceful coexistence and harmony among opposing factions, classes, and nations—to create an allegorical "balance of power" in short—organized around the redemptive and productive centering of the artist who is

himself in harmony with the source and origin of all so-
cial and personal reconciliation: unspoiled nature, rep-
resented by a landscape of Courbet's native Franche-
Comté on the easel before him.[19] Herding has ac-
counted for every aspect of the painting's iconography
and has satisfactorily contextualized it within the histor-
ical and discursive framework constituted by the Ex-
position Universelle, with all its attendant hopes and
ambitions. One might say that from the standpoint of art
history, indeed from that of a social history of art, Herd-
ing, in his closely reasoned and masterfully inclusive ar-
gument, has finally solved the riddle of the *Painter's
Studio.* The search for meaning is apparently exhausted:
there is nothing left to discover. We have come to the
end of interpretation.

Beginning with the End: From Work to Text, or The Allegorical Fumble

Having written this, I immediately feel a twinge of an-
noyance; indeed, a surge of rebellion. I have been put in
a position of intellectual distress. It would seem that the
more I know about the *Painter's Studio,* the less access I
have to collaborating in the production of its meaning.
There would seem to be nothing more to say about
Courbet's painting, no room for doubt: the interpreta-
tion is finished, the airtight case is closed; I, and by im-
plication, every other viewer, have been shut out of the
house of meaning. The only way I can get back in, it
would seem, is by bowing down to authority, and I don't
bow easily; in fact, I don't usually bow at all. What I
would like to do is force the doors, or, shades of De-
lacroix, storm the barricades! Partly, this feeling has to
do with the role of authorial authority in allegory, an au-
thority that calls forth a similar authoritativeness, not to
say authoritarianism, in its interpreters. Allegory, to
borrow the words of Angus Fletcher in his discussion of
the literary variety, "necessarily exerts a high degree of
control over the way any reader must approach any
given work. The author's whole technique 'tries to indi-
cate how a commentary on him should proceed.'
. . . Since allegorical works present an aesthetic surface
which implies an authoritative, thematic, 'correct' read-
ing, and which attempts to eliminate other possible
readings, they deliberately restrict the freedom of the
reader." Allegory, continues Fletcher, "does not accept
doubt; its enigmas show instead an obsessive battling
with doubt. . . . [The reader] is not allowed to take up
any attitude he chooses but is told by the author's de-
vices of intentional control just how he shall interpret
what is before him."[20] My distress may also be related
to the way that the devices of allegory seem to accord so
effortlessly with the hermeneutic practices of art history
itself, in which the production of meaning is all too
often foreclosed by restricting its operations to the field
of iconography, and within it, to unequivocal interpreta-
tions. Art history in this sense may be understood as an
allegory of allegory: a rebuslike translation of elements
in the pictorial "program" into verbal equivalents, with
an edifying synthesis at the end. Meaning is understood
to be finite, the interpretation of meaning restricted for
the most part, as in allegory, to deciphering the inten-
tions of the author. I seem to be faced with an open-
and-shut case, the end of interpretation rather than the
beginning; the suppression of doubt and ambiguity
rather than an opening up to them; the death of mean-
ing in the painting rather than its vivification.

2.3. Jean-Auguste-Dominique Ingres (1780–1867). *The Apotheosis of Homer*, 1827. Oil on canvas. Paris, Louvre.

This sort of interpretation, based on the assumed authority of the One Who Knows, while necessary from the vantage point of art history, tends not merely to close off the possibility of interpretation rather than opening it, but even more dubiously, to militate against coming to terms with the myriad concrete meanings produced by the painting itself, independent of any intentions of the artist and at times in opposition to his intentions. Although Courbet may indeed have meant to create a grand vision of harmony, the *Painter's Studio* in its existence as a system of signs producing meanings is anything but harmonious. This is so for several reasons. First of all, because allegory can be looked at from a very different viewpoint from that of authoritative closure and constriction of meaning; rather, it may be understood as a mode that operates in a theater of disjunction and disengagement. The presence of allegory signals to us the very opposite of that system of organic unity presupposed by the vision of harmony Herding has convincingly demonstrated to be present in the *Painter's Studio.*

Courbet as an artist came to maturity at a time when political revolution and, later, the failure of political revolution destabilized all socially produced meanings, calling such meanings, including the meaning of art,

into question. Like most of the interesting painters of the mid-nineteenth century, working in the uncertain space between the older Academy-Salon system and the still nascent one of free enterprise production for an uncertain public and an equally uncertain private market mediated by dealers, Courbet realized that he had to choose a way of painting: he could not merely inherit one. It was unclear where painting was going; what relation it had to tradition; what constituted a new or modern direction for art. What indeed was "tradition" in the 1840s or 1850s? Could it be understood as anything but fragments, ruins, fleeting and partial visions?

Allegory, as Walter Benjamin suggested in his great study of German Tragic Drama,[21] bears a natural affinity to disintegrative moments of history: times that are not merely disorganized, but, so to speak, "dis-organicized"; when the ideological assumptions holding things together and the power structures engaging with such unity begin to fall apart—when the center no longer holds. "Allegory," says Fredric Jameson in his penetrating analysis of Benjamin's study, "is precisely the dominant mode of expression of a world in which things have been for whatever reason utterly sundered from meanings, from spirit, from genuine human existence."[22] Central to Benjamin's understanding of alle-

gory, in his *Trauerspiel* study, is its wresting apart of the unity of signifier and signified, what is often, in the case of metaphor, and by extension, in the case of allegory, referred to as the "vehicle" and the "tenor" of the figure;[23] its insistence upon the material density and independence of the signifier, and the dead, mutilated insubstantiality of the signified. Allegories like Courbet's, in attempting acts of visible reunification, inevitably show their hand: "The more things and meanings disengage, the more obvious become the material operations of the allegories that fumble to reunite them," declares Terry Eagleton in his discussion of Benjamin's *Trauerspiel*.[24] "Fumble" is certainly the operative word here since no allegory ever succeeds in its attempted reunification. Indeed, there is a certain dark, even tragic pessimism implicit in the way allegory reenacts the dilemmas of disconnectedness, dilemmas that perhaps, in the last analysis, are not merely moral and epistemological, but ontological. Given what Jameson, in the analysis of Benjamin's *Trauerspiel* cited above, terms the "historical impossibility in the modern world for genuine reconciliation to endure in time," allegory becomes "the privileged mode of our own life in time, a clumsy deciphering of meaning from moment to moment, the painful attempt to restore a continuity to heterogeneous, disconnected instants."[25]

Of course, to return to the nineteenth century and to painting, there is allegory and allegory. Ingres, in his allegory of the position of art and the artist, *The Apotheosis of Homer* (fig. 2.3), constructs a figural equivalent of the most rigid authority, firmly positioning each figure within the hierarchy of creative achievement on either side of Homer, the blind father figure of all art, who holds sway in the exact center of the composition. The figure of the artist here rules over his belated cohorts with the hieratic authority of an archaic Zeus. In the *Apotheosis of Homer*, history is transformed by the allegorical impulse into an enabling myth of origins under the aegis of the classical, ordered by static symmetry into a permanent emblem of the pedigree and permanence of power. Aesthetic control in Ingres's work is overtly equated with a politics of domination. An almost desperate smoothness of surface, a near compulsive perfection of finish here anxiously attempts to secure a conviction of the perfect unity between things and meanings. Yet it is interesting to see to what extent Ingres has failed to convince us of the absolute authority of his expression of artistic totalitarianism; how, exactly because Ingres works so hard at the *retour à l'ordre*, we are made more than ever aware of the arduousness of the effort at the expense of the as-

sumed "naturalness" of the order he tries to instate. No more than in Courbet's far more destabilizing and imperfect allegorical image does the relation between form and meaning seem natural in Ingres's work, much less convincing. This of course has something to do with the history of the nineteenth century, not just the history of its art. To repeat Eagleton's phrase: "The more things and meanings disengage, the more obvious become the material operations of the allegories that fumble to reunite them." In the case of the allegorical mode operating in the *Painter's Studio*, its "material operations" are made all the more evident by Courbet's realist language, which calls our attention unrelentingly to the disjunctions between the things represented and their latent meanings, surely the very opposite of a "harmonious" relationship. But it is precisely in that "fumble"—that uncolonized territory between ball and hand, as it were—in the gaps between things and meanings, that is to say in the failure, spatially, to restore unity to fragments or, temporally, to impose continuity on disconnected instants, that the really interesting meanings of Courbet's allegory are produced: what one might be justified in calling the "real allegory" of the *Painter's Studio*.

What is interesting to me, as a reader who has been shut out of the house of meaning, is how Courbet's allegory fails, how it cannot create a complete and finished system of meaning. It is, after all, both figuratively and literally incomplete and unfinished—therefore, in Baudelairean terms, open to the infinite interpretative field of the imagination. This encourages me—and all those who insist on enjoying art as a text rather than merely consuming it as a work, to borrow Roland Barthes's terms—to collaborate in the production of meaning in Courbet's allegory.[26] For Courbet's real allegory is, in an important sense, also an allegory of the unfinished, of the impossibility of ever finishing in the sense of imposing a single, coherent meaning on a work of art.

Because it is literally unfinished, it is more than ever possible to consider the *Painter's Studio* as a field of uncertainty, in which vague and more substantial incidents rise, assert themselves for a while, and then fade away on the vast projective screen of the canvas. The slippery flow of unfixed meaning, the interminable production of significance has a material source in the painting's incompleteness. Undoing the phallic illusions of the author as well as the authority of the central image of the artist, an image that speaks to our own phallic illusions of plenitude, the unfinished condition of the painting

counters the apparent closure of Courbet's *tableau vivant* by creating other meanings, totally apart from authorial intentions and often working against them.

The unfinishedness of the *Painter's Studio* is a major element enabling me to read it against the grain. In the most literal way possible, the *Painter's Studio* speaks itself as an unharmonious fumble: it is, after all, unfinished, incomplete: can one really speak of an incomplete harmony, an unfinished unity? The fact that the *Painter's Studio* is unfinished is rarely discussed in terms of the meaning of the work.[27] Generally, it is simply mentioned as a contingency with little or no effect, simply an empirical accident in the history of the painting's creation. Courbet, it seems, caught jaundice and, despite working day and night, was unable to bring it to completion in time for the deadline for the submission of works to the jury of the Exhibition Universelle.[28] Yet of course, even speaking on the level of biography and personal intention, Courbet could have finished it after the fact if he had wanted to or been able to. For whatever reasons, it is an unfinished painting and our reading of it must be based on it as unfinished or, rather, as partly sketchy, with elements barely adumbrated, and partly richly painted, quite highly wrought: I maintain that this equivocal and disharmonious condition of the work must enter into our reading of it as much as its iconography, for it produces meanings as much as, though in a different way from, the iconography. *The Painter's Studio* would be a very different work, would mean something very different if it were completed, finished as highly as an allegorical painting like Ingres's *Apotheosis of Homer.* Indeed, one might say that the air of "mystery" by which the work is so frequently characterized is produced just as much by its unfinishedness as by its "hidden" iconographical implications, and that the mystery produced by this sketchiness, or figural unclarity and openness, continues even after and in opposition to the clarification provided by the authoritative readings of the hidden message of the piece provided by Toussaint and Herding. As such, the *Painter's Studio* constitutes an allegory of unfinishedness.

So far, I have been using "unfinished" and "incomplete" as though they were the same thing. Indeed, they are almost synonymous in English, although not in French. Baudelaire, in fact, in his famous discussion of the subject, made a good deal of the difference between a work that is completed (*fait*) and a work that is finished (*fini*). "In general," maintains Baudelaire, "what is *complete* is not *finished,* and . . . a thing that is highly *finished* need not be *complete* at all."[29] Courbet's *Painter's Studio,* however, is one of the few major paintings to be both in-

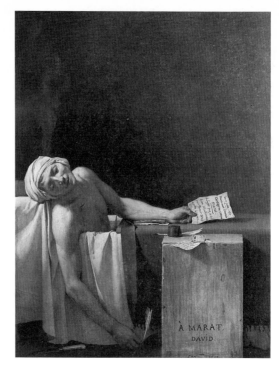

2.4. Jacques Louis David (1748–1825). *Death of Marat,* 1793. Oil on canvas. Brussels, Museum of Fine Arts.

complete, that is to say, left unfinished by the artist, and at the same time, not highly finished in many of the parts that the painter did bring to completion. Ironically, the painting is least highly "finished," is most overtly unmanipulated pigment, just where one might say it is most "complete"—in that part of the image of the artist where he may be said to demonstrate the originary roots of art: in the demonstrable lumps of highly visible paint on his palette.

Now there is a historical precedent for this contrast between the sketchy, with its overtones of evocation, of openness to imaginative possibility, and the finished, which implies perfection, closure, and deliberateness, and painters have long used this contrast to produce meanings.[30] There is one order of meaning in quite classical painting where a certain vagueness or sketchiness, an obliteration of clarity and specificity, has a primary function: that is, in producing significations of temporal distance or of universality. In David's *Marat* (fig. 2.4), for instance, the vaguely adumbrated background removes the dead figure, with all its specificity of circumstance, from the immediate present and sets it in the vast, unclarified spaces of History and Universal Truth. This speckled, luminous surface works on us like some angelic choir singing the hero Marat's praise in the background, moving us both backward in time to ennobling historical precedent and forward to a Utopian future. Closer to Courbet's time, Thomas Couture, in his *Romans of the Decadence* (fig. 2.5), used the relative

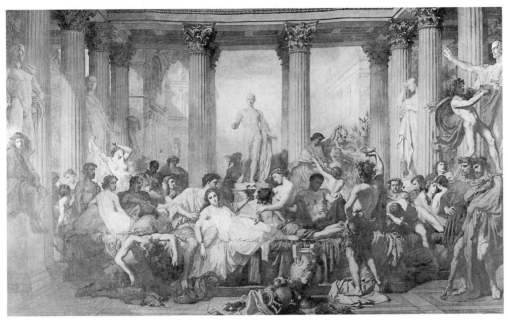

2.5. Thomas Couture (1815–79). *Romans of the Decadence*, 1847. Oil on canvas. Paris, Musée d'Orsay.

sketchiness of the depths of his painting to suggest a kind of pictorial pluperfect, the past within the past: a time, in fact, when the Romans had been upright and self-denying, the very opposite of decadent. In Courbet's *Painter's Studio*, the contrast between the parts of the painting that are merely adumbrated as opposed to those brought to completion also work to create temporal distance: his own past, explicitly cited in the title by the phrase "seven years of my artistic life" and constituted by the paintings hanging on the back wall, is hardly more than a ghostly presence, through whose transparent skeleton the texture of the canvas makes its appearance. Although in the letter to Champfleury, Courbet mentioned specific titles—*The Return from the Fair* and *The Bathers*—of works to be depicted on the back wall, they are hardly recognizable as individual works. Rather, there is a constant shifting taking place between our awareness of these "canvases" defining the back wall of the studio in the painting as painted images, and the intrusive presence of the actual canvas that serves as a support to the painting itself.

This perceptual oscillation between represented surface and literal one serves further to undermine the reading of the *Painter's Studio* as a finished product and to render it open to interpretation as process, a process of paint coming into being as form on canvas. Similarly, the contrast between the completeness and plenitude of the central section and the relative thinness and insubstantial vagueness of many portions of the lateral areas,

as well as the light and dark contrast between them, tends to deemphasize the social and political community "in the wings," as it were, in favor of the dominating group of the individual artist, his work, and his model, along with his two wealthy patrons. Inconsistencies of scale add to the sense of floating vagueness complicating the spatial relations of the *Painter's Studio:* figures in the rear of the painting, like the worker's wife, are so small in scale that they seem illogically distant; the position of the lovers on the right is undefined and indefinable; the back wall of the studio provides a spatially uncertain, as well as an almost transparent, boundary for the composition. The fact that Courbet based most of his images of his friends and associates—Champfleury, Bruyas, Buchon, Baudelaire—on preexisting portraits he had made of them, rather than having them come and pose for him in the studio, adds to my sense of the painting as a collage of temporally fragmented and materially unintegrated parts, in this case, parts obtained by a reappropriation of his own previous work.

As I look at the unfinished *Painter's Studio* with a full awareness that it is unfinished, that it is, in essence, a construction of fragments more or less successfully but by no means finally or definitively sutured together, hence, eminently deconstructable, and/or reconstructable, separate motifs begin to detach or combine themselves, insisting on their fragmentary presence, refusing to reintegrate themselves within the totalizing authority of the composition as a whole. One motif in particular

floats up from the brownish, undersea depths of the painting, commanding my gaze. What thrusts itself most insistently on my attention is the motif on the left—which can be read as a miniature allegory in itself—constituted by the descending trio of the *croque-mort;* the skull on the newspaper; and the black-clad Irishwoman, whom Courbet claimed he had seen "in a London street wearing nothing but a black straw hat, a torn green veil and a ragged black shawl, and carrying a naked baby under her arm."[31]

If an allegory is, as Benjamin has stated, in some sense a ruin, then the impoverished Irishwoman, emerging from the *non finito* of Courbet's composition, is the very epitome of allegory; at the same time, in the context of Courbet's iconography, she can be read as a figure more concretely signifying the unfinished. As Herding has pointed out, in his reading of the *Painter's Studio* as an *adhortatio ad principem*, this exhortation "implies mourning, warning and hope: a silent mourning is articulated with the mother dressed in rags, sitting near the feet of the Emperor; she proves drastically that his promise to eliminate poverty had by no means been fulfilled—after all Louis-Napoleon had written a book in 1844 bearing the title *De l'extinction du paupérisme*."[32] The ruinous Irishwoman, then, stands for unfinished business, an incompleteness in the realm of the political as well as that of the pictorial, a fumble in the unifying modality of allegory itself—an *aporia* in the realm of Utopian possibility.

Herding contrasts the beggar woman with the figure of the emperor, as a signifier of unfinished political business, but there are other important oppositions established by the figure. There are, first of all, intertextual readings within the history of art itself that endow this melancholy mourning figure, a figure of lack par excellence, with new significances: the historically delimited meaning embodied in Louis-Napoleon's failure to "extinguish" poverty is only the tip of the iceberg. I propose to read the Irishwoman as a modern figure of Melancholy. As such, within the context of a feminist hermeneutics,[33] she points directly back to the great mother figure of Melancholy herself, Dürer's *Melancolia I* (fig. 2.6), which, in a certain sense, can also be figured as the mother of allegory as it has been interpreted for our times.

At the heart of Walter Benjamin's study of allegory lurks *Melancolia I*, that massive emblem of saturnine genius disenabled, unproductive, in mourning for what one might think of as both a lost transcendence and a damaged immanence: the loss of meaningfulness itself. Indeed, a whole section of Benjamin's study of the

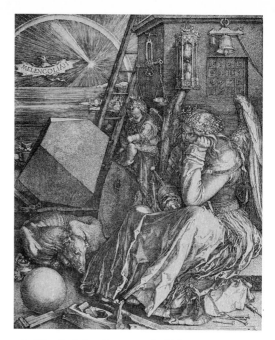

2.6. Albrecht Dürer (1471–1528). *Melancolia I*, 1514. Engraving. The Brooklyn Museum.

Trauerspiel is devoted to the subject of melancholy, of which Dürer's *Melancolia I* is the founding image and a constantly reinvoked object of contemplation. Benjamin associates melancholy with many other emblems. The prophetic wisdom of the melancholic is especially associated with the netherworld: "For the melancholic," he says, "the inspirations of mother earth dawn from the night of contemplation."[34] Norman Bryson elaborates on Benjamin's meditation on this figure by declaring:

In Dürer's Melancolia I, *the world ceases to be plenitude and becomes first allegory, existing piece by piece to transmit its emblematic meanings; but then once the allegory has been grasped and the content of signification has been released, the world is emptied, drained, sorrowful. Its signification has gone, the world persists but it has now lost something that can never be replaced or retrieved—its meaningfulness. After their excited discharge of meaning, its objects are spent, and the game of melancholy follows on the gaze of allegory. Dürer is clearly the classical source of statement of the connection between meaning and sadness . . .*[35]

The "connection between meaning and sadness" is clearly at stake in any serious interpretation of Courbet's figure of the beggar woman as she relates to the overwhelming precedent of Dürer's *Melancolia I*. If, in addition, like Dürer's *Melancolia*, the beggar woman is indeed an allegorical figure, which she surely is, then her meaning is subject to almost endless interpretation. In other words, she cannot be reduced to standing

merely for poverty or the condition of Ireland or any other single "tenor." Both her meaning and her sadness are too large for this. If, says Benjamin, allegory " 'enslaves objects in the eccentric embrace of meaning,' that meaning is irreducibly multiple."[36]

I am in this instance insisting upon another aspect of allegory, one almost diametrically opposed to the one I posited above when I complained so bitterly about the authoritarian control the allegorist, Courbet in this case, maintained over the reader-viewer, and the authoritarian reductivism of the resulting "translation" of the painted text. But allegory offers the reader very different possibilities, as Eagleton points out, citing Walter Benjamin to make his point. The nature of these possibilities is important enough to reproduce the passage at length. Says Eagleton:

The very arbitrariness of the relations between signifier and signified in allegorical thought encourages "the exploitation of ever remoter characteristics of the representative objects as symbols." . . . In an astounding circulation of signifiers, "any person, any object, any relationship can mean absolutely anything else." The immanent meaning that ebbs from the object under the transfixing gaze of melancholy leaves it a pure signifier, a rune or fragment retrieved from the clutches of an univocal sense and surrendered unconditionally into the allegorist's power. If it has become in one sense embalmed, it has also been liberated into polyvalence: it is in this that for Benjamin the profoundly dialectical nature of allegory lies. Allegorical discourse has the doubleness of the death's head: "total expressionlessness—the black of the eye-sockets—coupled to the most unbridled expression—the grinning rows of teeth."[37]

I, in my role of interpreter of the *Painter's Studio*, also have a certain doubleness, vis-à-vis the meaning of the allegory. If I am its prisoner in one sense, I am also its creator in another. "All commentary is allegorical interpretation, an attaching of ideas to the structure of poetic imagery," declares Northrop Frye, speaking of its literary variety.[38] If, as I believe, all interpretation is in some sense allegory, then in rereading Courbet's *Painter's Studio*, I am in turn really allegorizing the "real allegory." I am not, however, free to read this figure in any way I choose. Just how I allegorize the beggar woman depends on who I am and where and when I am doing the interpretation: interpretation occurs concretely, in specific historical circumstances, and, since the figure is a woman and I am a woman quite consciously reading *as a woman*, gender is a crucial issue here as well.

Beginning with the End: Reading as a Woman

For me, reading as a woman but nevertheless reading from a certain position of knowledge and hence privilege, in the United States in the twentieth century, the Irish beggar woman constitutes not just a dark note of negativity within the bright Utopian promise of the allegory of the *Painter's Studio* as a whole but, rather, a negation of the entire promise. The poor woman—dark, indrawn, passive, source of melancholy within the painting as well as reference to it outside its boundaries—constitutes both a memorial to melancholy past and the repressed that returns, turning against both the triumphant harmony of Courbet's allegory and the sermon of art's triumph that dominates its center. The Irish beggar woman is thus the really realist vehicle of the allegory, interrupting the flow of its intentional meaning. In her, the would-be allegorical connection between thing and meaning is really fumbled.

Because of the material specificity of Courbet's language, we are made aware, in the most substantial and moving way possible, of allegory's other potential: to emphasize the signifier at the expense of the signified. Embodying in a single figure the convergence of gender and class oppressions, a figure of lack par excellence, the Irishwoman for me becomes the central figure, the annihilation-cancellation of Courbet's project, not merely a warning about its difficulty. Figuring all that is unassimilable and inexplicable—female, poor, mother, passive, unproductive but reproductive—she denies and negates all the male-dominated productive energy of the central portion, and thus functions as the interrupter and overturner of the whole sententious message of progress, peace, and reconciliation of the allegory as a whole. In my rereading of Courbet's *Painter's Studio*, the Irishwoman as a figure refuses to stay in her place and be a mere vehicle of another more general meaning, whether that meaning be Poor Ireland or the Problem of Pauperism, an incidental warning signal on the high road to historic reconciliation. In her dumb passivity, her stubborn immobility, she swells to the dimensions of an insurmountable, dark stumbling block on that highway to constructive progress. Uneasily positioned within the composition, pressing up almost against, yet somewhat behind the edge of the canvas that establishes a barrier between the defeated world of the anonymous downtrodden and the triumphant one of the artist, her unstable spatial position reinforces the spatial ambiguity of the composition as a whole, at the same time that it threatens the apparent stability of the central group. Visible only by the fitful glow cast by the pallid skeletons

of Courbet's own past work on the wall behind her, radiating an ineluctable darkness that is also the substance of her body, the Irishwoman resists the light of productive reason and constructive representation, that luminous and seductive aura surrounding the artist and his minions.

Take her legs, for instance: bare, flabby, pale, unhealthy, yet not without a certain unexpected, pearly sexual allure, the left one folded back in on itself, exposing its vulnerable fleshiness to the gaze of the viewer yet suggestively leading to more exciting, darker passages, passages doubly forbidden because this is the figure of a mother as well as an object of charity. This pose of exposure in a woman, this revealing of naked legs is, in the codes of nineteenth-century decorum, a signifier of degradation, an abandonment of self-respect. The implication of self-abasement is reiterated by the place where she sits: directly on the ground, so that the bare legs also figure in a secular and untranscendent updating of the Madonna of Humility, a topos that we all have inscribed with our own uneasiness and guilt, having seen it often enough in the flesh, the flesh of those pale, varicosed, naked, unhealthy, sometimes filthy, often scabbed and scarred female legs, on the sidewalks of our own cities, in my case, New York, precisely as Courbet, it is said, saw them on the streets of London in his own time.

But the legs of the Irishwoman signify powerfully within the text of the painting itself, as the antithesis of another pair: that of Courbet himself. For a long time, I have been if not obsessed, at least fascinated by Courbet's legs—shapely, perky, aggressively thrust both forward toward the spectator and back into the pictorial space—but mostly by the green-striped trousers the artist has chosen to wear in the painting.[39] This fascination was intensified when I discovered, from what source I no longer remember, that Picasso too was fascinated by those green-striped legs, fascinated enough, so the story goes, although it may be apocryphal, to have trousers of his own made up just like them, at great expense, with the unusual horizontal, rather than vertical stripes. Perhaps Picasso associated such stripes with a notion of criminality—horizontally striped clothing conventionally defines the convict in the United States, and Courbet himself was not just an artistic rebel but condemned by the court as a bona fide lawbreaker after the Commune—so that the stripes may have connoted that transgressiveness so closely allied with the avant-garde project itself; in assuming the trousers (rather than donning the more conventional mantle) of Courbet, Picasso was symbolically assuming his role as the leader of artistic and social rebellion as well as literally stepping into the pants of an overtly phallic master painter. This difference, then, between the legs of lack and the legs of mastery and possession, establishes the gender terms underpinning the meanings generated by the painting as a whole.

There are still other infratextual readings possible for the figure of the Irish beggar woman in the *Painter's Studio*, other figures that construct its meaning. If, as a woman, I can read any other figure in the *Painter's Studio* in relation to the Irishwoman, it is inevitably Baudelaire to whom I must turn: Baudelaire, another dark negator of Utopian promises, the Baudelaire who later sardonically dismissed Courbet with the phrase "Courbet sauvant le monde,"[40] and who, like the beggar woman in the painting, is marked with the dark sign of melancholy. This crucial connection-opposition between Baudelaire and the poor woman is carried out on the formal level, too: the woman all emergent but muffled roundness, created by an outpressing, foreshortened fullness of form; Baudelaire curiously flattened, planar, outlined, a surface phenomenon, as sunken in his reading as she is extrusive in her embodied misery; together they constitute a paired vehicle connoting privatized absorption versus public demonstration.[41]

There is a sense, too, in that the woman may be read as a Baudelairean type, one more *exemplum* of that flotsam of the modern city that it is the project of the *flâneur* to glimpse in the course of his peregrinations. If she is not old enough to figure one of the little old ladies of the "Petites Vieilles," she is surely a prefiguration of one of those "singular, decrepit and charming beings" who take refuge in the "sinuous folds of old capital cities," and whose mysterious eyes harbor "mysterious charms / For him whom austere Misfortune nursed at her bosom."[42] Through the poet's eyes, or rather, his diction, we can see/read Courbet's beggar woman not merely as a conventional type, but as a figure as resonant with ambivalent values as Baudelaire's metaphoric nurse—"austere Misfortune"—nurturant yet denying in a single trope, she who nourished the poet at her breast. Especially potent in light of Courbet's triumphant self-assertiveness as the painter-creator in the center of the *Painter's Studio* is Baudelaire's self-denying projection of himself as the artist in the figure of "he whom austere Misfortune nursed." If we think of the Irishwoman as in some sense identical with Baudelaire's Misfortune, then the artist (the one nursed at her breast) is reduced from masterful protagonist to almost nothing, a mere nursling beggar, whose frail and

dependent existence is pitifully signified by the little white blob of the baby's cap, almost invisible in the dark folds of the Irishwoman's shawl, a white blob that refers at once to the fragile, moonlike tondo suspended on the wall slightly to the right above the central group, and, at the same time, to the ominous, shadowy skull on the newspaper to the left and behind the mother and child. Precarious life, inevitable death: What could constitute a more devastating response to the intended lesson of Courbet's allegory about the authoritative position of the artist than this alternative allegorization of the figure of the beggar woman and her almost invisible child?

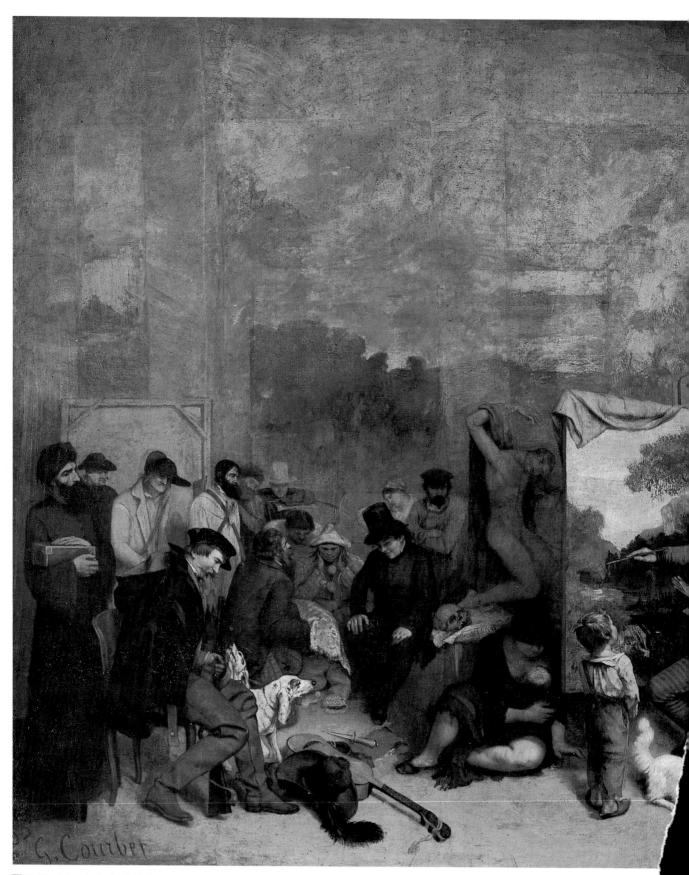

☐ II. *The Painter's Studio* (*L'Atelier du peintre*), 1855. Oil on canvas,
141 3/4 × 237 in. (359 × 598 cm). Paris, Musée d'Orsay.

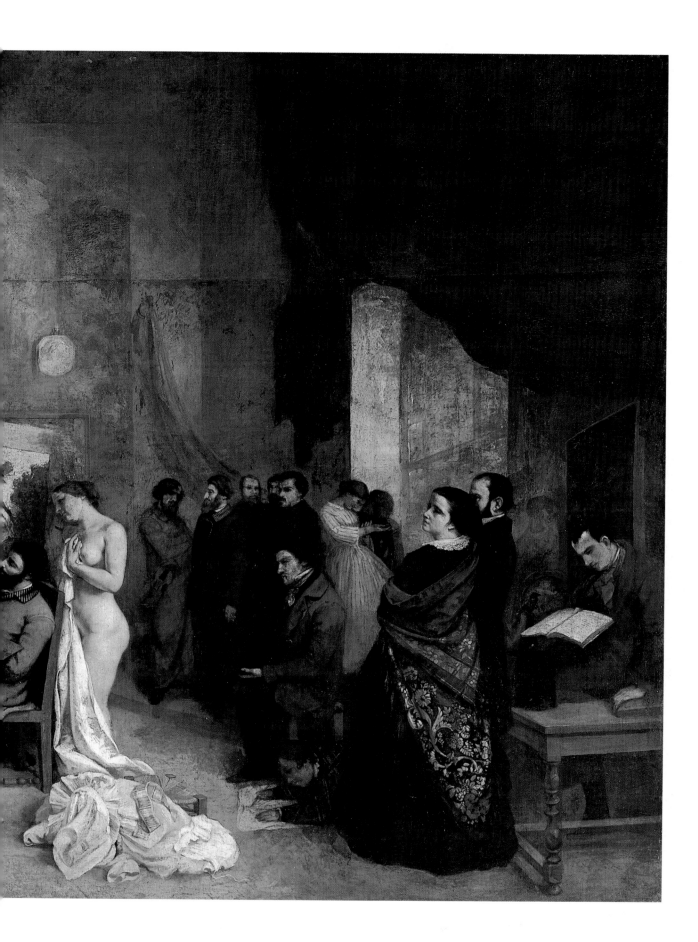

Ending with the Beginning: The Centrality of Gender

Although Courbet's allegory may indeed have been designed to teach a lesson of peace, harmony, and reconciliation to the emperor, there is another lesson inscribed, unconsciously, no doubt, at the very heart of Courbet's "Allégorie réelle": that is the all-important lesson about the gender rules governing the production of art—great art, needless to say. As such, it constitutes a lesson about the origin of art itself in male desire.[1] Although it is hidden to eyes blinded by the Oedipal construction of all meaning in patriarchy, there is nothing ambiguous about this lesson. No amount of analysis of Courbet's formal innovations[2] can obfuscate the message constituted by this central group, a group in which the major players literally replicate the Oedipal triangle. It is crystal clear in this, Courbet's construction representing representation:[3] the artist-father, Courbet, his Assyrian profile tilted at a confident angle, brush in hand, is unequivocally male, unambiguously active. The model-mother, to his right, and upon whom he turns his back, is equally unambiguously female, and passive. The pupil-son, follower or representative of the next generation who looks up at the artist's work, presumably with awe and admiration, like his alter ego, the little boy artist sprawled out sketching on the floor to the right, is as unambiguously male as the artist himself, or as any of the youthful ephebes in Harold Bloom's study of the uninterruptedly male, if anxiety-ridden, chain of poetic creativity.[4] The implications are, to me reading it as a woman, that if the next generation looks at Courbet's work and is stirred with fires at once imitative and com-

petitive, so did Courbet look at Rembrandt, Rembrandt at Raphael, Raphael at Rome, and so forth. That is how it is, how it has always been, how it is always going to be. If the artist leans from his space into ours, breaking down the barriers between fictive and actual presence, it is almost as though to reinforce this message: "as it is in representation, so it is in the real world." This too is part of the "real" in the real allegory. The only touch of ambiguity comes in the multiple roles assigned the female model, who may be read as either wife, mother,[5] mistress, or inspiring muse: but this is relatively inconsequential, since the sign "woman" is infinitely malleable in the representation of representation and can stand for any or all these positions in its anonymous objecthood.[6]

Courbet, then, allegorized as the artist in the heart of the *Painter's Studio,* is definitively gendered, and this gendering is underlined by the position of his opposite—his would-be object included in the image: the female model. Here gender is overtly and blatantly positioned as opposition—and domination. One might say that Courbet goes so far as to cross out woman in the Lacanian sense by substituting "nature" for her as the signifier of his creation on the canvas-within-the-canvas, a strategy of deletion he resorts to, incidentally, quite literally in the case of the *Portrait of P.-J Proudhon in 1853* later on, where he literally "erases" the adult female member of the family, Mme. Proudhon, from his composition, leaving only her work basket behind as a synecdoche of her absence-presence (pl. IX). This easy replacement of the woman's body by landscape—an incarnation of the nature/woman dyad par excellence—bears a precise relation to the almost infinite mutability

of the feminine itself under patriarchy. "Femininity," says Klaus Theweleit in his provocative study of gender relations, *Male Fantasies*, "has retained a special malleability under patriarchy, for women have never been able to be identified directly with dominant historical processes . . . because they have never been the direct agents of those processes; in some way or other, they have always remained objects and raw materials, *pieces of nature* [my emphasis] awaiting socialization. This has enabled men to see and use them collectively as part of the earth's *inorganic body*—the terrain of men's own productions."[7] This seems to be exactly the point at issue in Courbet's real allegory: women and nature are interchangeable as objects of (male) artistic desire—and manipulation.

To reinforce this (totally unintentional) message, Courbet has underlined this powerful strategy of displacement by introducing a surrogate male beholder right into his picture in the figure of the little boy gazing, in the position of the spectator, at the picture.[8] Woman nevertheless has a role, and a crucial if not an active one, in the image of origins Courbet has inscribed in the generative center of his real allegory: she stands as the passive Other to the artist's active subjecthood, and, at the same time, she forms an apex of the Oedipal triangle inscribed by painter, model, and observing child. Here, at the generative center of the real allegory, Courbet, separating the mother figure from that of the child, functions unequivocally as father, enforcing patriarchal law, in this case, the law of visual representation. If Courbet feels free, like many male artists, to "merge corporeally" with some of the female objects of his representation, as Michael Fried asserts in his catalogue essay,[9] he certainly does not wish to "feminize" himself represented in the act of painting, where, on the level of vulgar Freudian symbolism, he depicts himself as fully and unequivocally phallic, actively giving form to inert matter with his probing, dominating brush.

All the productive ambiguities proper to or characteristic of the murky wings of the altarpiece dedicated to the dominant position of male artistic genius are banished in the central portion, what Fried has aptly seen as the place where Courbet is "representing representation." It is perfectly clear who is meant to be represented with the phallus here. Thus, although Courbet may occasionally exercise the time-honored privilege of entering the bodies of women in his painting,[10] he rarely allows the opposite to happen—that is to say, he rarely lets women enter *his* represented body: allows himself to be "feminized," as it were. Courbet may well

have represented himself as the passive, wounded lover in the *Wounded Man*[11] (pl. 9), positioning himself as castrated (that is, vulnerable, womanish) in order to emphasize the extremity of the suffering caused by the female companion who nestled close to him in the original version of the painting, but whom he subsequently erased.[12] Reading as a woman, I might see the erasure of the woman as more significant than the suffering of the man, and the implication that being positioned as a woman functions as the unquestioned signifier for the one who suffers, the one who is abandoned, the helpless (wounded or castrated) victim, as more significant than either. Courbet constructs a position of femininity as a potent signifier for his defeated masculinity here—literally his "unmanning"; if this is an "openness" to the "feminine" side of his nature, it's a pretty negative formulation. "Womanishness" has always stood for a high degree of masculine failure, for the specific failure of masculinity; it is never a sought-after position in the representational schemata of heterosexual males.

Michael Fried, in his essay "Courbet's 'Femininity'" in this catalogue, makes a strong case for Courbet's openness to femininity, his ability, as it were, to enter into the bodies of his female subjects. Now to say that Courbet enters into the bodies of the women in his paintings is hardly to say anything new about the male representation of women, or of Courbet specifically. Men have always had the privilege of "entering," identifying or empathizing with, the female bodies they depict. One could certainly say this of Delacroix and the murdered women his surrogate-self watches so coolly in *Sardanapalus*. "Je suis la plaie et le couteau!" ("I am the wound and the knife") declared Baudelaire in "L'Héautontimorouménos"—another way of saying "I am the vagina, I am the penis"; more literally, for Courbet, the visual artist, "I am the female flesh, I am the male brush or palette knife." Male artists have had that dual privilege for a long time; women's bodies have always served as allegorized objects of desire, of hatred, of elevation, of abasement—of everything, in short. That is the point: woman's body has never "counted" in itself, only with what the male artist could fill it with, and that, it seems, has always been himself and his desires. To assert that Courbet has "entered" the bodies of his women—the nude bodies, above all—is hardly the same as postulating a protofeminist Courbet. After all, entering and/or taking over women's bodies have always been the privilege of the male artist, a privilege reinforced in the nineteenth century by the specific historical conditions associated with capitalism. Above all,

it is a totally asymmetrical privilege; no such entry is provided for women artists. Courbet's apparent identification with the bodies of the women he represents would, in this reading, be simply more of the same thing, transgression as usual.[13]

The gender rules inscribed in the center of the *Painter's Studio*—the artist is male and active, his model is female and passive—are, in my reading, manifestly in place in the construction of the erotic in Courbet's oeuvre as a whole. If, as Fried contends, Courbet came close to "thematizing the activity of painting as simultaneously man's and woman's work" in the *Sleeping Spinner*,[14] it is hardly "the *activity* of painting" that is at stake here: the female figure, if it indeed thematizes painting, is notably asleep at the switch. If painting is woman's, as well as man's, work, the female figure is overtly *not* engaged in it; painting as woman's work is characterized by disenablement, not activity, and the female figure, asleep at the job, whether spinning or, allegorically, painting, is thereby made available as the seductive object of the male gaze.

If, as Fried sees it, the powerful central figure of the *Grain Sifters* (pl. v) owes some of its unassimilability to current conventions for the representation of female labor, to Courbet's projecting of his own body image into the *cribleuse* in question,[15] doesn't its unusual, unsettlingly "masculine" configuration—embodied in the powerful musculature of the working arms, above all— owe something to a more conventional source for deviant imagery of women at the time? I refer to what might be called the imagery of perverse desire—an underground source nevertheless readily available and pointing to certain kinds of aberrant erotic preferences in men of Courbet's time. The strong woman plays a discreet but omnipresent role in the nineteenth-century iconography of fetishism. Such a preference, for example, is embodied in the unusual photographic collection of the Englishman Arthur Munby, who had heavily muscled, young working-class women, often wearing masculine clothing, photographed for his private pleasure.[16] Muscular arms were particularly admired (fig. 2.7). The muscular arms of the female figure in the *Grain Sifters* might suggest the identification of the artist with the representation; I might also, reading as a woman, suggest that the artist, like Munby, finds something vital, sexy, desirable, in women's muscular arms. A body like that of Courbet's *cribleuse* offers something both resistant and ultimately yielding to the male gaze, and this something has to do with the fetishization of the signifiers of class in nineteenth-century representation.

2.7. *Hannah in Traditional Shropshire Peasant Dress.* A studio photograph with rustic backdrop taken by H. Howle in 1872. Trinity College, Cambridge, Munby Collection.

Upper-class women, ladies, never have such arms; working-class ones frequently do. It is these vigorous, firmly grasping arms combined with the smallness of the waist, the inviting, rich swelling of the skirt, and the piquancy of the little feet that constitute the desirability of the whole image, as well as its ambiguity; the erotic persuasiveness of the composition as a whole is enhanced by the way the vigor of the central imagery is opposed by the more familiar languor of the female figure to the left.

Languor, sleep, resting are more characteristic modes of representation for female figures in the nineteenth century, for Courbet above all: and in Courbet's case, as well as for other artists, like Carolus-Duran (fig. 2.8) and the Catalan Realist, Martí y Alsina (fig. 2.9), for occasional male ones as well.[17] There is a tendency to assimilate all sleeping figures within a single signifying position within this pictorial discourse. But surely here is where gender-as-difference is most consequential: precisely where it is most unapparent, where the manifest content seems most similar, indeed, identical. Although sleep is a topos representing both men and women, it is figured differently for each. Of all the figures represented sleeping, only the female ones are represented nude: male ones are always represented clothed. Courbet's only nude male figures, the *Wrestlers* (fig. 2.2), are only

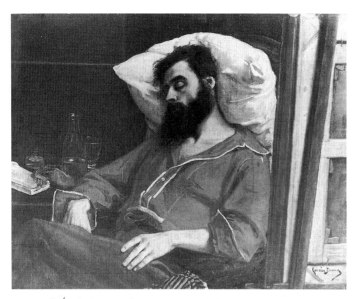

2.8. Émile-Auguste Carolus-Duran (1838–1917). *The Convalescent*, c. 1860. Oil on canvas. Paris, Musée d'Orsay.

partly so and vigorously active. The vulnerable flesh of the sleeping male figure in Courbet's work, or that of his followers, is veiled flesh, protected from the prying and possessive gaze—of women as well as of other men; male vulnerability is posited as momentary and conditional in a general state of potency. The meanings produced by this difference—sleeping women often nude, sometimes clothed versus sleeping men never nude, always clothed—must therefore be different. Gender makes a potent difference precisely within topical similarity or near identity: it is precisely within the same topos that the gender differential reveals itself most vividly. The sleeping male, with rare exceptions, does not suggest sexual availability to the male hetero-sexual gaze. Rather, it suggests a sort of poetic or imaginative availability open to the male viewer through identification with the sleeping male figure, embodi-ment of *le repos du guerrier,* as it were. The process of identification for the female viewer of the female sleeping figure, nude or clothed, however, is quite different: such an identification is inevitably either masochistic or narcissistic and connotes sexual avail-ability, especially in the case of the nude, but even in the case of the clothed female sleeper, as in the *Sleeping Spinner.* The sleeping or dozing female nude is the preeminent topos, open to and designed for the pleasure of the desiring male gaze. There is thus no symmetry between sleeping male and sleeping female. The naked woman can inscribe only passive available flesh. In the form of muse or model, mistress or

mother, asleep or awake, the nude female can inspire, perhaps reproduce, but cannot produce or create—that is the crucial distinction.

Paradoxically, however, it is in the representation of clothed female figures, in the *Young Ladies on the Banks of the Seine* (pl. 32), of 1857, that Courbet most vividly inscribes the discourse of female sexual availability on the topic of sleep. To be more precise, the foreground "demoiselle" is not, in fact, either fully asleep or fully "clothed," or certainly would not be considered fully clothed to the nineteenth-century viewer; rather, she is what might be thought of as lounging or resting and "half-clothed," committing the solecism of wearing her corset-cover and petticoat in public, a sure sign of im-propriety. She is in an intermediary, and all the more scandalous state, between being properly clothed and, for the purposes of painting, permissibly nude.[18]

The whiteness of lingerie, the very signifier of erotic availability in nineteenth-century sexual fantasy, could also serve in pictorial discourse, in its very purity (the material analogue it offers is to the blank page) as an ideal symbolic field on which to inscribe acts of desecra-tion. The *Young Ladies on the Banks of the Seine*, in its po-tent concatenation of whiteness, supineness, sleep, and sexual scandal, offers a striking visual analogue to a pas-sage describing the degradation of prostitutes from Flo-ra Tristan's *Promenades dans Londres*, first published in France in 1840. In this passage from her heartrending chapter on prostitution in London, Tristan describes in some detail the way English upper-class males make their prostitute-companions drunk and then, when the poor women are lying senseless on the floor, amuse themselves by pouring drinks on their unconscious bodies. "I have seen," declares Tristan, "satin dresses whose colour could no longer be ascertained; they were merely a confusion of filth. Countless fantastic shapes were traced in wine, brandy, beer, tea, coffee, cream and so forth—debauchery's mottled record. Alas! the human creature can sink no lower!"[19] The analogy with painting conjured up by Tristan's image of "debauch-ery's mottled record" is striking. But more striking still is the passage in which she describes the fall and dese-cration of a prostitute dressed in *white,*

an extraordinarily beautiful Irish woman . . . She arrived toward two in the morning, dressed with an elegant simplicity which only served to heighten her beauty. She was wearing a gown of white satin, half-length gloves revealing her pretty arms; a pair of charming little pink slippers set off her dainty feet, and a kind of diadem crowned her head. Three hours later, that same woman was lying on the floor dead drunk!

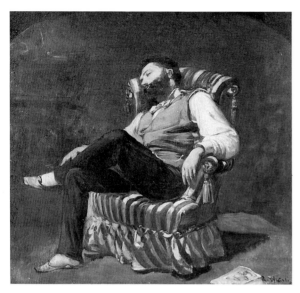

2.9. Ramon Marti y Alsina (1826–94). *La Siesta*. Oil on canvas. Barcelona, Museum of Modern Art.

Her gown was revolting. Everyone was tossing glasses of wine, of liqueur, etc., over her handsome shoulders and on her magnificent bosom. The waiters would trample her under foot as if she were a bundle of rubbish. Oh, if I had not witnessed such an infamous profanation of a human being, I would not have believed it possible.[20]

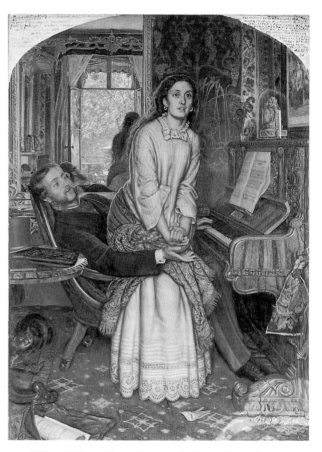

2.10. William Holman Hunt (1827–1910). *The Awakening Conscience*, 1853. Oil on canvas. London, Tate Gallery.

Courbet's representation of the white-clad fallen woman in the foreground of the *Demoiselles* does not go to quite the same lengths of moral allegorization as Tristan's, but it lends itself quite nicely to a pejorative reading within the codes defining nineteenth-century female decorum. Is it a mere coincidence that the gorgeously painted cashmere shawl in the foreground reechoes the position and function—veiling yet calling attention to the sexual part of the body—of the similar shawl draped about the hips of the heroine of Holman Hunt's *Awakening Conscience* (fig. 2.10), the quintessential Victorian morality-painting on the theme of the fallen woman?[21]

The misogynistic and moralistic P.-J. Proudhon, who figures prominently among the group of friends and supporters in the *Painter's Studio*, author of the major antifeminist text of the period, *La Pornocratie ou les femmes dans les temps modernes*,[22] found ample material for allegorical interpretation in the *Demoiselles*. He deals with the painting at length in his study of Courbet, *Du principe de l'art et de sa destination sociale*.[23] For him, as for so many other male allegorists, ranging from Emile Zola to Otto Dix, the sexual ("fallen" or "vicious")

woman functions as the prime allegorical vehicle of social corruption. Behind Proudhon's paranoid diatribe against the moral scandal represented by this painting, one must imagine another, very different representation of the feminine: the good, of course, married, woman, plainly and soberly dressed, sitting with her spindle or standing, her children about her at the stove; a woman completely controlled, mindless, sexless, privatized, powerless. It is hard to say what enrages Proudhon most: the fact that the women in Courbet's painting are represented as publicly available to the male gaze, that is to say, to the pleasure of *others;* or that they are represented as experiencing pleasure *themselves,* in some way independently, outside patriarchal control and authority, pressing their bodies lazily and voluptuously against the bosom of the earth. Proudhon immediately attempts to distance himself from the immediate sexual scandal of the *Demoiselles* by allegorizing it in terms of contemporary social failure: what Courbet really would have entitled the painting, if it had not seemed seditious at the time, was "Two fashionable young women under

the Second Empire." The implications of this title are, in Proudhon's reading, manifold, and ultimately political. They have to do with the moral corruption of the regime of Napoleon III, a corruption centered in the venality of women: their unwillingness to marry and have children; their tendency, as embodied in the foreground demoiselle, to be at once "somewhat virile," and, at the same time to "swim in erotic revery";[24] their unslakable thirst for luxury at its most refined. But what Proudhon hates most of all about the female types he sees embodied in the *Young Ladies on the Banks of the Seine* is their grotesque attempt to be fully human, that is to say, the preemption of the male prerogatives of creativity: "They cultivate what is called the ideal; they are young, beautiful, adorable; they know how to write, to paint, to sing, to declaim; they are real artists." Obviously, for Proudhon's allegorical imagination, such presumption on the part of women can only reap punishment, and it can only be, in visual terms, represented by the ugly: "But pride, adultery, divorce and suicide, replacing love affairs, hover about them and accompany them; they bear these in their dowry; it is why, in the end, they seem horrible."[25]

Although all of Courbet's paintings of eroticized women, like the *Demoiselles,* are open to allegorical interpretation based on gender difference, some of them would appear to be more resistant to the traditional, moralistic variety practiced by P.-J. Proudhon. Often, Courbet, like many of his contemporaries and followers, seems to have turned to the theme of sleep or "resting"—*La Blonde endormie* or *Femme couchée: Le Repos*—simply as a pretext for painting the nude female model. Often, and increasingly as the century progresses, even that pretext becomes unnecessary, and we are faced by what in English is designated by the *Reclining Nude* or simply *Nude* (female understood) *tout court.*

Detaching the female nude from its relatively constrained position within traditional iconography in the nineteenth century, positioning it—and, significantly, not the male nude—outside of narrative (or within the thinnest possible narrative pretexts as "Sleeping Model," "Odalisque," or "Bather") as an object at once of desire and of formal innovation may be read as a courageous step in the progressive evolution—or revolutionary progress—of modernism. Women's naked bodies have played a major role in modern artists' enterprise of "making forays into and taking up positions on the frontiers of consciousness," their attempts to "advance further in the dialectic of outrage." This is Susan Sontag and she is in fact talking about pornography,[26] not about the high-art nude, but what she says

has not a little resonance in the case of Courbet—and later, that of Manet, of Gauguin, of Picasso, of Matisse, and of the German Expressionists. The female nude as such is the contested site of vanguard versus conservative practices in the nineteenth century. The question is: How different are these presumably adversarial practices from each other, and, if different, how significant are these differences, and even more germane to the point at issue, in whose reading are these differences between the vanguard and the conservative nude stipulated as significantly different?

Reading as a woman, I might well come out with a different answer to these questions than if I were reading as a man.[27] Following Susan Suleiman's complex analysis of the centrality of the concept of transgressiveness in the strategies of modernism,[28] I would suggest that in the case of Courbet's more excessively eroticized nudes—his *Sleep* (pl. 65), for instance, or his *White Stockings* (Barnes Collection), his *Woman in the Waves* (pl. 68), and certainly, his part-image, the *Origin of the World* (pl. 66)—we are invited by a certain modernist discourse, or, perhaps, more accurately, a postmodernist one, to read the transgressive content of the work as a metaphor for the transgressive formal practices involved. Transposing Suleiman's analysis from the realm of fiction to that of art, one might say that what we see here is the transfer or slippage of the notion of transgression from the realm of experience (whose equivalent, in painting, is representation) to the realm of figuration (or form), with a corresponding shift in the roles and importance accorded to the signifier and the signified. The signified becomes the vehicle of the metaphor, whose tenor is the signifier. The sexually scandalous iconography of Courbet's *Sleep*—two naked lesbians locked together in a sexually explicit pose—is there to signify Courbet's formally scandalous pictorial practice: his tender, miraculously modulated, sensual handling of paint, the pulsating suggestiveness of the lush curves of breasts and thighs, the daring play of pearly blond flesh tones against deeper, rose-flushed brunette surfaces, the delicate threading of blue veins into an almost imperceptible weave of pinks and umbers connoting skin, the caress of the artist's supple brush or palette knife on the receptive surface of the canvas.[29]

Yet is this an adequate analysis for a painting like Courbet's, where "effects of the real" may in fact constitute the dominant formal practice, where brushwork, intentionally, tends to vanish into palpable flesh, palette-knife work into illusory breast or thigh, and where, as much as in any *Playboy* centerfold, arousal is the issue—arousal with a certain aesthetic bonus?

Reading as a woman who happens to be an art historian, I cannot entirely accept the first reading; reading as an art historian who happens to be a woman, I cannot wholly accept the second. Yet I must arrive at a position that maintains that simply to bracket the content and function of the work in a case like *Sleep*, or in any of Courbet's nudes, is to be blind to what they are doing, how they affect us specifically as women who view images. Surely I cannot simply take over viewing positions offered me by men—either the creator of the picture or his spokesmen—nor can I easily identify with the women in the picture as object of the gaze, which necessarily involves a degree of masochism on my part;[30] nor can I easily invent some other, alternative, position. Once more, I find myself at once invited into, but shut out of, the house of meaning, uneasily hovering on the brink of, moving into, withdrawing from the potentialities of the painting: the familiar shifty, feminine subject-position.[31] Ultimately, though, such work would seem designed to put me—the viewer who is a woman—in her place. This place is, as usual, problematic, and it might best be formulated as a question: Am I going to be one of the boys (that is, am I going to "enjoy it" as erotic stimulation, as artistic daring, as vanguard transgression) or one of the girls (am I going to acquiesce to [male] authoritative interpretations, am I going to reject it as "oppressive," am I just going to give up my status as viewer and lie down and identify with the bodies in the picture)? Or to end this discussion with still another question: Why must transgression—social and artistic alike—always be enacted (by men) on the naked bodies of women?

The obvious answer to this question lies in what I have read as the Oedipal center of the *Painter's Studio*. To answer it, I have to end with a still larger question, a question posed, in a different context, by Susan Suleiman: "Is there a model of *textuality* possible that would not necessarily play out, in discourse, the eternal Oedipal drama of transgression and the Law—a drama which always, ultimately ends up maintaining the latter?"[32] Reading as a woman, I see Courbet's vision of Utopia less as an ideal vision of the future, or even as unfinished business, than as business as usual; certainly, it does not seem transgressive in any deeply serious sense. It has become clear to me that it is only in gender difference that a real allegory of the transgressive might be constructed.

I can, with difficulty, imagine another scenario, a real allegory of transgression. Since it is a scenario that denies Oedipus, invokes gender reversal, it can only be read as a kind of—threatening—joke, a joke in bad

taste. It will, of course, be written off as mere frivolity by serious critics and a desecration by serious art historians. I will now stop reading as a woman and write as one.

Rosa Bonheur now sits in the central position of the *Painter's Studio*. Courbet, nude, or rather partly draped, stands modestly behind her. She is wearing a striped skirt (we can leave her Courbet's jacket; with a few alterations, it will do), and vigorously painting, with her loaded brush—a bull. A ragged little girl watches her intently. Suddenly, Champfleury can't stand it any longer. He rises from his seat in the wings and approaches the center. "But she's not even a *great* artist," he protests; "Why are there no great women artists?" The little girl turns around; we see that she is, in fact, the young Mary Cassatt (or Berthe Morisot or Georgia O'Keeffe or Hannah Höch—any number of possibilities are available). Now, the anonymous women in the picture, led by the Irishwoman, begin to converge on the center of the stage; the men gradually sink into the shadows, where they take off their clothes, and, equally important, lose their names: they are no longer Champfleury or Bruyas or Max Buchon, they are just naked male bodies.[33] Little by little, they take up their positions in a series of *tableaux vivants*: one of them holds a parrot over his head, offering his substantial nudity to the audience; two others are locked in a passionate, muscular embrace on a piece of blue drapery; another displays his buttocks to us in front of a waterfall backdrop; still another exposes his luminous but hairy flesh, recumbent, on white sheets before a landscape. Two of the women try to urge the naked Proudhon, misogynist author of *La Pornocratie ou les femmes dans les temps modernes*,[34] to join them in a picnic on the grass, but he resists; perhaps it is still too early; they leave him alone. Now all the women are gathered together in the center of the painting; the "rich patroness" lends her shawl to the nude model. They all have names: they are Marie, Angèle, Claire. They introduce themselves to each other and engage in animated conversation; they have a lot of catching up to do. They turn to look at the naked men in their ridiculous poses and suddenly, they all burst into laughter, great gales of body shaking, uncontrollable laughter; they laugh and they laugh and they simply cannot stop . . . As they laugh, as though a result of their laughter, the solidity of the painted matter begins to sparkle, melts, flows, diffuses "in an architecture of pure color, the sudden brightness in turn opening up color itself—a last control of vision, beyond its own density, toward dazzling light . . ."[35]

End of the scenario; but we have obviously left realism far behind for a kind of surrealism, although this is

an allegory of the transgressive the Surrealists never quite got around to. This is the unreal allegory, and perhaps the never real one as well:[36] an allegory of what can never be as long as we live in the land where Oedipus rules. The absurdity of my paraphrase of Courbet's real allegory could only be paralleled by rephrasing Freud's famous question "What does a woman want?" as "What do *men* want?" It is absurd because what *men* want is what want *is;* men's want defines desire itself.

Ending with the Ending:
The Politics of Place, the Place of Hope

If Courbet's *Studio* can in no sense be read as subverting the laws of gender—the ultimate subversion—it was nevertheless successful in fulfilling its author's intention to shake up some of the social and political assumptions of its time. Such a transgressive strategy might, from a certain point of view, even appear appropriate to the occasion for which it was painted: the Exposition Universelle of 1855. Courbet, following a time-honored tradition of carnival-sanctioned infraction of the rules, does resort to a trope of role reversal in the *Painter's Studio:* that popular imagery of "the world upside down," the destabilizing of the accustomed social hierarchy countenanced by carnival in which all normal relations of domination and subservience are reversed. In the carnival atmosphere created by the Paris World's Fair, Courbet, it would seem, felt free—indeed, called upon—to reverse the "normal" order of the world: now it is the monarch who must listen and learn, the artist who is on top, who grants the benefit of his example to the ruler. In this reversal of customary roles, his allegory and mine of gender reversal, no matter how different in every other aspect, share a common ancestry in popular tradition, for the laws controlling gender were exactly those most outrageously violated by the carnivalesque suspension of the normal mode of life, when men could dress as women and women, as Natalie Davis has demonstrated, could, during the Utopian days of carnival, however briefly, find themselves "on top."[37]

There are other ways, too, in which Courbet, in the *Painter's Studio,* contravenes accepted practices: those, for example, governing the codes controlling high art. There is a sense, as I indicated at the beginning of this essay, in which the *Painter's Studio* must be read as a political cartoon writ large: an allegory of the venality, or at least the futility of present political conduct and hope for a more positive political future.[38] In hiding politically subversive meanings under the cloak of allegory, the *Painter's Studio* looks back to a time-honored tradition connecting this rhetorical mode with political subterfuge. "Allegory," says Angus Fletcher, "presumably thrives on political censorship."[39] Certainly, Courbet's choice of an allegorical form for his painting owes a great deal to specific political conditions, most notably, official censorship, at the beginning of the Second Empire. But the *kind* of allegory he chose, an allegory related to the "low" form of the political cartoon rather than the "high" one of, say, classical mythology or antique epic points to another kind of politics at work in his

painting: a cultural politics involving that shifting and provocative relationship between high art and the materials of low or mass culture which has been posited as one of the defining characteristics of modernism in the recent literature.[40] In Courbet's work at the postrevolutionary Salon of 1850–51, in paintings like the *Burial at Ornans,* as T. J. Clark and Thomas Crow have pointed out in different contexts, the innovations that pointed ahead to fully fledged modernism "were carried forward in the name of another public, excluded outsiders, whose own emergent or residual signifying practices these pictures managed to address."[41] By 1855, such "excluded outsiders" had to be addressed more circumspectly than they had been five years earlier, if indeed they, or they primarily, were the intended public for the *Painter's Studio.*

Indeed, the political implications of the work are impossible to grasp without a consideration of the public for which it was intended; and this notion of a public is in turn impossible to understand without a knowledge of the place and circumstances for which Courbet designed the *Painter's Studio.* It was executed for a specific historical situation: the Exposition Universelle in Paris, inaugurated by Napoleon III on May 1, 1855, an exhibition to which the emperor had devoted a great deal of detailed attention over a considerable period of time.[42]

Within the context of the Exposition Universelle, an exhibition designed to enable France to display her technological prowess and cultural achievement to the world in competition, primarily, with its archrival, England, certain of the figures in Courbet's painting assume new importance. The "old-clothes merchant," for instance, positioned in the center of the left-hand group of figures, displaying his wares to exotic personifications of Turkey and China (—a figure whose centrality to the allegorical message Courbet indicated in his letter to Champfleury by declaring of him: "he presides over all this . . . displaying his frippery to all these people, each of whom expresses great interest in his own way"[43]—) can now be read as a crucial, and deflationary, figuration of that hawking of commodities that was the ultimate point of the Exposition Universelle itself. If the Irish beggar woman may be said to call into question the emperor's economic policies on one level, then the ludicrous rag-and-bone seller may be said to question it on another. This debased and parodic representative of the world of commerce—selling that which is devoid of value—provides an effective opposition to the image of the artist, engaged in producing that which *is* of value. Courbet, by representing himself in his own painting surrounded by his past and present pictorial production, has created an allegory of his beneficent role as a producer of valuable cultural goods. The real allegory then, in the context of the Exposition Universelle of 1855, may be read as Courbet's production of himself as a countercommodity—a free and self-determined man producing objects of genuine value— for a new and relatively unfamiliar public. That this public might include prosperous and enlightened purchasers is indicated by the pair of wealthy patrons prominent in the right foreground of the painting as well as the inclusion of Courbet's own patron, Alfred Bruyas, among the group of friends and supporters. *The Painter's Studio,* then, in the context of the year in which it was created, 1855, and the place for which it was intended, the French section of the painting exhibition of the Exposition Universelle, may be conceived of as a kind of miniature "universal exhibition" in its own right, in which the artist displays his wares to an interested public in much the same way as Napoleon III displayed his nation's commodities to would-be buyers and investors.

The public to be addressed was a vast, international, and socially heterogeneous one, and Courbet's sense of competition was keen. He intended his new painting to function as the keystone of an extended group of his works, fourteen in all. But his relationship to the government-sponsored exhibition, and especially to the powerful superintendent of the fine arts, Count Nieuwerkerke, was a stormy and ambivalent one,[44] leading ultimately to the rejection of the *Painter's Studio* from the official exhibition and Courbet's implementation, with the financial and moral encouragement of his patron, Alfred Bruyas, of his own private exhibition featuring the *Painter's Studio,* in the so-called Pavillon du réalisme on the Avénue Montaigne (fig. 2.11), an exhibition that competed with the official one in which he also showed a group of eleven paintings. "Whether inside or outside the official exhibition," as Herding points out, "Courbet wanted to participate and to maintain at the same time his independence from the organizers."[45]

The position of the *Painter's Studio* was thus at once marginal—Courbet's private exhibition was, so to speak, "marginalized" in relation to the official one— yet central in that it dominated the space, proclaiming Courbet's independence of government demands and stipulations. The real allegory, then, constituted within the context of Napoleon III's Exposition Universelle, declared Courbet's centrality within the terrain of the marginal, a position that vanguard artists ever since have avidly sought after and established as their own. Thus, if

2.11. The Pavillon du réalisme. Drawing in an autograph letter by Courbet. Reproduced in "L'Atelier du Peintre," Musée Gustave Courbet, Ornans, 1987.

the political allegory embodied within the painting was hidden, the allegory of cultural politics enacted by the placing of the painting in a specific site at a concrete moment of history was far more overt. Courbet had indeed maintained his independence, but at a price. This "price"—with its inevitable appeal to a "special" or in some sense "marginal" public—the price of uncertainty, of non-centrality in relation to the still-powerful government art establishment, and finally, of being in opposition to that establishment—would eventually, transvalued, define the position of modernist art in Paris and indeed, the world.[46]

The cultural politics involved in the physical placement of the *Painter's Studio* and its relation to the public—or publics—play major roles in the evolution of the critical discourse surrounding it. After the exhibition in the Pavillon du réalisme, the *Painter's Studio* languished for more than half a century in near oblivion, until it was rescued by public subscription for the Louvre in 1920.[47] It became, as a result of this transaction, at once, a part of the French cultural heritage, inserted into the "great tradition" of national art production, and at the same time, as part of the same operation, a work more or less completely divested of political implication. As a "great work," hallowed by its position of honor in the galleries of the Louvre, its meaning was now secured by the elevated language of the aesthetic, not the mundane discourse of politics; its references to contemporary issues, though hinted at from time to time, were, to all intents and purposes, as lost to the comprehension of a public blinded by the ideology of art-historical interpretation as its gender lessons are today made invisible to a public blinded by the ideology of patriarchy.[48]

If the place where a work is shown bears a crucial relationship to its meaning, then the new location of the *Painter's Studio* in the Musée d'Orsay rather than the Louvre would seem to demand new readings. Whereas in the Louvre, the *Painter's Studio*—far more than the ever-inassimilable *Burial at Ornans*—seemed to announce the end of a great tradition, now, in the Orsay, a museum devoted to the work of the second half of the nineteenth century, it seems to point ahead, if by no means unequivocally, to the modernist future.[49] I say "not unequivocally" because there are ways in which, set against the postmodern stoniness of Gae Aulenti's new walls, in the company of Manet's *Olympia* (if not that of Bouguereau or Bastien-Lepage) and beneath the galleries full of Cézanne, van Gogh, and Gauguin, the *Painter's Studio* looks, if not precisely "traditional," at least touchingly old-fashioned in some respects. Certainly, its iconography owes something to nostalgia for that sweeping and totalistic yet compulsively detailed Utopian vision characteristic of Fourier and his disciples.[50] Yet if in the context of its new placement in the Musée d'Orsay, Courbet's *Painter's Studio* looks Utopian, it does so not merely by preaching a pictorial lesson of reconciliation, by resorting to eccentric iconography, or even by transforming old traditions of popular resistance into new iconographic form. Rather, seen in the context of later nineteenth-century art and, thus, through imaginative projection, in the context of modernism and the vanguard of the future, it is not Courbet's iconography that seems to point ahead as a "principle of hope," to borrow the Marxist philosopher Ernst Bloch's eloquent phrase, but rather his pictorial practice in the *Painter's Studio*. In relation to the work of the Impressionists and Cézanne, the choice of landscape, considered by progressive critics of the time as the perfect democratic genre, as the motif on Courbet's easel becomes the vehicle of a progressive and liberating tenor within the allegorizing totality of the painting. The

pure pigment on the palette and the insistence on the surface and substance of the painting as elements of its meaning point even further ahead to the rejection of representation itself in the modernist practices of the twentieth century. The collagelike dissonances of the composition and its fragmentation as well as its appropriation of ready-made imagery and its rejection of finish and completeness point to still other vanguard strategies of the future. The *Painter's Studio,* read in this way, is Utopian in that it allegorizes the future of art and its—mostly unfulfilled—hopes of instrumentality in the production of revolutionary change. For Utopia is clearly not so much a place—how could it be?—or even an ideal, but, rather, once more to borrow the words of Ernst Bloch, who spent so much of his life considering it: "the methodological organ of newness."[51]

CODA: It may be of interest for the reader to note that this two-part essay allegorizes in textual form the pictorial structure of the *Painter's Studio.* At the "heart" or "vital center" of the essay (the second half of the first essay and the first of the second), I take over Courbet's role of "creator" and assume my femininity (as he has his masculinity) in the construction of a discourse of gender from the raw material offered by the visual artifact. In the "wings" (the first half of the first part and the last part of the second), I assume the "normal" voice and position of the art historian—a sort of neutro- or neutered-masculine one and give a more empirical— and entirely ungendered—account of the painting and its context.

MICHAEL FRIED · CHAPTER THREE

Courbet's "Femininity"

Power is at the tip of the phallus.
<small>VINCENNES 1970</small>

Recent feminist writing about the gender coding of visual images in the Western tradition, much of it centered on film and virtually all of it informed by psychoanalysis, has emphasized the extent to which the representation of women has been governed by a series of systematic oppositions: between man as the *bearer* and woman as the *object* of the look or gaze; between *having* the image (at a commanding distance from it, so to speak) and *being* the image (or at least lacking such distance); between *activity,* including the activity of looking, and *passivity,* as exemplified in merely being seen; and, perhaps most important, between man as *possessing* and woman as *lacking* (or, in Lacanian theory, *being*) the phallus.[1] In all these pairings, and they are by no means exhaustive, the first term historically has been privileged, the second subordinate. My basic claim in this essay is that although Gustave Courbet in ordinary life was a representative male of his time, what I take to be the core impulse of his enterprise—namely, to undo his own identity as beholder of his pictures by transporting himself quasi-bodily into them in the act of painting[2]— meant that the art he produced is often structurally "feminine," or at any rate is more closely aligned with the "feminine" than the "masculine" side of the above oppositions. Indeed to the extent that Courbet's art can be shown to call into question the oppositions themselves (and I don't say that this is always true of his work, or true to the same degree), there is perhaps a sense in which it might be termed femin*ist,* if by that we mean not aligning itself with a specific politics of gender

but rather seeking to establish a mode of representation one effect of which would be to break fundamentally with the masculinist, phallogocentric norms of the Western tradition. Probably, though, such a characterization goes too far, both because a truly fundamental break with those norms is unimaginable and because— as we shall see—Courbet's enterprise itself has masculinist implications. But I am convinced that it would be even more mistaken to conclude that Courbet's art merely confirms a representational order in which "femininity" is exploited to the greater glory of its opposite. I should add that I think of Courbet's compulsion to undo his own identity as beholder as essentially *antitheatrical,* which is to say that I understand it in relation to a central current or tradition in French painting that arose around the middle of the eighteenth century and continued at least until the advent of Manet. The opening phase of that current or tradition is the subject of my book *Absorption and Theatricality: Painting and Beholder in the Age of Diderot.*[3]

Take, for example, perhaps the most ambitious of his self-portraits of the 1840s, the *Man with a Leather Belt* (1845–46?; fig. 3.1). In that painting the apparent proximity of the sitter to the picture surface, especially toward the bottom of the canvas, seems designed to collapse all sense of distance and therefore of separation between sitter and painter (or as I shall say, painter-*beholder*) and ultimately between *painting* and painter-beholder. Then too the sitter's oblique posture, somnolent air, and shadowed, averted gaze combine to evoke a relationship between sitter (and painting) and painter-beholder fundamentally different from the rela-

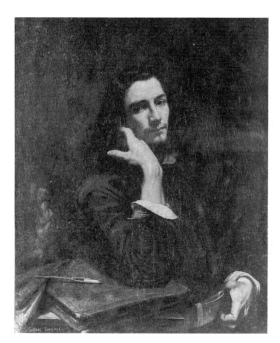

3.1. Gustave Courbet. *Man with the Leather Belt*, 1845–46
Oil on canvas. Paris, Musée d'Orsay.

tionship of intense face-to-face confrontation that typ-
ifies the self-portrait as a genre. Even more striking, the
conspicuously awkward orientation of the sitter's
strongly lit right hand and wrist matches what we know
on a priori grounds to have been the orientation of the
painter-beholder's right hand and wrist as he worked on
the painting, a congruence of depicted and "real" ele-
ments that contributes powerfully to the effect of quasi-
corporeal merger of sitter (and painting) and painter-
beholder that I want to claim characterizes Courbet's
self-portraits as a group. Finally, capping all this, the
otherwise inexplicable sense of muscular tension con-
veyed both by the sitter's right hand barely touching his
jaw and by his left hand gripping his belt may be seen as
evoking the activity of the painter-beholder's right and
left hands—the first wielding a brush or knife, the sec-
ond holding a palette—as they were actually engaged in
producing the *Man with a Leather Belt.*

In Courbet's great Realist paintings of 1848–50, the
self-portrait format is to begin with expanded to include
other personages, as in the *After Dinner at Ornans*
(1848–49; fig. 1.3), and is then ostensibly surpassed in
favor of an objective-seeming rendering, on a monu-
mental scale, of scenes from the life of his native Fran-
che-Comté, as in the *Stonebreakers* (1849; fig. 1.2),
Burial at Ornans (1850; pl. I), and *Peasants of Flagey Re-
turning from the Fair* (1850; pl. IV). But rather than re-
hearse the various strategies by which each of these
paintings attempts to undo what by the 1840s had be-
come the theatricalization of the relationship between
painting and beholder, I want to consider a picture

made a few years later, the fascinating *Grain Sifters*
(1854; pl. V), that will bring us directly to the topic of
this essay. Briefly, I see the central, kneeling woman as a
surrogate for the painter-beholder not only by virtue of
her posture (analogous to though not identical with his,
seated in a chair before the picture), her orientation
(facing into the picture and so roughly matching his),
and the character of the effort she is putting forth (con-
centrated, physical, requiring the use of both hands),
but also because the particles of grain that fall from her
sieve and gather on the whitish ground cloth irresistibly
suggest the image of a rain of pigment covering a blank
canvas that already embraces the sifter herself. The
seated, drowsy figure to her left who sits plucking bits of
chaff from her palettelike dish can also be characterized
as such a surrogate; in fact I would go further and pro-
pose, by analogy with a *Man with a Leather Belt*, that her
relative passivity and subordinate position make her a
figure for the painter-beholder's left hand holding his
palette in contrast to the kneeling sifter understood now
as representing specifically the painter-beholder's right
hand wielding a brush or knife. (Granted, the kneeling
sifter's upraised sieve in no way resembles a brush or
knife—but wait.) The small boy peering intently into
the dark interior of the primitive machine for sifting
grain known as a *tarare* I interpret as embodying a mode
of visuality that can't quite be called beholding: for one
thing he is too near the object of his looking for that no-
tion to apply; for another the absolute blackness of the
tarare interior suggests a denial or, better, an occultation
of vision such as would follow necessarily from the
quasi-corporeal translation of the painter-beholder into
his painting via the personages of the two female sifters.
Finally, I understand the patch of direct sunlight high
on the wall above the sifters as figuring a mode of repre-
sentation not made to be beheld (thus antitheatrical),
both because it appears to be the work of nature and be-
cause it goes unseen by the personages in the picture.

Courbet's next ambitious painting, the monumental
Painter's Studio (1855; pl. II), the full title of which in-
cludes the designation *Real Allegory Summing Up Seven
Years of My Artistic Life*, makes these concerns all but ex-
plicit by portraying at its center the painter-beholder
seated before his easel applying the final brushstrokes to
a river landscape into which he appears virtually to
merge even as the river and waterfall may be seen meta-
phorically to flow out of the canvas and beyond him, de-
scending to the studio floor in the long folds of the
otherwise naked model's white sheet and finally spilling
into a heap of pinkish, circular eddies—her discarded
dress (fig. 3.2). That the river landscape, seated painter,

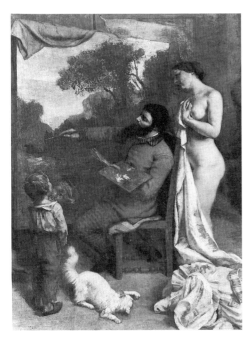

3.2. Gustave Courbet. *The Painter's Studio*, 1855, detail of central group. Oil on canvas. Paris, Musée d'Orsay.

3.3. Gustave Courbet. *The Source*, 1868. Oil on canvas. Paris, Musée d'Orsay.

and standing model are further bound together by a number of subtle but compelling visual rhymes—for example, between the model's hip and thigh and the painter-beholder's left shoulder and arm, or, a *tour de finesse,* between her neck and hair and the trees that thrust upward at an angle from the hillside in the picture on the easel—at once lends added support to my reading of the central group as representing the merger of the painter-beholder with the picture on which he is working and implicitly identifies the limits of that picture with those of the central group as a whole and perhaps by extension with those of the *Painter's Studio* itself. It is in relation to the issue of theatricality, I suggest, that the *Painter's Studio* most profoundly allegorizes Courbet's enterprise, though one consequence of my reading of other paintings in his oeuvre—the *Grain Sifters,* for example—is that, despite their manifest subject matter having nothing in common with the *Painter's Studio*'s, they too may be understood as allegories of Realism in precisely the same sense.[4]

Finally, to add one more work to our initial store, the ravishing *Source* (1868; fig. 3.3) at once recapitulates and condenses the central group in the *Painter's Studio* by eliminating the peasant boy; replacing the picture on the easel by an "actual" forest scene with trees, rocks, waterfalls, a stream; combining the figures of painter-beholder and model in that of a seated nude woman seen from the rear; juxtaposing the woman's left (or palette-) hand held palm upward under a small waterfall with her right (or brush-) hand lightly gripping a slender branch; depicting in no uncertain terms the flow of

water past the woman toward, and by implication beyond, the surface of the painting; and providing an equivalent to the central group's portrayal of pictorial representation via the reflection of the woman's lower body in the stream in the near foreground. Nothing better epitomizes the obsessiveness of Courbet's imagination than the multiple affinities between the *Painter's Studio*'s central group and the *Source,* affinities all the more remarkable in that they surely aren't the result of a conscious attempt to redo the central group thirteen years later.

If we now think back to my opening remarks, it becomes evident why I see Courbet's art as more closely aligned with the "feminine" than with the "masculine" terms of the oppositions I began by citing and why I want to suggest that his pictures sometimes call those oppositions into question. For example, there is in Courbet's project as I have explained it an emphasis on nearness to the image, even on a relation of something like identity with it, that feminist film theorists have persuasively associated with the position of the female spectator in the Western regime of representation.[5] More radically, the overriding aim of Courbet's enterprise in my account—to undo or at least suspend his own spectatorhood—leads to repeated attempts by him as painter-beholder to merge corporeally with various figures in his paintings, and, as my readings of the *Grain Sifters,* the *Source,* and, from a different angle, the *Painter's Studio* make clear, the figures in question can as well be female as male. (It isn't surprising, therefore, that a

leading practitioner of the social history of art has found it impossible to place the *Grain Sifters* as an image of female labor.⁶) Paintings such as these go at least part of the way toward eliminating the very basis of the distinction between seeing and being seen on which the opposition between man as bearer and woman as object of the gaze depends.

Another traditional, ideologically charged opposition that Courbet's paintings revise is that between active and passive, the first term coded as "masculine" and the second as "feminine." For not only do his paintings represent in diverse ways what might be called the passivity of activity (a phrase of Merleau-Ponty's⁷); they also recast the distinction between active and passive as one between the painter-beholder's relatively active right (or brush-) hand and his relatively passive left (or palette-) hand as both of these take part in the act of painting, a recasting that preserves the "masculine"-versus-"feminine" connotations of the original distinction only to the extent that it declares the painter-beholder to be inherently both the one and the other.⁸ In fact a kind of doubleness of gender is also implicit in the position of the painter-beholder relative to the *Grain Sifters*, the *Source*, and other canvases in which he seems to have identified strongly if unconsciously with female personages: for to the extent that the painter-beholder falls short of *literally* transporting himself into the painting before him—and of course he always does fall short of this—he is both the subject ("masculine") and the object ("feminine") of beholding, a condition perhaps expressed in displaced form by the emphatic muscularity of the kneeling farm girl in the *Grain Sifters*. (In the pages that follow I use the term *bigendered* to describe the outcome of these and similar identifications; the more familiar term *bisexual* implies a doubleness of object choice that, as I read Courbet's art, remains foreign to it from beginning to end. Even in the lesbian pictures of the mid-1860s, to which the notion of bisexuality might seem to apply, the object of desire is—naturally—a woman. I shall return to this point in my discussion of the greatest of the lesbian pictures, *Sleep*, toward the end of this essay.)

Or consider the representation of sexual difference in the central group of the *Painter's Studio*, which both is and isn't culturally stereotypical. On the one hand, by associating the act of painting with the male artist and that of beholding with the female model, the central group appears to confirm a conventional privileging of "masculinity" as active and productive over and against "femininity" as passive and supportive. On the other hand, by depicting the model as the bearer rather than

merely the object of the look (standing *behind* the painter-beholder, she is unavailable to his gaze even while she is exposed to ours), the central group characterizes "femininity" as implicitly active after all, while the rhyming at vital junctures of painter-beholder and model, and a fortiori the virtual merging of painter-beholder, model, and painting in a single pictorial-ontological entity coextensive with the central group as a whole, go a long way toward overriding the privileging of any one of these elements above the others.⁹

It might seem that the role of the phallus/paintbrush in Courbet's paintings would necessarily prove an exception to my insistence on the "feminine" or at least significantly antimasculinist character of his art.¹⁰ But it isn't hard to show how, in some of his most important representations of women, Courbet's metaphorizations of the painter's tools are themselves "feminized" in ways that make problematic, if not the distinction between having and lacking (or being) the phallus, at any rate the unequivocal sexual difference that the distinction traditionally signals. For example, in the *Sleeping Spinner* (1853; pl. 16), a work that precedes the *Grain Sifters* by roughly a year, our attention is instantly caught by the large distaff wound with wool (and bound with a bright red ribbon!) that has fallen from the spinner's grasp and now lies obliquely across her thighs. Both the form and the general orientation of the distaff proffer an analogy with the painter-beholder's brush, while the rendering of the partly unbound wool is at once vivid testimony to the actual work of that brush and a marvelously hyperbolic image of the brush's hairs. Furthermore, the distaff is phallic by virtue both of its shape and its traditional iconography,¹¹ and this particular specimen, owing to its coloristic brilliance, impressive dimensions, and vigorous diagonal thrust into the picture space, invites being seen as embodying the aggressive maleness of the painting's maker and in that sense as equating the act of painting with the sexual possession of the young woman. The fact remains, however, that the French word for distaff, *quenouille*, like its English equivalent, connotes femaleness as such; this suggests that what we find in the treatment of the distaff in the *Sleeping Spinner* is a fantasmatic conflation of "masculine" and "feminine," a conflation that comes close to thematizing the activity of painting as simultaneously man's and woman's work.

Something analogous though far more intricate takes place in the *Grain Sifters*, in which the fall of sifted wheat onto the canvas ground cloth immediately in front of the kneeling sifter has already been compared to a rain of pigment and hence to the actual making of the

painting. Now I want to suggest that the fall of grain and pigment—pigment representing grain representing pigment—can also be seen as a downpour of menstrual blood—not red but warm-hued and sticky-seeming, flooding outward from the sifter's thighs—and thus as expressing an even more extreme fantasy of "feminine" painterly productivity (this despite the fact that menstruation is an equivocal sign of *biological* productivity). We might gloss that fantasy by saying that it imagines painting to be a wholly natural activity—to be unmediated by anything beyond the (female) body itself.[12] The suggestion is given added force at the same time that it is complicated and in part even contravened by the recognition that the verb *cribler* (the French title of the painting is *Les Cribleuses de blé*) means not only to pass something through a sieve but also to pierce someone all over, to riddle with wounds as with a sword (figuratively, to make a sieve of him), an action or series of actions involving the use of a tool not dissimilar in form to a distaff and equally phallic in its connotations.[13] (I will simply mention that this is roughly the moment of the completion of the self-portrait called the *Wounded Man* (pl. 9), in which a sword and blood may be read as representing a brush and pigment respectively.)[14] There thus turns out to be an aggressively "masculine" dimension to the *Grain Sifters*—and here we may note that the orientation of the kneeling sifter's powerful body is exactly that of the phallus/paintbrush in the *Sleeping Spinner*—though having said this, I should add at once that the phallic resonances of the word *cribler* are visually drowned in the painting's imagery of menstruation. It is hard to imagine a more densely coded picture as regards questions of gender or one that more compellingly illustrates the value of approaching those questions from within an interpretive framework keyed to issues of beholding.

Another major work of the mid-1850s, the *Young Ladies on the Banks of the Seine (Summer)* (1856; pl. 32), depicts two young Parisiennes (the French title calls them *demoiselles*) relaxing in a secluded spot on a summer day. There has never been the least doubt that the women are prostitutes, though precisely what niche they occupy in the mid-century demimonde remains an open question;[15] in any case, their sexual availability and a fortiori their status as objects of "masculine" beholding are underscored by the man's hat in the rowboat moored to the bank in the middle distance. Accordingly, some commentators have found a morally motivated contrast between the overdressed women—the nearer of whom is in dishabille—and their natural surroundings, but I believe the truth of the painting, though perhaps not of the painter's intentions, is much more complex. In particular I want to call attention to the seemingly broken branch that enters the painting immediately below the brunette woman's hanging bonnet at the right, almost but doesn't quite touch the back of her left hand, then sweeps in an arc toward her right hand, just short of which it divides into an abbreviated twig and a second, thinner twig that skirts her extended right forefinger before bursting profusely into leaf. I take this interplay as implying that the branch is in the process of animating the woman through near-contact with her hands, or at any rate that between the branch with its sudden outpouring of leaves and the woman who, far from simply "resisting" the flowers and foiliage that surround her, not only is covered with embroidered flowers but can herself be taken as an elaborate bloom, there exists a more pointed relationship than those between other manifestly or metaphorically floral elements within the painting.[16] (The brunette's transparent yellow gloves are in my account less a barrier to that relationship than a heightening of it—certainly they draw attention to her right hand with its extended forefinger.) An art-historical analogue for such a feat of animation is the *Creation of Adam* on the Sistine ceiling, but the particular affinity I want to emphasize is between the blossoming branch in the *Young Ladies* and the distaff/brush in the *Sleeping Spinner* as well as, by extension, other metaphorical representations of the painter's primary tool, his paintbrush, in Courbet's art. (In the *Source*, as we have seen, the paintbrush will again be represented by a branch.) What is unusual about the *Young Ladies*'s representation of that tool, however, is that it is marginal, inconspicuous, one might almost say nonphallic by virtue both of its formal character (broken, curving, improbably slender) and of its manifest attributes (leafy, in that sense floral, which is to say "feminine"), or to put this slightly differently, what is striking about it is that it is so *un*striking, being barely distinguishable from the strongly gendered floral imagery pervading the painting as a whole.

The question that now arises is whether the floral imagery of the *Young Ladies* can be associated with the act of painting, and I want to suggest that it can. Briefly, I find a sufficiently close analogy between the bouquet of flowers that occupies almost the exact center of the composition and the painter-beholder's *secondary* tool, his palette covered with daubs and patches of raw pigment (as represented, for example, in the *Painter's Studio* of the previous year), to lead me to suggest that such a palette may have been the ultimate source of or sanction for the floral metaphor in the *Young Ladies* and

other paintings by Courbet, including the *Sleeping Spinner* and going back as early as the *Hammock* (1844; pl. III). (In the *Hammock* a blossoming rosebush bends amorously over a sleeping woman as if about to embrace her; I see the rosebush as a figure for the painter's [heterosexual] desire, which thus is given "feminine" expression.) In this connection it may be significant that the brunette's hanging bonnet filled with flowers—a second, conspicuously supported bouquet—is almost contiguous with the phallus/paintbrush/branch where it enters the picture, as if in acknowledgment that bouquet and branch, or the tools they represent, belong together. My argument can be summed up by saying that in the *Young Ladies* what appears at first to be a strongly oppositional thematics of sexual difference (the women as objects of "masculine" sexual possession) gives way to, or at the very least coexists with, a more embracing metaphorics of gender (a pervasive "feminization" of the pictorial field through an imagery of flowers), which in turn demands to be interpreted in the light of a specifically pictorial problem (Courbet's antitheatrical project). And when it is so interpreted, the basis of that metaphorics—the association of flowers with the painter-beholder's palette—resituates sexual difference "within" the painter-beholder rather than between him and the object of his representation.[17]

The same fundamental structure emerges when we consider the role of another traditional signifier of "femininity," women's hair, in paintings as separated in time as the *Hammock* and the marvelous *Portrait of Jo* (1866; pl. 54), the latter a depiction of a young Irishwoman, Jo Heffernan, looking absorbedly into a mirror she holds in her left hand while running her right hand through her Magdalen-like hair.[18] For just as Courbet's floral imagery can be associated with his palette, so his imagery of hair can be connected with his primary tool, the phallus/paintbrush, which being tipped with hair is revealed as figuratively "feminine" as well as "masculine." (Not only the painter-beholder but his phallus-brush itself may be thought of as bigendered.) At any rate, I see Jo Heffernan's lustrous, serpentine red-gold tresses as what I have called a hyperbolic image of the business (but also the pleasure) end of the painter-beholder's brush, and I find particular support for this reading in the way in which Jo's extended little finger—itself perhaps an expression of the mirror's hidden, phallic handle—comes close to touching the exquisitely painted pair of locks that seem almost independently to wind or flow toward the viewer at the lower left.[19] The rest of the mirror—the round reflecting glass the face of which we don't quite see—invites being understood

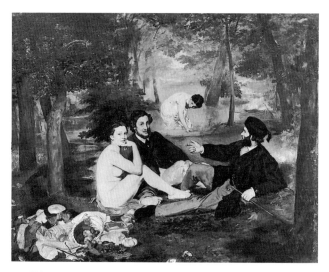

3.4. Edouard Manet, (1832–83). *Le Déjeuner sur l'herbe*, 1863. Oil on canvas. Paris, Musée d'Orsay.

(provisionally) as an image of a palette and (more profoundly) as a figure for a painting capable of all but physically absorbing the painter-beholder into itself. In short we find in the *Portrait of Jo,* as in the *Source,* painted two years later, a radically condensed and seductively "feminine" variation on themes, figures, and structures that received their decisive articulation in Courbet's major allegories of the mid-1850s.

Two larger and more obviously ambitious works of the same year, the *Woman with a Parrot* and *Sleep* (both 1866), introduce further complexities. In particular they force us to take account of the relation of Courbet's art at this stage of his career to the early work of the foremost Realist painter of the younger generation, Edouard Manet (1832–83).[20] As I see them, Manet's masterpieces of the first half of the 1860s would have been inconceivable without Courbet's path-breaking example; and yet the two men could hardly have been more different in origins and manner, and there is an acute sense in which Manet's version of the pictorial enterprise was antithetical to Courbet's as concerns the crucial issue of beholding. That is, Manet seems intuitively to have recognized that Courbet's attempt to undo his own spectatorship by transporting himself into the painting on which he was working was doomed in every instance to ontological (though not necessarily artistic) failure, or at any rate that complete success in that endeavor was literally unimaginable, and that it therefore was necessary to establish the beholder's presence abstractly—to build into the painting the separateness, distancedness, and mutual facing that had always char-

acterized the painting-beholder relationship in its traditional or unreconstructed form—in order that the worst consequences of the theatricalization of that relationship be averted. Such a reading identifies Manet's enterprise as simultaneously antitheatrical and theatrical (or theatrical and antitheatrical), which also means as not exactly one or the other as we have been using the terms until now. Thus Manet's paintings of the first half of the 1860s repudiate the anecdotally theatrical pictures, often costume pieces set in earlier centuries, that enjoyed great popularity at the Salons of the 1850s and 1860s. But they do so by exploiting a strictly presentational—as opposed to actional—mode of theatricality, the primary historical source and sanction for which was Watteau and the ultimate function of which in Manet's art was to acknowledge more perspicuously and, as it were, defamiliarizingly than ever before what I have elsewhere called the primordial convention that paintings are made to be beheld (crucial aspects of Manet's "modernism" consist above all in this act of acknowledgment). It is also at least arguable that one effect of Manet's strategy, and doubtless also a principal cause of the extreme provocation that his paintings of the 1860s offered to contemporary audiences, is that the actual beholder sensed that he had been made supererogatory to a situation that ostensibly demanded his presence, as if his place before the painting were *already occupied* by virtue of the extreme measures that had been taken to stake it out.[21]

The blandly yet aggrandizingly presentational force of Manet's art is nowhere more evident than in two major canvases of the first half of the 1860s that crucially involve the figure of a naked woman gazing enigmatically out at the beholder (or at least out of the painting), the *Déjeuner sur l'herbe* (1862–63; fig. 3.4) and the *Olympia* (1863; fig. 3.5). And what I want to emphasize at this juncture is, first, that between these two extraordinary productions and Courbet's ambitious nudes of 1866 there appears to have taken place a competition that had the two men responding to one another's art across the immitigable difference in their temperaments and the seemingly much slighter but in fact absolutely fundamental disparity in their historical positions. And second, that the traditional erotic nude as a pictorial genre was especially suited to Manet's enterprise because it involved a type of subject matter that more emphatically than any other offered itself to a masculinist public as an object of beholding and thereby provided maximum purchase for his far-reaching attempt to reverse traditional power relations by implying that the beholder was now under the painting's controlling gaze

3.5. Edouard Manet (1832–83). *Olympia*, 1863. Oil on canvas. Paris, Musée d'Orsay.

rather than the other way around. Whereas precisely these considerations were at odds with Courbet's altogether different project and in fact made it likely that his pictures in this vein would be more than usually marked by a disturbing aura of compromise.[22]

This is particularly true of the *Woman with a Parrot* (fig. 3.6), which depicts a naked female figure sprawling on her back across a four-poster bed and holding aloft on her left hand a brightly colored parrot with outspread wings. The woman's discarded dark brown gown occupies much of the immediate foreground, while she herself lies directly on a rumpled sheet of brilliant white, part of which somewhat improbably covers the upper portion of her right thigh and in doing so just manages to conceal her sex. Her breasts are full, her hands and feet (as always in Courbet) are delicate, her upside-down mouth opens in a smile that reveals a row of perfect white teeth, and her great shock of tawny hair spreads outward from her head in burnished snakelike waves. Beyond one twisted bedpost toward the left we glimpse as if through a window a wooded landscape at dusk; toward the right our view is screened by a dark green tapestry that presumably hangs along the window wall (all but the nearest spatial relations in the picture are unresolvably ambiguous); and at the foot of the bed Courbet has provided a wooden stand for the parrot with multiple perches and, at the top, a metal bowl.

I think it is fair to say that although the *Woman with a Parrot* contains much that is superb, it palpably evinces a sense of difficulties only partly overcome. The composition, for example, is strongly weighted toward the left, so much so that the right-hand half of the picture feels

3.6. Gustave Courbet. *Woman with a Parrot*, 1866. Oil on canvas. New York, The Metropolitan Museum of Art. Bequest of Mrs. H. O. Havemeyer, 1929. The H. O. Havemeyer Collection.

strangely empty (this sort of thing almost never happens in Courbet) while the parrot stand in its bareness and isolation seems an intrusion from another, alien representational system. (A more Manet-like one? In any event, Manet soon would make a stand such as this his own in his *Woman with a Parrot* [1866].) Then too there is an uncharacteristically stark contrast between, on the one hand, the brightness of the woman's naked body and the white sheet on which she lies and, on the other, the dark tonality of her surroundings, with the result that the subtle play of reflected lights within the shadows along her legs and right arm scarcely makes itself felt. Also uncharacteristic of Courbet is the sleekness verging on abstraction of the woman's body below her breasts, which contributes to our sense of the painting's vacancy toward the right and is oddly reminiscent of the smoothness and unreality of the highly popular nudes of lesser artists such as Cabanel and Baudry. And yet the *Woman with a Parrot* isn't simply another more or less standard, albeit magnificently painted, erotic nude; instead it struggles fascinatingly (if almost surreptitiously) against the basic conventions of the genre, in particular against the convention that would have the woman coyly, straightforwardly, or indeed shamelessly display herself for the delectation of a male viewer located unproblematically at a distance from the painting that allows him easy command of the pictorial field and by so doing at once heightens and gratifies his desire for visual, and by implication physical, possession of the image.

Consider, for instance, the significance of the figure's orientation, by which I refer not only to her position on

her back but, more important, to the fact that her head and upper body must be understood, in view of the axis of her face, the location of her left leg, and the angle of the bed as we are shown it toward the right, as nearer to us than her feet.[23] Such an orientation corresponds, in a certain sense, to that of the painter-beholder seated before the canvas, though we could hardly be further from the sort of manifest alignment of figure and painter-beholder that we have noted in other paintings by Courbet. A more restricted (and partly for that reason more salient) locus of struggle is the naked woman's upside-down head and face, whose smiling but also undeniably disquieting expression remains unreadable unless one approaches the left-hand portion of the painting and perhaps also tilts one's head sharply to the left as if in an attempt to look directly down into the woman's upturned features.[24] (It seems inconceivable that Courbet could have painted her face without himself achieving that superior position.) Moreover, the woman's waves of tawny hair may be seen as flowing toward the picture surface as if in reciprocation of an implied movement into or at least toward that sector of the painting; obvious analogies are the outward rush of water and waterlike representations from the canvas on the easel in the *Painter's Studio* and the forest stream in the *Source,* though perhaps even more apposite is the early *Hammock* (pl. III), in which the metaphorical waterfall of the sleeping woman's unbound hair is juxtaposed with the windings toward the bottom of the picture of a ribbony creek that we intuitively perceive as flowing in our direction, no doubt in contrast to the distant sunlit clearing that so attractively solicits imaginary penetration.[25] In a slightly different key, already familiar to us from the *Portrait of Jo*, there is also an analogy between the consummate paint-handling of the parrot woman's hair and the treatment of the phallic distaff/paintbrush in the *Sleeping Spinner* of the previous decade, the wavy spreading tresses in the later work serving as one more hyperbolic image both of the painter-beholder's primary implement (that is, of its hairy working tip) and of the activity of that implement at its most inspired. And that analogy is strengthened both by the obvious painterliness and strident colorism of the vivid-hued parrot, a "phallic" creature whose outspread wings and tail in effect mirror the woman's outward-streaming hair, and by something else as well: the bedpost that rises vertically just to the left of and beyond the woman's upraised arm. My point isn't simply that the bedpost and the woman's hair together form an image of a giant brush; I am struck too by the coincidence that the French word for bedpost, *quenouille,* is the same as

that for distaff, a doubleness of meaning that I read as supporting the notion that, for all the obvious differences between them, the *Woman with a Parrot* and the *Sleeping Spinner* share a common preoccupation.

All this is not to claim that the different means by which the *Woman with a Parrot* challenges the norms of the traditional erotic nude are mutually consistent or that, once alerted to those means, we are likely to find the general effect of the painting significantly different from that of works by Courbet's contemporaries in which nothing of the sort takes place. But it is to suggest that, even at their most conventional, Courbet's paintings of the nude can fully be understood only in relation to a larger project in which beholding as such is repeatedly and fundamentally called into question.

Courbet's other ambitious erotic canvas of 1866, the astonishing *Sleep* (pl. 65), was painted for Khalil Bey, formerly Ottoman ambassador to Athens and St. Petersburg and at that time a wealthy collector living in Paris. It represents, more or less life-size, two naked women, one with dark brown hair and the other—Jo Heffernan—with red hair, asleep with bodies entwined on a large bed. In the left foreground there appears as if floating the decorated top of a squarish table on which stand two decanters and a crystal goblet, while on the far side of the bed and toward the right a narrow shelf (or table?) bears a yellow vase overflowing with multi-hued flowers. The wall itself is a dark Prussian blue and almost indiscernibly carries a floral imprint; behind the women at the head of the bed a blue curtain also bearing a floral pattern has been gathered by a velvet rope; and in the near foreground, to the right of the table, the brunette sleeper's hand (perhaps the most exquisitely sensuous in all of Courbet, which is saying a lot) rests lightly atop the edge of a rose-pink coverlet, the bulk of which must be imagined to have fallen to the floor. The juxtaposition of the snowy white of the bedsheets with the light pink of what seems to be the exposed underside of the coverlet, and of both of these with the stronger rose-pink of the latter's largely hidden upper surface, could hardly be more suggestive. Another coloristic touch that enhances the picture's sensuous impact is the slight but telling difference between the darker and lighter skin tones of the brunette and redhead respectively.

Not surprisingly, discussions of *Sleep* have tended to dwell on Courbet's apparent attraction to the theme of lesbianism, which from the perspective of that picture may be seen to have had several mostly less explicit antecedents in his art.[26] In this connection, too, various nineteenth-century literary representations of lesbian love have been adduced, Baudelaire's "Femmes damnées" from the *Fleurs du mal* being probably the nearest equivalent to Courbet's canvas.[27] What remains unclear, however, is the nature of Courbet's interest in the subject. As Steven Z. Levine has noted, two of Courbet's early critical advocates, Castagnary and Proudhon, interpreted his depictions of lesbianism as political commentaries on the Parisian society of his time ("You who tolerate the Empire, take care," Castagnary reads the painter of *Venus and Psyche* [1864] as saying to the bourgeoisie, "here are the women that the Empire is in the process of forming"), while Levine himself has argued that "the Sapphic practices described by Baudelaire and depicted by Courbet should be seen as proposing an ideal love not subject to the constraints of commodity exchange that were said to characterize both prostitution and marriage."[28]

This is intriguing, but the sheer persistence of the theme of women reclining together in Courbet's art indicates that we are in the presence of still another obsessional motif, the essential significance of which far exceeds the artist's conscious intentions. And as so often in Courbet, *Sleep* must be compared as well with works that on narrowly thematic grounds might seem impertinent: the early drawing *Sieste champêtre*, for example, which depicts Courbet and a female companion asleep against the base of a tree, or, again, the *Hammock*, with its sleeping woman and amorous rosebush, the latter associable, I have proposed, with the painter-beholder. As the last comparison recalls, moreover, the painter-beholder—or his desire—is repeatedly thematized in Courbet's art as implicitly "feminine" (or at least as bigendered), which suggests that the lesbianism of *Sleep* ought perhaps to be seen as a transposition into an explicitly "feminine" and manifestly erotic register of the aspiration toward merger that I have claimed was basic to Courbet's enterprise throughout his career. That the nearer woman has been portrayed partly from the rear reinforces the suggestion, as does the fact that her dark hair and tannish skin function in this context as secondarily "masculine" traits that in turn may be taken as linking her with the painter-beholder.

Put slightly differently, it is as though in *Sleep*, enjoying the security of working for a collector he knew wouldn't be shocked, Courbet gave free rein to a fantasy of total corporeal presence that had never before been allowed to erupt so dazzlingly in his art—the fantasy that a sufficiently sensuous, which for him meant a spectacularly "feminine," object could draw the beholder literally out of himself, or at the very least could eliminate all sense of difference between himself as

painter-beholder and what he beheld, thereby resolving at a stroke the issue of theatricality that had conditioned Courbet's endeavors almost from the first. As is also true of the *Young Ladies on the Banks of the Seine,* the (male or female) viewer's experience before *Sleep* approaches sensory overload, but the later painting differs sharply from the earlier one in its stunning assertion of the two women's entire nakedness: between them we are shown not only a seemingly endless expanse of flesh but also complementary aspects (for example, front and rear, from below and from above) of what gradually we realize may be seen as virtually a single (bigendered) female body, framed by a single pair of arms.[29] (The darker pink of the coverlet contributes its intimation of an *interior* aspect, as of the inside of a mouth or vagina.) And no more than in the *Woman with a Parrot* are we offered a full revelation of either woman's sex, but instead of the abrupt displacement of interest to the parrot woman's inverted face and hair and consequent devaluation of the rest of her body, our attention finds itself divided and dispersed among multiple competing foci, each of which appears to have been rendered with equal relish for the pleasures of representation. In short, the viewer's experience before *Sleep* is simultaneously that of a comprehensive quasi-corporeal unity and of a highly mobile perceptual multiplicity, a combination not uncharacteristic of Courbet's art but here given its extreme expression as regards the human figure.[30]

A further index of the radicalness of *Sleep* as a projection of painterly desire might appear to be the absence from it of signs of its making of the sort I have been claiming to detect elsewhere in Courbet's oeuvre, including the *Woman with a Parrot,* on the face of it an unlikely candidate for such a reading. But once again the rendering of both women's hair invites being seen in connection with a thematics of the brush, in addition to which it is at least conceivable that the squarish table in the left foreground and the vase of flowers against the wall at the right may be understood as expressions of the painter-beholder's palette and brush respectively, the flowers here vividly embodying the work of the brush (another instance of bigendering) and the vase itself being blazoned with a highly colored image, hence perhaps figuring the painting as well. I suggest too that the spatial elision by virtue of which the string of pearls alongside the sleeping brunette appears to emerge from the goblet on the table allows one to imagine the entire scene—indeed the painting as a whole—as issuing magically from the goblet (thus indirectly from the palette).[31] So even in *Sleep* a rather rich thematics of pictorial creation can be brought to light.

What must be emphasized in closing, however, is that neither that thematics nor the general relation of *Sleep* to Courbet's antitheatrical project mitigates in the least the painting's erotic, even semi-pornographic character, which remains at the farthest pole from an actual putting into question of the masculinist norms inherent in its genre. On the contrary, it seems likely that the pursuit of antitheatricality functions in *Sleep* as a new and powerful technology for the production of semi-pornographic effects, a technology Courbet cannot be said to have knowingly exploited but that nonetheless yielded sensational results. More ravishingly than any other painting in his oeuvre, *Sleep* represents the limits of Courbet's "femininity."[32]

POSTSCRIPT (November 1987). There is space here (and time now) to respond only very briefly to Linda Nochlin's adverse comments on "Courbet's 'Femininity'" in the third section of her essay in this catalogue, "Ending with the Beginning: The Centrality of Gender." I will settle for the following basic points:

1. I think Professor Nochlin oversimplifies and in the process misrepresents the treatment of gender in Courbet's art. Take for example her repeated insistence, in the opening paragraphs of "Ending the Beginning," that "there is nothing ambiguous" about the Oedipal "lesson" or "message" constituted by the central group in the *Painter's Studio.* Is this really so? The gist of my reading of that group is that something importantly ambiguous *is* going on, not least because the separate identities of the individual figures and indeed of the picture on the easel are called into question by the visual rhymes, accords, and metaphors to which I have drawn attention. Or consider Professor Nochlin's claim that the positioning of the figures of the painter and the model in the central group is "overtly and blatantly" oppositional. Among the facts this ignores are: that the two figures face in the same direction; that their bodies are rhymed in ways I have described; that for all the obvious differences between their respective actions there is also a sense in which precisely as regards the issue of positioning each figure's hands are analogously deployed (it's easy to miss noticing how her right hand is raised to her hair); and that the painter and model are chiasmically opposed *as a pair* by the Irishwoman and manikin on the other side of the easel. Inasmuch as none of these observations seems to have impressed Professor Nochlin, it is hardly surprising that she finds reinforcement for her views in the idea that the female model "stands as passive Other to [the male artist's] active

subjecthood." But to phrase the matter in these terms (that is, to rest content with the cliché) is to fail to engage with the larger question of the role of passivity in Courbet's art, a role I have associated with the figuring of his left or palette-hand and have further linked with a thematics of automatism (in distinction to will) that invites comparison with the concerns of a major French philosophical text of the late 1830s, Félix Ravaisson's *De l'habitude.* . . . Obviously I can't rehearse the richness and complexity of this material here. My point in mentioning it (again) is to suggest how much is lost to view and thought when a work like the *Painter's Studio* is declared (not shown) to be unambiguously and unproblematically patriarchal in its depiction of gender.

2. Professor Nochlin repeatedly alludes to the male painter's "time-honored privilege of entering the bodies of women in his painting" as a means both of normalizing my account of Courbet's (or, as I say, the painter-beholder's) efforts to merge quasi-corporeally with female surrogates and of implying that what is at stake in such "entering" is in essence sexual possession. But here too I find she is being simplistic, this time at my expense as well as Courbet's. For the projections and identifications to which I have called attention are neither traditional (how many other painters ever represented themselves in the act of painting through the figure of a seated naked woman depicted from the rear, as I have claimed Courbet did in the *Source*?) nor essentially sexual (*vide* the same canvas, which incidentally comes close to positioning the [presumably "masculine"] beholder in the place of the naked model in the *Painter's Studio*), which isn't to deny that sexual possession of a female figure by the painter-beholder *is* more or less straightforwardly implied in certain specific paintings by Courbet. In fact I state that this is so in the last note in my essay, where I also remark that "to the extent that a metaphor of penetration has been implicit throughout my account . . . Courbet's antitheatrical project itself may be understood as figuratively 'masculine.'" But the language and tenor of such a formulation differ fundamentally from Professor Nochlin's literalist rhetoric. Moreover, just as she refuses to recognize the special nature of Courbet's investment in many (by no means all) of the female figures in his paintings, so she is compelled to insist that the figures in question are fully as powerless, as disenabled, as she seems to believe *all* female figures under a patriarchal pictorial regime are always and inevitably bound to be (this is the point of her comments in a note on my reading of the *Sleeping Spinner*). But her a priori commitment to a rigidly oppositional thematics of gender fails

to do justice to what I have tried to demonstrate is the extraordinary suppleness of Courbet's paintings in this regard: for example, to the fact that the phallic distaff is nonetheless literally and symbolically a "feminine" object; to the metaphorics of menstrual blood and indeed pregnancy in the *Grain Sifters*; and to the association between flowers and the painter-beholder's palette and between women's hair and the tip of the painter-beholder's brush in others of the pictures I have discussed. For her part, of course, Professor Nochlin is completely unconvinced by my vision of Courbet's art (in her words, she finds "not the slightest support" for my reading of the *Sleeping Spinner*). So what we have is a conflict of interpretations—and ultimately of approaches—concerning an issue that could hardly be of greater contemporary interest.

3. I don't consider my account of the treatment of gender in Courbet's art to amount to a defense of him either as man or painter, which appears to be how Professor Nochlin can't help taking it. Thus for example I never attribute to him "an 'openness' to the 'feminine' side of his nature" (Courbet as Phil Donahue), and I never refer to "a protofeminist Courbet" (look again at the first paragraph of my essay). By the same token, for all Professor Nochlin's insistence upon "reading as a woman," the tone I mainly hear in her remarks about my own work is that of outraged art-historical positivism even if the lingo is that of reductive, biological feminism. And in fact the two conspire together precisely because both are rigid, exclusive systems of meaning: thus the only strong alternative to "the boys'" interpretation of the *Painter's Studio* she is able to come up with is an imaginary reworking of the painting that substitutes Rosa Bonheur for Courbet, displaces and unnames the male figures while bringing the female figures forward, and so on—an exercise that by its very nature is powerless to challenge in the least degree the intellectual structures of traditional art history that Professor Nochlin claims to find so oppressive. What she fails to consider, in other words, is that both within the field of art history and outside it strategically by far the most subversive sense that can be given to the program of "reading as a woman" is that of reading not oppositionally but *differently*, a point made over and over in the writings of nonreductive, nonessentialist feminists. But of course to embrace such a program requires a willingness to countenance the unfamiliar, and it also means accepting the fact that reading differently will not be the prerogative only of women.

"It Took Millions of Years to Compose That Picture"

Though constituting approximately two-thirds of his total oeuvre, Gustave Courbet's landscape paintings have received little attention in the voluminous literature devoted to the artist in recent decades. Ever since Meyer Schapiro's pioneering article of 1941, "Courbet and Popular Imagery,"[1] Courbet research has focused on the artist's figure paintings, notably those of the early 1850s, in an ongoing attempt to place their subjects—and, by extension, their author—in the context of the political, social, and cultural history of mid-nineteenth-century France.

In the past few decades only three major articles dealing exclusively with Courbet's landscapes have appeared. In the first of these, Klaus Herding suggests that the landscapes—a genre to which Courbet was increasingly attracted from the 1850s on—continue, in an altered and more subtle way, the polemic-ideological tone of the earlier figure paintings.[2] Herding's thesis is that the choice of motif, the compositional schemes, the distribution of light and dark, and the brushwork of Courbet's mature landscapes all reflect his growing inclination toward anarchism in response to the crucial nineteenth-century conflict between democracy and equality, on the one hand, and authority and hierarchy, on the other.

By contrast, Anne Wagner considers the landscapes a departure from Courbet's earlier figure paintings.[3] Wagner proposes that the landscape paintings, with their emphasis on *effet* and *facture*—the sensorily perceived materiality of painting—to a large extent sprang from the demands of a middle-class public for a non-tendentious, unproblematic art.

Michael Brötje offers a Gestalt approach to Courbet's landscape paintings.[4] Brötje is fascinated by the contradictions that arise from the confrontation between a perspectival view of the landscape and a view of painting as a flat plane. He suggests that the guiding principle of Courbet's landscape paintings is never to render nature for its own sake, but to show the problematic aspects of seeing; Courbet's landscapes are simultaneously representations and visual similes of nature.

Although the arguments of Herding, Wagner, and Brötje have intrinsic merit, they fail to explain the unique character of Courbet's landscapes within his oeuvre as a whole. The political, economic, and Gestalt-psychological factors cited as having made an important contribution to the characteristic form of Courbet's landscape paintings are in no way uniquely applicable to them alone but in principle have the same validity for other categories of Courbet's oeuvre, such as his still lifes or nudes. Why, then, are the novel choices of motif, the often unusual compositions, and, especially, the unorthodox facture of Courbet's landscapes not found in his works in those genres? This question can be answered by dealing with the most important determinant of Courbet's landscape painting, namely, the way in which he experienced landscape.

In this study, my aim is to reconstruct, from direct and indirect evidence, the nature of that experience and to assess how it affected Courbet's art.[5] I also hope to demonstrate that Courbet's attitude toward landscape was unlike that of the foremost French landscape painters of his day, those of the Barbizon school, but that it

was related instead to contemporary views of nature and landscape found in Germany and Switzerland. My arguments will be based on the premise that the way people experience landscape is not merely a product of their visual alertness and aesthetic sensibility but that it is conditioned by a number of nonvisual factors, notably: their geographic origins and the nature and depth of their emotional ties to their native land; their economic relation to the land; their idea of landscape; and their conception of nature. All of these factors in turn are affected by the time in which they live.

Courbet's geographic origins lay in Ornans and Flagey, two villages in the Département du Doubs, halfway between Besançon and Pontarlier. Located on the border with Switzerland, the Doubs is the easternmost department of the Franche-Comté, historically important as the Free Countship of Burgundy and one of the more isolated and independent regions of France. The larger part of the department is occupied by the Jura plateau, through which the meandering Doubs River and its tributaries (for example, the Loue and the Conche) form deep gorges and dramatic waterfalls. The porous limestone of the Jura plateau allows the smaller rivers occasionally to go underground, disappearing and reemerging from deep caves. In Courbet's time, parts of the Doubs highland were covered with tall pine forests, while other areas were cleared for pasture. The southern slopes were covered with vineyards that produced an agreeable local wine. The numerous rapids and streams were tapped as sources of energy for various light industries, such as the fabrication of paper. Although the climate in the summer was warm enough to allow viticulture, the winters, especially in the Doubs highland, were long and hard and marked by abundant snowfalls.[6]

This was the country where Courbet was born, where he roamed as a child, and to which he returned as an adult for countless hunting and fishing trips. His love for the region, borne out by his frequent returns as well as by numerous contemporary accounts, had a powerful sensual and physical basis. Here, at one time or another, he had rolled in the grass, climbed the trees, smelled the pine and the hay, swum in the brooks, found shelter from rain or sun in deep caves, trudged in the snow, picked berries or mushrooms, listened for the sound of wildlife, cut open freshly killed venison and fish, eaten the fruit, and drunk the wine.[7] These myriad physical encounters had forged an emotional bond with the land that was independent of family or friendship ties.

The French social historian Jean-Luc Mayaud has shown that Courbet descended from a family whose rapid economic and social ascendance was closely tied to the land.[8] Courbet's grandfather, Claude-Louis Courbet, was an agricultural laborer who profited from the sale of land confiscated after the Revolution (*biens nationaux*) to acquire some lots of his own. His son, Régis (Courbet's father), managed to expand these modest landholdings, becoming the richest landowner in his home village of Flagey and the sixteenth richest in the canton of Amancey. Both Claude-Louis and Régis married above their social stratum, thus ascending first to the lower middle class and then to the upper middle.[9]

Even though Régis Courbet was in a position to lead a life of leisure, he preferred to cultivate his land himself with the help of hired labor. His landownings were varied and included farmland, pasture, and vineyards, as well as woods. A self-styled agronomist, Régis bought and sold land in order to centralize his holdings in Flagey, and he also turned increasing amounts of land over to pasture.[10] His active interest in improving agricultural tools further confirms his progressive approach to farming.[11]

Gustave Courbet shared his father's interest in real estate, as is apparent in both his own correspondence and the cadastral records of the Département du Doubs. The latter show that between 1849 and 1870 he invested a good part of his earnings in land, acquiring a total of thirty-seven lots that together occupied about nine acres. Though this may not be very impressive by contemporary American standards, it must be kept in mind that 80 percent of the landowners of Flagey owned less than the approximately seven-and-one-half acres deemed necessary to support a family.[12]

Like his father, Gustave Courbet was interested not only in land acquisition, but also in its use and cultivation, and his letters provide ample evidence of his preoccupation with the productive adaptation of his land. In a letter to his friend Urbain Cuenot written in 1866, for example, the artist gives detailed instructions, illustrated by a sketch (fig. 4.1), for the planting of an orchard on one of his terrains:

I'll order 30 grafted cherry trees which you will have [someone] plant like those that are there already. . . . Lavigne will [also] send you 82 apple trees, for open terrain and grafted, if possible, for I want to make cider. That [drink] agreed very well with me in Trouville; it softens the stools and will be a favorable substitute for beer.[13]

In an earlier letter, written in 1859 to his sister Juliette, the artist describes his plans for a terrain on the route de Besançon, which he had recently bought with the idea of building a new studio. On the "pleasant and nicely

4.1. Gustave Courbet. *Sketch of Orchard* (in a letter of 1866, to Urbain Cuenot).

wooded lot" he intends to plant clumps of different trees that will be useful for his landscape paintings.[14]

It is clear that Courbet had close economic ties to the land in which he had invested a considerable portion of his assets. Although some of this land may have brought him monetary profit, Courbet seems to have looked to his property above all as a means to improve his personal comfort and well-being or to serve him in his artistic pursuits. In addition, land lent Courbet upper-middle-class status, at least in his native region, where the cadastral records ranked him among the *propriétaires*.[15]

It is easy to establish Courbet's geographical origin and to assess his emotional and economic ties to the land, but it is more difficult to grasp his idea of landscape or his concept of nature. The artist said or wrote little about these issues and it is necessary, therefore, to turn to circumstantial evidence.

An important aspect of life in the Doubs during Courbet's time was the *Société d'émulation du Doubs*, which was composed of Courbet's fellow landowners and notables (many of them close relatives and friends), whose aim was the improvement of the economic conditions in the region by means of fostering scientific research focused on the land—for example, its geology, botany, zoology, hydrology—and possibilities for its exploitation through agriculture, dairy farming, forestry, and product-related industries, such as wine production, cheese making, and the fabrication of paper.[16]

The Société d'émulation du Doubs was one of several similarly named organizations founded in France in the early nineteenth century. Such organizations appear to have been particularly popular in the isolated regions of eastern France, where the Franche-Comté alone counted three of them in each of its departments, Doubs, Jura, and Haute-Saône. The Société d'émulation du Jura, founded in 1818, was the oldest and most respectable of the three. It numbered among its members many important writers, politicians, scholars, and scientists, including Courbet's friends Max Buchon, Jules Marcou, and Francis Wey, as well as Victor Hugo, Alphonse Lamartine, and Charles Nodier.[16] The Société d'émulation du Doubs was established in Besançon in 1841, at the time when Courbet was a college student there. The society included among its founders Pierre-François Delly, Courbet's mathematics professor at the Collège Royal de Besançon and his landlord for one year.[17] The membership of the Doubs society, in the first few decades of its existence, included several of Courbet's closest friends, among them Dr. Blondon, Urbain Cuenot, Léon Isabey, and Dr. Edouard Ordinaire, in addition to numerous less intimate acquaintances. In 1853 Courbet himself registered as a member, but he seems to have remained that only for one year since his name does not occur on the membership lists of subsequent years.

At regular intervals, the society published the *Mémoires de la Société d'émulation du Doubs*. This publication reported the activities of the society, and it also contained lengthy scholarly articles written by members on the geology and paleontology of the Doubs region, its history and archaeology, its flora and fauna, as well as its agronomy and industry. The early volumes, published between 1841 and 1850, include articles on such diverse topics as the insect population of the Doubs; the Porte noire, a Roman triumphal arch in Besançon; the carbonization of wood in the forest; the history of the medieval château d'Ougney, in ruins since the end of the seventeenth century; local rock formations; a new harvest machine. In the 1850s numerous articles relate to the then much-publicized archaeological controversy about the location of ancient Alesia, the place where Julius Caesar had captured the rebel Gallic leader Vercingetorix. The society played an important part in this controversy, organizing several field trips to the hamlet of Alaise, near Salins, where its members presumed Alesia to have been, and forming committees to draw maps of the site and collect historical materials.[18]

With all their apparent variety, nearly all the articles in the *Mémoires* deal with the Doubs landscape—its his-

tory, its present features, or its potential for exploitation. Their common denominator is an awareness of landscape as a dynamic entity, subject to change from the operation of natural and human forces.[19] This dynamic idea of landscape is closely related to an idea of nature that may be called evolutionary, whereby the term is used not in a narrow Darwinian sense (indeed, Darwin's *On the Origin of Species* was not published until 1859) but in a broader cosmological sense, meaning subject to continuous and progressive change.[20] This idea of nature was rooted in late-eighteenth-century science. Authors like Georges Buffon, Jean-Baptiste Lamarck, and Erasmus Darwin, who first formulated the evolutionary concept, were themselves inspired by the historical studies of Turgot and Voltaire, who recognized that progress—in the sense of change, process, and revolution—is central to historical thought.[21] In the nineteenth century the development of the evolutionary idea of nature went hand in hand with the growth of modern historical thinking, and historians drew a conscious parallel between "natural" and human history.[22]

Did Courbet share the dynamic idea of landscape and the evolutionary idea of nature that seem to underlie most of the articles in the *Mémoires*? As he was a member of the organization for only one year, it seems doubtful that he read these often-dry scholarly articles. Yet, he was a close friend of many of the active members of the society and through them probably had a continuing awareness of its activities, goals, and basic philosophy. Through his family and upbringing, moreover, he would have been aware of the dynamics of landscape, as he witnessed the changes wrought on the land owned by his father. With the latter, who apparently was fascinated with the Alesia question, he also shared an interest in the archaeological past of the region, as is clear in an unpublished letter to Jules Castagnary, in which he invites his friend to travel with him through the Franche-Comté: "you will see Salins, you will see Poupet and Alaise, or Alesia, according to the Druids, Nans and the source of the Lison."[23]

That Courbet shared the evolutionary concept of nature with the members of the Société d'émulation du Doubs is further confirmed by his interest in the natural sciences, which were at the root of this concept. As a young boy he was famed for his skills in catching butterflies,[24] and his adult zoological interests were bound up with his passion for hunting, from which he gained his intimate familiarity with the habits and habitats, as well as the anatomy and physiology, of the wild animals in the region. A systematic interest in zoology is suggested by a contemporary description of his studio on

4.2. Gustave Courbet. *La Roche pourrie*, 1864. Oil on canvas. Salins-les-Bains, Town Hall.

the route de Besançon, where jars with preserved reptiles lined the shelves along the walls.[25]

Courbet also appears to have taken an active interest in botany. At least two instances have been recorded in which he joined field trips of groups of botany students.[26] One of these was conducted by the well-known botanist Gaspard-Adolphe Chatin, a professor at the Ecole de Pharmacie in Paris. Chatin was well known in his time not only for his popular *herborizations publiques*, but also for his remarkable scientific work on the organogenesis of plants.[27]

Courbet's awareness of the unique geological and paleontological history of the Jura mountains is clearly documented in his painting *La Roche pourrie* (fig. 4.2). First exhibited in 1867 under the title *Etude géologique*,[28] the work was painted three years earlier at the request of Jules Marcou, one of the leading French geopaleontologists of the first half of the nineteenth century, whose work was of sufficient importance to be cited by Alexander von Humboldt in his epoch-making book *Kosmos* (1845–62).[29] Courbet may have been introduced to Marcou by his close friend Max Buchon, who knew the geologist well and even wrote his biography in 1865.[30] Like Buchon, Marcou was a native of the town of Salins. He studied in Switzerland, where he became acquainted with the famous Swiss scientist Louis Agassiz, who was later to found the zoology museum at Harvard University. In 1846 Marcou became professor at the Sorbonne, and from 1848 to 1854 he worked with Agassiz at Harvard. Although he lived in locations mostly outside France, he regularly returned to his native Salins.

It was only natural that Marcou should specialize in the study of the Jurassic period. His interest in geology stemmed from early amateur studies of the rock formations near Salins, which contained significant deposits of all phases of the Jurassic system. In 1847 he published his first major article, "Recherches géologiques sur le Jura Salinois," which launched his geological career.[31] Marcou had made a special study of a mountain near Salins, the so-called *Roche pourrie,* where he had found unique deposits of iron and calcium iron from the lower oolite stratum for which he was later to coin the terms *fer de la Roche pourrie* and *calcaire de la Roche pourrie.*[32] Marcou's commissioning of Courbet to paint the Roche pourrie may be seen as a compliment by a scientist to an artist whose renderings of rock formations surely appealed to his geologist's eye. Courbet's acquaintance with Marcou may also underlie a series of early drawings of unusual rock formations near Salins.[33] These drawings, which are in Louvre sketchbook *RF* 29234, are all identified by site: Fort Bélin, Salins (p. 29 recto), Source de Lison (p. 30 recto), Creux Billard (p. 29 verso), and Grotte Sarrasin (fig. 4.3), for example. Done in charcoal, they characterize in a highly suggestive way the uniformly leveled Jurassic rocks with their long vertical striations and weathered surfaces. Stylistically related to Courbet's drawings of Alpine scenes in Switzerland in sketchbook *RF* 9105, which Hélène Toussaint has convincingly dated to 1842,[34] the Salins drawings seem somewhat more mature and were probably done one or two years later. It is possible that Courbet drew them in the summer of 1844 when Marcou did the research for his article on the Jura Salinois, and it is tempting to assume that, like *La Roche pourrie,* these drawings were done on Marcou's urgings.

The geographic and economic factors, as well as the idea of landscape and the conception of nature, that underlie the way a person experiences landscape are intrinsic to the rich layering of associations that make up the totality of Courbet's landscape experience. The view of a particular site, for example, might suggest to him some form of sensual experience other than visual; or it might suggest ownership and social status, financial profit, or material well-being that could be obtained through cultivation or industrial exploitation of the land; then again, the view might suggest the natural and cultural history of the site. Relating all these various associations was the sense that landscape was ever-changing, as it was subject to the combined impact of man and nature.

This sense of landscape as an intermediate stage in an ongoing process of change appears to have been a

4.3. Gustave Courbet. *Grotte Sarrasin,* 1843–44(?). Charcoal. Sketchbook RF 29234, Paris, Musée du Louvre, Département des arts graphiques.

major determinant of Courbet's choice of motifs. It may explain an aspect of that choice that is particularly puzzling, namely the simultaneous occurrence in Courbet's oeuvre of typical Romantic elements, like ruins, woodcutters, and abandoned boats, and elements that are clearly Realist, such as paper mills, cement drinking troughs, and podoscaphs. In addition it may suggest why many of Courbet's landscapes, especially those showing rocks and caves, are without staffage figures: to Courbet such landscapes were so full of intrinsic drama that the presence of any kind of human activity would be superfluous, if not distracting. The following examples may illustrate this thesis.

A considerable number of Courbet's landscapes suggest the combined impact of nature and man on landscape. His early sketchbooks, particularly *RF* 29234, are filled with drawings of medieval architecture, most often in the context of a landscape setting. His drawing of a ruined gate (fig. 4.4), for example, shows how manmade structures, like their natural counterparts (cf. fig. 4.3), are subject to the passage of time. The same idea underlies his painting of the *Bridge at Ambrussum* (fig. 4.5), a monumental Roman bridge now reduced to a fragmentary ruin.

The idea of nature slowly effacing man's imprint on the landscape is expressed even more explicitly in the

4.4. Gustave Courbet. *Ruined Gate*, 1843–44(?). Charcoal. Sketchbook RF 29234, Paris, Musée du Louvre, Département des arts graphiques.

4.5. Gustave Courbet. *Le Pont d'Ambrussum*, 1854–57. Oil on paper, mounted on board. Monpellier, Musée Fabre.

Oak at Flagey (cat. 44). First shown at Courbet's private exhibition at the Rond-Point de l'Alma in 1867, the painting was referred to in the catalogue as "Le chêne de Flagey, appelé 'chêne de Vercingétorix,' Camp de César, près d'Alésia, Franche-Comté." The representation of Caesar's camp as a field of trees is highly suggestive of the dynamics of landscape, which through the alternate operations of man and nature can turn from *Naturlandschaft* to *Kulturlandschaft* and back to *Naturlandschaft*.[35]

In the *Château d'Ornans* (cat. 11), first exhibited under that title in 1855,[36] Courbet suggests the progressive course of history as the painting depicts the site once occupied by the château of the feudal dukes of Burgundy, now by the houses of the provincial middle class, men like Courbet's friend Urbain Cuenot and others whose families owed their wealth and status to historical change, notably the French Revolution.[37] The paradox between the painting's subject and its title puzzled contemporary viewers like the critic Ernest Gebauer, who wrote:

That which seems most curious in the Château d'Ornans *is that we were not yet able to discover the château. We see well the little houses on the height [and] . . . in the foreground a fountain at which a woman washes her linen; but the château? Where is the château?*[38]

The ongoing impact of man's activities on landscape in Courbet's own time may be seen in such paintings as the *Stonebreakers* (fig. 1.2, above), which hints at the new roads that will wrench the Franche-Comté from its geographic isolation, as will the railroads found in his drawing for an illustration of one of Champfleury's chansons (fig. 4.6).[39] The *Country Nap* (cat. 91) and the *Blue Well* (Fernier 1977, no. 823), with its woodcutter felling a tall pine tree, demonstrate Courbet's awareness of innovative agronomic tendencies in the Doubs region, while his water mills (for example, Fernier 1977, no. 387) and paper mills (fig. 4.7) are evidence of his preoccupation with the industrialization of landscape.

Not only the Franche-Comté paintings but also Courbet's landscape paintings of other regions evoke the changes—for better or worse—wrought in the landscape by technological and social progress. His numerous depictions of Norman beaches with abandoned boats (for example, fig. 4.8), may be considered as evidence of the disastrous effects of tourism on the local fishing industry rather than as Romantic clichés. Sea bathing, which became the rage during the Second Empire, slowly drove the fishermen away from the Normandy coast, notably near such major bathing resorts as Dieppe and Etretat. These changes were noted with regret by concerned contemporaries such as Jules Michelet, who wrote in *La Mer* in 1861:

I saw numerous abandoned boats, useless. Fishing has become sterile. The fish have fled. Etretat pines away, perishes, while nearby Dieppe is languishing. Increasingly its resources

4.6. Gustave Courbet. Illustration for Champfleury's *Chansons populaires de France*, 1860. Conté crayon. Cambridge, Massachusetts, Fogg Art Museum, Bequest of Grenville L. Winthrop.

4.7. Gustave Courbet. *The Paper Mill*, c. 1865. Oil on canvas. Ornans, Musée Gustave Courbet.

are reduced to bathing; it waits to get its life from the bathers, from the haphazard residential hotels which are now rented, then empty, eventually leading to impoverishment. Getting mixed-up with Paris, the mundane Paris, however much it pays, is a calamity for the country.[40]

Not only the impact of man but also that of nature is evoked in Courbet's works. His paintings of rocks and caves reveal the telltale monuments of nature's history. Like the wrinkles in the face of an old man or woman, the crevices and weathered surfaces of Courbet's mountains, caves, and rock formations prove their eventful past. The *Source of the Loue* (pls. 47, 48), the *Gour de Conche* (cat. 46), the *Isolated Rock* (fig. 4.9), and the *Rock at Bayard* (fig. 4.10) are but a few of Courbet's paintings that present rocks and caves not as scenic backdrops for human activity, but as subjects that tell their own story and have their own intrinsic dynamic. It is instructive to compare Courbet's painting of the *Rock at Bayard* of 1855 with a watercolor of the same subject, dated 1835, by the Dutch Romantic painter Barend Koekkoek (fig. 4.11). In Koekkoek's watercolor the rock provides the backdrop for human activity. The artist seems to wish to bring out the contrast between the immovable and unchangeable eternity of the rock and the ephemeral activity of man in the fleeting evening hour. Courbet's painting, in its straightforward presentation, is rather in the tradition of scientific illustration and may be compared with the prints found in eighteenth- and

early nineteenth-century geological treatises.[41] For Courbet there is no need for human action in his compositions as there is sufficient drama in the rocks themselves.

Courbet's concept of landscape as a continuously changing presence subject to the evolutionary processes of nature and the progressive history of mankind determined not only his selection and presentation of landscape motifs but also his unique procedure and painting technique. The artist's working method was much discussed by his contemporaries, who were as fascinated with the artist's creative process as with his creations. In large part this interest was fostered by Courbet himself, who worked often and willingly before an audience.[42] Many eyewitness accounts describe Courbet's unorthodox technique, notably his habitual substitution of the brush with the palette knife, or using on occasion even more unusual paint applicators, such as sponges, rags, or fingers.[43] Courbet himself stressed that his technique was aimed at paraphrasing natural, even cosmic processes. On the use of the palette knife for the depiction of Jurassic rock formations, for example, he had this to say: "Try a brush to do rocks like that, rocks that have been eroded by the weather and the rain, which have formed long seams from top to bottom."[44] And on his frequent use of darkly primed canvases and his method of working from dark to light, he is quoted as having said: "Nature without the sun is dark and obscure; I work like the light: I illuminate the high

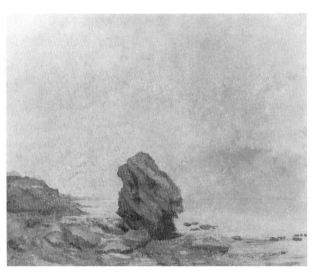

4.8. Gustave Courbet. *Normandy Beach with Abandoned Boat*, 1870. Oil on canvas. Paris, Musée d'Orsay.

4.9. Gustave Courbet. *The Isolated Rock*, c. 1862. Oil on canvas. The Brooklyn Museum, Gift of Mrs. Horace Havemeyer.

points,"[45] and, on another occasion, "I do in my paintings what the sun does in nature."[46]

Courbet's insistence on being an apprentice of nature[47] further confirms his notion that the artist learns his procedure and technique by studying nature's processes. This idea that art forms and artworks evolve organically, like nature, was not unique to Courbet but, as Miriam Levin has pointed out, was gaining currency in Positivist-Republican artistic and philosophical circles in the 1860s among men like Emile Zola and Hippolyte Taine,[48] who concluded that "life is the same in works of genius and of nature."[49] By simulating the processes of nature that had caused the appearance of his landscape motifs instead of imitating that (temporary) appearance itself, Courbet has created landscapes that are visual metaphors rather than literal translations of natural motifs into paint. Just as the rocks that Courbet painted betrayed their evolution in their layering and surface texture, so his paintings have a "transparent" structure in which the process of their creation is clearly visible.[50] His works lack "finish"[51] and suggest, like nature, a stage in an ongoing process rather than an ultimate statement.

Courbet the landscape painter fits uncomfortably in the history of nineteenth-century French art. Even though he is commonly treated as an appendix to the Barbizon school,[52] his landscapes differ distinctly from those of Théodore Rousseau, Jules Dupré, or Jean-

François Millet, for example. This difference lies not only in the choice of landscape motifs—Jura mountains and rocks versus Barbizon plains and trees—but also in their interpretation and technique. Neither the stark presentation nor the unorthodox facture of Courbet's works is found in those of Barbizon artists. At the root of these differences is a totally different landscape experience, which in turn is caused by different geographical and social backgrounds, and perhaps especially by a different idea of nature.

The work of Rousseau, commonly recognized as the key artist of the Barbizon school, may serve as an example. Seven years older than Courbet, Rousseau had championed the cause of landscape painting in France since the 1830s, and he helped it become an acceptable genre during the years of the Second Empire, when he was widely and officially recognized as the foremost French landscape painter of his day.[53] Two works of similar subject matter—Rousseau's *Oaks at Apremont* (fig. 4.12), a work of 1850–52, and Courbet's *Oak at Flagey* (cat. 44), painted in 1864—reveal very different experiences of landscape. Rousseau's painting shows a cluster of oak trees seen from a distance sufficient to allow it breathing space in the surrounding landscape and sky. A clear midday light illuminates the terrain and filters through the foliage of the trees, creating a complex patchwork of light and dark—"myriads of solar combustions," in the words of Rousseau's biographer and friend, Alfred Sensier.[54] The trees themselves are

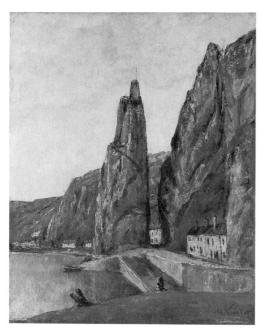

4.10. Gustave Courbet. *The Rock at Bayard*, 1855. Oil on canvas. Cambridge, England, Fitzwilliam Museum.

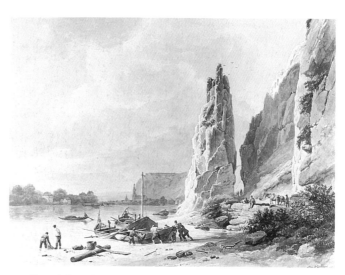

4.11 Barend Cornelis Koekkoek (1803–62). *The Rock at Bayard*, 1835. Black chalk, pen and brown ink, watercolor. Haarlem, Teylers Museum.

painted with great subtlety, and although not every leaf has been rendered individually, the multitude and density of the foliage has been clearly conveyed. A cowherd with his cows has withdrawn to the benevolent shadow of the trees, and their presence lends to the scene a sense of peace and pastoral happiness.

By contrast, Courbet's painting shows a close-up image of an oak tree, whose giant crown fills nearly two-thirds of the canvas, leaving room for only tiny patches of sky to appear between the lower branches and the terrain. Light and atmosphere are treated indifferently, and one would be hard put to determine the weather or time of day. The foliage consists of thinly sponged-on green paint spread like a net over the tree's dark skeleton. Exactitude, light, atmosphere, mood are all lacking in Courbet's painting. Instead there is a forceful presence, an interior dynamism, and a purposefulness that we look for in vain in Rousseau's work.

The differences between Courbet's and Rousseau's oak trees are due as much to composition as to painting technique. Sensier has described Rousseau's working procedure extensively.[55] In contrast to Courbet's prodigious speed, Rousseau worked slowly, often taking six months to a year to complete a painting. His works were based on prolonged contemplation of reality,[56] followed by a patient and meticulous painting process. In a letter to Sensier of 1863, which was partly published in one of the Parisian papers, Rousseau defended his slow and painstaking working method:

I understand by composition that which is within us, entering as much as possible in the exterior reality of things.

If it were otherwise, a mason armed with his lathe would be soon finished with the composition of a painting representing the sea. He would only have to trace a line at any height of the painting. But really, who composes the sea, if it is not the soul of the artist? . . .

There is composition when the objects are not represented for their own sake, but in view of containing, under a natural appearance, the traces they have left in our soul. Though one can argue whether trees think, it is certain that they make us think, and in return for the modesty with which they elevate our thoughts, we owe them, for the price of their spectacle, not an arrogant virtuosity, nor a pedantic classicist style, but all the sincerity of a grateful attention to the reproduction of their beings, for the powerful action they invoke in us. For all they give us to think, they only ask that we do not disfigure them, that we do not deprive them of that air that they need so badly. . . .

For God and as thanks for the life that he has given us, let us see to it that in our works the manifestation of life is the first of our thoughts; let us see to it that a man breathes, that a tree can really grow.[57]

Rousseau's landscape experience sprang from an idea of nature that was diametrically opposed to that of Courbet. His conservative-religious idea of nature as the perfect product of God's creation demanded that man approach it with reverence, indeed "with all the re-

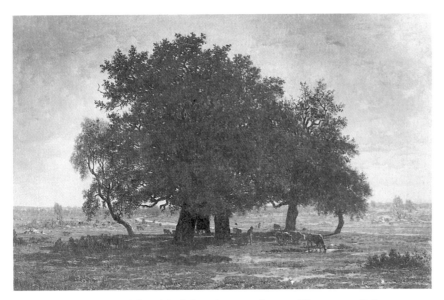

4.12. Theodore Rousseau (1812–67). *Oaks at Apremont*, 1850–52. Oil on canvas. Paris, Musée d'Orsay.

ligiousness of one's soul."[58] Such a religious attitude to nature did not exclude the scientific study of its elements. Rousseau is known to have observed plants, animals, and rocks with the dedication of a botanist, zoologist, or geologist.[59] But this study was geared not to retrace the origin of nature by examining its processes but rather to get to the essence of creation. The contemplation of nature left "traces" in Rousseau's soul and invoked "powerful action" in him as he adhered to the belief—common in the Romantic period—that in nature God's intentions toward mankind were symbolized.[60] Consequently, in representing or "translating" nature (Rousseau said *traduire un monde réel*),[61] one needed to enter "as much as possible in the exterior reality of things," and to respect even the smallest details because, as Rousseau had said elsewhere, "all is useful in the great chain of beings."[62]

Unlike the reverential landscape paintings of Rousseau, Courbet's landscapes are closely allied with the evolution of landscape painting in Switzerland. His intimate familiarity with landscape, which combined lifelong physical closeness with scientific knowledge, is paralleled by Swiss painters from the eighteenth century on. The prototypical example of this kind of *Naturerlebung* is found in the work of the Swiss painter Caspar Wolf, who, after spending his childhood in the Swiss countryside, became part of the circle around Albrecht von Haller, one of the most important natural scientists of the eighteenth century. Wolf's best-known works are a series of oil sketches made over a four-year

period during several hiking trips in the Alps. These sketches were commissioned from the artist by the publisher Abraham Wagner for use in several illustrated volumes on the Alps that stressed a scientific, natural-historical point of view.[63] Wagner's albums were a conscious reaction against the picturesque view of the Alps promoted earlier in the eighteenth century. Their scientific tenor is clearly expressed by the title page of the *Alpes Helveticae*, which shows an Alpine landscape with rocks and waterfalls, furnished in the background with a draftsman, in the foreground with a collection of rock crystals and various fossils.[64] The art of Caspar Wolf was well attuned to the scientific aspirations of his publisher. According to Willi Raeber, the artist was much influenced by his contacts with scientists, which made him experience the "wilderness of the mountain tops not as a primordial chaos, but as the pendant, molded by natural laws of the cultural landscape formed by man over several thousands of years."[65]

There are several striking similarities between the landscapes of Wolf and Courbet, as can be seen by comparing Courbet's *Source of the Loue* (pls. 47, 48) with Wolf's view of the *Grotto of St. Beatus* (fig. 4.13). Both artists present a close-up view of the cave in such a way that the image is dominated by a black hole in the center, framed by dark rocks. Devoid of picturesque trappings, these grottoes are presented as entries into the inner depth of the earth, where the answers to its primordial beginnings may be found.[66]

Inspired by the writings of such Swiss and German

4.13. Caspar Wolf (1735–98). *Grotto of St. Beatus*. Oil on canvas. Aarau, Aargauer Kunsthaus.

authors as Horace Bénédict de Saussure, Johann Wolf-gang von Goethe, Alexander von Humboldt, and Louis Agassiz, the scientific approach to landscape painting introduced by Caspar Wolf remained important in Switzerland throughout the eighteenth and nineteenth centuries and influenced to a greater or lesser degree the work of such later landscape painters as Joseph Anton Koch, Karl Bodmer, Alexandre Calame, and Ferdinand Hodler.[67] The often striking similarities that may be found between the landscapes of Courbet, on the one hand, and those of Calame and Hodler, on the other, are due less to the art historical concept of "influence" than to the similar way in which all three artists experienced landscape.[68]

Courbet's Reception in America Before 1900

American awareness of Courbet coincided with the dramatic blossoming of public interest in the arts that began in the decade preceding the Civil War. This metamorphosis in popular taste was effected by the activities of two groups: foreign art dealers and American artists. The former group, often operating from offices in Paris or London, began exploring the potential for sales of foreign paintings in the United States during the late 1840s. The collections they showed were often large, progressive, and stylistically varied, and they included works by leading French, British, German, and Flemish artists.[1] As a result of their efforts, within one generation the American market became saturated with a wide range of contemporary works.

American artists who elected to study abroad also played a crucial role in transforming public taste and awareness.[2] By 1860, Paris had quickly supplanted Europe's most popular centers for study—Rome, Florence, Munich, and Düsseldorf—because it offered a wider range of opportunities, from the regimented Ecole des Beaux-Arts to the independent ateliers of Couture, Gleyre, and Suisse. When they returned home, American painters brought with them works by the French moderns, as well as their own works, rendered in the newer, more sophisticated styles they had learned. Their works found a ready audience among local dealers and private collectors, who often asked them to serve as intermediaries in making future purchases.

On the eve of the Civil War, the *New-York Daily Tribune* reported that

It is not many years since a room, full chiefly of "Portraits of a Gentleman," and "Portraits of a Lady," shown once a year, satisfied both the popular knowledge and the popular taste. The artist has taken a higher flight since then, and has given to the citizen, taught to appreciate something better, something more worth looking at than a good map in colors of his next door neighbor. . . . [This transition] is a sign of growing culture among ourselves. Names that were only known to us through fame, and faith, are becoming familiar through works.[3]

These words were written in connection with the exhibition that featured the first Courbet to be shown in the United States. The exhibition was one of five sponsored by the London art dealer Ernest Gambart between 1857 and 1867.[4] The shows, which were all held in New York, featured works by French, Flemish, and British artists. It was the second of these, held in 1859 at the National Academy of Design, that included a work by Courbet entitled *Sorting the Corn.*[5] Although the work can only be identified by the title—reviews of the exhibition do not illustrate, discuss, or even describe it—the painting in question is almost certainly the well-known *Grain Sifters* (pl. v).[6] The painting was the only one by Courbet to be exhibited in the United States before the Civil War, and its brief appearance passed without any popular or critical reaction.[7]

In March 1866, the Paris-based publishers Cadart and Luquet brought an expansive, and highly progressive, collection of French paintings to New York and Boston. The exhibition was held primarily to promote the French Etching Club,[8] but it was also designed to test the waters for the more lucrative market in original paintings. "French artists wish to know for themselves their position here," wrote a correspondent

for the *New-York Times*, "and have chosen this method to ascertain which of them can look for admirers among the generous patrons of genius in America."[9] Measured in these terms, the exhibition must have been quite a success, for the *Times*'s writer went on to report that "[a] large number of paintings still on exhibition have readily sold at the artists' own figures . . ."[10] The paper also described the exhibition as well attended, and it chided some of the viewers for "fail[ing] to admire the eccentricities of Gallic genius so conspicuous in this collection, . . ."[11]

The exhibition also introduced Monet to the American public, and it featured works by Daubigny and Corot as well. The star of the exhibition, however, was Courbet, who was represented by an unidentified marine and three major works: *Return from the Conference* (fig. 5.1), the *Wrestlers* (fig. 2.2), and the *Quarry* (pl. VI).[12] The catalogue was prefaced by a three-page essay devoted to Courbet and the nature of Realism. Its author was Jules-Antoine Castagnary, who had come to know Courbet in 1860 and became his most loyal supporter:

[Courbet's] works are all grounded upon one and the same principle . . . to represent the manners, the ideas, the aspect of his time according to his own estimate; in a word to produce LIVING ART. *I know of no more legitimate aim, and I doubt whether the great Masters of the past ever dreamed of any other.*[13]

Although the *Grain Sifters* had garnered no critical response during its brief appearance in New York, the Courbets shown in Cadart's exhibition elicited considerable comment from the press. *The Round Table*, a New York–based magazine, published a lengthy critique of Courbet's paintings, but their anonymous reviewer found little in them to admire. He called the *Return from the Conference* a scene of "utter and irredeemable vulgarity," and he attacked the artist for handling a "delicate" subject "without gloves."[14] Courbet's stinging attack on the clergy had been rejected in France, even by the *Salon des Refusés*, and so its subsequent rejection in America was not surprising. *The Quarry*, although inherently less controversial, received only a tepid response. The author credited Courbet for his technical abilities, but found the lack of sentiment in the work disconcerting:

The dogs are drawn and painted with force, but there is a want of motive in the composition. The man leaning against the tree does not look as if he had the least idea why he should be there; and the dog-boy with the great brass horn suggests

5.1. Gustave Courbet. *Return from the Conference*, 1862–63. Oil sketch. Oeffentliche Kunstsammlung Basel, Kunstmuseum.

rather the tuning up process in an orchestra than anything associated with the spirit of the chase.[15]

The reviewer concluded that the exhibition did not show

a single one of the best artists . . . at anything like his full power. As a study of the living exponents of the French schools it is an interesting exhibition enough; but the whole thing is to be taken cum grano salis, *and some of it would not be easy to swallow even with that.*[16]

By the time that Cadart brought the collection to Boston at the end of April, the naturalist style of the Barbizon school had gained a foothold among a number of private collectors. This was due largely to the efforts of a knowledgeable and influential group of figures, among them, William Morris Hunt, Seth M. Vose, Thomas Robinson, and Joseph Foxcroft Cole.[17] These men were instrumental in establishing many of the small, but imposing, private collections that flourished in the Boston-Providence area after 1850. The critic William Howe Downes later compared these private collections with their counterparts in New York:

Boston amateurs [that is, collectors] have never made such extensive, costly, and showy collections as those of the Vanderbilts, Belmonts, and Stewarts in New York, or of Mr. Walters in Baltimore, but the number of good pictures modestly housed in the homes of "the upper ten thousand" of the city is astonishing; and it is a significant fact in the history of art that

*there was a time when New York dealers who had a good
Corot or Courbet were obliged to send it to Boston in order to
sell it.*[18]

In the spring of 1866, when the *Quarry* was first
shown in Boston, Hunt had already founded the Allston
Club. The club had quickly become the most respected
and most successful of the many artists' groups in the
city.[19] Its membership roster, aside from Robinson and
Hunt, included the prominent attorney Henry Sayles
and the artists Winckworth Allan Gay and Joseph Fox-
croft Cole. It was the club's treasurer, Albion H. Bick-
nell, who saw the *Quarry* at Cadart's exhibition and,
excited by the opportunity to purchase a major work by
Courbet, enlisted the aid of Robinson and Hunt to raise
the necessary funds.[20] They secured the work for
$5,000—an extraordinarily steep price at that time.
Downes reports that when Courbet learned of the sale,
he remarked: "'What care I for the Salon, what care I
for honors, when the art students of a new and a great
country know and appreciate and buy my works?'"[21]

Meanwhile, the Allston Club had immediately set to
work on organizing an exhibition where the *Quarry*
would serve as the focal point. Within a month's time,
the club rented rooms in the Studio Building, where
they showed the *Quarry* along with other paintings by—
or owned by—the club's members. Among the paint-
ings displayed was Millet's *Sower* (1850; Boston, Mu-
seum of Fine Arts), which Hunt had seen at the Salon
of 1850, and which had provided the initial impetus for
him to contact the Barbizon painter. The show's cata-
logue declared that the *Quarry* was the "finest modern
picture yet brought to this city,"[22] but most of the critics
did not agree. In an article devoted entirely to the *Quar-
ry*, the reviewer for the *Boston Daily Evening Transcript*
echoed the assessment provided earlier by the *Round
Table* during the show's New York run: he praised
Courbet's technical skills, and commented favorably on
the execution of the dogs and the deer.[23] But, like the
earlier reviewer, he also complained that the overall
composition was inadequate and too objective:

*The faults of this picture are obvious. There is no imaginative
interest or suggestion, because the artist is a very great artist
without soul. No concentration or fusion of elements in the
white heat and forgetfulness of genius. It is heavy and unin-
teresting to the world at large, but a whole academy to artists.
There is no refinement anywhere or fineness of drawing. No-
ble painting, but no composition. . . . The deer is as fine a bit
of painting as we ever saw, perhaps the finest, for color, tone,
texture, execution, and management . . . the sympathy with*

*which it is done, the faithfulness of it, and the conception of its
interest and its life in death.*[24]

This attitude toward Courbet's work persisted among
American critics well beyond the 1890s. Although
Courbet was respected as a technician, American view-
ers felt distanced by his candid Realist style. Courbet's
work lacked the overt moralization of the Pre-Raphael-
ites, the passion of the Romanticists, and the classical
tendencies of the Salon painters. Further, he took pains
to avoid traditional narrative representations. All these
qualities, which Courbet omitted by design, were
qualities that the American public not only appreciated,
but even expected, in works of art. So although Courbet
found a niche among cognizant American artists and
collectors, the general public remained respectful of his
work but aloof. As the public became more familiar with
Courbet's work, particularly his landscapes, they began
to see in it the poetic power of the forces of nature. This
ethos of sentimentality, which dominated the American
popular aesthetic of the late nineteenth century, was a
prime cause for the soaring popularity of Millet and
Jules Breton.[25] Aware of Courbet's importance, viewers
molded this aesthetic to fit his scenes of nature—scenes
that were essentially antithetical to the artistic ethos of
the period. *The Quarry* remained available for public in-
spection at the Boston Athenaeum's annual exhibitions
between 1868 and 1872.[26] It was later acquired by
Henry Sayles, a former officer of the Allston Club, who
placed it on loan with the newly established Museum of
Fine Arts from 1877 to 1889.[27]

The World's Fair of 1876, held in Philadelphia to
commemorate the nation's centennial, provided the op-
portunity for the country to demonstrate its political,
cultural, and economic resurgence following the Civil
War.[28] The event received international publicity and
attracted huge crowds. By this time, French painting
was usually the star cultural attraction at such events,
but the French exhibition received poor notices all
around. In *The Nation*, Earl Shinn lamented over "cer-
tain walls of unbroken ennui."[29] Three of the four
Courbets on display were owned by the collector A. H.
Reitlinger, about whom little is known.[30] Reitlinger
showed two views of Chillon Castle, and a *Huntsman*, all
undated. No owner was listed for the fourth work, a
Bather, which Shinn described as "a savage expression
of the essentials of womanhood."[31]

In addition to the *Quarry*, one of the earliest and most
important works by Courbet to enter an American col-
lection was the *Young Ladies of the Village* (cat. 14). The
work was acquired by the Boston collector Thomas

Wigglesworth from the Duchess of Morny in 1878 or 1879.[32] Unfortunately, Wigglesworth showed the work publicly only once—in 1879 at an exhibit sponsored by the Boston Art Club—and thus the painting was little known to the general public. Wigglesworth also owned an unidentified landscape by Courbet, which he showed in 1881 at the fourteenth exhibition of the Massachusetts Charitable Mechanic Association.[33]

By the time of his death on December 31, 1877, Courbet had been featured in over a dozen exhibitions in New York, Boston, Chicago, Cincinnati, and Philadelphia.[34] In most of these Courbet was represented by only a single work. These included a portrait, *A Young Girl,* auctioned at Goupil's New York gallery in 1861;[35] an Ornans landscape, shown at the Cincinnati Industrial Exposition of 1873;[36] a seascape of the Normandy coast, displayed at Schenck's Gallery in New York in 1875;[37] a *Landscape near Interlachen,* exhibited at the Chicago Academy of Design in 1876;[38] and a Trouville seascape shown at the second exhibition of the French Etching Club (1866–67).[39] In addition, two works by Courbet were prominently featured in the second Allston Club exhibition (1867): the *Quarry* and an unidentified Ornans landscape.[40]

By this time, Americans had had several chances to see Courbet's art. The only accounts of his life and art that had appeared in the popular press, however, were brief notices excerpted from a variety of British serials. The earliest and most important of these was a single paragraph taken from an eleven-page article in London's *Temple Bar.*[41] Despite its brevity, this passage is significant because it approached Courbet's art as an independent, noteworthy subject, rather than as a mere outgrowth of a current exhibition:

in 1849 his "Après dîner à Ornans" made him famous. He dared to people a genre *piece with lifesize figures! . . . His contributions to the Salon of 1851 were the "Casseurs de pierres" and the "Enterrement à Ornans." They elicited a fiendish scream of disgust from nearly every art critic in Paris. Charlatan, revolutionist, blasphemer, were the weakest epithets hurled against the painter. And yet, in confidential letters to Champfleury, the charlatan speaks neither of system, nor revolution, nor defiance; he complains that his studio (a barn) is too small and that everybody in the village asks to sit to him!*[42]

Other articles, reprinted from the *Daily Telegraph* and the London *Standard,* focused on Courbet's participation in the Commune of 1871, during which the Vendôme column was overturned.[43] Courbet ardently denied any ties to the event, and part of his plea was reprinted by the *New-York Times:*

There is no other decree against the column than that voted by the Commune, and that is dated eleven days before I was elected a member of the Commune. When the decree was to be put in force I already belonged to the minority of the Commune that withdrew from the majority . . . but I was forced to give way to the decision of the majority. . . . [T]he majority would listen to nothing. Having fulfilled my duty, all I had to do was withdraw. Such was my rôle in the whole affair.[44]

Despite his pleas, Courbet was branded a "celebreted [*sic*] Communist" by the American press, and the label remained for many years thereafter.[45]

These few accounts were the only treatments of Courbet's life and art, aside from exhibition reviews, that appeared in the American popular press during the artist's lifetime. In the years following Courbet's death, the number and frequency of these biographical essays increased dramatically. In many of them, the myths about Courbet's life and work that had flourished in the Parisian press were repeated to an equally enthusiastic audience. In an obituary dated January 17, 1878, the *New-York Times*'s Paris correspondent wrote:

The painter of Ornans was a singular genius. I met him frequently in 1869, and had no idea that he thought of politics. True, he abused the Empire, but only as he abused everything else, for he was one of those rude, vulgar persons who make objections to everything, and on principle. He was slouchy, dirty, and negligent in regard to his person, and looked as if he never cleaned his nails or combed his hair. He used to smoke a clay pipe and affect extremely democratic habits. The Père Courbet always had a crowd of young painters and students about him, and every evening I watched this little court, the painter keeping his friends laughing by his monstrous oaths and his obscene stories. He had a fund of the latter and had no hesitation in telling them. Personally he was an extremely vulgar man, extremely coarse, extremely rude, and yet he had a large fund of kindness about him. He was always ready to help a friend, and gave liberally in charity. He was full of the milk of human kindness, and this made it manifest that he affected to be a bear or a barbarian merely, and that it was really foreign to his nature.[46]

A few months later, in *Lippincott's Magazine,* Charlotte Adams of Philadelphia portrayed Courbet as a crusader for the poor and disfranchised:

I think of him as the leader of a group of young men of genius, strong, active, saturated with [a] sense of beauty; filled with the divine impulse of creation; scorning to cringe to the world;

5.2. Gustave Courbet. *The Violoncellist*, 1847. Oil on canvas. Oregon, Portland Museum of Art.

holding themselves aloof from the patronage of the great; hating the sordid prosperity and narrow life of the bourgeois [sic] and the tyrannous supremacy of caste; holding art and republicanism as synonymous; glorifying the poor, the simple, the oppressed, the down-trodden. They were men to whom their art was not a thing apart from the interests of the people, but a motive-power, the living incarnation of a nation's hopes and fears and joys; and who, in studying the humanity of the streets and the cellars and the garrets, gained the strong conviction, the resistless impulse, that made of them the exponents and arbitrators of a country's destiny. . . .[47]

The first comprehensive biography of Courbet in the American press came from Dr. Titus Munson Coan, who traveled to Ornans to research his essay for the popular *Century Magazine*.[48] Coan's article illustrates, with engravings, two important Courbets that were in American collections: the *Quarry*, and the *Violoncellist* (fig. 5.2), which was then owned by the prominent New York collector Erwin Davis. The essay covers Courbet's life as a whole, from his childhood in Ornans, to his death in exile in La Tour-de-Peilz. It reflects, once again, conservative nineteenth-century American expectations of a work of art: "Courbet was a realist, but a narrow realist in spite of his power; for to him emotion was merely a sentimentalism, instead of a prime truth with which art is concerned."[49] Coan even carries this idea into his evaluation of Courbet's landscapes, in regard to which he quotes Théophile Silvestre: " '[His landscapes] are true, but they express only the material truth of nature. They do not express her vast and mysterious aspects.' "[50] These words echo clearly the recep-

tion of the *Quarry* in Boston, and Coan carries them through in his enumeration of Courbet's merits, which he felt were mainly technical.

More than a year later, *Century* published a lengthy reply to Coan's article from M. G. van Rensselaer, who was easily the most astute art critic of the day.[51] Mrs. van Rensselaer portrayed, for the first time in the American press, the vital connection between Courbet's art and French politics, and she gave her readers a real sense of the issues raised by Courbet in the *Burial at Ornans* and the other early works dating from the Second Republic. She wrote:

[Courbet] was the prime mover in what was proved almost a revolution in art, and his example has largely molded the practice of our later day. . . . [He and Millet] were the first to insist . . . that peasants were as well worth painting as kings, humble contemporary life as [worthy as] history or mythology Dr. Coan's words give us but a faint idea of the fury with which Courbet especially was attacked. . . . It was in the year 1850 that Courbet's so-called brutal peasants first made their appearance on the Salon wall—just when the republic was disintegrating and before the coup d'état *had restored security at the price of liberty. . . . The prevailing terror of socialism and revolution caused critics and public alike to see in these rustic figures, and in the uncompromising portraits of the* Burial Scene at Ornans, *an attempt to exalt a dangerous class and to discredit the priesthood with the people; and the wildest political fury was turned upon them and their creator.*[52]

Mrs. van Rensselaer's insights were not generally reflected in the writings of other critics. One notable exception was Clara Stranahan's comprehensive survey of French painting, which was published in 1888.[53] Like van Rensselaer, she discusses in detail the public and critical responses to Courbet's nine entries in the combined Salons of 1850–51:

What did it mean that the vile masses, these breakers of stones, the hungry and ragged, should also with Millet's peasants sit down among the ideal characters of art, the divinities of Greece, the heroes of Rome, the plumed knights of the middle ages, the gallants of the day? It seemed that the battle fought by Géricault for the right of the victims of the shipwreck of the Medusa to claim for their sufferings some of the attention freely given to the griefs of Andromache and Hector was to be fought over again. But, in fact, it was not a battle of art entirely, though fought under its banner, and superficially so considered. It was a battle of politics that burst upon the unsuspecting artist. In 1850 the political reaction had begun that was to destroy the Second Republic, and it was a fear of

the power of the masses that led to the severe condemnation of Courbet's art at this time.[54]

In 1896, John C. Van Dyke, a professor at Rutgers College, edited a volume of biographical and critical reviews of modern French masters by American artists.[55] The anthology included essays by such luminaries as J. Alden Weir, Theodore Robinson, Will Hicok Low, and Wyatt Eaton, all of whom had studied in France with Gérôme (the last two with Millet as well). The essay on Courbet was written by Samuel Isham, an academically schooled portraitist who had most recently studied with Boulanger and Lefebvre.[56] Isham's opening remarks summarized conventional American attitudes toward Courbet at the end of the nineteenth century:

It is difficult, outside of France, to gain a correct idea of Courbet, either of the painter, or the influence that he has exercised on painting. It is not that his pictures are rare in America. The enterprise of the dealers has made them common enough, and most of the museums and large private collections have one or more examples. They appear regularly in the auction sales, and in the stores of the dealers, and prices are paid for them which would seem to indicate that they are fully appreciated. . . . The critics praise them, and the collectors buy them, yet they leave the general public which looks at pictures rather cold. They are admitted to be good; but people "don't care for them," and they treat them and Courbet with a sort of respectful indifference.[57]

Although there may be some truth to Isham's statement, the remainder of his essay does little to illuminate the merits of Courbet's oeuvre. The essay shows none of the insight of van Rensselaer's political analysis, and where Isham, as an artist, had a prime opportunity to create a revised—or at least a better defined—portrait of the artist, he instead provides a superficial text with little innovative content. In an extraordinary statement, he wrote:

It is a pity that [Courbet's] vanity limited him socially to the lower ranks of life, in which he found his subjects, for he had no sincere sympathy with them as Millet had, and he could have painted as no one else the elegance of the Third Empire[?], somewhat flashy and superficial perhaps, but still with real beauty and distinction.[58]

Because Isham's background and taste were so artistically conservative, one is left to wonder why Van Dyke selected him to write the essay in the first place.

The frequency with which these highly opinionated accounts were written after Courbet's death indicates a steadily growing level of interest in his art in nineteenth-century America. This was reinforced by the continued inclusion of his work in major exhibitions and by the enthusiasm with which collectors pursued it. Among the major exhibitions in which Courbet's work was featured after his death were the Boston Foreign Exhibition and the Pedestal Fund Art Loan Exhibition, both held in 1883.

The Boston Foreign Exhibition was a much touted event, designed as a minature world's fair of sorts. The preexhibition publicity stressed the quality and selection of paintings that were to be shown, but the display received miserable notices from all quarters. The *New-York Daily Tribune* wrote that the "mind that has been prepared for great things by these announcements receives a shock when it sees the collection."[59] The *Art Amateur* added that the exhibition "comes very near [to] being a failure."[60] Courbet was represented by three paintings: *Wreck in a Snowstorm, Runaway Horse,* and *In the Forest of Fontainbleau* [sic].[61] Neither the catalogue nor the reviews provided dates or descriptions for the works, which, like the show, were poorly received. The *New-York Daily Tribune* reported that "there are three large Courbets, none of which is equal to many other products of this artist's brush that have been seen in Boston, while all show that not without reason did he suffer during his life at the hands of detractors."[62]

The Pedestal Fund Art Loan Exhibition was organized to raise the money needed to construct a support for Bartholdi's Statue of Liberty, which France was to present to the United States in 1886.[63] Even though some had proposed that the funds be raised through private donations, the loan exhibition was championed as a more democratic process, thereby allowing everyone who wished to contribute to do so by paying admission fees.[64] The exhibition opened at the National Academy of Design on December 4, 1883, and featured thousands of objects, from lace, china, and ivory, to tapestries, armor, and musical instruments.

The show's Committee on Painting and Sculpture was chaired by the noted American Impressionist James Carroll Beckwith, and it included his respected contemporary J. Alden Weir. However, the committee's guiding light was William Merritt Chase, who, along with Beckwith, selected nearly all 195 works in the show during the three month period preceding it.[65] Chase and Beckwith carefully chose works that represented the most progressive aspects of French painting, from Romanticism through Impressionism, and carefully avoided the conservative tendencies of Salon painting. The show included seven Courbets—the

most that had been assembled simultaneously in the United States to date.[66] Three of the works were loaned by Erwin Davis: *Landscape;* the *Wave;* and the *Violoncellist* (fig. 5.2), which the *New-York Daily Tribune* described as "dark, mysterious and powerful."[67] Two more works, *Ocean* and the *Valley,* were loaned by the Moore and Clarke Company, while Daniel Cottier and William T. Evans each loaned one: *Cave* and *A Mountain Gorge,* respectively.

Almost all of Courbet's works received favorable mention in the press, but many critics kept their remarks brief owing to the huge number of entries in the show. John C. Van Dyke, whose volume on modern French masters I discussed earlier, wrote in *Studio* magazine that

Courbet, the revolutionist, the brother painter of Millet, has here seven pictures, and such magnificent ones, that we are almost tempted to rejoice that they have been barred out of the Salon, *if that proceeding had anything to do with bringing them to our shores.*[68]

The critic for the *New-York Times* added that "at no previous exposition has it been possible to see so many Courbets and such magnificent ones."[69]

The Pedestal Fund exhibition was an extraordinary one, because the works on display were all loaned by private collectors, and thus normally would not have been seen by the public. As a result, the show attracted huge crowds; amidst great controversy, the academy voted to open its doors on Sundays for the first time in order to meet public demand.[70] Furthermore, the number and quality of the works displayed clearly show how strong a force Americans had become in the international art market: they were able to compete with European collectors and dealers on any terms. In its review of the exhibition, the *Art Amateur* wrote that "the plaints of some of the Paris critics, over what they term the expatriation of the best pictures of the modern French school, are but little exaggerated. Certainly, it would be no very easy matter to get together as good a collection from private galleries in Paris itself."[71] These sentiments were echoed even more forcefully by the French critic E. Durand-Gréville, who, in 1886, spent six months surveying American private collections on behalf of the French government. The following year, in the *Gazette des Beaux-Arts,* he lamented that the number of quality French paintings in American collections "must be counted by the thousands."[72]

By extension, the 1880s saw a rapid rise in the role of auction houses,[73] and while Durand-Gréville was busy making the rounds of private collections, a number of connoisseurs were preparing to bring all or part of their extensive holdings to the gavel, thereby paving the way for a second or third generation of owners. Between 1885 and 1895, Courbet's work was featured in at least ten major New York auctions. About half of these featured New England collections built under the guidance of Seth Vose, Thomas Robinson, and Joseph Foxcroft Cole.[74] These included the Wall and Brown collections (sold jointly 1886), part of Robinson's own holdings (1886), and the Capen and Warren collections (1889). Typically, these Boston collections were rich in works by Barbizon painters, and canvases by Corot, Millet, Daubigny, Troyon, and Rousseau often sold for $1,500 or more. Courbet's paintings, by contrast, usually brought about half this amount.[75] Because sales catalogues do not fully describe the works, almost all the paintings in question remain unidentifiable.

Two weeks after the Capen and Warren sale, the New York collector Erwin Davis brought part of his extensive holdings to the gavel in a scandalous sale at the Fifth Avenue Art Galleries.[76] Davis exemplified the type of New York collector that Downes had profiled in *Atlantic Monthly* the year before: he was an astute businessman who collected art strictly for its investment potential.[77] Among the works up for auction was Courbet's *Violoncellist,* which had been acquired on Davis's behalf by J. Alden Weir in the summer of 1881.[78] By the time of the sale, Davis had acquired three additional Courbets: the *Blacksmith's Shop, In the Jura Mountains,* and *Marine.* When and where he purchased these three works is uncertain, but the public was already familiar with the last two: Davis had shown them at the Pedestal Fund show of 1883 (as *Landscape* and the *Wave,* respectively), along with the *Violoncellist.*

Disappointed by the light bidding on the first evening of the sale, Davis secretly hired an intermediary to pose as an agent from Chicago.[79] This "agent" was given a mandate to raise the bidding aggressively, and even to repurchase Davis's works at premium prices if necessary. At evening's end, his bids totaled $125,000, including $7,000 for Courbet's *Violoncellist.*[80] When the local press uncovered the scheme the following day, Davis attempted to salvage his reputation by donating three works to the Metropolitan Museum of Art.[81] The other three paintings by Courbet apparently received genuine bids: the *Blacksmith's Shop* sold for $800, the *Marine* went to Charles T. Barnum for $1,000, and *Jura Mountains* brought $1,175.[82]

In 1892, the Philadelphia attorney John G. Johnson privately published a catalogue of his extensive holdings.[83] The catalogue listed seven Courbets—at that

5.3. Gustave Courbet. *Willows by the Riverside*, 1862. Oil on canvas. Philadelphia Museum of Art, John G. Johnson Collection.

5.4. Gustave Courbet. *Torso of a Woman*, 1863. Oil on canvas. New York, The Metropolitan Museum of Art, Bequest of Mrs. H. O. Havemeyer, 1929. The H. O. Havemeyer Collection.

time, the largest number in any American private collection. Although it is not completely clear when and where Johnson acquired all the works, one of them, the *Willows* (fig. 5.3), was previously owned by Thomas Robinson, who had put it up for sale at the 1886 auction of his collection.[84] Johnson, however, acquired the work sometime thereafter.[85] The other Courbets in his collection were: *La Pluie* (1866, now titled *Marine*, pl. 52); *La Vallée* (1857); *Château Chillon* (n.d.); *Source of the River* (1873); and *La Vague* (1869) [all works, Philadelphia Museum of Art]. Johnson also owned a Courbet titled *Landscape* (the work later titled *Sea Coast*, now *Souvenir des Cabanes*, pl. 22), which he exhibited in 1893 at the American Fine Arts Society to enthusiastic reviews.[86] A winter scene, which Durand-Ruel showed at the same exhibition, was criticized for its rough, textural surface.[87]

It was, however, Henry and Louisine Havemeyer of New York who acquired the greatest number of Courbets in nineteenth-century America. The 1931 catalogue of their holdings lists thirty-four Courbets, plus another ten that had been sold at auction.[88] The Havemeyers purchased at least ten of these before 1900: *Landscape with Cattle* (1859; current location unknown; acquired 1889); *Torso of a Woman* (1863; acquired 1892); *Hunting Dogs* (1856; acquired 1892); *Woman in the Waves* (1868; acquired 1893; pl. 68); *Portrait of Monsieur Suisse* (1861; acquired c. 1893–94); *Deer* (c. 1865; acquired 1895); *Source of the Loue* (1864; acquired c. 1895–96); *Stream* (n.d.; acquired 1897);

Woman with a Parrot (1866; acquired 1898); and *Portrait of Jo* (*La Belle Irlandaise*) (1866; acquired 1898; pl. 54) [all works, Metropolitan Museum of Art, New York].[89]

The young Louisine Elder was introduced to Courbet's works in 1881, at an exhibition at the Théâtre de la Gaîté in Paris.[90] She was brought there by Mary Cassatt, whom she had met in Paris in 1874, and with whom she maintained a lifelong friendship. Lousine fell in love with Courbet's works from the start, and she later described Courbet in her memoirs as the "most real and living personality to me of any of the modern painters whose works hang in our gallery."[91] By coincidence, the Courbet nude she saw with Cassatt in 1881 (*Torso of a Woman*, fig. 5.4) made its way into Durand-Ruel's New York galleries a decade later.[92] Although she and her husband had agreed to buy no nudes, Henry eventually relented to Louisine's "firmly defiant" stance, and the work became the second by Courbet to enter their collection.[93]

Shortly after the Havemeyers acquired *Hunting Dogs* (fig. 5.5), they were persuaded to display it at the 1893 World's Columbian Exposition in Chicago.[94] The work was the sole Courbet in the exhibit and was, unfortunately, overlooked by most of the critics.[95] The few notices it did receive were mixed. William Coffin, writing in *The Nation*, called it "an inferior work,"[96] while Hubert Howe Bancroft decided that it was "an excellent study."[97] Bancroft added, surprisingly, that the artist was "as yet but little known in America"[98]—an assertion nearly impossible to believe. The Havemeyers

later acquired *After the Hunt* (c. 1859; pl. 33), a companion piece to the *Quarry*.[99]

Unlike Erwin Davis, who had acquired paintings mainly for their investment value, the Havemeyers—particularly Louisine—specifically aimed to create a collection that would bring progressive works of quality to the United States. The couple's most notable acquisition during the 1890s was *Woman with a Parrot* (fig. 3.6, above), which Louisine had first seen at the World's Fair of 1889 in Paris.[100] When Durand-Ruel put the painting up for sale in 1898, Louisine

begged Mr. Havemeyer to buy the picture . . . just to keep it in America, just that such a work should not be lost to the future generations nor to the students who might with its help, and that of other pictures, some day give a national art to their own country.[101]

It was in 1899 that the first American exhibition devoted solely to Courbet's works was mounted. The show was sponsored by Paul Durand-Ruel and held at his New York galleries, at 389 Fifth Avenue. Durand-Ruel had previously exhibited works by Courbet, both in his own galleries and elsewhere, but always with the work of other artists. Unfortunately, no record of the exhibition exists in the Durand-Ruel archives,[102] and it is nearly impossible to identify the works through exhibition reviews. It is clear, however, that the exhibition featured exclusively the landscapes and seascapes that had become so popular among American collectors. The show ran from April 29 to May 15, 1899, and received the following evaluation in the *New York Times:*

The little exhibition of thirteen examples of Courbet now at the Durand-Ruel galleries is remarkably interesting, and, although the subjects are all landscape ones . . . [it] gives an excellent idea of the painter's versatility. . . . So contrasted are some of these canvases in color, treatment, and atmosphere that it seems almost impossible to believe that the same hand painted them. . . . In this little display Courbet has run the gamut of the [four] seasons.[103]

The *Tribune* added that "[o]ne feels always in his work a rude strength that hovers on the edge of brutality, and [yet] one feels almost as often the magic of a painter who was sensitive to the deeper things in nature and could interpret them with subtlety and tenderness."[104]

The warmth and sentimentality of the reviewer's tone are in sharp contrast to the cool and remote public reception recounted by Isham only three years earlier.[105] These divergent reactions to Courbet's work—an emotional fondness for his potent depictions of nature, and a "respectful indifference" toward his technical prow-

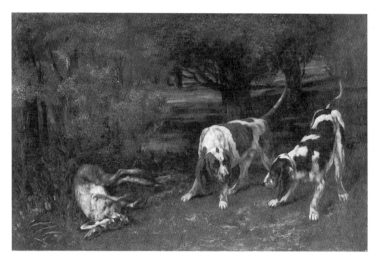

5.5. Gustave Courbet. *Hunting Dogs*, 1856. Oil on canvas. New York, The Metropolitan Museum of Art, Bequest of Mrs. H. O. Havemeyer, 1933. The H. O. Havemeyer Collection.

ess—existed side by side from the time of his earliest exhibitions in America. The former quality was most strongly derived from a fin de siècle aesthetic, which clung to moral and sentimental prerequisites for works of art. Those who sought this quality in Courbet's works found their vision fulfilled in his landscapes.

The second current is more directly attributable to people's perceptions of Courbet's life. Courbet was often dismissed in the popular press as an egotist or a communist, and his life in general remained shadowed in mystery to many Americans. It is likely that people's impressions of the man negatively colored their opinions of his art. Those who understood the interconnection between Courbet's art and French politics, however, were able to appreciate the revolutionary qualities of his earlier paintings. It was this group, mainly composed of artists and collectors, who also appreciated his landscapes for their lack of sentiment—what they perceived as straightforward reportage, "the truth." Despite claims by Isham and Coan that this aspect of Courbet's work "left the public cold," the fiery enthusiasm of Rensselaer, the Havemeyers, Cassatt, and others leads one to draw a different conclusion. Courbet's paintings were avidly collected by American *amateurs* and the vast number of his works in America today provide ample testimony to his long and continued popularity.

Who Is Buried at Ornans?

Modern Courbet scholarship has concentrated on the interpretation of the artist's works after the exhibitions in Dijon and the Paris Salon of 1850–51. Yet in order to understand Courbet's development fully, and indeed to understand his concept of Realism itself, one must consider his work before 1850, especially as it relates to his experiences in his native Franche-Comté. Of particular importance are some paintings done between 1848 and 1850, which I term *personal history paintings*. Their subjects reveal social attitudes and economic conditions among the provincial bourgeois, and, as Courbet intended, the series serves as a pictorial record of Franche-Comtois life and traditions.[1] The group includes the *After Dinner at Ornans* (1848–49), the *Stonebreakers* (1849), and the *Peasants of Flagey Returning from the Fair, Ornans* (1850, 1854, pl. IV), but the most significant painting is the *Burial at Ornans* of 1849–50 (pl. I).

I shall argue here that the setting and society depicted in the *Burial* represent the context in which Courbet's social, political, and artistic viewpoints were first formed, and that by identifying both the specific event and the individual figures in the painting one can begin to understand the origins of Courbet's independent, nonconformist stance as an artist. About the painting the artist himself was later to write to his friend and patron Alfred Bruyas: "*The Burial* . . . was my beginning and my statement of principles."[2] His first Realist manifesto is thereby found in the recording of this moment. What, then, does the *Burial at Ornans* document? Or, to put it more simply: Who is buried at Ornans?

Courbet has carefully described the local topography of his native village in the setting for the painting. In the left background is represented an area known as the Château d'Ornans, a former residence of the dukes of Burgundy. The escarpments to the right are the projecting cliffs of the Roche du Mont. Ornans itself, located at the bottom of the narrow Loue river valley between the fore- and backgrounds, lies hidden from view (fig. 6.1). These details establish the location as the "new" cemetery at Ornans, which had been opened in September 1848 after a lengthy debate over its establishment. The nature of the dispute about the new cemetery and its resolution bear directly on the interpretation of Courbet's *Burial*.

In the early nineteenth century, with the rise of densely populated urban centers, hygienic concerns regarding burial grounds were formally recognized. After the French Revolution, measures pertaining to the location of cemeteries were swiftly adopted in Paris, outside of which the well-known Père Lachaise and Montparnasse cemeteries were opened. As a consequence, the requisite for new and more sanitary locations for cemeteries had markedly Republican and Parisian origins. Many of the concerns centered on the notion of providing burial grounds outside of church control, as well as providing accessibility to permanent burial plots for those who could afford them.[3] These measures were formalized by the Napoleonic decrees of June 12, 1804, and March 7, 1808. In order to conform to these decrees, many French towns moved their traditional churchyard cemeteries outside city limits.

Yet Ornans took an unprecedented thirty-three years to transfer the location of its cemetery, as documentary evidence from 1813 on makes clear.[4] The dispute and its length acutely reflect both local conservatism and the resistance to outside authority in the Franche-Comté.

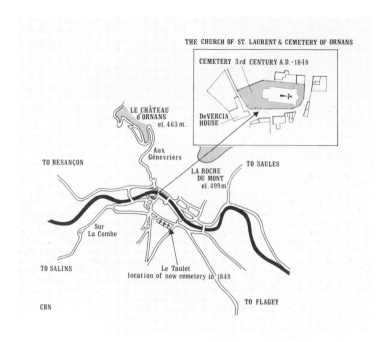

6.1. Plan of Ornans showing locations of the old and new cemeteries.
(Drawing: Casslyn B. Nawrocki)

For the citizens of Ornans, the resistance to change was largely due to an antipathy toward tutelage from Paris and the centralist state, but it was also due to a desire to maintain tradition in a village whose burial ground had stood in the same location since Roman times.

Strong opposition to the first practical steps taken by the municipal council toward relocation was formalized in June 1821 in a petition signed by 126 people from different levels of Ornans society.[5] The document makes clear that the people most objected to the cemetery's removal from proximity to the church building. And in a region like the Doubs where the Catholic Church was unusually strong, the relocation of the cemetery represented a threat to the church's control. Yet because the town cemetery came under civil jurisdiction, the church had no legal basis for influencing the Ornans decision. Nevertheless, the archbishop of Besançon expressed serious sentiments against the relocation in a letter to a local cleric, Curé Bonnet, who is represented in Courbet's painting.[6]

Opposition to the establishment of a new cemetery was strengthened in 1828 when Jean Cuenot, a lawyer and justice of the peace who had signed the 1821 petition, sent a letter to the prefect signed by members of the council. Again they protested on religious and historical grounds:

since Ornans left the darkness of Idolatry which goes back to the IIId century no other place is known where the parish church with its cemetery had existed in such a way that it is

there that the ashes of all the generations of Christians who had inhabited Ornans rest, since its conversion to Christianity.[7]

By the late 1820s it became clear that the mayor of Ornans was deliberately neglecting the cemetery relocation issue. The mayor was Claude-Hélène Prosper Teste (1801–68), who served in office from 1825 to 1829, and again between 1830 and 1861. Teste, whose father and maternal grandfather had signed the 1821 petition,[8] had ignored four letters from Jean-François Joseph Guyot de Vercia (1747–1834),[9] a member of the local nobility who was the original proponent for relocation. Although Teste certainly knew that outside officials would be displeased, he also knew that the town and the council, the majority of whom had elected him, were against the relocation. Teste was absent each time there was an important cemetery resolution to be considered by the council, thereby exonerating himself of official involvement. It was not until January 1846, in fact, that the conservative and cautious council agreed upon the location and cost of the site. Yet in spite of the prolonged duration of the dispute, its ultimate resolution was accomplished without the need for external administrative force.

The cast of characters and the events in this drama were known to Courbet, even while he was in Paris. His satirical observations of social and political life in Ornans survive in letters and manuscripts.[10] His decision to paint a burial taking place in this new cemetery,

6.2. Plaque affixed to the right pillar of the main entrance to the "cemetery of 1848," Ornans. (Photo: Mainzer)

therefore, cannot have been accidental, notwithstanding the fact that the site was adjacent to his family's own land.[11] As was his habit, Courbet returned to the Franche-Comté every autumn to paint, and he often remained through the winter. He was in Ornans in September 1848,[12] his grandfather Jean-Antoine Oudot—to whom he was much attached—having died on August 14 of that year. Sometime after his grandfather's death, Courbet acquired space in Oudot's house in the Isles-Basses area of Ornans for use as a studio. It was here that he reportedly began work on the *Burial* in December 1849.[13] In the past it has often been speculated that the painting commemorated Jean-Antoine Oudot's funeral, but since he was buried in the old graveyard, this interpretation can no longer be accepted.

More to the point, the unusual presence of two beadles as well as major civic officials suggests that this burial commemorates instead an important local event, in this case the opening of the controversial new cemetery. Over the entrance to the cemetery today remains the Latin inscription: "In novissimo die de terra surrectus sum" ("in the newest of earth we are resurrected")—a maxim that seems to have a conciliatory nature in light of the opposition to the relocation having been based on not wanting to break with religious tradition.

Equally interesting is a plaque, today affixed to the right pillar of the new cemetery's main entrance (fig. 6.2).[14] It informs us that the first person buried in the "cemetery of 1848" was "Claude-Etienne Teste,

The death certificate gives the date of Teste's death as September 6, 1848, and Courbet, who was then in cultivator" (a man unrelated to Prosper Teste, Ornans's mayor). According to one of his last surviving descendants, Abbé Emile Teste, Claude-Etienne, born in 1765, was like Grandfather Oudot a liberal and a Republican during the French Revolution. He was known as a *casse banc* for his activities, which included destroying church benches belonging to the aristocracy.[15] In 1790 Teste was a wine grower, and as a group these cultivators were considered subversive.[16] Various records show that Teste was a member of the class of small landowners, and that he held civic offices in Ornans.[17] He was a municipal council member from 1816 to 1830, during the height of the cemetery controversy.[18]

These things alone might have made Courbet interested in painting Claude Teste's funeral. But in addition, in 1790 Teste had married Thérèse Oudot (1771–1843), the sister of Jean-Antoine Oudot, Courbet's grandfather, who witnessed the marriage with his signature in the Ornans civil register. Thus, Claude-Etienne Teste, the first Ornans citizen to be buried in the new cemetery, was Courbet's great-uncle by marriage.

Ornans, would have attended the funeral. From this it is possible to suggest that the charcoal sketch for the *Burial* (pl. 96) might be dated to 1848, possibly having been executed by Courbet on the spot or shortly after the funeral. More telling is the original position of Teste's grave itself. Within the cemetery, the view of the pro-

6.3. View of the cliffs of the "Château d'Ornans" and the Roche du Mont, from near the main entrance to the cemetery. (Photo: Mainzer)

jecting cliffs in the distance varies depending upon where one is standing. From Teste's grave site, the "first plot on the left upon entering,"[19] one has the same viewpoint as that represented in the *Burial* (compare pl. 1 and fig. 6.3). One must conclude, then, that it is Claude-Etienne Teste's funeral that is depicted in Courbet's painting.

Setting the *Burial* in an open plain, on the actual site of the new cemetery, rather than in the old cemetery crowded with other graves, allowed Courbet to develop the friezelike concept of the composition. This horizontal arrangement is found in both the charcoal sketch and the finished painting. The device, of course, permits Courbet to accommodate the more than fifty participants in the funeral, while maintaining many of the organizational elements of Franche-Comtois funerary tradition. Men and women, for example, were kept in separate groups. By local custom, the cortege was headed by the clergy, followed by the candle-carrier, the *porte-croix*, the bier, the family or persons of the same sex as the deceased, and the rest of the mourners, in that order.[20] Meyer Schapiro, in fact, first likened Courbet's composition to popular imagery in which a hierarchy of figural groups is created.[21]

These hierarchical groups can be broadly defined by age and by social status. Principally there are three generations represented: that of the artist, that of his parents, and that of his grandparents, the last being the generation of the deceased as well. Within each generation, there are separate groups—family, including Courbet's parents and three sisters, relatives, and friends, including Max Buchon and Urbain Cuenot—with another group, overlapping the others, composed of Church and civic officials. The *Burial at Ornans* is not merely the record of local funerary customs. It is, as I have shown, the burial of a specific individual, Claude-Etienne Teste, and in transferring the generalities of the charcoal sketch to canvas, Courbet also created individual, recognizable portraits of the participants. Of the fifty-one figures still visible on the darkened canvas, the identity of thirty-seven can be substantiated. Based initially on identifications provided by Courbet and Champfleury, and recorded in Riat's study,[22] the list has been emended and expanded by Hélène Toussaint in the centenary catalogue.[23] The most recent, graphically clear, and substantially documented identifications are published in an article by Jean-Luc Mayaud.[24]

The inclusion of two figures in particular helps to define the date of the funeral depicted as being in 1848. The first of these is the gravedigger, Antoine Joseph Cassard, who supplemented his income by acting as Ornans's gravedigger only until the end of 1848.[25] The second is that of "Mère Gagey," the old woman third from the right of the three white-bonneted women at the far right of the painting. Born Jeanne Baptiste Groslambert, she was the wife of Claude François Gagey, the model for the old stonebreaker (see fig. 1.2), and she died in March of 1849.

One of the recent identifications helps to correct previous interpretations of the *Burial*. The figure of the

central, cleanshaven man to the right of the gravedigger, a "M. Proudhon," was long taken to be that of a cousin of the social theorist P.-J. Proudhon, who came from a Besançon family. Because of Courbet's later friendship with and support of Proudhon (see pl. IX), this identification permitted an easy connection between the ideas of Proudhon and the *Burial.* In the centenary catalogue this cousin is identified as Melchior Proudhon, who was a Freemason,[26] thus helping to substantiate a Masonic interpretation of the work. However the Melchior Proudhon who was a cousin of P.-J. Proudhon as well as a prominent Freemason of Besançon would have been nearly eighty years old in 1848.[27] Mayaud argues convincingly, and my research confirms, that the figure is that of Hippolyte Proudhon, a well-to-do lawyer of Ornans, brother-in-law of Courbet's friend Urbain Cuenot, and no relation of the Besançon Proudhons. The inclusion of Hippolyte Proudhon in the painting further emphasizes the presence of prominent citizens and civic officials at the opening of the new cemetery. Rather than demonstrating a specific connection either to P.-J. Proudhon's social philosophy or to Freemasonry, his figure helps to define the event as one attended exclusively by residents of Ornans, many of them linked to the artist by relationships of family or friendship. This linkage can now be seen as extending to the central figure of the painting—the man being buried.

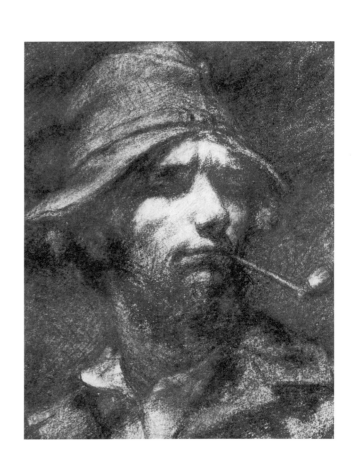

Chronology

1819 Born June 10 in Ornans near Besançon in the Franche-Comté. Son of Régis, prosperous farmer from Flagey, and Sylvie, née Oudot. Grandson of Jean-Antoine Oudot, a veteran of the Revolution. Brother of Zoë, Zélie, and Juliette.

1831–37 Day pupil at school in Ornans. Began lifelong friendship with Max Buchon, who would become a noted regional poet and political dissident. Discovered art as a pupil of "père Baud," a former student of Baron Gros who began teaching in Ornans in 1833.

1837–39 Student at Collège Royal in Besançon; after unhappy first term gained permission to live outside college and study art with a painter called Fajoulet, former student of David.

1839–43 Arrived in Paris late in 1839 and began to study painting despite his father's wish that he should study law. Attended the studio of Steuben, but worked mostly by copying in the museums, especially Flemish, Dutch, Venetian, and Spanish painting. Began sending paintings to the Salon in 1841. Established pattern of spending part of each year in Ornans.

1844–45 *Self-Portrait with Black Dog* accepted at the Salon of 1844. Works refused in 1845 included the *Guitar Player*, the *Hammock*, and the *Portrait of Juliette*.

1846–47 Trips to Holland and to Belgium confirmed admiration for Northern painting.

1848 February revolution opens Salon, enabling Courbet to show ten paintings, including the *Cellist*. Friendship with Baudelaire and with Champfleury, who becomes a critical supporter. Together with Buchon, Murger, and others, they form a group at the Brasserie Andler that wins it the name "temple of realism." In August, death of Grandfather Oudot.

1849 Settled in the rue Hautefeuille, on the left bank near the Pont St. Michel. Beginning of friendship with Francis Wey. Eleven works shown at artist-juried Salon. *After Dinner at Ornans*, the first of his ambitious paintings of Ornans subjects, is bought by the state, and Courbet is awarded a medal, permitting open entry to Salon.

1850–51	Winter and spring spent painting at Ornans. Completed *Stonebreakers, Peasants of Flagey*, and *A Burial at Ornans*, which were shown with six other works at the Salon that opened December 30, 1850. (The *Burial* was first shown at Besançon and Dijon.) Immense critical outcry, directed especially at the *Burial*. Travels to Brussels and Munich on invitation from artists of these cities.
1852	Political tension following the December 1851 coup d'état; Courbet believes he is under surveillance, Buchon flees to Switzerland. *The Young Ladies of the Village*, with two other works, shown at Salon. Though already bought by the comte de Morny, the *Young Ladies* is attacked.
1853	Salon entries are the *Bathers*, the *Wrestlers*, and the *Sleeping Spinner* (the *Bathers* causing shock even to admirers). Alfred Bruyas, philosophical young collector from Montpellier, buys the *Bathers* and the *Sleeping Spinner*, commissions a portrait of himself, and begins a relationship of great importance to Courbet.
1854	*Man with a Pipe* bought by Bruyas. Courbet stays with him at Montpellier from May through September. Paints portraits, coastal subjects, and the *Meeting*. After return to Ornans, work begun on the *Painter's Studio*.
1855	Preparation for the Exposition Universelle and for Courbet's own exhibition on a building constructed near the exposition and called Pavillon du réalisme. Eleven works shown at the exposition, including the *Grain Sifters*, the *Meeting*, and *A Spanish Lady*. Forty paintings at the Pavillon, including *A Burial at Ornans* and the *Painter's Studio*, which had been refused at the Exposition. Pavillon less successful in terms of visitors and sales than Courbet had hoped.
1856	Summer visit with Clement Laurier in Berry. Invited in the autumn to Ghent, he travels also to Brussels, Antwerp, Bruges, Ostend, and he returns to Ornans via Liège, Cologne, and the Rhine to Mainz, Strasbourg, and Besançon.
1857	Salon rules changed to establish a jury of members of the Academy and to require open entry only to members of the Institute or recipients of the Légion d'Honneur. Courbet's submission includes new subjects: the hunt (*The Quarry* and *Deer Trapped in the Snow*) and a major figure painting drawn from Parisian life, *The Young Ladies on the Banks of the Seine*, which provokes critical attack. Summer visit to Montpellier with Champfleury; stays with François Sabatier as well as Bruyas. In August, travel to Belgium, where he stays nearly a year.
1858–59	Invited to Frankfurt, where his German hosts provide him with a studio and introduce him to stag hunting on a grand scale. Paints the *Lady of Frankfurt* and the *Hunt Breakfast* and begins work on the *Battle of the Stags* and the *Stag at Water*, but does not show at the Salon of 1859.

1860–61	Visit of young critic Jules-Antoine Castagnary to Courbet's studio begins a friendship lasting to the artist's death, and a loyalty to his reputation that continued beyond. Shows five paintings at Salon of 1861, of which four are scenes of the hunt, well received by the critics. Director of Beaux-Arts recommends State purchase of the *Battle of the Stags,* and rumor spreads that Courbet might receive the Légion d'Honneur, enabling him to submit freely to Salon. Both purchase and decoration turned down by the emperor. Growing requests to show in exhibitions in Antwerp, Brussels, Lyon, Metz, Nantes, where he is awarded medals. Late in 1861 opens a school for young painters dissatisfied with the Ecole, but in an open letter of December 26 outlines reasons why it is impossible to teach painting. School lasts two months.
1862–63	Etienne Baudry, patron and friend of Castagnary from Saintes, invites Courbet to stay at his property, Rochemont. Courbet thrives on environment and companionship of Baudry and friends, stays in the Saintonge at different locations until April 1863. Paints landscapes, portraits, and a new theme, flowers. At Saintes in January, shows forty-eight canvases, forty-three of them done in the Saintonge. Saves for submission to Salon the *Return from the Conference,* an anticlerical satire intended to retaliate for the insult received from the emperor in 1861. *The Return* refused not only for regular Salon but for Salon des Refusés. Courbet opens his studio for public viewing and enjoys rebutting the critical attack on the *Return.*
1864–65	Painting of two female nudes, *Venus and Psyche,* refused at Salon on grounds of indecency. Shown in Brussels later that year. Most of year spent in Ornans, painting landscapes, including series of *Puits Noir* and *Source of the Loue.* Death of Proudhon in January 1865. At Salon Courbet shows *Portrait of P.-J. Proudhon in 1853.* Fall 1865 spent in Trouville, painting portraits and seascapes. Whistler also in Trouville; his mistress is subject of Courbet's *Jo.*
1866	Growing demand for pictures by private collectors. Sent to Salon are *Woman with a Parrot* and the *Gathering of the Deer,* both given place of honor. Expected purchase of *Woman with a Parrot* falls through, resulting in lengthy controversy with Director of Beaux-Arts. Fall trip to Deauville, staying with patron, the comte de Choiseul. Painted seascapes, enjoys companionship of Boudin and Monet. *The Sleepers* commissioned by noted collector Khalil Bey. *The Quarry* bought by Allston Club in Boston, first painting to go to United States. Participates in shows in Lille, Amsterdam, Brussels, The Hague.
1867	Winter in Ornans, concentrating on landscapes of snow and hunting themes. Shows only four earlier paintings at the Exposition Universelle. Concentrates on preparing for a second one-man show, held at the Rond-Point de l'Alma: Manet's exhibition was around the corner. Shows 115 paintings, many borrowed from collectors. *L'Hallali,* the *Rest During the Harvest Season,* and recent snow paintings shown for the first time. Courbet hopes to make gallery permanent, to include Bruyas collection as well, but Bruyas prefers to remain in Montpellier.

1868–69	Two paintings at Salon, a *Hunt* and the *Beggar's Alms.* Castagnary reports a rumor that Courbet will have a seat in the Institute, which Courbet refutes. Landscapes at Ornans and at Maizières, staying with Castagnary at home of Dr. Ordinaire, an amateur painter. Showed *L'Hallali* and the *Rest During the Harvest Season* at Salon. Visits Etretat, painting seascapes, including the large *Stormy Sea* and the *Cliff at Etretat After the Storm.* Trip to Munich, warm reception by young artists, and royal recognition. Death of Buchon at end of year brings on depression.
1870	Large Etretat paintings shown at Salon. Nominated for Légion d'honneur in June; refused on grounds of his principled opposition to imperial government. Refusal gains him applause of friends and increased suspicion of government. Outbreak of war with Prussia ends in defeat of Empire, proclamation of Republic on September 4. Courbet serves Government of National Defense as President of Arts Commission, charged with protection of artworks in Paris and environs against destruction of war. Calls for dismantling of Vendôme column as imperial symbol; publishes open letter to the German army and German artists, calling for an end to the war and fraternity between peoples.
1871–72	Formation of Commune in March. Courbet head of Federation of Artists, plans liberalization of art institutions as well as protection of art works. April 16, elected representative from sixth arrondissement. Meanwhile, Commune government had arranged for toppling—not dismantling—of column, which took place May 16. Commune defeated late May; Courbet arrested June 7. Imprisoned, tried, and sentenced to fine and six-month prison term. Enters Ste.-Pélagie prison in September; is transferred to clinic in Neuilly for operation and recuperation. Begins to paint fruit still lifes. Paintings sent to Salon refused on political grounds.
1873–77	Government votes for reconstruction of Vendôme column, with expenses paid by Courbet; property is threatened. In late July he leaves Ornans for Switzerland, accompanied by Dr. Ordinaire and a woman friend. Settles in La Tour-de-Peilz, near Vevey. Though warmly received by Swiss friends and visited by Castagnary, Baudry, and others, he suffers from the exile: drinks too much, permits collaborators on some paintings; grows increasingly ill. May 1876, final judgment of 323,091,68 francs to pay for reconstruction of column destroys hopes for return to France. Dies December 31, 1877.

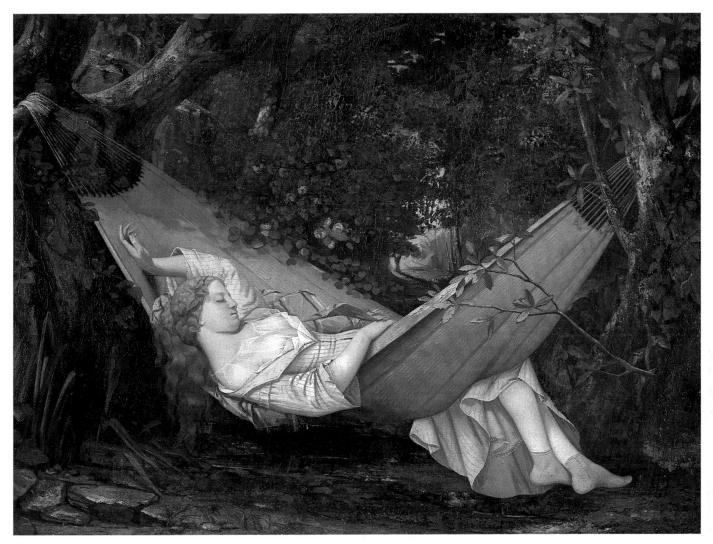

III. *The Hammock* (*Le Hamac*), 1844. Oil on canvas, 27 1/2 × 38 1/4 in. (70 × 97 cm). Winterthur, Oskar Reinhart Collection, "Am Romerholz."

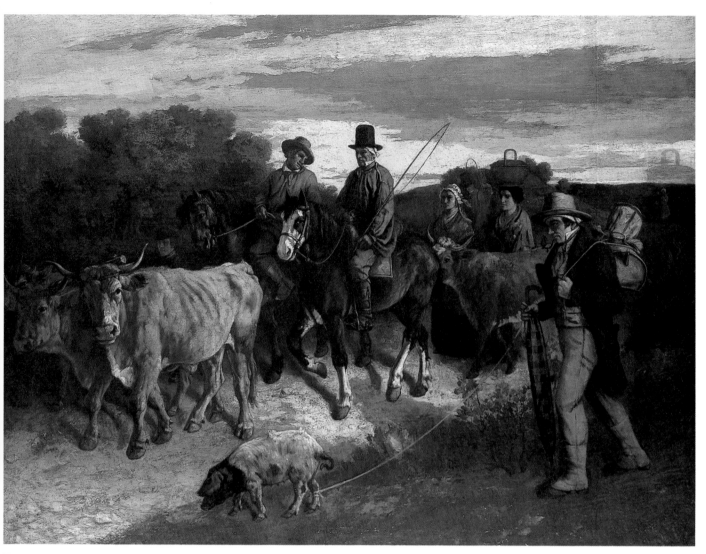

☐ IV. *The Peasants of Flagey Returning from the Fair (Doubs),*
(*Les Paysans de Flagey revenant de la foire [Doubs]*), 1850–55. Oil on
canvas, 81 1/2 × 109 1/2 in. (206 × 275 cm). Besançon, Musée des
Beaux-Arts et d'Archaeologie.

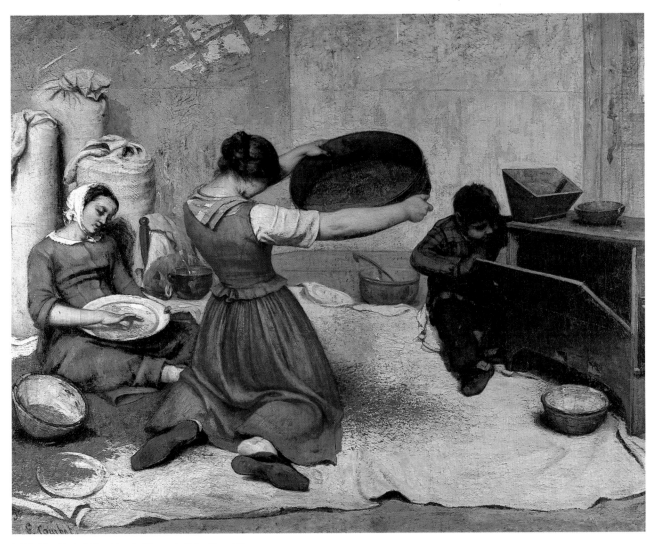

V. *The Grain Sifters* (*Les Cribleuses de blé*), 1855. Oil on canvas,
51 3/4 × 66 in. (131 × 167 cm). Nantes, Musée des Beaux Arts.

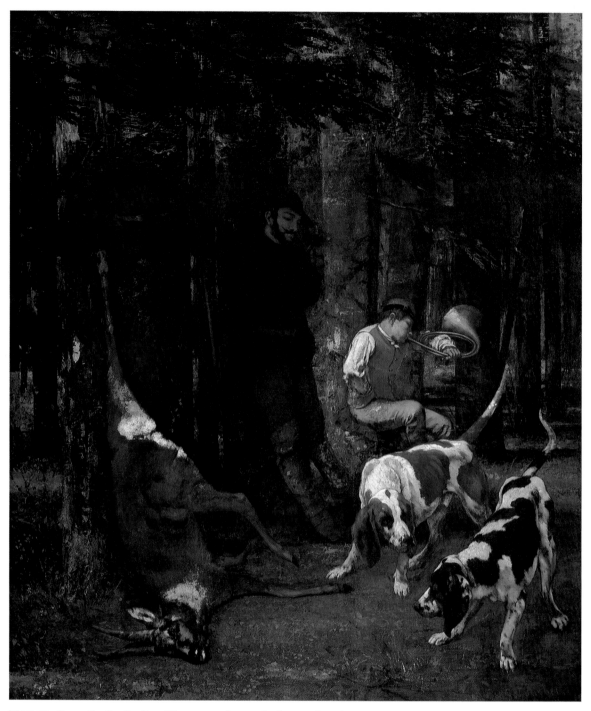

☐ VI. *The Quarry* (*La Curée*), 1857. Oil on canvas, 83 × 71 in. (210 × 180 cm).
Boston, Museum of Fine Arts.

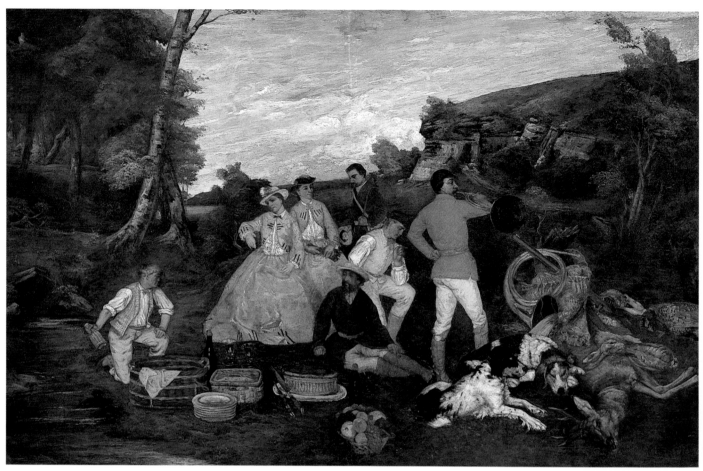

☐ VII. *The Hunt Breakfast* (*Le Repas de chasse*), 1858. Oil on canvas,
81 3/4 × 128 1/2 in. (207 × 325 cm). Cologne, Wallraf-Richartz Museum.

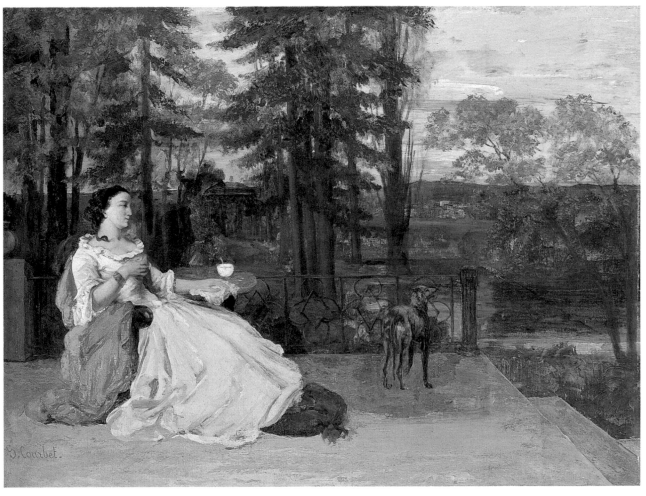

☐ VIII. *The Lady of Frankfurt* (*La Dame de Francfort*), 1858. Oil on canvas,
31 × 55 1/4 in. (104 × 140 cm). Cologne, Wallraf-Richartz Museum.

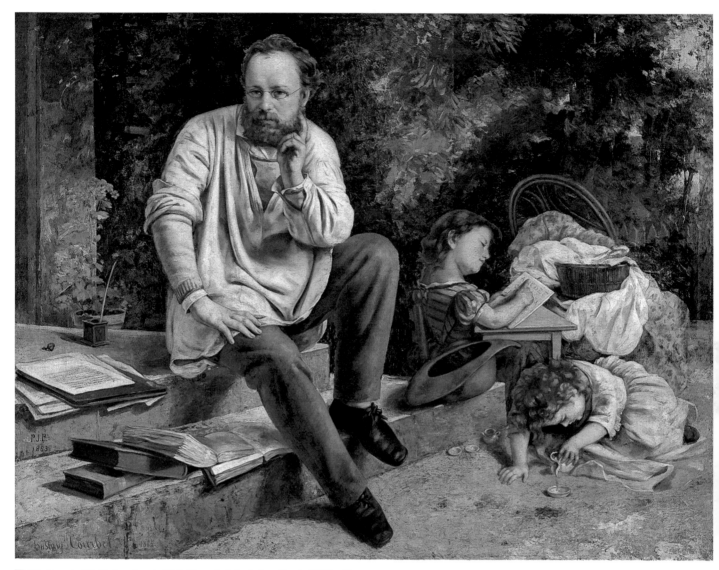

☐ IX. *Portrait of P.-J. Proudhon in 1853* (*Portrait de P.-J. Proudhon in 1853*), 1865.
Oil on canvas, 58 × 78 in. (147 × 198 cm). Paris, Musée du Petit Palais

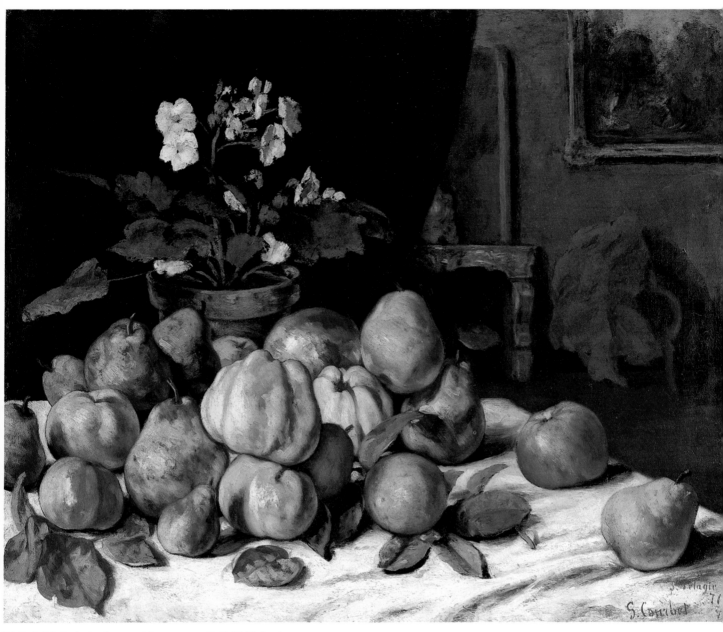

☐ X. *Still Life: Apples, Pears, and Primroses on a Table* (*Table de salon
couverte de fruits*), 1871–72. Oil on canvas, 24 × 28 3/4 in. (61 × 73 cm).
Pasadena, The Norton Simon Museum.

Catalogue

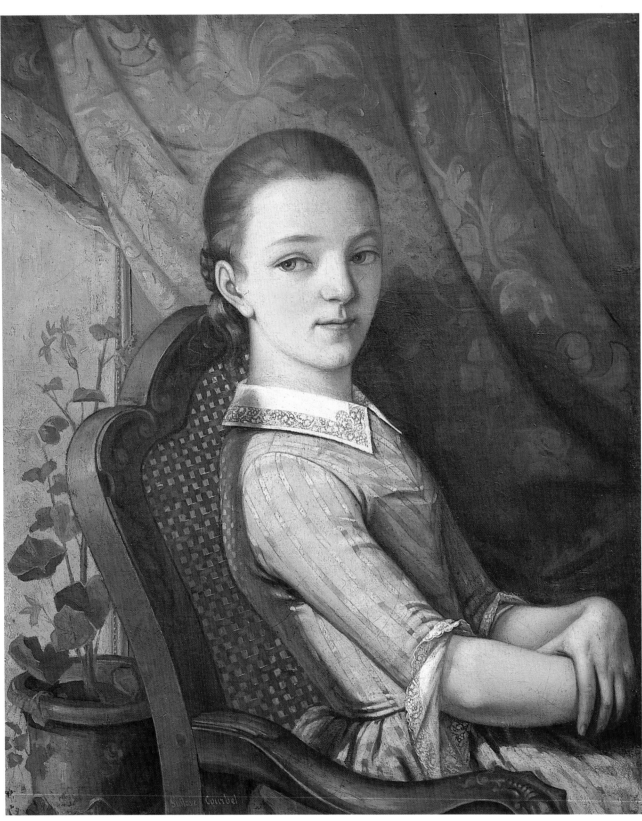

I

Catalogue

The entries on the individual works in the exhibition have been written by Rae Becker (R.B.), Ann Dumas (A.D.), and Abigail Solomon-Godeau (A.S.-G.); a few are the work of Sarah Faunce (S.F.) and Linda Nochlin (L.N.). Books, articles, and exhibition catalogues are not separated in the listing of bibliographic references. We have not attempted to repeat the substantial bibliographies and provenances provided in the Philadelphia-Boston catalogue of 1959–60, the Paris-London centenary catalogue of 1977–78, the Fernier catalogue raisonné of 1977, and the Hamburg catalogue of 1978. In the catalogue entry bibliographies Fernier 1977 is cited first. Subsequent references are chronological. Additional references are found in the entry texts. All references in abbreviated form (for example, Paris 1977) are listed alphabetically in the bibliography. In all catalogue dimensions, height precedes width. The symbol □ indicates works that could not be exhibited.

1. Portrait of Juliette Courbet 1844

Portrait de Juliette Courbet

Oil on canvas, 30 3/4 x 24 1/2 in. (78 x 62 cm)
Signed and dated, lower left: *Gustave Courbet, 1844*
Literature: Fernier 1977, I, no. 42; Riat 1906, p. 35; Rome 1969, no. 3; Paris 1977, no. 8; Montpellier 1985, no. 5.

Paris, Musée du Petit Palais

Courbet submitted this portrait of his youngest sister to the Salon of 1845. It was refused, as were three of his other submissions; the single exception was the *Guitar Player* (pl. 3). Interestingly, Courbet chose to title the painting *Portrait de la Baronne de M . . .* , which could be interpreted as either a private joke or a more calculated provocation. In marked contrast to the poise, the suavity, or the graceful stylishness one might expect in the depiction of a young aristocrat, Juliette Courbet is painted in a way that emphasizes a certain stiffness, even an awkwardness—particularly in the positioning of the right hand—that belies her patrician title. The inclusion of the homely houseplant and the style of the sturdy armchair may also signal the title's duplicity. If, as certain commentators have suggested, the example of Ingres's portraits was a factor in Courbet's own production, it was surely an influence he was reacting against, or attempting to subvert rather than to emulate.

Especially striking in this early portrait of Juliette (Courbet is known to have made two earlier portraits of her) are the directness and the lack of rhetorical flourish with which the sitter is portrayed. Consequently, the rigidity of the pose, accentuated by the oblique angle of the back and the somewhat cramped placement of the

hands, suggests both the awkwardness of adolescence and the search for a manner of painting that itself signifies a spontaneous and "sincere" response to the individual subject. These attributes in turn contribute to the painting's naive and somewhat provincial quality. The attention given to the material objects that surround Juliette—the brocade swathe of curtain, the striped silk dress, the carefully delineated pattern of light and shadow reflected through the cane—all bespeak a desire to render the things of the world in their corporeal specificity. A.S.–G.

2. Portrait of Paul Ansout c. 1842–43

Portrait de Paul Ansout

Oil on canvas, 31 7/8 x 25 3/4 in. (81 x 65.2 cm)
Signed "par grattage," lower left: *Gustave C.*
Literature: Fernier 1977, I, no. 57; Riat 1906, p. 34; Léger 1929, p. 199; Paris 1977, no. 4.

Dieppe, Château-Musée

Born just one year after Courbet, Paul Ansout (1820–94) was the son of a Dieppe cloth merchant and came to Paris to study law in the early 1840s. One of the artist's first Parisian friends, he was the subject of at least two paintings and two sketches (the latter now in the Louvre collection) during the early years of Courbet's career (Paris 1977, p. 80).

The date usually ascribed to this picture, 1844, is based on a letter from Courbet to his parents informing them that he had a "gentleman from Dieppe" posing for him (Riat 1906, p. 34). More recently, a somewhat earlier date, 1842 or 1843, has been proposed. This new dating is based partly on style and partly on a document that registers a canvas by Courbet, *Portrait of M. Ansout*, which is of different, but proximate dimensions; this work had been submitted to the Salon of 1843, but it was rejected (Paris, 1977, p. 81).

The portrayal is primarily objective, attentive to the external rather than the inner qualities of its subject, and in this sense might be said to predict Courbet's mature style. It is, however, the work of an artist whose style is still in the process of formation, a painting ably crafted but patently obligated to countless numbers of contemporary portrait models for pose and clarity. Compositionally severe and somewhat mannered though it may be, the image also entertains a measure of intimacy, conveyed in its nearness to the surface of the picture plane and the outward thrust of the tabletop in

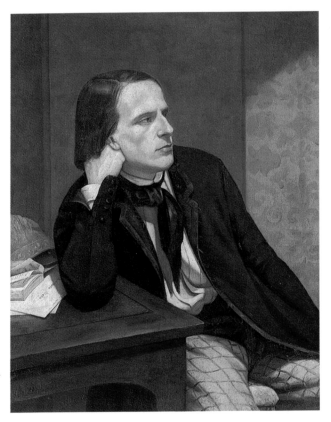

2

the direction of the viewer, and in the admission into the setting of ornamental patterns: the stylized designs on the screen or wallpaper to the right; the swirls along the edge of pillow or fabric on the left; the striped shirt and checked trousers at the center. Some of the charm and naiveté later praised by Champfleury as an essential ingredient of Courbet's style, its relationship to the stiff figures of popular imagery, and its additive approach to composition are already to be discerned here (Nochlin 1976, p. 28). A reliance upon draftsmanship and strong contours, as opposed to the fluid paint application and thick material masses common to Courbet's later work, suggests an accommodation to and an exploration of approved practices that, along with fulfilling a requirement for clarity, may have been a course chosen to exhibit professionalism to his young patron. The inclusion of two personal objects as attributes of the sitter, the open copy of *Paroles d'un croyant* and a letter to his mother, suggest Ansout's religious interests and his close family ties. Courbet would use a similar device in his 1853 portrait of Bruyas (pl. 18). R.B.

3. The Guitar Player 1844

Le Guitarrero

Oil on canvas, 21 5/8 x 16 1/8 in. (55 x 41 cm)
Signed and dated, lower right: *Gustave Courbet/1844*
Literature: Fernier 1977, I, no. 52; Riat 1906, pp. 35–36; Léger 1929,
p. 32; Philadelphia 1959, no. 5; Forges 1973, no. 33.

New York, Private Collection
Exhibited in Brooklyn only

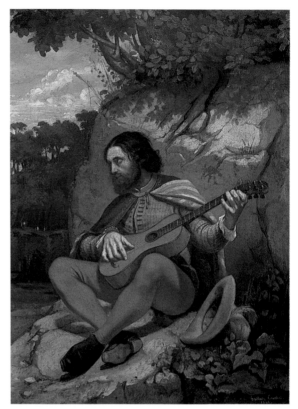

3

The Guitar Player, called "Le Guitarrero, jeune homme
dans un paysage" in the catalogue of the Salon of 1845,
where it was first exhibited, is one of several pictures ex-
ecuted during Courbet's first four or five years in Paris
that vary greatly in degree of success. In this early peri-
od, Courbet was struggling with technical problems and
conflicting theories of art, as well as working within the
context of an already academically debased Roman-
ticism. Some of his subjects were drawn from Romantic
literature: an *Odalisque* inspired by a poem by Victor
Hugo, *Lélia* from George Sand's novel by that name,
and *Walpurgis Night* from Goethe's *Faust,* along with
many other less specific literary motifs.

Courbet had had his first Salon acceptance in 1844
with *Portrait of the Artist,* called *Courbet with Black Dog*
(Paris, Petit Palais), in which he is seated in the land-
scape of his native countryside (his fashionable clothes
and his posture emulating the dandy), with his proud
new possession, a purebred English spaniel, marking his
identity as a member of the Parisian Bohemian circle.
No doubt, his first success encouraged further efforts,
like this one, to attempt to unite man with nature; in-
deed the *Guitar Player* was his second successful en-
deavor to exhibit at the Salon and the only one of five
entries to have been accepted in 1845 (see Hamburg
1978, pp. 194–95, for works of the same year that have
figures in a landscape). It is related to a "series" of
paintings and self-portraits in which Courbet assumed
various "disguises" (Forges 1973, p. 28); he scrutinized
his face before the mirror partly in an effort "to affirm
himself in his work," but also to construct a public per-
sona (Boudaille 1969, p. 19).

The Guitar Player was called a self-portrait by Thé-
ophile Silvestre and accepted as such by subsequent
critics; Forges (1973, p. 30) rejected the identification,
and Hélène Toussaint has argued persuasively that the
sitter was actually the violinst Alphonse Promayet, the
boyhood friend with whom Courbet came to Paris,
whose portrait he drew in 1847 (Paris, Louvre, Cabinet
des Dessins), and who appears in the *After Dinner at Or-
nans* and in the *Painter's Studio.* Pointing to the identical

dimensions of the *Guitar Player* and the *Sculptor,* a work
of the same year also considered a self-portrait (New
York, private collection), Toussaint proposed that the
two were conceived as pendants as an avowal of
friendship.

In terms of its costume, its allusions to Spain, to a
distant, unspecified time, and its reference to music and
the solitary player, the picture is in full accord with pop-
ular taste for the so-called Style Troubadour. In terms
of handling, the *Guitar Player,* like its pendant, "suffers
from the formal contradiction" common to many paint-
ings in the 1840s: the attempt to merge a Baroque mas-
sing of form with a neoclassical emphasis on contour
and clarity (Clark 1973a, pp. 39–40). R.B.

4. Bather Sleeping by a Brook 1845

Baigneuse endormie

Oil on canvas, 32 x 25 1/2 in. (81.3 x 64.8 cm)
Signed and dated, lower left: *45*/G. Courbet
Literature: Fernier 1977, I, no. 59; Riat 1906, p. 35; Léger 1929, pp. 33, 62, pl. 2; Philadelphia 1959, no. 7.

The Detroit Institute of Arts, City of Detroit Purchase

As early as 1845, when Courbet was still formulating his style, he had nonetheless fastened on certain motifs, themes, subjects, and poses that would regularly reappear in his oeuvre. *Bather Sleeping* was itself a replica of a painting done that same year (now in the Oskar Reinhardt collection at Winterthur), and Courbet also recycled parts of the model's pose for the 1857 *Sleeping Woman* (*La Blonde endormie*, Fernier 1977, no. 226; Philadelphia 1959, no. 29, Paris 1977, no. 20). More significant than the literal replication of the model and her pose is the appearance here of the motif of sleep, frequently, although by no means exclusively, represented by a female figure or figures. The conjunction of woman and sleep appears even earlier in Courbet's work, as in the painting *The Hammock,* also at Winterthur (pl. III), submitted to the Salon of 1844. When

Courbet's sleeping subject is a woman, either nude or clothed, the painting is invariably given a distinctly erotic charge. In the *Hammock,* for example, the bodice of the sleeping girl is opened, while the notorious *Sleep* (pl. 65) depicts a specifically sexual subject.

The fleshy, heavy-necked figure is one of Courbet's most characteristic female types. By draping her in her discarded clothing, one sleeve dangling over her arm, Courbet has attempted, with only partial success, to integrate the studio-posed model into a forest landscape, her feet submerged in the stream at the base of the canvas. This difficulty in accommodating the nude to the landscape is paralleled by two different kinds of paint application: the tighter, more carefully modeled areas of the body, and the freer, almost sketchy treatment of the stream's banks, the water, and the forest vegetation above the model's head. A.S.-G.

5. Portrait of H. J. van Wisselingh 1846

Portrait de H. J. van Wisselingh

Oil on panel, 22 1/2 x 18 1/8 in. (57.0 x 46.0 cm)
Signed and dated, lower left: *Gustave Courbet, 1846*
Literature: Fernier 1977, I, no. 68; Riat 1906, p. 40; Léger 1929, pp. 34–35; Philadelphia 1959, no. 10; Paris 1977, no. 14; *The Burlington Magazine* cxxvii, June 1985, p.416.

Fort Worth, Kimbell Art Museum

The young and handsome subject of this portrait is the Amsterdam collector-dealer, H. J. van Wisselingh, a man of Courbet's own age who was one of the artist's earliest patrons and the person through whose efforts contemporary French Realist trends were introduced into Holland. It is probable that the two first met either in 1845 or 1846, when Courbet's engagement with seventeenth-century Spanish and Dutch realism, as well as with other traditional sources, combined with romantic inclinations to produce intensified and poetic images and self-portraits. At the Salon of 1846, in which Courbet exhibited his *Portrait of M. XXX,* sometimes thought to be *Man with a Leather Belt* (fig. 3.1) or the *Self-Portrait* in the Musée des Beaux-Arts in Besançon, the young connoisseur might have recognized the early stages of a robust and original personal style. The unknown Dutch dealer who purchased the *Sculptor* (see cat. 3) at about this time was very probably van Wisselingh, who may have used the occasion of a visit to the artist's studio to commission this portrait.

4

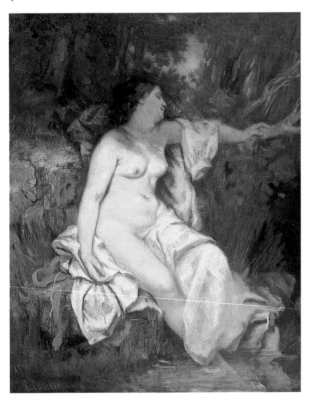

This small but powerful image, with its warm tones, strong chiaroscuro contrast, broad brushwork, and emphatic plastic modeling of features, reveals an appreciation for and knowledge of Rembrandt's work gained during the course of Courbet's first trip to Holland, which Forges argues took place in the summer of 1846, rather than the traditional date of 1847 (Paris 1977, p. 26). Nonetheless, van Wisselingh's informal costume is contemporary; the casual slant of his pillbox hat and the loosely tied cravat carry implications of freedom that accord with contemporary notions of the Bohemian and the nonconforming artist. The candid, frontal pose, the expressive tilt of the slim and graceful figure, the attractive features, and the intelligent, penetrating glance suggest a sensitivity and self-awareness not unlike Courbet's own.

The execution of the painting on wood is unusual for Courbet, and it may relate to Toussaint's suggestion that it was painted in Amsterdam (Paris 1977). It was probably this work that was exhibited at the annual *Exhibition of Living Artists in Amsterdam in 1846* under the title *Portrait of a Man*. It remains a fitting tribute to its host country and to the reciprocal connections between Courbet and van Wisselingh. R.B.

5

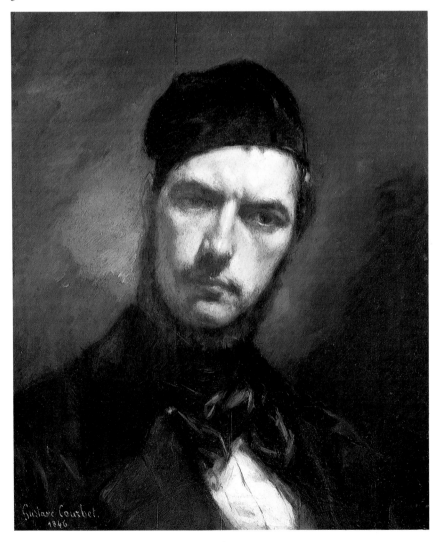

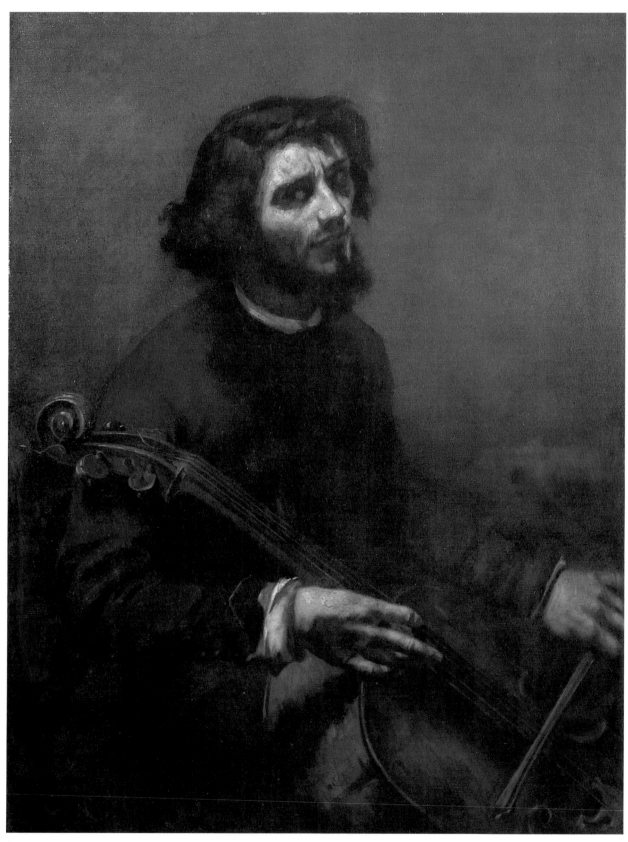

6

6. The Cellist, Self-Portrait 1847

Le Violoncelliste, Portrait de l'artiste

Oil on canvas, 46 1/8 x 35 1/2 in. (117 x 90 cm)
Signed, lower left: *G.C.*
Literature: Fernier 1977, I, no. 74; Riat 1906, pp. 45, 48–49, 133, 254;
Léger 1929, pp. 41, 62, 128; Philadelphia 1959, no. 11; Forges 1973, no.
38; Paris 1977, no. 16.

Stockholm, Nationalmuseum

The Cellist, Self-Portrait is one of a series of works
Courbet undertook early in his career in an effort to find
himself as an artist and define himself as a personality.
It is generally thought to have been painted in about
1847 and, according to Toussaint (Paris 1977, p. 93), is
probably one of the three paintings rejected for the Sa-
lon of 1847, where it had been submitted under the title
Memory of Consuelo, thereby suggesting a relationship
with George Sand's highly romantic novel *Consuelo*.

The work, accepted in the Salon of 1848, attracted
critical attention. It was immediately likened to the por-
traiture of Rembrandt. More recently, Nochlin has sug-
gested a source in Rembrandt's 1660 *Self-Portrait* in the
Louvre, remarking on the "subtle and expressive light-
ing of the head, the inquietude of the expression and the
general composition, including the fact, unusual for
Courbet, that he has chosen to represent himself almost
full length in a life-size format" (Nochlin 1976, p. 51).
T. J. Clark has called it "Rembrandt confused by the
. . . concern for elaborate posing and spatial arrange-
ment—undecided whether to set the figure in a dissolv-
ing chiaroscuro or against a background which presses
it to the canvas surface" (Clark 1973a, p. 42).

In a reversal of the standard procedure for musicians,
it is the left hand (according to Nochlin, Courbet's right
or "painting" hand) that here holds the bow, suggesting
an affinity between the musical and artistic modes of
creation. If the *Cellist* was in fact inspired by the fan-
tastic adventures and the supernatural setting dedicated
to music in George Sand's *Consuelo*, as Toussaint pro-
poses, the player here does not, as she suggests, play on
broken strings; all four are intact, and the loose frag-
ment at the pegbox is by no means unusual.

Another version of this subject is in the Portland Art
Museum, Portland, Oregon (see fig. 5.2). The latter
painting consists of several canvases sewn together and
a portion at the upper right appears to have been added
to accommodate a musical score. The Portland version
of the *Cellist* was one of the earliest Courbets to enter an
American collection: it was acquired by Erwin Davis of
New York in 1881. L.N.

7. Portrait of Baudelaire c. 1848

Portrait de Baudelaire

Oil on canvas, 20 7/8 x 24 in. (53 x 61 cm)
Signed, lower left: *G. Courbet*
Literature: Fernier 1977, I, no. 115; Riat 1906, p. 110; Léger 1929, pl. 5;
Nochlin 1976, pp. 65–69; Clark 1973a, pp. 74–76; Bowness 1977b;
Paris 1977, no. 15; Rubin 1980, ch. 6; Montpellier 1985, no. 7.

Montpellier, Musée Fabre

The friendship between the painter and the poet is
thought to have begun in 1847, and possibly as early as
the latter part of 1846 (Bowness 1977b, p. 191). In Feb-
ruary 1848, Baudelaire and Courbet, together with
Champfleury and Charles Toubin, were witnesses to
the first of the revolutionary insurrections. In addition to
their passionate concern for the democratic ideals of the
Revolution, the two shared interests in Fourierist social
theories of art and the ideas expressed in Proudhon's
recently published (1846) *Philosophie de la misère*.
Baudelaire's career had been launched with his review
of the 1845 Salon, and his initial critical formulations on
the nature of art in the modern era were published in
his review of the 1846 Salon. Courbet's career was less
advanced than that of his friend. He had had one work
accepted in each of three Salons (*Self-Portrait with Black
Dog*, 1844; *The Guitar Player*, 1845; *Portrait of M. XXX*,
1846), but had received no critical notices. Nonetheless,
he felt himself "on the point of success," and wrote to
his parents that he was surrounded by "influential peo-
ple in the press and in the arts" with whom he hoped to
"constitute a new school, of which I shall be the repre-
sentative in painting" (Rubin 1980, p. 48). Baudelaire's
influence on Courbet is perhaps suggested by the fact
that Courbet painted three allegorical canvases during
these years: *Classic Walpurgis Night*, exhibited in the
1848 Salon and later overpainted with the 1853 Salon
entry, *The Wrestlers; Man Delivered from Love by Death;*
and *The Chariot of State* (Bowness 1977b, p. 193).
Baudelaire's taste for modern allegory indeed found its
quintessential Realist response in 1855 in *The Painter's
Studio*.

This portrait may well be based on Chardin's *Boy
with the Top (Portrait of August-Gabriel Godefroy)* or
Young Draftsman Sharpening His Pencil, both of which
are from a tradition that was enjoying a revival in the
1840s, a tradition important in the formulation of
Courbet's Realism. Using a still-life motif and a paint-
erly handling similar to Chardin's, Courbet has repre-
sented the poet at his desk, pipe in mouth, his hair
closely cropped, with the traditional tools of his trade

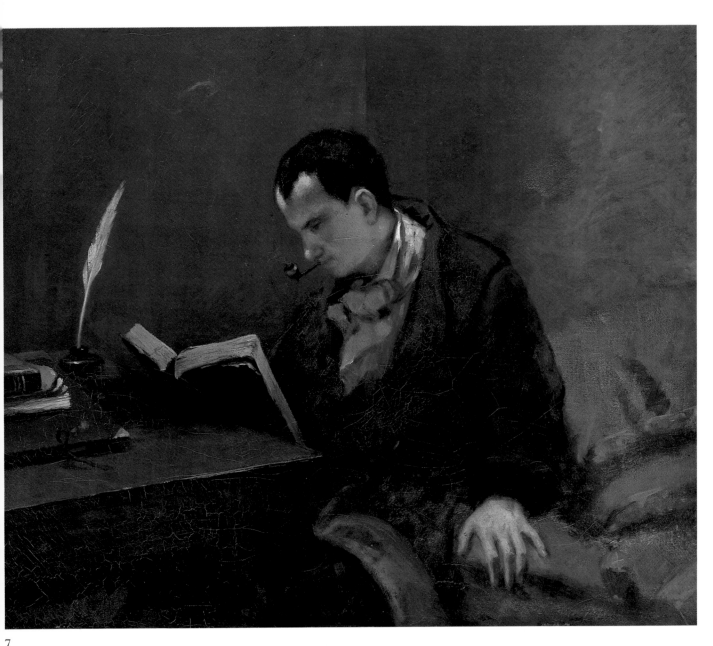

7

(books, paper, writing table, a prominent white feather quill) set before him. Yet, at the same time that he has relied on traditional motifs, Courbet has made a calculated departure from his forerunners in the creation of this image.

Rather than having the visual focus around the central figure, for example, Courbet has dispersed it into individually lit objects and parts and flattened the space through the use of truncated and peculiarly scattered orthogonals. Locked between the oblique tabletop and open volume on the left and the broadly brushed, indistinct furnishings on the right, the subject of the portrait is a figure shaped by his environment, his physical presence recorded in the same painterly facture as the objects about him, his distinguishing qualities borne almost entirely by a deep immersion in intellectual activity. The idea of the artist-worker, which was to underlie much of Courbet's later self-imagery and which was to serve as his conception of the artist's role in society, is introduced here precisely by this unconventional handling of the composition, by the deliberate breakdown of a central focus into a gathering of seemingly arbitrarily highlighted and shaded parts. The egalitarian concerns of both the poet and the painter are thus given expression in a stylistic shift that moves from traditional compositional unity to an ostensibly more truthful portrayal of the artist's connections to the world of material objects; yet the curves that contour the figure and distinguish it from its surroundings also call attention to the poet's enterprise, to his deep concentration on the contents of the book in front of him and the special nature of intellectual labor.

The dating of the *Portrait of Baudelaire* is problematic. It was given a date of 1848 in an etching by Bracquemond, but current opinion suggests that it was probably painted in the last days of 1848 or in 1849, that is, at a time when Courbet's own Realist style was beginning to emerge. That Baudelaire was displeased with this portrait (Bowness 1977b), or that by 1855 he had rejected Realism, does not diminish his importance to Courbet at this moment in the artist's development. Rather, the portrait emphasizes Courbet's continued commitment to artistic and social principles as they could be fashioned into visual imagery. These aspects of the portrait were later incorporated into the grand scale and complex iconography of the *Painter's Studio*. The *Portrait of Baudelaire* represents one of Courbet's first fully Realist achievements, and its importance is signaled by the fact that Bruyas bought it from its owner in 1874, to include it in his collection at the Musée Fabre. R.B.

8. Portrait of the Artist, *called* Man with a Pipe
c. 1848–49

Portrait de l'artiste, dit *l'homme à la pipe*

Oil on canvas, 17 3/4 x 14 5/8 in. (45 x 37 cm)
Signed, lower left: *G. Courbet*
Literature: Fernier 1977, I, no. 39; Léger 1929, pp. 49, 128; Philadelphia 1959, no. 9; Nochlin 1976, pp. 45–46; Clark 1973a, pp. 42–46; Forges 1973, no. 40; Paris 1977, no. 19; Fried 1978, pp. 108–11; Montpellier 1985, no. 3.

Montpellier, Musée Fabre

Man with a Pipe was exhibited in the Salon of 1850–51 along with the *Stonebreakers, Burial at Ornans,* and the *Peasants of Flagey Returning from the Fair.* It is one of the artist's most celebrated self-portraits, the culminating work in a series of personal and artistic pursuits that mark the years between his arrival in Paris in 1840 and his emergence as an authoritative Realist master. It follows a series of images in which he explored and assimilated influences from earlier Spanish, Dutch, and Venetian traditions and from such popular sources as Epinal prints and the more recent lithographic and photographic processes.

Related to such portrayals of himself as the *Wounded Man* (cat. 9), *Lovers in the Country* (Lyon, Musée des Beaux-Arts), and *Man with a Leather Belt* (fig. 3.1), *Man with a Pipe* is cast in a Romantic spirit, but projects neither an image of suffering or distance in time and/or space, nor a vacillating and uncertain technique; rather, it asserts an unsentimental, if mannered, portrait of a modern young man conscious of the advantages of his own extraordinarily handsome and sensitive features and the ostensible freedom of the Bohemian life. It is noteworthy that apart from the *Self-Portrait at Ste.-Pélagie*—painted following his anguished struggle to reassert his artistic and moral person—this is the only oil painting in which Courbet exhibits himself with the pipe clenched between his teeth (Paris 1977, p. 97).

The painting was sold to Alfred Bruyas in 1854, and Courbet, with his typical bravado, claimed to have refused it to the state. That he regarded it as the penultimate step in a search for artistic identity, a "salutation to the future" (Nochlin 1976, p. 46), is indicated in his much quoted, enigmatic comments addressed to his patron in a letter of May 3: "It is not only my portrait, but also yours. I was struck, in seeing it, that it is an awesome element for our solution. It is the portrait of a fanatic [*fantastique*], of an ascetic, or aesthete [*assète*]; it is the portrait of a man disillusioned with the foolishnesses

that served for his education, and who is trying to establish himself in harmony with his principles" (Montpellier 1985, pp. 124–25).

As with many of Courbet's early self-images, the date of this portrait is imprecise. An X-ray examination indicates that it was painted in two stages, with the original composition showing the figure wearing a cap much like that in drawings now in the Fogg Art Museum at Harvard and in the Wadsworth Atheneum, Hartford (Paris 1977). A chalk drawing of a seated young man (possibly before an easel), now in a private collection in Paris, presents the figure in a similar frontal, upwardly inclined positioning of the head and with the tousled hair as in *Man with a Pipe* (see Hamburg 1978, no. 306). It is also related compositionally to the *Wounded Man* (cat. 9) and the *Cellist* (cat. 6), underscoring the developmental character of Courbet's self-imagery. For the Exposition Universelle of 1855 the painting was labeled "Portrait de l'auteur, Salon 1850–51," and in Courbet's private showing of 1867 it was exhibited with a sardonic notation about its refusal by the Salons of 1846 and 1847 "by a jury composed of members of the Institute" (Paris 1977). Fernier accepts this dating, but in fact no painting of this description was entered in the Salons of 1846 or 1847 (Paris 1977, pp. 25–26). A plausible date, in the opinion of Philippe Bordes, is 1848–49, between the *Self-Portrait with Black Dog* and the *Wounded Man* (Montpellier, p. 43). On the basis of its rich facture, Marie-Thérèse de Forges dates the picture "towards 1850" when it was first exhibited in the Salon (1973, no. 40).

Copies of *Man with a Pipe* were requested by several enthusiastic connoisseurs. For an exhibition organized by the Durand-Ruel Gallery for the *Artistic Circle of Vienna* in 1873, Courbet offered to send a copy of the picture that he had made for himself from the original belonging to Bruyas (Paris 1977). R.B.

9. Portrait of the Artist, *called* The Wounded Man 1844–54

Portrait de l'artiste, dit l'homme blessé

Oil on canvas, 31 7/8 x 38 1/4 in. (81 x 97 cm)
Signed, lower left: *G. Courbet* (authentic?)
Literature: Fernier 1977, I, no. 51; Riat 1906, p. 277; Rome 1969, no. 10; Forges 1973, pp. 9–22; Paris 1977, no. 35; Hamburg 1978, no. 218; Fried 1978, pp. 91–94.

Paris, Musée d'Orsay

The Wounded Man is a self-portrait whose composition is believed to have originated with the two-figure drawing, *Country Nap (Sieste Champêtre;* cat. 91). An X-ray of the painting revealed two previous images: the first is an unrelated form of a woman, and the second closely resembles the drawing of the napping lovers (Forges 1973, p. 10), a two-figure design of a handsome youth protectively embracing a young woman who lies nestled at his side with her head resting demurely on his shoulder. With compositional alterations necessitated by a transmuted theme, the pose, the features, and the setting of the *Wounded Man* are related to those of the young lover. However, the painting is far more dramatic than the charcoal sketch: the figure is foreshortened considerably, turned on a sharp oblique, and pushed up to the surface of the canvas; the right hand and arm in the sketch are suppressed in favor of a voluminous, dark cape, and the left hand is brought around to rest at the figure's center on a diagonal line with the open wound and the patiently suffering face.

The picture is confirmed as a self-portrait in a listing that Courbet sent to Alfred Bruyas in a letter dated May 3, 1854, in which he wrote: "I have made many portraits of myself as gradually the conditions of my spirit changed. In a word, I have characterized my life. The third was the portrait of a man gasping and dying . . ." (Montpellier 1985, p. 124). The theme of the artist as martyred hero is, of course, an often-used Romantic theme, and it is certainly a biographical mode that Courbet exploited throughout his career. In this presentation of noble suffering, it is perhaps noteworthy that he employed traditional *chiaroscuro* techniques that tend to "heighten the tangible tactile parts of the figure . . . rather than dissolving them into the surrounding shadows, as in a romantic portrait" (Nochlin 1976, p. 39).

The Wounded Man belongs to that body of Courbet's work in which he was constructing an artistic *persona*, freely modifying his self-image according to his moods

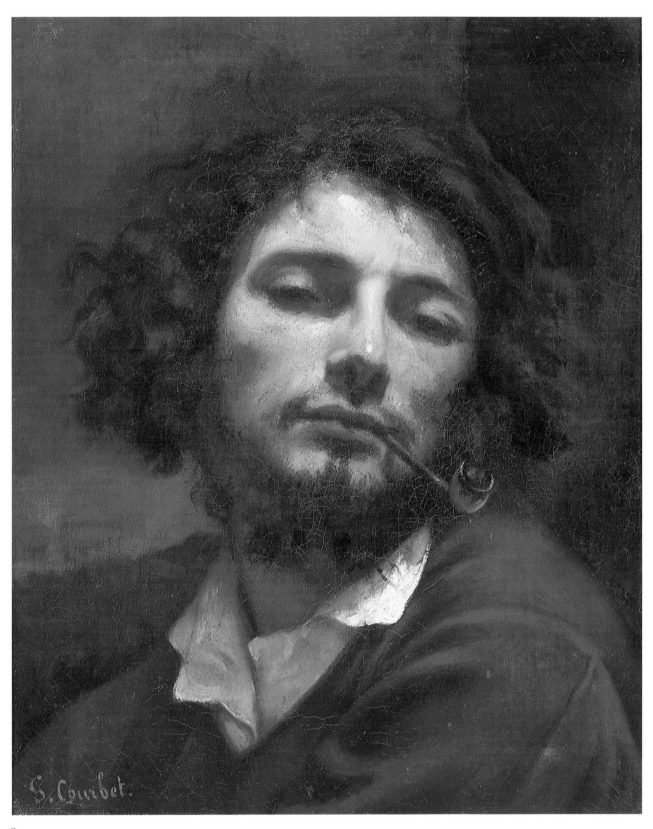

8

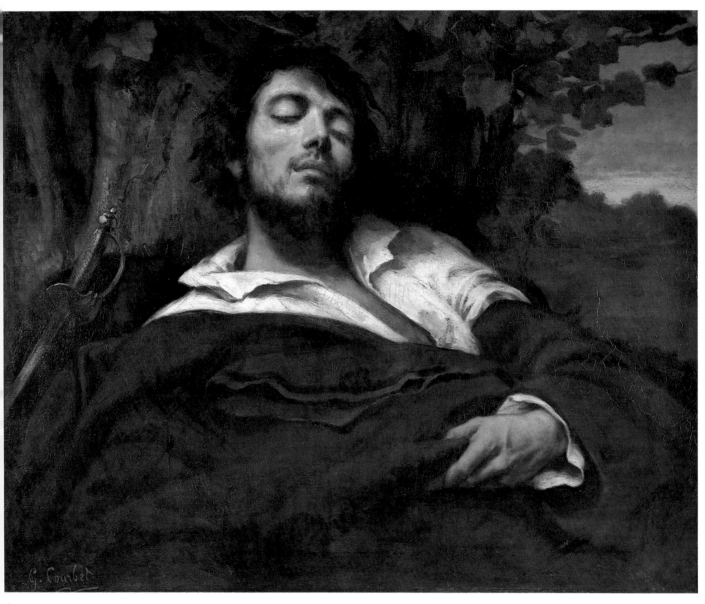

9

and needs at a specific moment. Yet the similarity in design to the *Country Nap* also supports the belief that the painting represents the denouement of a once happy and innocent love (Paris 1977). In 1851 or 1852, and again in 1854, Courbet wrote candidly to Champfleury of his regrets and deep bitterness over the dissolution of his liaison with Virginie Binet, with whom he "had been together for fourteen years" and with whom he had had a son. *The Wounded Man* may be an expression of the artist's "terribly sad spirit" and "very empty soul" (Paris 1977) caused by the abandonment.

The title for the painting was set by 1855 in a caricature by Quillenbois in *L'Illustration* (July 21, 1855; see Hamburg 1978, fig. 218a), although it is sometimes referred to in texts as *The Duel* or *The Duelist*. The dating is more problematic. For his private exhibitions in 1855 and 1867, Courbet dated the original version of the picture, with his mistress, to 1844, adding in the 1867 showing that it had been refused by the Salons of 1844, 1845, 1846, and 1847. In a list of works accompanying a biography of the artist in 1866, Castagnary dated the present version of the picture to 1854, and for the Courbet retrospective in 1882, he set the work apart from such earlier images as *Man with a Leather Belt* (fig. 3.1) and *Lovers in the Country* (cat. 94) by virtue of its more "free and supple facture" (Forges 1973, p. 9). Assuming that the picture stems from the *Country Nap* design, with its connecting links to *Lovers in the Country*, these questions remain: Was it transposed into the *Wounded Man* in 1844 and retouched for the one-man exhibition in 1855 (Riat 1906, p. 227)? Was it painted around 1848–49 (Montpellier 1977, p. 43)? Or, is it a work of around 1854, as Castagnary's commentary would indicate? The later dating is preferred by Toussaint and Forges (Paris 1977). R.B.

10. The Valley of the Loue in Stormy Weather c. 1849

La Vallée de la Loue par temps d'orage

Oil on canvas, 21 1/4 x 25 5/8 in. (54 x 65 cm)
Signed, lower left: *G. Courbet*
Literature: Fernier 1977, I, no. 104; Riat 1906, p. 64; Philadelphia 1959, no. 76; Rome 1969, no. 5; Paris 1977, no. 23; Hamburg 1978, no. 220.

Strasbourg, Musée des Beaux-Arts

The view depicted here, a sweeping panorama of the Loue Valley, is the same as that in the *Château d'Ornans* (cat. 11), but from a lower vantage point. The two works are similar in several respects. In both, Courbet adopts a traditional landscape formula for his composition: here, the foreground tree in the lower right acts as a framing "wing," and from there he establishes spatial recession through a series of planes. Another similarity with the *Château d'Ornans* is the inclusion of small figures in the immediate foreground—in this case, two hunters and a dog—that function as mediators, leading the spectator into the landscape. Figures with their backs turned to the spectator in order to contemplate a scenic view are a convention of Romantic painting, where they often carry suggestions of the fragility of man in the presence of the vastness of nature. In this painting they are in keeping with the generally Romantic mood created by the lowering storm clouds and the dramatic contrasts of light and dark, between the areas of deep shadow and the rocky bluff brilliantly lit by a shaft of acid light.

The Valley of the Loue in Stormy Weather was long thought to date about 1870, from late in Courbet's career, but this has been refuted by Toussaint (Paris 1977, no. 23), who places it convincingly about 1849, or even earlier, on the grounds that this type of traditional formula for composing landscape is characteristic only of Courbet's very early period. He soon adopted the more radical approach, pioneered by the Barbizon painters, especially Rousseau, of eliminating a foreground plane and creating depth principally through light.

It was once assumed that this was the painting that was submitted to the Salon in 1849 under the elaborately descriptive title, *The Valley of the Loue Seen from the Roche du Mont: The Village on the Bank of the River Is Montgesoye (La Vallée de la Loue prise de la Roche du Mont, le Village qu'on aperçoit au bord de la Loue est Montgesoye)*. This kind of description of a precise location was typical of Courbet's practice at that date, but the registers of the Salon entries at the Louvre have revealed that the Salon picture was of larger dimensions (Paris 1977, no. 23). This work may, in fact, have been a study for that painting, which is now lost. A.D.

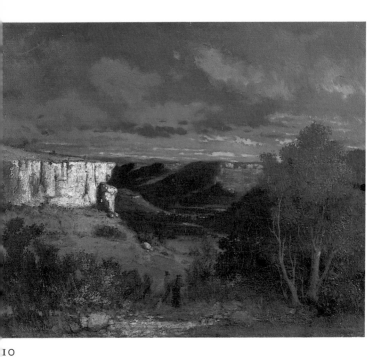

10

11. Château d'Ornans c. 1850

Le Château d'Ornans

Oil on canvas, 32 1/8 x 46 in. (81.6 x 116.8 cm)
Signed and dated, lower right: *55/G. Courbet*
Literature: Fernier 1977, I, no. 173; Riat 1906, p. 115; Stuckey, 1971–73; Paris 1977, no. 22.

The Minneapolis Institute of Arts, The John R. Van Derlip Fund and The William Hood Dunwoody Fund

One of Courbet's most ambitious landscapes, *Château d'Ornans* reflects the painter's knowledge of the conventions of landscape painting established in the seventeenth century: this masterful composition has the balance and atmospheric space of a painting by Claude. A splendid panoramic vista embraces the valley of the Loue, which is framed on either side by screens of trees and bluffs of high ground faced with the rock escarpments characteristic of this region of France. The small village of Château d'Ornans is perched on the left elevation while far below on the floor of the valley the village of Ornans appears as a cluster of houses that straddle the river Loue. A small figure of a woman laundering clothes by a stone trough in the foreground, her presence accentuated by a splash of bright red at her feet, serves as an indicator of scale, but also revives an established device of picturesque landscape painting in which laundresses made frequent appearances. Standing with raised arms as she holds out her linen, her ges-

ture seems to embrace the view spread out behind her and at the same time to invite the spectator imaginatively to enter the scene and journey through the landscape. Courbet achieves a consummate rendering of depth by modulating his color from the soft greens of the spring foliage in the foreground through the brownish patches of barren upland in the middle distance to the misty blue-violet of the far distance. The idea of landscape implicit here, where the artist selects an advantageous viewpoint and adopts a coherent pictorial scheme, is evident in several of Courbet's early landscapes, but it was later largely abandoned in favor of a willfully unpicturesque view of nature in which the conventional laws of landscape composition are disrupted and overthrown.

Courbet evidently intended this work to be a major exhibition piece. It was included in the Universelle Exhibition of 1855, as well as the regional exhibitions he organized in Bordeaux, Besançon, and Le Havre in 1858, and it later appeared in his one-man exhibition in 1867. Courbet dated the work 1855, but it seems more than likely that it was painted somewhat earlier, which would be entirely in keeping with Courbet's habitual practice of dating a work when he entered it in an exhibition rather than when he finished painting it. Stuckey has suggested a date of 1854, deducing from the new green foliage on the foreground trees that Courbet painted the picture when he was in Ornans in the spring of 1854, in preparation for the Exposition Universelle in early 1855 (Stuckey 1971–73, p. 29); Toussaint places it earlier, comparing it, convincingly, on stylistic grounds with the *Valley of the Loue in Stormy Weather* (cat. 10) and the *Study for the Young Ladies of the Village* (Brussels, Musée des Beaux-Arts), a work to which it is particularly close. Furthermore, she argues that by 1855 Courbet would not have followed this kind of landscape format because it would have been considered outmoded (Paris, 1977). It seems reasonable to suppose, therefore, that the work was painted in the early 1850s.

The absence of a castle in *Château d'Ornans* puzzled more than one critic when the work was shown at the Universelle Exhibition. The name is that of the modest hamlet that stands on the high ground to the left on the site once occupied by a medieval castle, the summer residence of the dukes of Burgundy who, with a relative degree of independence from the monarchy, controlled the Franche-Comté until 1482, when Louis XI disbanded the Burgundian states. The castle was razed in the seventeenth century under orders from Richelieu, as part of a military strategy to prevent provincial militias from resisting the monarchy.

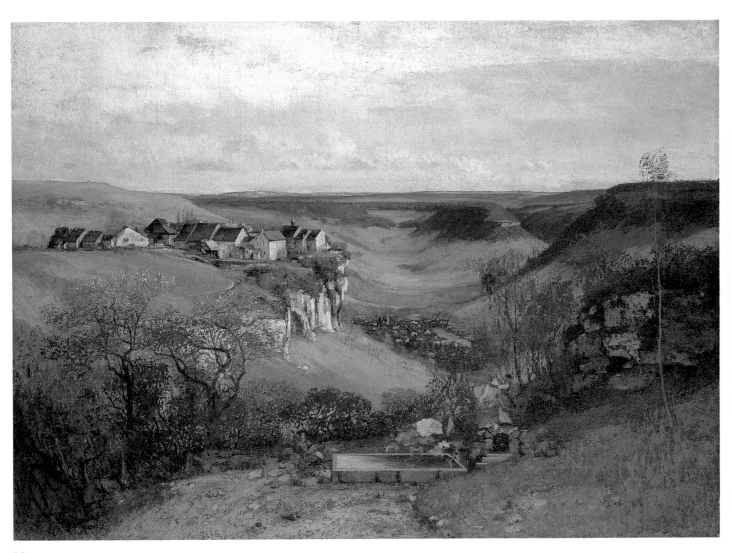

11

11 CATALOGUE 103

Recent scholarship has sought to establish that Courbet's landscapes embody the kind of social and political meanings that are more overtly expressed in some of his great figure compositions. Stuckey, for instance, has suggested that, in this straightforward presentation of a place steeped in medieval history, Courbet was subverting the trite theatricality of the scenes of medieval history that regularly filled the walls of the Salon. He has also interpreted the subject, in a more general way, as a sort of *Vanitas* symbol that conveys the idea that the splendor of medieval French history cannot withstand the processes of time: the modest village represents the "embodiment of the present victorious over the past, peasants' houses over feudal ruins, and reality over fantasy" (Stuckey 1971–73, pp. 31, 33). Herding, who has gone farther in a metaphorical interpretation of Courbet's landscapes, has proposed that the Jura cliffs, and by extension castles, can represent in a symbolic way a challenge to the centralized authority of Napoleon III by evoking the earlier political resistance of the provinces to the power of the monarch (Herding 1975).

The extent to which *Château d'Ornans* contains this kind of meaning must, of course, remain speculative, but there is little doubt that the view of nature presented in many of Courbet's landscapes conforms to a general belief in primal nature that was widespread in the mid-nineteenth century. The Franche-Comté, like the Auvergne or Brittany, was one of those regions that during the nineteenth century came to be viewed as a particularly remote, unspoiled, and "primitive" part of France—in opposition to the corrupting and constraining effects of Paris—and one that was characterized by a strong spirit of regional independence. For the poet Max Buchon, Courbet's close friend, the Loue embodied this spirit: he saw it as a river that was more genuine and wild than the Seine, and whose banks, unlike those of the Seine, were unenclosed (see "La Loue," in *Poésies Franc-Comtoises,* Besançon, 1868). It seems plausible, therefore, that in this confident and expansive landscape Courbet was expressing not only his love of his native region, but the independence, wildness, and free spirit of the Franche-Comté. A.D.

12. White Bull and Blond Heifer c. 1850–51

Taureau blanc et génisse blonde

Oil on canvas, 34 7/8 x 45 1/4 in. (88.5 x 115 cm)
Signed, lower left: *G. Courbet*
Literature: Fernier 1977, I, no. 111; Riat 1906, pp. 96, 173; Mainardi 1979.
Zürich, Galerie Nathan

In a kind of postscript to his critique of the Salon of 1859 (based on a visit to the studio of Courbet, who had not participated that year), Zacharie Astruc gave this painting high praise. "It is," he wrote, "the sentiment of Potter with more vigor, and a tone of wider understanding" (quoted in Riat 1906, p. 173). For both conservative and advanced mid-century critics, Paulus Potter's *The Bull* (opposite) served as an example of an "original feeling for nature" to be emulated by contemporary painters (Thoré-Burger, quoted in Nochlin 1966, p. 54).

In the 1850s rural genre scenes and animal paintings were very much in vogue; pictures produced by such painters as Raymond Brascassat, Constant Troyon, and Rosa Bonheur pleased Salon audiences and rarely disturbed them in the way that Courbet's scenes of country life did. As an independent work, this portrayal of animals standing naturally in a countryside of trees, cliffs, hills, and distant farmhouses should have been a neutral subject, acceptable to critics and Salon viewers. Yet within the larger context of a much disputed picture— *The Young Ladies of the Village,* for which it served as a study—the heifer and the bull proved to be unresolved features of a problematic spatial structure, as well as reinforcements of explosive social topics (Mainardi 1979, pp. 99ff).

Undoubtedly Courbet knew the Potter picture, either directly from his trip to Holland in the summer of 1846 (see cat. 5), when he wrote home that he had seen the finest collections at The Hague, or indirectly, from readily available reproductions. In this study, the pose of the blond heifer is remarkably close to that of the Potter bull. Courbet's actual models were, of course, the local cattle, a mixed breed called "Comtoise," indigenous to his native region. It was with a touch of irony that Courbet, in his critically troubling *Young Ladies of the Village,* offered domestic animals that recalled, but inverted and reinvented, the revered Potter ideal. Courbet has transmuted the Potter prototype into a double image of the more prosaic, but real, creatures that inhabit the Franche-Comté.

The painting was exhibited in the 1855 Pavilion with the title *Génisse et Taureau au Pâturage* (Heifer and Bull at Pasture). R.B.

Paulus Potter. *The Bull*, 1647. Oil on canvas.
The Hague, Mauritshuis.

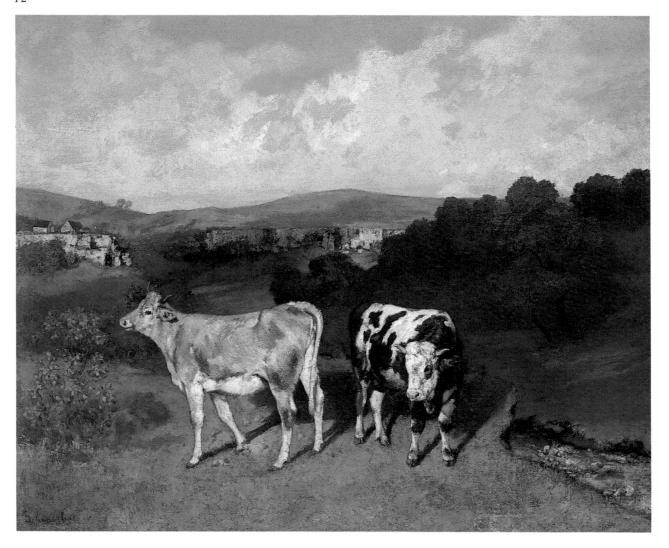

13

13. Study for The Young Ladies of the Village 1851

Les Demoiselles de village, esquisse

Oil on canvas, 21 1/4 x 26 in. (54 x 66 cm)
Signed and dated, lower left: *G. Courbet '51*
Literature: Fernier 1977, I, no. 126; Riat 1906, pp. 95–96; Léger 1929, p. 52; Philadelphia 1959, no. 17; Rome 1969, no. 8; Paris 1977, no. 29; Hamburg 1978, no. 223; Mainardi 1979; Lesko 1979.

Leeds, City Art Galleries

This picture is a study for the artist's major contribution to the Salon of 1852 (cat. 14). The prelude to a work whose meaning and formal disparities vexed and puzzled contemporary critics and audiences, it lends insight into a visual imagination acutely tuned to the art and life of its time, and it also suggests the initial phases of a vigorous and transforming creative process.

Here, as in much of his oeuvre, Courbet draws upon the familiar landscape and local inhabitants of his native village of Ornans in the Franche-Comté. Site, people, and objects are specific: the setting is thought to be the area situated behind the chateau at Ornans that includes a stream that leads to the mouth of the Mamouc River. The figures are the artist's three sisters and an unidentified young cowherd; also present is a dog of mixed pedigree and two cows belonging to the region's dominant breed (see cat. 12). The material represented is much the same for both the preliminary and final pictures; only in some seemingly minor changes, such as the elimination of two trees (one originally placed just behind the figural group at center and later overpainted, and the other placed parallel to the vertical edge of the picture plane on the far left), does it differ. Yet such decisions, coupled with the more striking and radical alterations in figural scale and perspectival relationships in the final image, establish crucial distinctions in mood, and ultimately in content.

The focal point of the study is the landscape itself, a pictorial category relatively free of conventional ex-

pository demands, and in the 1840s and 1850s the vehicle preferred by advanced artists for poetic and personally perceived transcriptions of nature. Panoramic in scope, evenly focused across an inclusive vista of sprawling meadow, cliffs, hills, local denizens, and a brilliant blue sky, it offers a characteristic view of country life. A format relatively equal in width and height, small in size, and closed off on the left by a tree, on the right by a mass of rock, and in the rear ground by a high-set horizon line, the setting is given a sense of intimacy, protection, and rational control.

This benign and comparatively conventional image, vibrant with the pleasures of season and hospitably disposed to human and animal life, was but the provisional framework for a more profound and encompassing translation of country life at midcentury. The single, slender tree set precariously in the middle ground provides the clue to Courbet's larger intentions. Awkwardly proportioned and conspicuous in its centrality and instability, it inserts a distracting and dissonant note into an otherwise integrated and harmonious composition; crudely, but clearly, it calls attention to the exchange taking place between the fashionably clad "ladies" and the barefoot peasant, visually indicating a connection between human relationships and disturbing elements in the landscape. Not yet fully articulated here, but present in inchoate form, are the social transitions and class distinctions that were apparent and troubling realities in the contemporary rural scene (Clark 1973a, pp. 152–54).

Courbet's decision to include this seminal statement among the sixty pictures shown in his Pavillon du réalisme at the same time that the completed picture was exhibited in the Exposition Universelle of 1855 may have been motivated by a desire to illuminate, for defenders as well as detractors, the connecting link between a powerfully perceived reality and the radically bold stylistic properties necessary to express it, as he did in the final image. R.B.

14. The Young Ladies of the Village 1851

Demoiselles de village

Oil on canvas, 76 3/4 x 102 3/4 in. (195 x 261 cm)
Signed, lower left: *G. Courbet*
Literature: Fernier 1977, I, no. 127; Riat 1906, p. 96; Léger 1929, pp. 52, 59, 127; Philadelphia 1959, no. 16; Metropolitan Museum of Art, *Catalogue of French Paintings*, vol. II, 1966, pp. 106–09; Nochlin 1976, pp. 178–85; Mainardi 1979; Lesko 1979.

New York, The Metropolitan Museum of Art, Gift of Harry Payne Bingham, 1940
Exhibited in Brooklyn only.

In a reference to this large-scale composition painted at Ornans in the fall and winter of 1851–52, Courbet wrote to Champfleury, "It is difficult for me to tell you what I have done this year for the exhibition . . . To begin with I have thrown off my judges, I have shifted them onto new ground. I have done something gracious . . ." (cited in Mainardi 1979, p. 96).

At first glance the picture appears to be a relatively simple genre scene in which three fashionably dressed young women—Courbet's own three sisters, Zélie, Juliette, and Zoë (see cat. 13)—strolling leisurely with their dog in the country on a clear summer's day, have stopped for a moment to chat with and offer alms to a peasant child tending cattle. Courbet's "new ground" may have been a calculated borrowing from the painted anecdotes of country life popular with Salon audiences, or an incorporation of an equally acceptable charity motif (Nochlin 1971b, p. 124); certainly it launched a series of paintings concentrating on women that eventually included the *Sleeping Spinner*, the *Bathers*, the *Grain Sifters*, and *Dressing the Dead Girl* (Mainardi 1979, p. 102). In any case, critical response to the exhibition of the *Young Ladies of the Village* at the 1852 Salon was immediate, explosive, sustained, and nearly unanimous in its attack, which centered primarily on the puzzlingly distorted figural scale and the odd perspectival relationships. In addition, the women were found graceless and "lacking in charm," the cows conceived as representations "from Liliput," and the dog characterized as a "frightful little bastard"; even the choice of "demoiselles" for the title was assessed as inappropriate and pretentious; only the landscape, with its fresh atmosphere and natural character, elicited some measure of approval (Lesko 1979, p. 173).

It is, however, safe to assume that Courbet neither naively misconstrued the taste and expectations of his audience nor intended to paint a critically conciliatory work. Rather, as recent scholarship has established, the

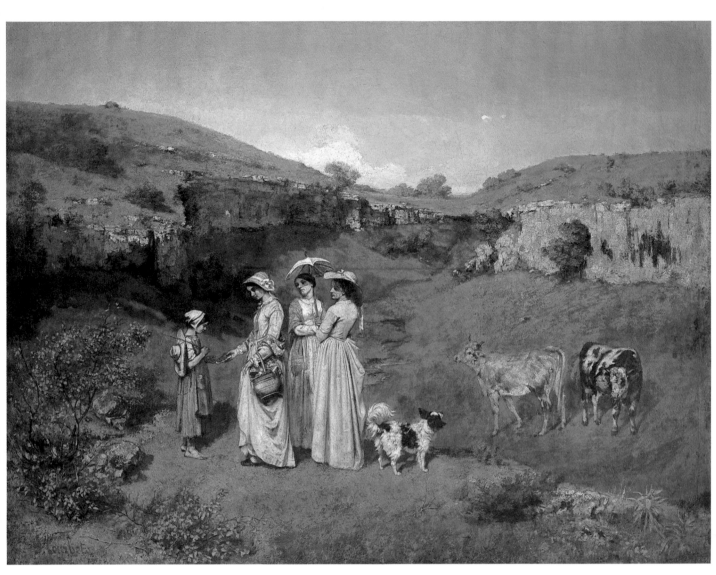

14

Young Ladies of the Village was conceived as an iconographically complex work fashioned on the conventions of normally picturesque rural imagery and transformed into a direct and unembellished portrait of shifting caste systems in the countryside with the full measure of their troubling implications for all of French society (Nochlin 1976, Mainardi 1979, Lesko 1979). Moreover, it traverses several aesthetic categories at once—genre, landscape, and history (Mainardi 1979, p. 100)—as a parallel to the hybrid character of its human and animal subjects and under the personalized stamp of regional and family biography. It is also noteworthy that the work was painted at approximately the time that Louis-Napoleon's coup d'état ushered in a climate of repression that effectively stifled overt expressions of dissent. Whether the painting was a consciously veiled attempt at political statement remains a matter of conjecture, but that Courbet's contemporaries sensed the picture's underlying meaning is affirmed by the vehemence of the critical onslaught. It was sufficiently severe for Champfleury to list the work as the second of four scandals in Courbet's career, the *Burial at Ornans,* the *Bathers,* and the Realist Manifesto comprising the other three (Mainardi 1979, p. 101).

Here, as in all of his major compositions, Courbet drew upon a wide range of traditional and popular imagery, ultimately converting his sources into a precise, personal, and original formal language. The pose of the three sisters looks back to the "classical attitude of the Three Graces" (Lesko 1979, p. 174) in such pictures as Rubens's *Education of Marie de Medici,* and perhaps to a specific prototype in Watteau's *Fortune-teller,* which also includes a spotted, bushy-tailed dog (Mainardi 1979, p. 100, Lesko 1979, pp. 175–76); the cattle are anchored in a Dutch model (see cat. 12). It is, however, in a small picture utilizing similar material that was painted in the fall of 1851, the *Landscape at Ornans* (Brussels, Musées Royaux des Beaux-Arts), and in the study for the final composition exhibited in the Pavillon du réalisme in 1855 (cat. 13) that the developing ideas for the painting and the crucial structural adjustments that express and underscore its meaning are best revealed.

In the Brussels picture the figures are small, barely discernible, and placed in a distant middle ground; enlarged in the study, they are moved forward to a low, but more centralized position on the canvas and comfortably integrated into the ancient terrain. For the final composition, Courbet increased the size of the figures in a disproportionate scale to their surroundings, raised them to the viewer's eye level, sharpened the details of

costume, and presented the women as if seen through a close-focus camera lens. The cattle remain spatially unresolved, mediating between far and near ground, but generally aligned on a horizontal line with the dog, the "ladies," and the peasant, they form the final links in a chain of visual and social connections. The enclosure around the now raised site, formed by a row of flowering bushes on the left and the arched body of the spotted bull on the right, is paralleled by the circle of stony, ancient cliffs in the distance, urging the eye to attend to the occurrences and interactions in the foreground.

Ironically, the *Young Ladies of the Village* was bought in advance of the opening of the Salon by the duc de Morny, the half-brother of the emperor, and although there is every indication that he may have regretted his purchase, it remained in the family collection until the death of the duchess in 1878 (Mainardi 1979, p. 96). R.B.

15. La Signora Adela Guerrero, Spanish Dancer 1851

La Signora Adela Guerrero, danseuse espagnole

Oil on canvas, 62 1/4 x 62 1/4 in. (158 x 158 cm)
Signed and dated, lower left: *G. Courbet Bruxelles 1851*
Inscribed, lower right: *La Signora Adela Guerrero*
Literature: Fernier 1977, I, no. 125; Rome 1969, no. 9.

Brussels, Musées Royaux des Beaux-Arts de Belgique/Koninklijke Musea voor Schone Kunsten van België
Exhibited in Brooklyn only

Courbet painted this portrait of the Spanish dancer Adela Guerrero in honor of a fête organized for King Leopold I of Belgium on September 24, 1851. Courbet had visited Belgium probably in 1846 and 1847, and he was there again in 1851, when it seems that gratitude for an invitation from Le Cercle Littéraire et Artistique de Bruxelles to exhibit the *Cellist* (1847; cat. 6) and the *Stonebreakers* (1849; destroyed) prompted him to present this painting.

A theatrical performer is an unusual subject in Courbet's work, the only other example being *Louis Gueymard as Robert le Diable,* 1857 (New York, The Metropolitan Museum of Art). Equally unusual is the Spanish subject matter, for, although the style of a number of Courbet's early works displays his enthusiasm for the great Spanish masters of the seventeenth century that he would have seen in the Musée Espagnole in Paris, the only other paintings in which the sub-

15

jects have Spanish overtones are the *Guitar Player* (1844; cat. 3) and the *Spanish Lady* (1855; cat. 21). In choosing such a subject Courbet was certainly conforming to the immensely popular vogue for Spanish art and culture that blossomed in France from about 1840.

Courbet's painting suggests an affinity with Goya's *The Duchess of Alba* (1799), then in the collection of Louis-Philippe (New York, Hispanic Society; see Rome 1969, no. 9), but a more striking rapport is felt with Manet's *Lola de Valence* (1862; Paris, Musée d'Orsay): both dancers (albeit so different in physical type) share the same proud bearing, sturdy build, brilliantly colored skirt, and both have their feet in a classical ballet position. It is unlikely, however, that Manet would have seen this painting, because it had been in Brussels since 1851. One possible explanation for their similarity is that they both derive from popular images, such as posters or handbills. As Hanson has demonstrated, images of dancers shown in similar poses were frequently the subject in popular graphic arts (Anne Coffin Hanson, "Popular Imagery and the Work of Edouard Manet," *French 19th Century Painting and Literature*, ed. Ulrich Finke [Manchester, 1972], pp. 152–55). Adela Guerrero, like Lola de Valence, was probably a member of a troupe of Spanish dancers of the kind that enjoyed great popularity and that Courbet had no doubt seen while he

was in Brussels. The red drapery and a vague suggestion of painted scenery indicate that Courbet's dancer, like Manet's, is standing on a stage, and it is quite possible that he took his image from a piece of theatrical advertising, an impression that is corroborated by the dancer's name at lower right, painted in a manner that simulates printed lettering.

A study for this work was exhibited in 1966 when it was in a private collection in Paris (*Courbet dans les collections privées françaises* [Paris, Galerie Claude Aubry: 1966], no. 16). A.D.

16. The Sleeping Spinner 1853

La Fileuse endormie

Oil on canvas, 35 7/8 x 45 1/4 in. (91 x 115 cm)
Signed and dated, lower left: *G. Courbet 1853*
Literature: Fernier 1977, I, no. 133; Riat 1906, pp. 104–05; Paris 1977, no. 31; Hamburg 1978, no. 237; Montpellier 1985, no. 12.

Montpellier, Musée Fabre

Although less scandalous than the other two paintings Courbet exhibited in the Salon of 1853—*The Wrestlers* (fig. 2.2) and *The Bathers* (pl. 7)—the *Sleeping Spinner* inspired its share of caricatures and ridicule. Satirically dubbed "Marguerite of the Inn," the painting provoked caricatures that represented the female figure as both gross and dirty. This suggests that Courbet's distinctive admixture of sexuality and class specificity, as well as his relatively heroic treatment of what normally would have been a modest and self-effacing genre subject, was at least subliminally perceived.

Various women have been proposed as the model for the spinner. Earlier commentators identified the sitter as Courbet's sister Zélie. Alternatively, Léger (1948) cited Courbet's own identification of the model as a shepherdess. Courbet, however, also described her to Proudhon as a proletarian. Alan Bowness (Paris 1977) confidently proposed Courbet's sister Zoë as the subject. Such debates about identification collectively seem to establish the fact that Courbet's artistic gifts did not include a mastery of physiognomic precision or accuracy, and certain female portraits notwithstanding, it seems more reasonable to speak of Courbet's feminine *types* than to try to pinpoint the literal models. In any case, what would appear most germane to the *Sleeping Spinner* is the confluence of the theme of sleep—a physical state that Courbet constantly explored in his work—and the feminine theme, both of which are here

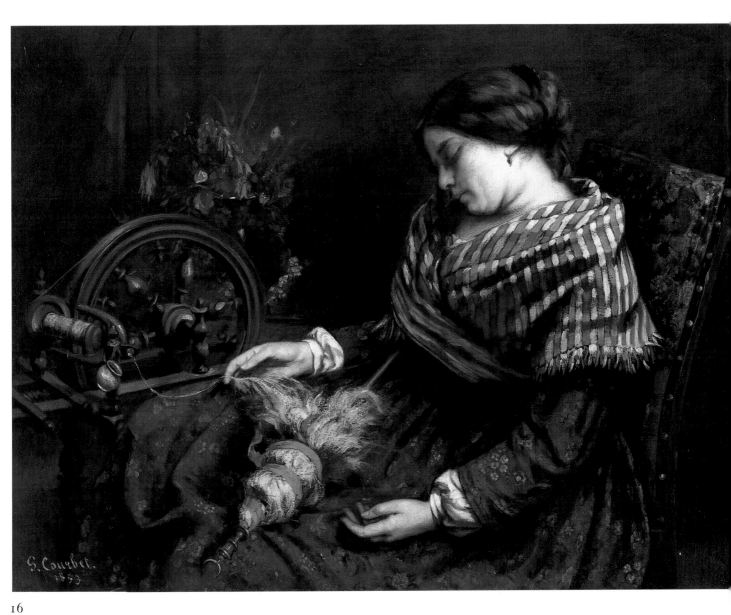

16

anchored in the social specificity Courbet describes—
namely, the embourgeoisement of the rural peasantry.
Courbet has signified this aspect in the delicate hands of
the woman, her dark flowered dress and elaborate
shawl, and the embroidered chair.

The centrality of sleep in Courbet's oeuvre has been
linked by Aaron Sheon (1981) to scientific and literary
investigations of unconscious states, including theoriza-
tions about the unconscious itself. Such investigations
were prevalent in the 1840s and 1850s, whether moti-
vated by scientific, scientistic, or mystical concerns.
However, whether Courbet was specifically influenced
by these researches remains for now largely conjectural.
In the case of his subjects of sleeping women, the tenor
and mood would appear to be geared more to the erot-
icism of the beholder than the psychological state of the
sleeper. The marked flush of the spinner's cheeks and
her upholstered bosom are surely intended to heighten
the picture's erotic connotations. Indeed, the sensuality
of the painting was promptly recognized by Champ-
fleury, who referred to the spinner's "moist and humid"
sleep. The rich, dark, brown tonality of the painting,
with its shadowed background, also contributes to the
effect of a weighty, passive eroticism. More recently,
commentators such as Werner Hoffman (Hamburg
1978) have made much of the sexual symbolism of the
distaff and spindle, and they have linked the painting to
a long tradition of moralizing images of sleeping women
who neglect their domestic tasks. Courbet, however,
was anything but a moralizing painter, and if his en-
counters with such paintings—seventeenth-century
Dutch minor masters, for example—served in some
fashion as prototypes, it could only have been in the
most general way.

The Sleeping Spinner was purchased by Alfred Bruyas
for 2,500 francs at the time of the Salon of 1853 exhibi-
tion, along with the *Bathers*. A.S.-G.

17. The Bathers 1853

Les Baigneuses

Oil on canvas, 89 5/8 x 76 in. (227 x 193 cm)
Signed and dated, lower right: *G. Courbet 1853*
Literature: Fernier 1977, I, no. 140; Riat 1906, pp. 102–05; Léger 1929,
p. 53; Farwell 1972, pp. 67–79; Paris 1977, no. 32; Montpellier 1985,
no. 10.

Montpellier, Musée Fabre

It is one of the paradoxes of Courbet's art that despite
its stated realist agenda, despite the quantities of infor-
mation about it provided by Courbet, his friends, his
critics—whether hostile or sympathetic—it is often
profoundly enigmatic; many of the major paintings have
the quality of pictorial ciphers that obdurately resist de-
finitive interpretation. *The Bathers*, which was the *succès
de scandale* of the 1853 Salon, is a case in point. Re-
cently, art historians, confronting the ambiguous ges-
ture of the massively proportioned nude and the no less
odd, beatific response of the servant woman, have pro-
posed a range of readings that in their very diversity
confirm the fundamental elusiveness of Courbet's
painting. For example, Bowness (Paris 1977) identifies
the nude with Courbet's mistress Josephine, the servant
with his sister Zoë, and their implied association as a
"first statement of that interest in lesbian relationships
which so fascinated Courbet . . . a hint of those private
sexual relationships between Courbet and his mis-
tresses . . ." (p. 16). More prosaically, Scharf (1968)
identifies the nude with a photograph taken by Julien
Vallou de Villeneuve, the extended arm being myste-
rious only because it lacks the actual support used in the
photograph. For Farwell (1973), the rhetorical gesture
of the nude, and the choice of subject matter itself, sig-
nals a complicated play with the traditions of high art,
the iconography of erotic popular imagery, primarily
lithographic, *and* a utilization of photography as well.
For Fried (1981), the figure of the nude woman is read
both allegorically and phenomenologically as none other
than the artist himself.

When it was first shown, interpretation of the paint-
ing was similarly diverse, but the critics were predomi-
nantly negative, not to say appalled. Further, the
incomprehension or outrage focused on the figure of
the nude woman, an affront to Second Empire taste in
her very proportions. "A Hottentot Venus," sneered
Gautier, "a bourgeoise Callipyge." In the caricature by
Cham, the legend reads: "A 45 year old woman at the

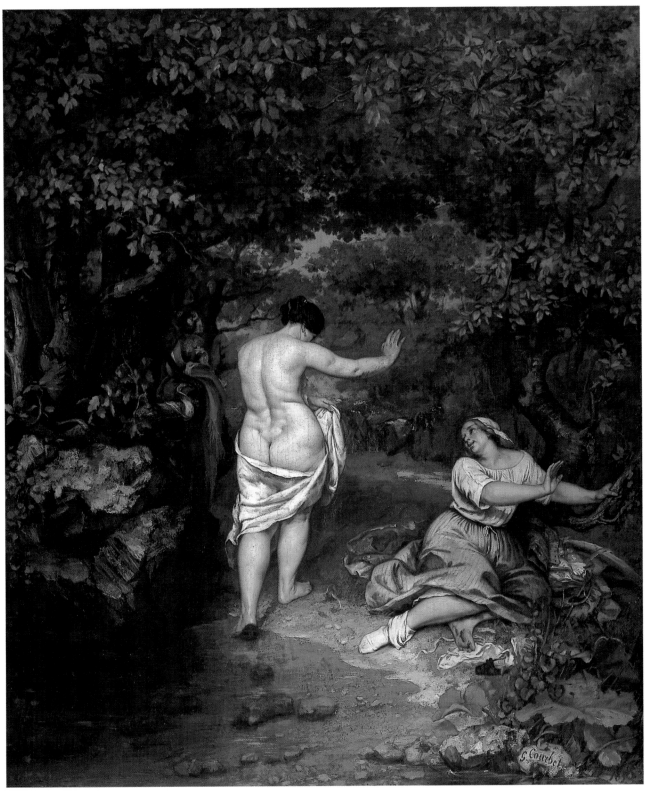

☐ 17

point of washing herself for the first time in her life in the hope of relieving her varicose veins." For Proudhon, who championed the painting, its merit lay in what he perceived as its moralizing condemnation of the gluttony, greed, and parasitism of the bourgeoisie. Even when sympathetic, however, the salon critics were perversely fascinated by the body of the nude: "She is not so much a woman as a column of flesh, a rough-hewn tree-trunk, a solid . . . Courbet has constructed this brawny mass with a power worthy of Giorgione or Tintoretto. The most surprising thing about it is that his ponderous woman of bronze, articulated in layers like a rhinoceros, has faultlessly delicate knees, ankles, and all joints in general" (Edmond About, cited in Lindsay 1973, p. 103).

The references to dirtiness, to "vulgarity" (Delacroix), the surprised acknowledgment of the "delicacy" of the nude's joints, no less than Proudhon's specific identification of the bather with the bourgeoisie, suggest that for Courbet's contemporaries, not the least of the provocations of the painting had to do with the inscription of class, not just on the level of narrative but on the body itself. It is significant to recall here that the *Sleeping Spinner,* exhibited in the same Salon, was similarly pilloried as dirty, or declassé, and, moreover, contradictorily mocked for her "duchess's hands" (see cat. 16). The problem then, as with Courbet's great paintings of the late 1840s, was not so much to do with the fact that a particular class was being represented, but, rather, with the pictorial terms in which that representation was made. As Farwell points out, the iconographic tradition of the nude bather and attendant in high art mandated a setting that was either biblical, mythological, exotic, or arcadian. Courbet's bather, her discarded clothing on the branches, or the servant's stocking, variously functioned to suggest a contemporaneity (and a class) whose only other pictorial existence was in the erotic prints and photographs that were produced in great numbers. Ten years later, Manet's *Déjeuner sur l'herbe* and *Olympia* would incite a similar scandal. Finally, the lack of formal integration between the figures and the landscape may have prompted those very readings of the painting that perceived the women as transgressing the norms of the tradition supposedly represented. Accordingly, the histrionic gestures, the ghostly evocations of the iconography of the *Noli me tangere,* and the heroic scale of the canvas alluded to an exalted realm of art that the "bourgeoise" bather, with her corpulence and her bonnet, appeared to subvert.

Despite the furor of his work's reception, Courbet had the great good fortune at this time to meet his *mécène,* Alfred Bruyas, who purchased the *Bathers* and the *Sleeping Spinner.* Courbet exhibited the *Bathers* in both his 1855 and 1867 retrospectives at the Rond-Point de l'Alma. A.S.-G.

18. Portrait of Alfred Bruyas, *called* Tableau-Solution 1853

Portrait d'Alfred Bruyas, dit *Tableau-Solution*

Oil on canvas, 35 3/4 x 28 3/8 in. (91 x 72 cm)
Signed and dated, bottom left: *G. Courbet/1853*
Literature: Fernier 1977, I, no. 141; Riat 1906, pp. 110–17; Léger 1929, p. 53; Paris 1977, no. 33; Hamburg 1978, no. 227; Montpellier 1985, no. 13.

Montpellier, Musée Fabre

This is the first of three single-figure images by Courbet of his patron and lifelong correspondent, Alfred Bruyas (1821–77). According to Théophile Silvestre, Courbet intended the subtitle, *Tableau-Solution,* to attest to the "affection and perfect accord" that he felt for his new friend and Maecenas (Montpellier 1985, pp. 51–52), with whom he was united in mutually reinforcing aspirations: for Bruyas, the effective insinuation of his presence into contemporary art and society, and for Courbet, the realization of spiritual and economic independence. In 1855, their collaboration produced the Pavillon du réalisme, Courbet's famed one-man exhibition that is now a nineteenth-century historical landmark.

Bruyas, a young man from a well-to-do family in Montpellier, was possessed with a vocation to foster the moral imperatives of art and with a passion for modern painting. He had commissioned several portraits of himself from such contemporary figures as Alexandre Cabanel, August Glaize, Gustave Ricard, Octave Tassaert, Thomas Couture, Narcisse Diaz, and Eugène Delacroix. Motivated by a mystical search for redemption that was reinforced by current Fourierist and St.-Simonian beliefs in the social mission of art—an ideal that he shared with Courbet—he dedicated himself to gathering the collection that he gave to the Musée Fabre in 1868, catalogued and annotated with profoundly felt, but oddly personalized and incoherent, artistic commentary. It was, however, with a newly charged feeling of expectation, as Philippe Bordes has

18

noted, that he discovered the moral force of Courbet's work in the Salon of 1853 (Montpellier 1985, p. 28). Of the artist's three entries (*The Bathers, The Sleeping Spinner,* and *The Wrestlers*), it was the *Bathers,* the *succès de scandale* of the exhibition, that he singled out and enthusiastically proclaimed the example of "free art"; its truth and visual power struck him as the "solution" that he sought to the unanswered questions in contemporary aesthetics and life. A meeting with the artist and a commission for this portrait followed immediately.

This image was posed in Courbet's studio on the rue Hautefeuille in the late spring of 1853 and is a publicly oriented portrayal that combines the dignified bearing of an affluent, well-attired bourgeois and the compositional stability of traditional portraiture with an accurate description of Bruyas's sensitive features and his restrained, but evident, taste for ornament. Of particular importance to the portrayal is the volume with the inscription: "Studies of Modern Art. Solution. A. Bruyas," in the lower right. Singled out for attention by the conspicuously uptilted left hand, which appears to be a gesture intended to seal a pact (Silvestre, quoted in Montpellier 1985, p. 52), it alludes to the mutually understood "solution," the equation of art—specifically Courbet's new realist art—with the moral order in contemporary life. The term *solution* was characteristic of the titles of works by Fourierist authors, for example, Victor Considérant's *La Solution ou le gouvernement direct du peuple,* published in 1851. R.B.

19. The Meeting, *or* "Bonjour Monsieur Courbet" 1854

La Rencontre, ou *"Bonjour Monsieur Courbet"*

Oil on canvas, 50 3/4 x 58 5/8 in. (129 x 149 cm)
Signed and dated, lower left: . . . *54, G. Courbet*
Literature: Fernier 1977, I, no. 149; Riat 1906, pp. 118–20; Léger 1929, p. 55; Nochlin 1967; Clark 1973b, pp. 156–60; Paris 1977, no. 36; Montpellier, 1985, no. 15.

Montpellier, Musée Fabre

The Meeting, one of Courbet's most important and best-known pictures, marks the encounter between the artist and his patron, Alfred Bruyas, as they embarked on an aesthetic and moral voyage that both believed would be the answer to the problems of modern art and life. The two had met in Paris in the previous year, 1853, when Bruyas purchased the *Bathers* and the *Sleeping Spinner* from the Salon and had his portrait painted by Courbet (see cat. 16–18). Each recognized the other as the complement to his own private and social aspirations, the reciprocal artistic and Utopian ideals to which they gave the Fourierist term *solution.* It was with a feeling of high hope and a sense of important work to be done that Courbet wrote to Bruyas in May 1854, shortly before he left for Montpellier: "I have met you; it was inevitable, as it was not we who have met, but our solutions . . . As for me, I am ready . . . I will do all that you wish and all that is necessary" (Montpellier 1985, pp. 124–25). *The Meeting,* which was commissioned by Bruyas to commemorate the artist's stay as his guest at Montpellier between June and October 1854, captures precisely the spirit and meaning of Courbet's words and his understanding of their respective roles as creator and benefactor.

The painting brings together the artist, the patron, and the humble working manservant in an image of ceremonial greeting that takes place on the raised ground of a simultaneously concrete and symbolical crossroad, the converging country routes that lead, respectively, to Sète and St.-Jean-de-Védas at Lattes (Montpellier 1985, p. 54). Under the brightly lit, atmospheric Midi landscape that stretches out toward a low, distant horizon, the bourgeois patron stands erect, but fragile, between his meekly bowing attendant and his dog, extending a grave and reverent welcome to the youthful, healthy, and handsome traveler-artist. The picture is at once a visual parallel for the prevalent Fourierist belief in the union of genius, capital, and work for the benefit of society (Hamburg 1978, p. 209)—a notion that Courbet and Bruyas shared with other French intellec-

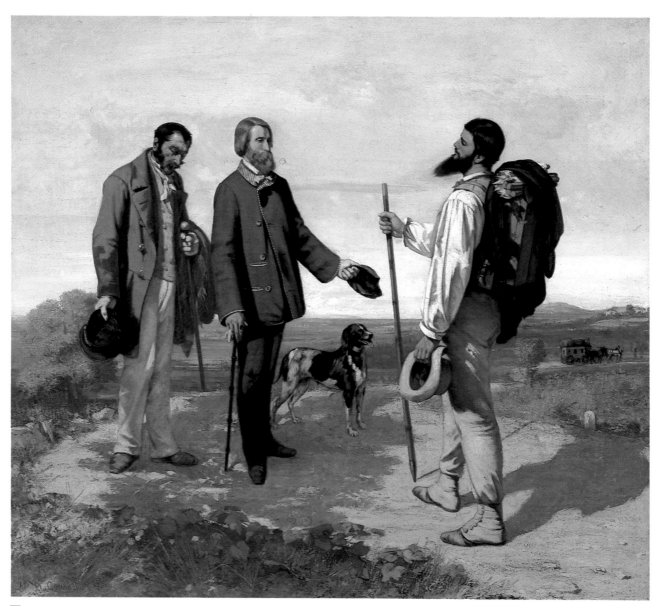

☐ 19

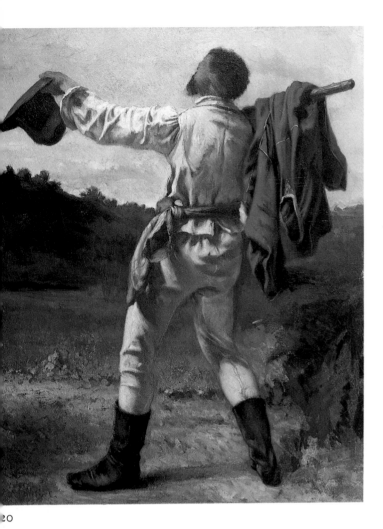

20

The prototype for the painting is from a portion of a broadside of the Wandering Jew (Nochlin 1967), a source in the body of popular imagery from which Courbet made meaningful borrowings in his major figural compositions of the 1850s, and which his friend and supporter Champfleury used as the frontispiece for his *Histoire de l'imagerie populaire* (1869). Moreover, Courbet had used the theme of the Wandering Jew for an image of the radical evangelist and Fourierist missionary, Jean Journet, who, with staff in hand, goes off to convert the world (*The Apostle Jean Journet Setting Off for the Conquest of Universal Harmony*, lithograph, 1850; Nochlin 1967, fig. 20).

Courbet's presentation of himself in the role of traveler, on foot as opposed to riding in a carriage (like the one disappearing in the distance), firm in stance and self-confident in manner, his staff in one hand, his hat in the other, with his easel, paints, and belongings strapped to his back, translates the popular image into a portrait of the artist as a modern man living a free and vagabond life and serving the personal and secular mission of Realism (Nochlin 1967, pp. 216–17).

The scene of the *Meeting* is one that probably did not actually take place when Courbet first arrived at Montpellier, but more likely depicts a return from a painting trip at the sea on a subsequent day (Montpellier 1985). The landscape and the sultry southern atmosphere, like the distinct features and detailed costumes of each of the figures, are rendered with a scrupulousness born of close and precise observation. The composition's high key is an "effort [both] to capture [the actualities of] the Provençal sunshine" (Nochlin, 1976, p. 209) and "to keep things clear, in the manner of popular models" (Clark 1973a, p. 157). In a similar vein, there is a coupling of figural accuracy with highly silhouetted forms that underscores the picture's fusion of observation and allegorical implication. R.B.

tuals—and a more personal expression of Courbet's complex conception of his own role as artist and social being. Ultimately, it is the formal language and organization of the composition that determine how to understand the richness and intricacies of the picture. For example, the placement of the painter at a proportionately greater distance from his host and servant than they are from each other, and the placement of the painter in a position more immediately accessible to the observer than either of the others are devices that signify the distinctiveness of the artist. In his correspondence with Bruyas, Courbet had written of self-portraits that he made that traced the course of his inner life, adding "there remains one more to do . . . the man firm in his beliefs, the free man" (Montpellier 1985, p. 124). Although contemporaries judged it a manifestation of Courbet's notorious narcissism and derisively called it "Fortune saluting Genius," the *Meeting*, as Nochlin has perceptively illustrated, can be seen as the picture that fulfills this stipulation (1976, p. 44).

20. The Homecoming c. 1854

Le retour au pays

Oil on canvas, 31 7/8 x 25 1/4 in. (81 x 64 cm)
Signed, lower left: *G. Courbet*
Literature: Paris 1977, no. 30; Hamburg 1978, no. 225.

New York, Private Collection

The Homecoming is a powerful study, possibly the picture in Juliette Courbet's collection until 1882, where it was listed as a "self-portrait greeting" (Paris 1977, pp. 115–

16). The figure bears certain resemblances to Courbet as he appears in the *Meeting* (1854; Montpellier, Musée Fabre), dressed in traveling clothes, wearing a yellow vest, a loose-sleeved shirt, carrying a hat of similar shape, and with a cloak dangling from the walking stick that is slung over his shoulder. In the *Sea at Palavas*, a contemporary portrayal of himself standing before the Mediterranean, Courbet announces his presence to the world as he holds a hat of the same sort in his gesturing left hand. Other physical similarities are the closely cropped hair, the compactly rounded head, and, to some extent, the shorter, blunter, but correspondingly full, outwardly thrust beard, the slight upward tilt of the head, and the sturdy physique. The landscape here corresponds to general features in many of his paintings of the countryside around Ornans. Given these similarities in attire and landscape, it is reasonable to assume that the painting dates from around the time that Courbet returned from Montpellier in late 1854.

The Homecoming is a record of a joyous, spontaneous, and perhaps even ceremonial, reencounter with the soil to which Courbet returned regularly for refreshment and renewal. With arms and legs outflung, knees bent slightly in a gesture partly simulating genuflection, and with his feet in solid contact with the ground, he portrays himself symbolically embracing (Lesko 1979), and physically implanted in, his beloved homeland. The exuberance and ingenuousness of the pose and the carelessly wrinkled, knotted, and disheveled attire recall Courbet's letter to Francis Wey in 1850 in which he expresses his need to embrace the life of a vagabond: "In our overcivilized society, I must lead the life of a savage, I must even free myself from governments . . . I have, therefore, just started out on the great, wandering, and independent life of a gypsy" (Nochlin 1967, p. 216). The free, open, and unrestricted life of the artist as vagabond, with its full measure of excitement and pleasure, is succinctly captured in this image of a return to vitalizing sources.

Another side to the *Homecoming* is its relationship to Courbet's developing ideas about the artist's role in society, which move from this picture's image of a carefree and unfettered wanderer to a portrayal, in the *Meeting*, of the painter as a fully committed, traveling missionary of Realism. Peter-Klaus Schuster points to Courbet's depiction of the *Apostle Jean Journet Setting Off for the Conquest of Universal Harmony* as an intermediary between the two (Hamburg 1978, p. 208, fig. 225a), and indeed, there is a crudity to this lithographed image and a stiffness to its forms that parallel the painting's rough, unfinished surfaces and

the returner's unpolished and vagabond manner. It is likely that the popular broadside of the Wandering Jew, which was the prototype for both the Fourierist Journet and the Realist Courbet (Nochlin 1976, p. 215), was also the model for the traveler in the *Homecoming*.

The relationship between the *Homecoming* and the *Meeting*, most obvious in the parallel ceremony of greeting, is complex, both conceptually and formally, and connected to other images of the period. They can be seen, as Schuster proposes, as complementary and contrasting self-portraits that are pendants in an interrelated social and aesthetic program (Hamburg 1978, pp. 209–10). R.B.

21. A Spanish Lady 1854

Une Dame espagnole

Oil on canvas, 31 7/8 x 25 5/8 in. (81 x 65 cm)
Signed and dated, lower right: *G. Courbet . . . '55*
Literature: Fernier 1977, I, no. 170; Riat 1906, pp. 122, 138; Léger 1929, p. 36; Philadelphia 1959, no. 21; Paris 1977, no. 41; *The Second Empire 1852–1870: Art in France under Napoleon III*, Philadelphia 1978, no. 195.

Philadelphia Museum of Art, John G. Johnson Collection

A Spanish Lady is one of Courbet's finest female portraits. The identity of the model is not known, although traditionally she is thought to be a Spanish woman who cared for Courbet in Lyon while he was recovering from the cholera that he had contracted in Montpellier during his stay with Alfred Bruyas in the summer of 1854. As he wrote to Alfred Bruyas in December of that year: "At Lyon fortunately I encountered a Spanish lady of my acquaintance who introduced me to a remedy which produced a radical cure" (Montpellier 1985, p. 127, letter no. 11).

This is not a portrait that tells us a great deal about the sitter's character, but rather it accords with a type of dark, languorous woman who held a particular appeal for Courbet: similar women can be found in the *Young Ladies on the Banks of the Seine* (cat. 32), the *Portrait of Gabrielle Borreau* (cat. 39), and the *Sleepers* (cat. 65). It has been suggested that the model for the *Spanish Lady* could be the same one who appears in the portrait, traditionally identified as a portrait of the artist's sister Juliette (Pulitzer Collection) or the dark woman in the portrait known as *L'Amazone* (New York, The Metropolitan Museum of Art; see Charles Chetham, *Modern Painting, Drawing and Sculpture, Collected by Louise and Joseph Pulitzer, Jr.*, vol. III [Cambridge, Mass.: Fogg Art Museum, 1971], pp. 381–84). These three women

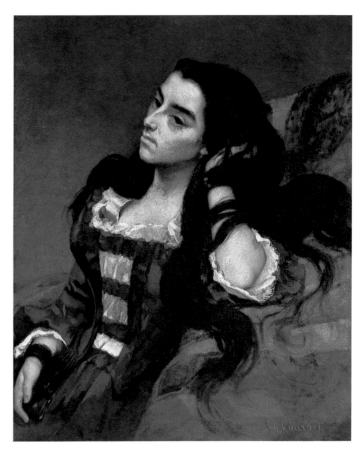

A Spanish Lady. Overall view of X-ray composite, August 3, 1978. Philadelphia Museum of Art.

21

share the same dark coloring and rather angular facial features, and given that all three works were probably painted in the mid-1850s, it seems entirely possible that the same model posed for all of them.

The figure's pose, leaning on one hand, is a convention of Renaissance portraiture and may, as Toussaint suggests, derive from a self-portrait by Raphael that Courbet would have seen in the Louvre (Paris 1977). Here, as in the *Portrait of Gabrielle Borreau*, it serves to establish the mood of reverie and passive sensuality that so frequently conditions Courbet's portrayal of women. The thick black tresses that wind over the woman's arm, the inert weight of her other hand as it encloses the fan on her lap, and the dreaming, heavy-lidded eyes all contribute to the mood of languid torpor that pervades this portrait. The opulent red of the chair and the deep blue dress serve to offset the sitter's bold, dark coloring, which is relieved only by the lighter touches of the white corsage and the pale pink ribbons that ornament her costume.

Evidently, however, this fine portrait did not conform to contemporary canons of beauty, for when it was in-

cluded in the eleven works by Courbet shown at the Exposition Universelle in 1855, it attracted a good deal of attention, even though it was poorly hung, and it aroused the scorn of the critics. One critic described the portrait as being made of Spanish leather and, writing in *Le Journal officiel*, Théophile Gautier remarked: "We have seen gipsy women—thin, gaunt, and sunburnt— on the threshold of the caves of Monte Sagrado at Granada, or in the Barrio de Triano at Seville; but none of them was so dried-up, blackened or strangely haggàrd as the face painted by Monsieur Courbet" (*Beaux-Arts en Europe* [Paris, 1856], p. 156). However, by 1883, Paul Baudry, in his introduction to the catalogue for the sale of Courbet's work at the Hôtel Druout, was more responsive to the painting's Baudelarian exoticism: "cascading hair, smoldering eyebrows and eyelashes, ardent eyes, dark and flushed tones, thin arms and a throat of great refinement, the languorousness of a cat, such is the description of this person, an etching of whom could well serve as an illustration to the *Fleurs du Mal*" ("un teint surchauffé, avec des bras maigres et une naissance de cou très fine, un alanguissement de chat, tel est le

signalement de cette personne dont une eau-forte servirait si bien d'illustration à un exemplaire des *Fleurs du Mal*" [Cited in *The Second Empire 1852–1870*, p. 329]).

X-ray examination has revealed that Courbet reused a canvas for this painting; beneath this portrait is clearly visible, but the other way up, a highly worked portrait of another woman wearing an elaborate costume in which the lace cap and collar are very distinct (opposite, left). A.D.

22. Souvenir of Les Cabanes 1854 or 1857

Souvenir des Cabanes

Oil on canvas, 37 1/2 x 53 1/2 in. (95 x 136 cm)
Signed, lower left: *G. Courbet*
Literature: Fernier 1977, I, no. 151; Riat 1906, p. 178; Montpellier 1985, p. 32, fig. 7.

Philadelphia Museum of Art, John G. Johnson Collection

Although Courbet's *marines* painted on the Channel coast are better known, it was at the Mediterranean that he made his earliest series of paintings on the edge of the sea. As Philippe Bordes notes (Montpellier 1985, p. 54), while the *Meeting* (pl. 19) does not represent an actual event, it does evoke the artist as landscape painter, returning from a day's painting in the Montpellier countryside in the direction of the sea; the background landscape is recognizably the particular kind of terrain along the shore of the region. It was during that first and fruitful visit to Bruyas in 1854 that Courbet painted for his patron the *Seaside at Palavas* (fig., cat 50), in which he shows himself greeting the grandeur of nature with a gesture akin to that with which Bruyas greets the artist in the *Meeting*. The Philadelphia painting has in common with the *Seaside at Palavas* the dark blue sea and the firm horizon line, evocative of the brilliant light of the Mediterranean, which very nearly bisects the pictorial field. However Bordes doubts (Montpellier 1985, p. 31) that Courbet did many paintings of the sea while he was painting exclusively for Bruyas in 1854; on the other hand he is known to have worked in a coastal area called Les Cabanes in June of 1857, during his second visit to Montpellier (Montpellier 1985, p. 59, cat. 23). Les Cabanes was a remote group of fishermen's huts near Palavas along the marshy pools behind the sandbars that are characteristic of the coast of the Languedoc. (When the painting was bought by Johnson from Durand-Ruel in 1891 it was titled *La Camargue*, a better known site with similar coastal topography, but

farther to the east.) These cabins can be seen at the right side of the Philadelphia painting. Fishermen haul their nets to dry toward the center of the painting, and a curious feature, between the two groups, is an outsized signpost, an object that clearly caught the painter's attention, perhaps because of its oddity in this untamed spot. With the exception of the white sail on the dark sea, these signs of human activity are visually subordinated to their surroundings; the pictorial effect is of an unpeopled world composed of the colors of earth, sea, and sky. The complex and nuanced handling of color in the painting of the marsh and dunes is especially fine. S.F.

23. The Stream of the Black Well, Valley of the Loue (Doubs) 1855

Le Ruisseau du puits noir, vallée de la Loue (Doubs)

Oil on canvas, 41 x 54 in. (104.1 x 137.1 cm)
Signed and dated, lower left: *G. Courbet '55*
Literature: Fernier 1977, I, no. 174; Riat 1906, pp. 114–15; Léger 1929, p. 60.

Washington, D.C., National Gallery of Art, Gift of Mr. and Mrs. P. H. B. Frelinghuysen in memory of her father and mother, Mr. and Mrs. H. O. Havemeyer

The subject of this painting is a famous spot near Ornans known as Le Puits noir (Black Well) where a small river, the Brême, flows through a narrow gorge of steep rocks and lush vegetation. Painted by 1855 and shown at the Exhibition Universelle in Paris that year, this is the first of many variations of the subject that Courbet was to paint.

This cool sylvan retreat, a secret and mysterious spot, its silence undisturbed by the presence of man, typifies a type of landscape that fulfilled a widely held idea of nature in the mid-nineteenth century: an idea that remote natural places could offer peace and a restorative respite to the city dweller wearied by the noise and commotion of urban life. Not surprisingly, this kind of landscape was immensely popular with collectors in Second Empire Paris, and it was in order to satisfy this demand—a demand no doubt augmented by the fact that one variation (now in the Louvre) was acquired in 1866 for Napoleon III by the comte de Nieuwerkerke, Superintendent of Fine Arts—that Courbet repeated the subject so many times, changing the seasons and times of day and adopting different viewpoints (Paris 1977, p. 181).

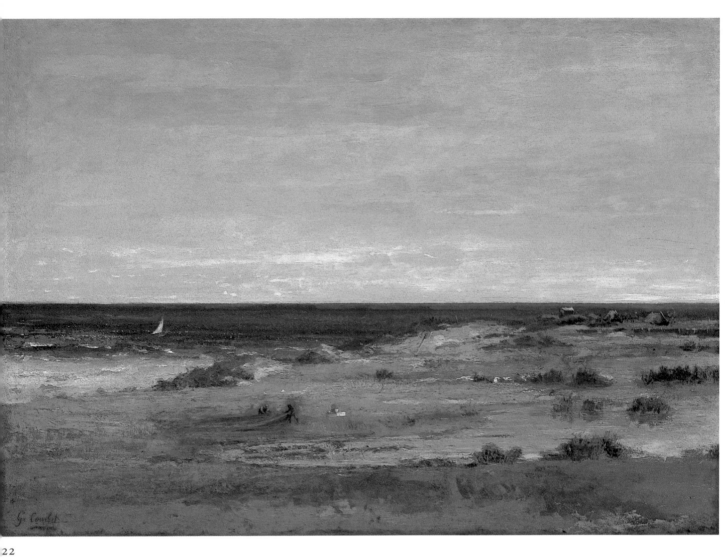

22

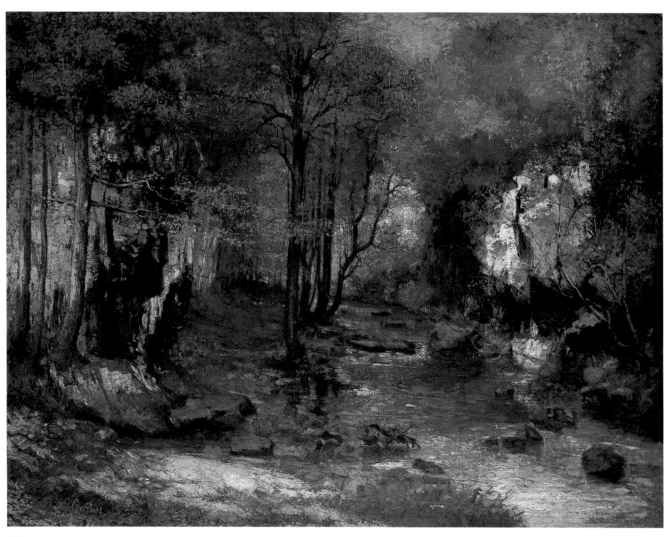

23

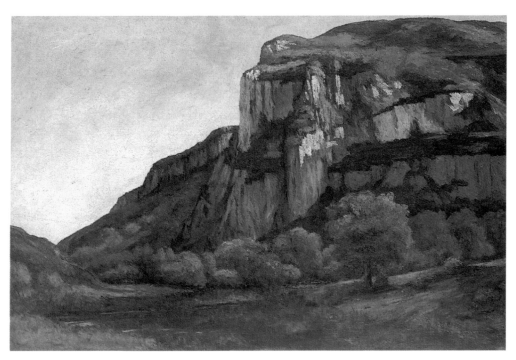

24

That Courbet felt a particular attachment to this celebrated site of his native region is evident in a letter to his patron Alfred Bruyas where he describes the version of the subject he was about to paint: "a superb landscape of profound solitude, made in the depths of the valleys of my country" ("un superbe paysage de solitude profonde, fait au fond des vallons de mon pays": letter dated January 1866; Montpellier 1985, p. 135). And when Courbet showed the present work in the Exposition Universelle of 1855, he took pains to make the specific location clear when he listed the title in the catalogue as: "Le Ruisseau du Puits-Noir; Vallée de la Loue." In the catalogue of his one-man exhibition in 1867, he was more precise, even noting the regional department: "Le Ruisseau du Puits-Noir, Vallée de la Loue (Doubs)." Once such a work was exhibited at the Salon or other major exhibitions (this work was also included in the exhibitions Courbet organized in Bordeaux, Dijon, Le Havre, and Besançon in 1858), it established a prototype upon which future commissions could be based. The titles of these subsequent variants, however, tended to reflect a shift away from the identification of a particular place toward a more general idea of nature (Wagner 1981, p. 422). For example, the work bought by Alfred Bruyas in 1866, a replica of the one in the Louvre, is called *Solitude* (Montpellier, Musée Fabre) and many are known simply as *Le Puits noir* or *Le Ruisseau du puits noir.*

The Washington painting has the feel of firsthand experience. Through continuous shifts from brushstrokes to knife work Courbet creates a rich and vibrant surface texture that subtly enhances the play of light and shade throughout the canvas. This dark and damp forest interior, where no sky is visible and only intermittent shafts of sunlight break through the dense wall of foliage to make bright splashes of light on the rocks and water, exemplifies Courbet's deep attachment to nature's enclosed places and represents the opposite pole in his vision of landscape from the panoramic views of the Franche-Comté or his luminous, expansive seascapes. A.D.

25

24. Rocks at Mouthier c. 1855

Les Rochers de Mouthier

Oil on canvas, 30 3/8 x 46 1/8 in. (77 x 117 cm)
Signed, lower left: *G. Courbet*
Literature: Fernier 1977, I, no. 112; Riat 1906, facing p. 16; Philadelphia
1959, no. 13.

Washington, D.C., The Phillips Collection

These rugged cliffs are characteristic of the Franche-
Comté landscape. They are probably the Rochers de
Hautepierre that overhang the village of Mouthier-
Haute-Pierre at the entrance of the gorges of Nouaille,
about fifteen miles from Ornans. Formerly called *Rocks
at Ornans*, the painting was identified as a view of the
Rochers de Hautepierre by Gaston Delestre, Curator of
the Musée Gustave Courbet at Ornans (letter, Sep-
tember 25, 1955). This subject, which first appeared in
1848 in *Surroundings of Ornans—Morning*, 1848 (Fer-
nier 1977, I, no. 89), is one that Courbet repeated sev-
eral times and, on occasion, incorporated into his late
memory paintings of the Normandy coast, for example,
Cliffs by the Sea, 1872 (Fernier 1977, I, no. 816). This
work is difficult to date exactly, but the broad handling
suggests that it was painted no earlier than the
mid-1850s.
 Rocks at Mouthier was acquired by Duncan Phillips in
1925. A.D.

25. View of Ornans, *also known as* The Bridge of Scey mid-1850s

Vue d'Ornans, appelé Le Pont de Scey

Oil on canvas, 28 x 35 1/2 in. (71 x 90 cm)
Signed, lower left: *Gustave Courbet*
Literature: Fernier 1977, I, no. 414; Riat 1906, p. 336; Philadelphia
1959, no. 46; Paris 1977, no. 24.

New York, Private Collection Exhibited in Brooklyn only

This placid, domesticated landscape depicts the village
of Ornans with its distinctive church belfry rising above
the houses grouped picturesquely along the banks of the
Loue. In the background is the Roche du Mont. The
bridge in the foreground has traditionally been identi-
fied as the bridge in the village of Scey-en-Varais, a few
miles farther down the Loue, an identification that is
accepted by Fernier. The painting has been variously
dated, c. 1864 (Philadelphia 1959 and Fernier 1977)
and c. 1850 (Toussaint, Paris 1977). Although such
composite views are typically found in Courbet's later
work, the composition and the style here indicate an
earlier date. While the graceful ordering of delicate ele-
ments within the composition and the traditional device
of trees framing a central pool of water are in keeping
with Courbet's early landscape style, evident for exam-
ple in the *Château d'Ornans* (cat. 11), and support Tous-
saint's date of c. 1850, the broad handling and solid
facture suggest a somewhat later date of perhaps the
mid-1850s. A.D.

26

26. View of Ornans with the Bell Tower
c. 1856–59

Ornans et son clocher

Oil on canvas, 19 7/8 x 24 in. (50.5 x 61 cm)
Signed, lower left: *G. Courbet*
Literature: Fernier 1977, II, no. 803; Philadelphia 1959, no. 30; London 1978, no. 56.

London, Private Collection, on long-term loan to The National Gallery of Scotland, Edinburgh.

This view of Ornans church and the surrounding houses has a gentleness and quiet reticence that are unusual for Courbet: indeed, the delicacy of touch, the harmonious range of soft grays and greens, and the discreet modulations of tone are more reminiscent of Corot. Although Fernier dates this painting 1871–72, its style is more characteristic of Courbet's earlier work and supports Bowness's date of the late 1850s (London 1978, no. 56). A photograph of the same scene taken in 1849 by Alfred Daber (published in Mack 1951, p. 32) shows that Courbet slightly modified the background of his composition, raising the line of the mountains, but otherwise he has remained faithful to the scene as it actually is. A.D.

27. Dressing the Dead Girl mid-1850s

La Toilette de la morte, ou *La Toilette de la mariée*

Oil on canvas, 74 x 99 in. (188 x 252 cm)
Literature: Fernier 1977, I, no. 251; Gros-Kost 1880, pp. 29–30; A. V. Churchill in *Bulletin of the Smith College Museum of Art,* April 1929, pp. 2–4; Leger 1929, p. 81; Philadelphia 1958, no. 50; Nochlin 1971a, pp. 30–54; Paris 1977, no. 25.

Northampton, Massachusetts, Smith College Museum of Art, Drayton Hillyer Fund

Although it was never completed and was not exhibited during Courbet's lifetime, *Dressing the Dead Girl* (formerly known as the *Toilet of a Bride*) belongs to the great cycle of paintings that Courbet did during the first half of the 1850s, a cycle in which he sought to document the fast-disappearing customs of his native Franche-Comté. These works—including the *Burial at Ornans* of 1850, the *Peasants of Flagey Returning from the Fair,* exhibited in the Salon of 1850–51, and the *Grain Sifters* of 1854—constitute Courbet's attempt to create a history painting of modern life: the life and customs of the provincial peasantry and petite bourgeoisie. The painting should probably be dated to the mid-1850s, for its composition shares some of the ambitions of the *Painter's Studio* as well as the latter's problematic attempt to situate a multitude of variegated figures in a large-scale interior setting.

The subject of the painting remains problematic. Until the Grand Palais Courbet exhibition of 1977, the *Toilette* was considered to be that of a bride, not a dead woman. *La Toilette de la mariée* was the name under which it was published by Guy Eglington in 1924 ("An Unpublished Courbet," *International Studio* [September 1924], 447–53) and by which it was known when it was purchased by the Smith College Museum of Art in 1929 (see A. V. Churchill, 1929, pp. 2–4). In 1977, Hélène Toussaint asserted that the painting represented not bridal preparations but those for a funeral. She based her contention on the fact that the title *Toilet of a Dead Woman* figures in two lists of paintings of Courbet's works drawn up after the artist's death, most notably in the list of Courbet's works still in the possession of his sister Juliette after the public sales of 1881 and 1882; no mention is made of a painting of bridal preparations (Paris 1977, p. 97). A second argument for the subject being a funeral toilet is based on examination of the x-ray photograph of the figure of the protagonist, which reveals a young woman who is not only nude, but who looks strangely limp for a living bride and seems to be holding her mirror in a highly unnatural

Francisco Oller (1833–1917). *The Wake (El Velorio)*,
c. 1893. Rio Piedras, Museum of the University of
Puerto Rico.

27

manner. The third argument for considering this to be a funeral painting is based on the iconography: the painting seems unusually solemn and restrained for a wedding picture—a mood out of keeping with the atmosphere of joyful celebration associated with the representation of weddings.

Although the first two arguments for believing this to be a dead woman's toilet seem convincing enough, the argument based on the iconography of the scene and the solemnity of its atmosphere is not as convincing. Courbet had indeed communicated to his friend and biographer, Gros-Kost, his intention to depict the funeral ceremony of a young girl in the Franche-Comté, but this was to be a *wake,* not a toilet scene, and it was definitely far from solemn as he described it. The painting was to have represented the corpse of a young girl lying in state, surrounded by the hubbub of funeral festivities, with groups of merrymakers eating and drinking around the already greenish body: "a very realist subject," Courbet pronounced it (Nochlin 1971a, pp. 36 and 52 *nn.* 30 and 31). This description of a wake corresponds more closely to the lively and festive funeral customs depicted in the *Wake* (fig. p. 127), by Courbet's Puerto Rican follower, Francisco Oller (1833–1917), than it does to Courbet's solemn canvas of the toilet of a dead woman. Paradoxically, from the point of view of iconography, Courbet's painting does in fact correspond closely not merely to popular images representing wedding preparations, but also to the specific features of the nuptial scenario as it was carried out in Courbet's own region (Nochlin 1971a, pp. 36–46). Indeed, the very solemnity of the scene can be accounted for by the rather dim view of the bride's future conveyed by the melancholy song, advising the bride to bid farewell to youth and freedom and assume the sad responsibilities of the married state, customarily sung to the bride by the young girls of the neighborhood on the morning of the wedding (Nochlin 1971a, pp. 37–38).

The likelihood nevertheless remains that this painting originally represented the toilet of a dead woman; it certainly was left in an unfinished state, a condition that, because of its formal abstractness, makes it particularly appealing to twentieth-century taste. If it was transformed into a "Bridal Preparations," this was probably done to make the work more salable when it was put on the market in 1919; it is still possible, however, despite the lack of documentary confirmation, that Courbet himself attempted the transformation and then left the work incomplete because the spatial problems remained recalcitrant. L.N.

28. The Clairvoyant, *or* The Sleepwalker
1855?

La Voyante, ou *La Somnambule*

Oil on canvas, 18 1/2 x 15 3/8 in. (47 x 39 cm)
Signed and dated, lower left: *65, G. Courbet*
Literature: Fernier 1977, I, no. 438; Riat 1906, p. 248; Léger 1929, p. 123; Rome 1969, no. 24; Paris 1977, no. 48; Hamburg 1978, no. 238.

Besançon, Musée des Beaux-Arts et d'Archéologie

The haunting portrait known as the *Sleepwalker* represents one of the continuing paradoxes of Courbet's artistic career: that of the self-proclaimed realist and insistently materialist painter who is nonetheless fascinated by those physical and psychic states that lie outside the purview of the conscious and rational mind. Related to this are his early interest in Baudelaire's experiments with hashish and the hallucinations it provoked, the pictorial description of extreme mental states (*The Desperate Man*), the repeated motif of sleep, and the ambiguous, but clearly abnormal state represented by the sleepwalker herself.

Recent scholars (Sheon 1981; Toussaint 1977; Hoffman 1978) have discussed Courbet's exploration of these states within the context of mid-nineteenth-century interest in the paranormal, the occult, and the unconscious. Toussaint has gone so far as to suggest Courbet's possible connection to Freemasonry, with its symbolist and mystical concerns. It is possible, however, to take the notion of paradox literally and conceive of Courbet's project as a fully materialist exploration of the *appearance* of unconscious or abnormal states of being. In other words, as a realist by conviction and a sensualist by temperament, Courbet's approach to the representation of such states drew upon both his aesthetic philosophy and his immense physicality.

As is often the case with Courbet's paintings, there are questions about dating. Despite the 1865 date painted in Courbet's hand, Toussaint gives the tentative date of 1855, noting that Théophile Sylvestre admired a canvas entitled *Voyante* in Courbet's studio in 1856. She argues further that the manner of painting is closer to the style of the mid-1850s (which was also the period when the interest in such phenomena as somnambulism was at its height), and she suggests that the sitter may have been Juliette Courbet.

In part, the power of the painting derives from the lighting and positioning of the subject's head. Beneath a broad, domed forehead, the sitter's eyes, deeply shadowed, stare out at the spectator with preternatural fixity

28

and intensity. The dark shadow beneath the chin suggests that we are looking up into the face rather than directly into it. The pale skin is accentuated by the dark hair that both frames the face and thorax and blends into the equally dark and relatively unmodulated dark background.

Courbet exhibited the painting on numerous occasions, including the 1867 Exposition Universelle, until consigning it to Durand-Ruel in 1871. A.S.-G.

29. Mère Grégoire 1855

La Mère Grégoire

Oil on canvas, 50 3/4 x 38 3/8 in. (129 x 97.5 cm)
Signed, lower left: *G.C.*
Literature: Fernier 1977, 1, no. 167; Riat 1906, pp. 54, 173, 366; Léger 1929, pp. 41–42; Paris 1977, no. 45; Herbert 1980, pp. 75–89; Toussaint 1982.

The Art Institute of Chicago, Wilson L. Mead Fund

In his striking painting of *Mère Grégoire,* Courbet turns to the theme of the woman behind the counter or bar, a theme that was to become popular in the 1870s and 1880s and was to receive its apotheosis in Manet's *Bar*

at the Folies-Bergère of 1883. *Mère Grégoire* was previously thought to be a portrait of Mme. Andler, wife of the owner of the Brasserie Andler, a Bavarian beer-cellar favored by Courbet and his companions. Recently, however, Hélène Toussaint has demonstrated that it is actually based on the likeness of Courbet's model, Henriette Bonion, whom Toussaint believes also posed for the left-hand nude in the *Bathers* of 1853 (Toussaint 1982, pp. 16–17 and fig. 11, p. 17).

What did Courbet mean to convey with this Halsian figure of *Mère Grégoire,* an ample brunette, rather chastely clothed in a dark dress with white lace collar and cuffs, seated behind a marble-topped counter? Two somewhat different, and at times opposing, interpretations of the work are offered in the recent literature by Robert Herbert and Hélène Toussaint.

According to Herbert (1980, pp. 75–89), *Mère Grégoire* is an homage to the popular poet, Pierre-Jean de Béranger (1780–1857), and is based on the latter's song, "Madame Grégoire." Like the heroine of the song, a dispenser of both drink and sexual favors, Mère Grégoire, in Herbert's view, incarnates both a disrespect for bourgeois morality and a subversive political culture rooted in the *goguettes* and brasseries of Courbet's time as well as Béranger's. Further, Herbert points out, a visual reference to Béranger in the mid-1850s was politically significant, despite the poet's somewhat ambiguous reputation, since it came at a time when Béranger was being anathematized by the far right. In 1855, the year Courbet assigned to his painting when he showed it in his exhibition of 1867, attacks on both Béranger and on popular freedom of expression were particularly severe. At this time, to choose to portray "Madame Grégoire" could be construed not only as a criticism of government censorship, but also as an attack on the very government of the Second Empire itself; it is significant, Herbert believes, that the blossom that Mère Grégoire holds in her hand carries the red, white, and blue of the French flag. "If this was a conscious act, Courbet would be opposing the true Frenchness of Béranger to the usurped authority of the government he detested" (Herbert 1980, p. 81).

In dramatic contrast, Hélène Toussaint (1982, pp. 5–17) identifies the image of Mère Grégoire as an anti-Republican satire, in which her depiction as a procuress, evidenced by her extended hand, the money on the counter, and the large ledger presumably listing the available prostitutes of the establishment, is intended to mock the official representations of the Republic, which had been the subject of a government-sponsored com-

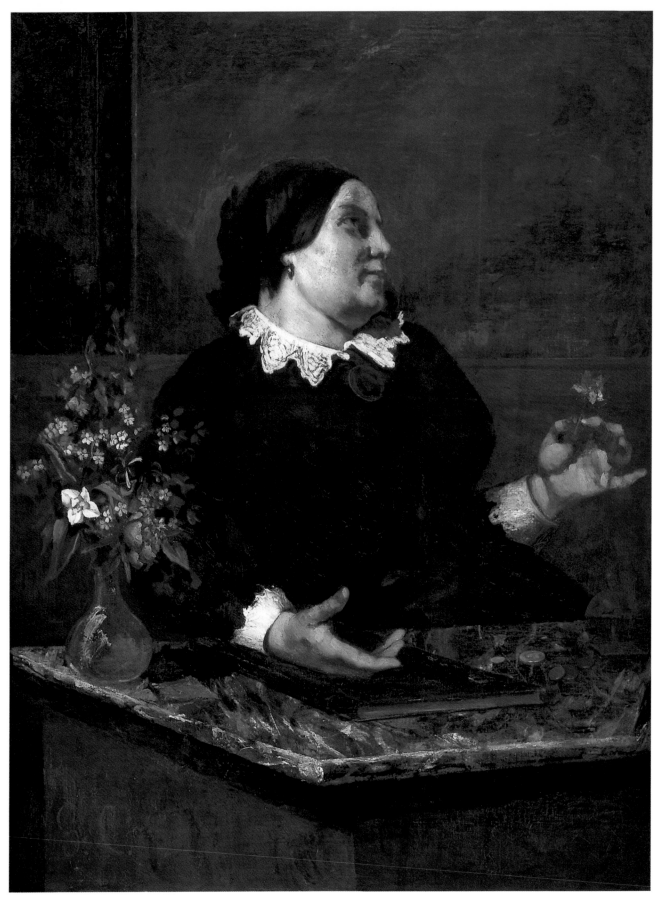

29

petition in 1848. In line with her anti-Republican interpretation, Toussaint dates the painting in 1849, near the time of the competition, arguing that the dark tonalities and the unmodulated contrast between darks and lights link it more closely to the *Burial at Ornans* than to later paintings (Toussaint 1982, p. 17). Although Toussaint makes some convincing points in her analysis of the painting, and although one can never be absolutely sure of the artist's intentions without his documented statement of them (and in Courbet's case, one must be wary even of his statements), it seems unlikely that Courbet, despite general disillusionment in 1849 about the newly founded Republic, would have gone so far as to caricature it in the form of a grasping procuress. Nor does it seem likely that the work was painted in 1849. Courbet himself dated it 1855 at the time of his 1867 exhibition, and although it is true that he sometimes misdated his own work, there is no reason to believe this to be the case for *Mère Grégoire*, which certainly has more in common with the sensual richness and voluptuous figure style of a work like the *Young Ladies on the Banks of the Seine* of 1856–57 (cat. 32) than the relative austerity of the *Burial at Ornans*.

Mère Grégoire gave rise to vastly different evaluations in Courbet's own day. The critic Théophile Silvestre in 1856 condemned it as manifesting "a hideousness which would put in the shade the witches and dwarves used as foils by Shakespeare and Velasquez in their vigorous compositions" (cited by Herbert 1980, p. 83), whereas Courbet's friend and supporter the art-historian Thoré-Burger declared in about 1865 that the painting should really be in the Antwerp Museum, where he would like to see it alongside the works of Rubens (Paris 1977, p. 137). L.N.

30. Portrait of Clément Laurier 1855

Portrait de Clément Laurier

Oil on canvas, 39 1/2 x 31 7/8 in. (100 x 81 cm)
Dedicated, signed, and dated, lower left: *A mon ami Laurier—Gustave Courbet 1855.*
Literature: Fernier 1977, I, no. 171; Riat 1906, p. 83; Léger 1929, p. 63; Paris 1977, no. 46; *Bulletin* 1968, no. 39.

Milwaukee Art Museum Collection, Gift of Friends of Art

Clément Laurier (1831–78), the young attorney who is the subject of this portrait, was a man of affairs whose role in the changing structure of French political life is still a matter for conjecture. A specialist in finance and the author of *La Liberté de l'argent* (published 1858), he

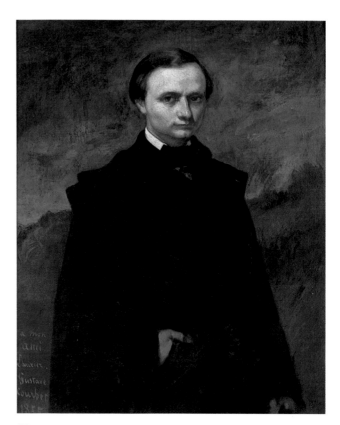

30

entered public life as a Republican and socialist sympathizer, earning his reputation within the complex framework of left-wing politics. Listed in the registry of barristers at the time of this portrait as secretary to the Liberal parliamentarian Adolphe Crémieux, he became a jurist in the Parisian court of appeals who gained renown for his acute handling of the famed assassination suit brought by the family of the journalist Victor Noir against Pierre Buonaparte in 1869, and for his legal prowess in the trial of the Marseille communards in 1871. He served as deputy in the National Assembly to the radical socialist Louis Blanc and as a member of the Ministry of the Interior for Gambetta in the Government of National Defense; one of his most important contributions to the public welfare was the arrangement of state loans to restabilize the economy following the Franco-Prussian War. Yet Laurier is an enigmatic figure whose loyalties and ideological commitments shifted during the course of his career, and who stands accused of opportunism and cynicism by the journalist and communard Jules Vallès, who saw him as the "Machiavelli of the era," a man of bloodied sword and pallid convictions (Paris 1977).

Whether Laurier relished intrigue, the fact remains that there is no record of his support for Courbet during the artist's legal and personal trials in the period following the Paris Commune; the relationship between the two was heavily taxed by time and political circumstance. Nonetheless, in the 1850s painter and patron were good friends, as attested to by the inscription on this portrait, "To my friend Laurier," and Courbet's two sojourns, one in 1851 and the other in 1856, at the attorney's Château Epineau in the Berry region. Each visit came at a crucial period in the artist's career: the first following the scandal that accompanied the Salon of 1851, and the second in the stormy aftermath of the Pavillon du réalisme in 1855. On both occasions Laurier offered respite and hospitality, commissioning in 1856 the *Portrait of Mme. Maquet* (his mother-in-law; Stuttgart, Staatsgalerie), and several landscapes of the surrounding countryside.

This portrait, executed in 1855, is handled with the objectivity characteristic of Courbet's fully developed Realist style. While its strong tonal contrasts and unfinished landscape background recall the dramatic proclivities of *Lovers in the Country* (1844) and the *Wounded Man* (1844–54), it is a sober and revealing image, focused upon the sitter's physical particularities and his boldly scrutinizing gaze. A brilliant, almost harsh, light, reserved exclusively for the strongly modeled head and the strip of collar that surrounds it, serves as counterpoint to the figure's somber attire and milieu; it calls attention to markedly individual features: the unusually wide forehead, deep-set eyes and heavy nose, the broad cheekbones and narrow line of lips, and the receding chin. Laurier is portrayed here as a commanding and strongly felt presence, his class and social station conveyed by his upright posture and fastidious grooming, his confidence and control implied in the deliberateness of his glance and in the lack of idealization and embellishment to his countenance. Set off from his environment by firm contours and distinctions in brushwork, and emotionally distanced from the viewer by a pose more formal than the images of Baudelaire (cat. 7), Marlet (1851), Champfleury (1854), or other close friends, this comparatively large-scale, three-quarter-length figure dominates the canvas while it retains a physical and emotional separation from the observer, the artist, and the immediate surroundings. R.B.

31. Portrait of Mme de Brayer, *called* The Polish Exile 1858

Portrait de Mme de Brayer, dit *l'exilée polonaise*

Oil on canvas, 36 x 28 5/8 in. (91.4 x 72.7 cm)
Signed and dated, lower right: *G. Courbet 58*
Literature: Fernier 1977, I, no. 232; Léger 1929, p. 74; Philadelphia 1959, no. 34, L. W. Havemeyer, *Sixteen to Sixty, Memoirs of a Collector,* New York 1961, p. 188; Paris 1977, no. 56.

New York, The Metropolitan Museum of Art, Bequest of Mrs. H. O. Havemeyer, 1929, The H. O. Havemeyer Collection

Courbet painted this exceptionally fine portrait during a trip to Brussels in 1858. Nothing is known of the sitter except that she is thought to have been a Polish exile living in Brussels.

Unlike many of Courbet's female portraits, which seem to be more portrayals of a type than of individuals, this work is remarkable for the degree of characterization and the sensitive response to the sitter's personality that it displays. It is not surprising that Degas admired this portrait; its penetrating characterization and its se-

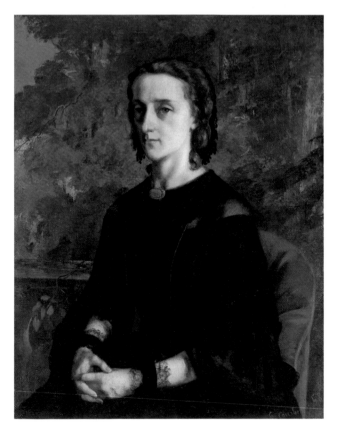

31

verity bring to mind certain of his own portraits, for example, a work such as *Mme. Gaujelin*, 1867 (Boston, Isabella Stewart Gardner Museum).

Courbet adopts the conventions of Renaissance portraiture by setting the figure against a stone balustrade and a painted landscape background. The handsome, rather than beautiful, face, the large solemn eyes, the high, intelligent brow, the grave expression that, to Mrs. Havemeyer, expressed "the suffering of her race," and the containment of the pose bespeak a restrained and noble dignity. This mood is underscored by the sitter's somber dress, her black velvet gown relieved only by a simple, deep red brooch at her throat and the black lace wristlets. Indeed, it is possible that she is wearing mourning dress, and that the brooch is a hair brooch, of the kind that were frequently worn in the nineteenth century as momentos of the deceased.

This portrait remained with the sitter's family until it was acquired by Mary Cassatt for Mrs. Havemeyer. A.D.

Edouard de Beaumont. *Paysage d' été* (*Summer Landscape*), 1852. No. 31 of suite, *À la campagne*, 1847–51. Lithograph. Paris, Bibliothèque Nationale, Cabinet des Estampes.

32. The Young Ladies on the Banks of the Seine (Summer) 1856–57

Les Demoiselles des bords de la Seine (Été)

Oil on canvas, 68 1/2 x 79 in. (174 x 200 cm)
Signed, lower left: *G. Courbet*
Literature: Fernier 1977, I, no. 203; Riat 1906, pp. 143, 148, 341; Proudhon, *Du principe de l'art*, 1865, pp. 198ff; Léger 1929, repr. p. 65; Suzanne Kahn and Martine Ecalle, "Les Demoiselles des Bords de la Seine," *Bulletin*, 1957, no. 19, pp. 1–17; Paris 1977, no. 52.

Paris, Musée du Petit Palais

The Young Ladies on the Banks of the Seine is one of Courbet's most appealing paintings. Two fashionable Parisiennes have escaped the heat of the city to seek refuge in a cool, leafy spot along the banks of the Seine. The still air and languid torpor of the figures that so effectively convey the heat of a sultry summer day, the details of costume, and the slightly technicolor landscape all combine to create an image of great charm.

Such scenes of contemporary outdoor recreation were unusual in painting at the time, although they were a common subject in contemporary popular prints, for example, Edouard de Beaumont's *Paysage d'Été* (1852; above). Seven years later Manet would depict a contemporary outdoor idyll in his *Déjeuner sur l'Herbe* of 1863, and scenes of Parisians enjoying their day off at the new leisure spots along the Seine—La Grenouillère, Chatou, and Bougival—were to gain wide currency with the Impressionists and Seurat and his circle.

From the agreeable appearance of this painting today, it is perhaps difficult to understand how it could have provoked such a scandal when it appeared at the Salon of 1857, but, in fact, it was perceived as provocative on several counts that are lost to modern eyes. The title alone was enough to outrage bourgeois audiences. Gautier remarked on its strangeness, noting that Courbet had deliberately chosen a provocative subject to draw the crowds ("C'est un coup de tampon a tour de bras sur le tam-tam de la publicité, pour faire retourner la foule inattentive"; *L'Artiste*, 1857, p. 34, cited in Kahn and Ecalle, 1957, p. 11). For Castagnary, Courbet had "taken his revenge this year by exhibiting a double insult to Paris and the people. *Les Demoiselles*—whose jocular title reveals his impertinent idea" (*Salons*, 1857, vol. 1, p. 29, cited in Kahn and Ecalle, p. 13). The provocation lay in the fact that these were clearly not "young ladies" at all, but working girls of easy virtue who, dressed to kill in all the frippery of the latest fashion, have thrown decorum to the wind and stretched out with sensual abandon on the grass. The same subversive intention lay behind the title of the earlier *Young Ladies of the Village*, 1852, in which the coarse appearance and unstylish dress of Courbet's sisters betrayed their provincial origin and shocked viewers at the Salon (Mainardi 1979, p. 96). In a sense the two paintings can be seen as pendants, as rural and urban counterparts of a similar theme.

Implicit in the work's provocative title was a deeper challenge to the social order. Mainardi has proposed that taken together the *Young Ladies of the Village* and the *Young Ladies on the Banks of the Seine* encapsulate a social phenomenon that was widespread in nineteenth-century France: the migration of the rural population to the large cities. By moving to the cities, country girls could escape the limitations of their background, although the resulting collapse of their traditional values often led them into marginal prostitution (Mainardi 1979, p. 10). Proudhon, who wrote one of the most vitriolic diatribes against the painting, interpreted these women as symbols of social corruption and commented that the title of the work should have been "Two Young Women of Fashion under the Second Empire," implying a criticism of the morality of the empire of Napoleon III (see chapter 2, above). By emphasizing the sexuality and the vulgarity that accompanied these women's social mobility, Courbet was, in effect, posing an unsettling threat to the recently acquired bourgeois status of his audience.

The Young Ladies on the Banks of the Seine is redolent with a languid sensuality. Sleeping or dozing women who suggest a passive sexual availability and imply the presence of a male spectator, indicated here by the straw hat lying in the boat, can be seen in the context of a frequently recurring theme in Courbet's work. But in this painting the specificity of context gives an erotic meaning that is more challenging. While erotic female figures of the type manufactured by a Bouguereau or a Cabanel abounded at the Salon, generally these were safely removed to the realm of allegory, remote in time and place and, therefore, entirely in accordance with respectable taste. These women, however, were uncomfortably contemporary Parisiennes and possibly, as Toussaint suggests, even known personally to some visitors to the Salon (Paris 1977, no. 52). The recumbent figure in the foreground is, moreover, in a state of semi-undress, her paisley cashmere shawl flung carelessly across her diaphanous, gauzy petticoats, making explicit the eroticism of the subject. Indeed, as Nochlin has demonstrated, the whiteness of lingerie was a potent conveyer of sexual availability to the nineteenth-century erotic imagination (chapter 2, above; see also David Kunzle, "The Corset as Erotic Alchemy: From Rococo Galanterie to Montaut's Physiologies," in *Woman as Sex Object*, eds. Thomas B. Hess and Linda Nochlin, New York, 1972, pp. 91–165).

There are several related works (see Fernier 1977, I, nos. 204–09), but it is not clear whether they are preparatory studies for the finished painting. Three of

these, nos. 207, 208 (National Gallery, Prague) and 209 (which belonged to Matisse), depict the woman with the straw hat leaning against the tree. Matisse also owned a tracing made by Courbet of the reclining dark-haired woman, a work that displays a remarkable affinity with his own drawing style (reproduced in Hamburg 1978, p. 232). Fernier no. 204 appears to be a sketch for the finished composition, and a more resolved study is in the National Gallery, London (Fernier, no. 206), although its authenticity has been doubted. A further sketch was owned by Juliette Courbet, but this was destroyed in 1940 (Paris 1977, no. 52).

The painting was included in Courbet's 1867 exhibition (no. 8) and in the 1882 exhibition at the Ecole des Beaux-Arts (no. 10). It was owned by Etienne Baudry, who acquired it from Durand-Ruel in 1875. In 1897 Baudry gave the painting to Juliette Courbet with the stipulation that it should be given to a museum. She donated it to the Petit Palais in 1906—in her own name. A.D.

33. After the Hunt c. 1859

Après la chasse

Oil on canvas, 93 x 73 1/2 in. (236.2 x 186 cm)
Signed, lower left: "G. Courbet"
Literature: Fernier 1977, I, no. 342; Metropolitan Museum of Art, *Catalogue of French Paintings*, vol. II, 1966, p. 117.

New York, The Metropolitan Museum of Art, Bequest of Mrs. H. O. Havemeyer, 1929, H. O. Havemeyer Collection
Exhibited in Brooklyn only

In her memoir Louisine Havemeyer recalls how pleased she was to acquire one of "Courbet's two large hunting scenes" (*Sixteen to Sixty: Memoirs of a Collector*, 1961, p. 194). She was thinking of the *Quarry* (pl. VI), a painting which had been in Boston since 1866; presumably she did not know *The Hunt Breakfast* (pl. VII), now in Cologne. *After the Hunt* has links with both. Like the Boston painting it is vertical in format, a forest interior dominated by a standing figure leaning against a tree, while animals are the focus of the lower half of the composition. Also like the *Quarry*, it is far from being a literal description of an aspect of the hunt. Both paintings combine a profound painterly realism, especially in the depiction of animals, with a remoteness from narrative verism. The collection of game in *After the Hunt* is as "unreal" in such a setting as any formal, emblematic game picture by Desportes or Oudry; it is, in fact, more fantastic, in that the earlier artists would have decorously combined no more than two kinds of game of a

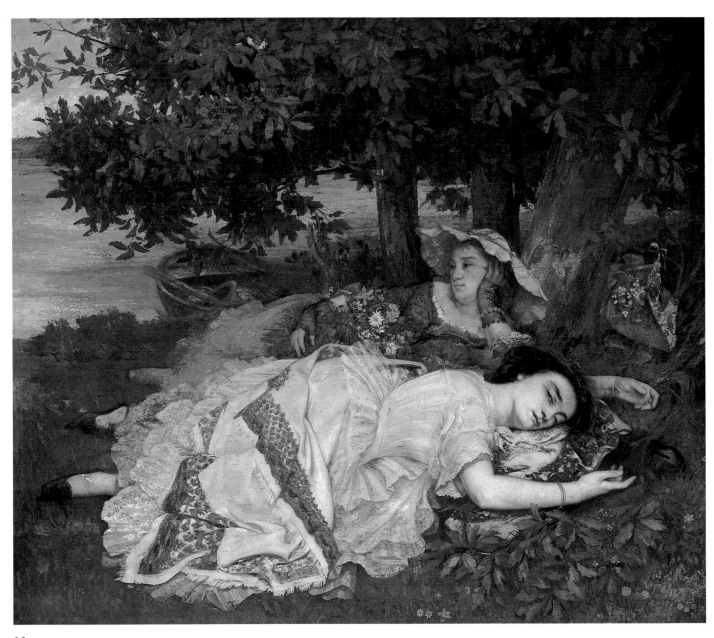

32

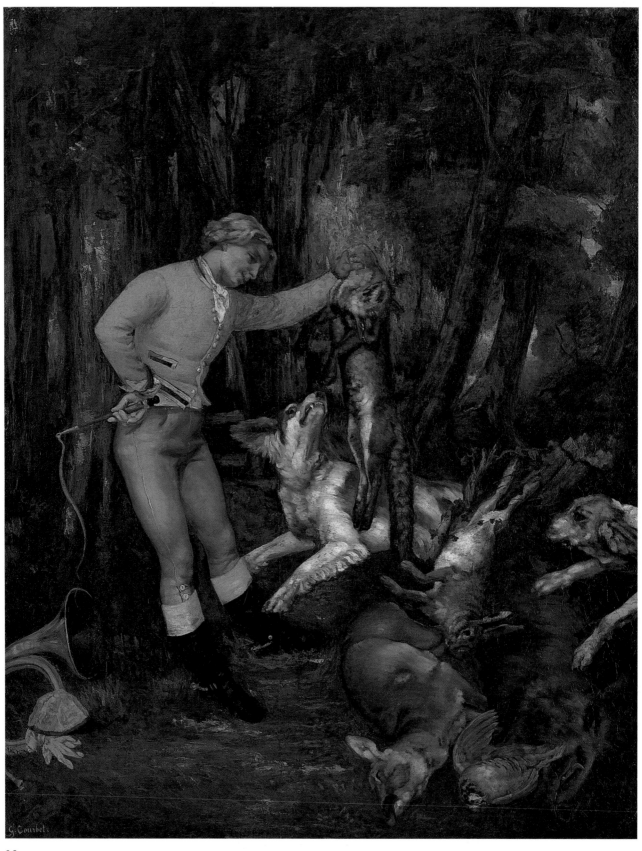

33

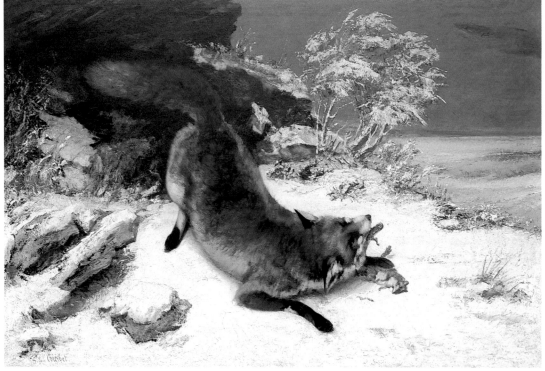

34

similar scale, while here the great boar and deer are to-gether with a partridge, hare, and fox. The promiscuous profusion is like that of a Frans Snyders fish stall, but the Flemish picture has the plausibility of a market scene, whereas such mixing of quarries on a single hunt is out of the question. Thus the painting becomes an-other meditation on the hunt, like the *Quarry* but less introspective, perhaps more ambivalent.

A similar heap of mixed game is found in the *Hunt Breakfast*—equally incongruous, but here playing a dif-ferent role. In *After the Hunt* one is permitted to experi-ence these beautiful animals in terms of loss; in the Cologne painting, they contribute to an image of fulfill-ment and earthly abundance. Another link between the two paintings is their color, the brilliant reds and yellows set against the forest greens in strong shapes of flat local color that call to mind late medieval painting. The fig-ure of the *valet de chasse* in *After the Hunt* seems drawn from the same world as that of the standing huntsman to the right of the *Breakfast*. For these reasons it seems more than likely that the New York painting was made sometime during or in the aftermath of Courbet's so-journ in Frankfort in 1858–59. By January 1863 it was owned by Etienne Baudry, because it was shown in the big exhibition at Saintes as belonging to the artist's host (no. 73 in the Saintes catalogue; see Bonniot 1973, pl.

55). Thus Fernier's date of 1863 for the painting is un-tenable; also incorrect is his listing of its first owner as Phoedora Gaudin, Baudry's friend. Since Baudry had become a patron of Courbet before the invitation to Saintes in May 1862, it seems logical to suppose that he had brought *After the Hunt* out of the Paris studio some-time before the visit and had been willing to lend it both to the Saintes exhibition and to the exhibition in Bor-deaux at the Société des Amis des Arts in April 1863 (Bonniot 1973, p. 273). S.F.

34. Fox in the Snow 1860

Le Renard dans la neige

Oil on canvas, 33 1/2 x 50 in. (85 x 127 cm)
Signed, lower left: *Gustave Courbet*
Literature: Fernier 1977, I, no. 263; Riat 1906, p. 188; Léger 1929, p. 82.

Dallas Museum of Art, Foundation for the Arts Collection, Mrs. John B. O'Hara Fund

Exhibited in the Salon of 1861, *Fox in the Snow* was purchased by the *Commission de la loterie* and included among the works for sale in the state-run annual benefit lottery. It was subsequently purchased by Khalil Bey.

Writing about a similar subject painted by Courbet shown in the Salon of 1857, the critic Edmond About had this to say: "He seizes nature like a glutton; he snaps up great chunks and swallows them unchewed with the appetite of an ostrich . . ." (*Salon de 1857*, Paris 1858). Surely this seems an apposite commentary with respect to the gusto and éclat with which Courbet painted the fox in the act of energetically consuming a small rodent. The dynamic curve of the fox's body with its raised rear and luxuriant brush and the wholly convincing portrayal of a predator eating not only reflect the keen observation Courbet brought to bear on his animal subjects, but also suggest the physical pleasure Courbet took in painting them. It is interesting, in this respect, to compare the playful white cat between the little boy and the artist in the *Painter's Studio.* Substitute convex for concave lines and it is virtually the same action and pose, but as true to the feline as it is to the feral. Courbet's empathy for the animals he painted extended equally to the predators and to their prey. Endlessly satirized for his "animal" appetites, these were in fact an inseparable component of Courbet's art. And although Courbet was not above anthropomorphizing his beasts from time to time (as, for example, in *Stag Taking to the Water*), his most powerful and convincing images of animals are predicated on the huntsman's unsentimental respect for and attentiveness to the natural world. A.S.-G.

35. Stag Taking to the Water, *or* The End of the Run 1861

Le Cerf à l'eau, ou *Chasse à courre*

Oil on canvas, 86 5/8 x 108 1/4 in. (220 x 275 cm)
Signed and dated, lower right: *Gustave Courbet* 61
Literature: Fernier 1977, I, no. 277; Riat 1906, p. 188; Léger 1929, p. 82, Philadelphia 1959, no. 35; Paris 1977, no. 62.

Marseille, Musée des Beaux-Arts

Hélène Toussaint has justly described this large painting as representing "one of the last great romantic pages of French painting" (Paris 1977, p. 155). Begun in Frankfurt in 1858, it was completed in Paris and exhibited in the Salon of 1861 along with the even more heroically scaled *Fighting Stags.* In a letter to Francis Wey, Courbet described a hunt he had participated in at Rambouillet during which the stag had been pursued during a five-week period. He also elaborated on the effects he had attempted with the landscape and the evening light. Finally, he indicated that "the [stag's] head must please the English, recalling the sentiment of Landseer's animals." Sir Edwin Landseer (1802–73), it should be remembered, was not only the most famous and popular painter of animals of his time, but had been the great favorite of the Exposition Universelle. Courbet may well have been competing with Landseer's enormous success with anthropomorphized animals, insofar as the stag has been endowed with a degree of pathos, not to say anguish, that Courbet typically eschewed in his representations of the hunt. Linda Nochlin (1967), moreover, has demonstrated the probable source of the image in an engraving after Landseer published in *Le Magasin pittoresque* in 1851.

Springing from a deserted and somber landscape beneath a cloudy, darkening sky, its head illuminated by the last rays of the setting sun, the stag looks heavenward, open-mouthed and desperate. The drama of the painting—and its implied narrative—was enthusiastically glossed by Zacharie Astruc: ". . . this stag, this beautiful epic stag, of life size, has just crossed a deserted terrain . . . he is magnificent! What élan! What fever! How he interests us, this beautiful animal [*ainsi jeté comme éperdu*] and vaguely terrified, in this solitary expanse!" (Fernier 1977).

Both *Stag Taking to the Water* and *Fighting Stags* were well received; the former was purchased by the city of Marseille for 3,000 francs. A.S.-G.

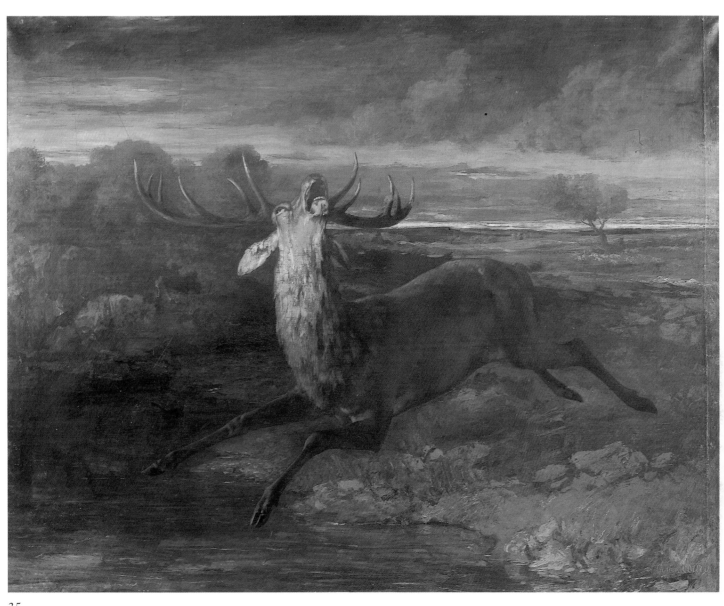

35

36

36. The Fringe of the Forest 1862(?)

L'Orée de la forêt

Oil on canvas, 34 1/2 x 45 3/8 in. (87.6 x 115.2 cm)
Signed, lower left: *G. Courbet*
Literature: Fernier 1977, I, no. 194; Philadelphia 1959, no. 23; Cooper 1960, p. 245.

Philadelphia Museum of Art, The Louis E. Stern Collection

It is difficult to ascribe a date to this work or to ascertain the locale depicted. Douglas Cooper, on the basis of a stylistic comparison with the Boston *Forest Pool* (cat. 37) and other works of the early 1860s, proposed that it was painted in 1862 and represents a scene in the Saintonge (1960, p. 245). However, the massive trees and hilly, uneven terrain strewn with boulders and clothed with undergrowth have little in common with the slender elms and dappled glades that are features of many of Courbet's Saintonge paintings and seem more characteristic of the forest of Fontainebleau. Compare, for example, Corot's *Rocks in the Forest of Fontainebleau* (1860–65; Washington, D.C., National Gallery of Art, Chester Dale Collection), or other paintings by Courbet said to be of the forest, notably *Forest of Fontainebleau* (Copenhagen, Ny Carlsberg Glyptotek), which resembles the present work. Courbet made several trips to Fontainebleau during his career and this painting could well be contemporaneous with the Copenhagen picture and date from the late 1850s (see Haavard Rostrup, "Trois Tableaux de Courbet," in *From the Collection of the Ny Carlsberg Glyptotek*, 1931, p. 114).

In this kind of landscape Courbet breaks with all the traditional notions of landscape painting that had prevailed since the seventeenth century. Any idea of an overall scheme, of an eloquent ordering of different parts of the composition and a harmonious balancing of light and shade—conventions Courbet had often adopted in his earlier landscapes—is here willfully disregarded. There is no sense of atmospheric depth, and the tangle of trees and undergrowth deny the viewer any feeling of being able to enter the landscape and move freely back into distant space. Indeed, the viewer's penetration is instantly occluded by the screen of trees and the steeply rising ground. Courbet is reputed to have remarked to Corot that the exact spot he chose to depict in a landscape was irrelevant to him (Mack 1951, p. 68), and here we have the sense that rather than selecting a particular vantage point, he has set up his easel on a random spot and painted the uncomposed patch of nature that immediately confronted him. As he does so frequently with his figure subjects, Courbet has posi-

tioned himself very close to his motif, heightening our sense of the tactile substances within the landscape. Using an autumnal or late summer palette of greens and russet browns boldy and loosely applied with the brush and palette knife, Courbet has distributed particles of color over the canvas in a manner that does not always coincide with the forms of objects, but creates a dense fabric of leaves, earth, and rock, yet without—at least in the background hillside—emphasizing their different textures. This overall application of color and texture together with the arbitrary vision implied in the composition anticipates the approach to landscape that the Impressionists were to pursue a decade later. To some contemporary critics it signified ineptitude: Maxime Du Camp, reviewing Courbet's work in the 1857 Salon, noted, "He does not know how to select, nor to compose, nor to interpret" ("Il ne sait ni chercher, ni composer, ni interpréter"; *Le Salon de 1857* [Paris, 1857]). At the same time, others saw these unstructured landscapes as simple and therefore undemanding: the viewer could absorb their *effet*, the restorative sensation they emanate (Wagner, 1981, p. 426). Recently, Herding has interpreted these "uncomposed" landscapes as a challenge to social as well as artistic values, their lack of structure functioning as a metaphor for the breakdown of social order (Herding 1977, p. 160).

The Fringe of the Forest conveys an almost sinister feeling of congested growth, and its claustrophobic atmosphere is only partially relieved by the small area of blue sky at the upper left. The powerful interlocking forms of rocks and tree trunks in this airless forest interior prefigure some of Cézanne's *sous-bois*, those painted at the Château Noir, for instance, or a work such as *Rocks in the Forest* (New York, The Metropolitan Museum of Art), painted in the 1890s, which may also represent a view of the forest of Fontainebleau. A.D.

Gustave Courbet. *Undergrowth at Port-Berteau: Children Dancing*, 1862. Oil on canvas. Cambridge, England, Fitzwilliam Museum.

Camille Corot (1796–1875). *Corner of the Park at Port-Berteau*, 1862. Oil on canvas. Belgrade, National Museum of Belgrade.

37. Forest Pool 1862

Ruisseau dans la forêt

Oil on canvas, 61 7/8 x 44 7/8 in. (157 x 114 cm)
Signed, lower left: *G. Courbet*
Literature: Fernier 1977, II, no. 637; Leger 1929, pl. 52; Philadelphia 1959, no. 68; Cooper 1960, p. 245; *Bulletin* 1961, no. 27, p. 4.

Boston, Museum of Fine Arts, Gift of Mrs. Samuel Parkman Oliver

Courbet probably painted this peaceful forest scene during his stay in the Saintonge in 1862 when he was the guest of Etienne Baudry, who was the painting's first owner. Although Fernier dates the work c. 1868, Douglas Cooper, on aesthetic grounds, judges it a Saintonge painting of 1862 (1960, p. 245). Furthermore, this may be the painting that was exhibited as *Interieur de Forêt* twice in 1863, at Saintes in January and at Bordeaux in April, by the Société des Amis des Arts (Bonniot 1977, p. 273, pl. 55). Moreover, the moist atmosphere, verdant terrain and slender elm trees together with the bright palette of fresh greens and tawny yellows are consistent with Courbet's other views of the Saintonge region.

Forest Pool is closely related to another work Courbet painted in the Saintonge, *Undergrowth at Port-Berteau: Children Dancing* (Cambridge, England Fitzwilliam Museum; above left), a painting that is almost identical in subject to Corot's *Coin du Parc à Port-Berteau*, 1862 (Belgrade Museum; below left). Corot was Baudry's guest for about twelve days in August 1862, and during this time the two artists sometimes worked side by side from the same motif. Both of Courbet's paintings display the vertical format, tall graceful trees, and dappled light found in a number of Corot's works of around this date, but in *Forest Pool* he has animated his woodland glade not with the groups of dancing nymphs so favored by Corot, but with a single deer that glances up as if startled by an unexpected sound. The inclusion of this kind of detail was popular with Courbet's patrons, and it is probable that *Forest Pool*, the largest and most finished of his Saintonge landscapes, was painted with the market in mind, especially since he informed his dealer Luquet that he planned to deliver thirty-three canvases painted in the Saintonge and offered advice on how best to sell them (Wagner 1981, p. 415). A.D.

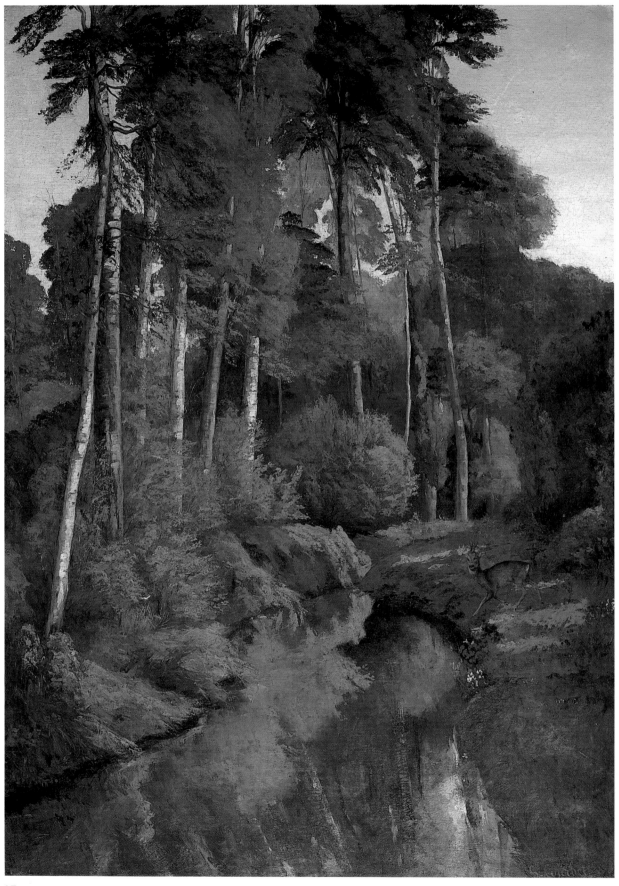

37

38

and the Spanish masters whose works he had studied. These are manifest in the animation of the dark surfaces by the éclat of the brushwork (note particularly the painting of the folds in the black satin sleeves) and the dazzle of the whites. And, in a characteristically bold gesture, Courbet has modeled the face with an audacious shadowed line that runs from the left eyebrow, along the length of the nose, and culminates at the chin. A.S.-G.

38. Portrait of Mme. Robin, *called* The Grandmother 1862

Portrait of Mme. Robin, dit *La Grand-mère*

Oil on canvas, 36 x 28 3/4 in. (91.4 x 73 cm)
Signed and dated, lower left: *62 G. Courbet*
Literature: Fernier 1977, I, no. 297; Philadelphia 1959, no. 37; Paris 1977, no. 63; Bonniot 1973, p. 214; Callen 1980, p. 80, no. 48.

The Minneapolis Institute of Arts, The William Hood Dunwoody Fund

Although it was previously thought to have been painted during his stay in the Saintonge (Philadelphia 1959), Roger Bonniot conclusively determined that the portrait had, in fact, been painted in Paris in repayment of a loan made to Courbet by the sitter's son, Gustave Robin. Courbet has here worked within a rigorously delimited range of dark colors, the rich blacks of Mme. Robin's gown and the deep background browns predominating. These somber tones are enlivened by the sparkle of the white lace collar, the embroidered white undersleeves, and the pale olive skin of the sitter. The crimson flower in Mme. Robin's dark hair is the one highly keyed color accent. In this restrained and dignified portrait, Courbet displays his formal assimilation of the lessons of Hals

39. Portrait of Gabrielle Borreau 1862

La Rêverie

Oil on paper mounted on canvas, 25 7/8 x 30 1/4 in. (63 x 77 cm)
Signed and dated, lower left: *G. Courbet 62*
Literature: Fernier 1977, I, no. 334; Léger 1929, p. 95; Rome 1969, no. 17; Bonniot 1973, p. 216; Paris 1977, no. 67; Hamburg 1978, no. 242.

The Art Institute of Chicago, The Winterbotham Collection

Courbet's sojourn in the Saintonge, which lasted (with two brief interruptions) from May 1862 until April 1863, was a highly productive period for him, significant, among other things, for the appearance of a new subject—flowers—in his work. (His first host, Etienne Baudry, was an accomplished amateur botanist, whose estate included greenhouses and elaborate gardens.) During his stay in the Saintonge, Courbet became attached to Mme. Laure Borreau, the wife of a local merchant whose portrait he painted on three occasions, and with whom he stayed on his last visit from January to April 1862. This portrait, traditionally identified as being of Mme. Borreau, was identified by Roger Bonniot as a portrait of her daughter, then fourteen years old (1973, pp. 209–16, pl. 51).

This confusion of sitters is easily understandable. A comparison of the portrait of Gabrielle with the portrait of her mother entitled *Woman in a Black Hat* (cat. 40) shows at once the striking similarities. The principal difference lies in the greater fleshiness of the mother, but the shapes of their faces and their individual features are remarkably similar. Furthermore, despite the fact that the portrait of Gabrielle has a horizontal format, and the portrait of Mme. Borreau a vertical one, the formal organization of each is the same. Thus, both women are portrayed from the waist up, with the right hand included, an undifferentiated mass of dark foliage comprising the left-hand part of the canvas, and the right-hand part given to an open vista dominated by the sky. The colors of the portrait are quite vivid. At the

39

horizon, the sky is painted in tones of vivid scarlet and orange that modulate into alternate areas of mauve, coral, and violet. The intensity of color in the sky is offset by the scumbled dark area of the tree trunk and surrounding foliage and the more neutral tones of the beige dress trimmed in black. This is Courbet at his most Titianesque.

Despite the "literary" title given by Courbet—*La Rêverie*—the portrait of Gabrielle Borreau does not suggest a logical placement with the paintings of Courbet that depict unconscious or semiconscious psychic states. Courbet's portraits, for the most part, are not psychologically probing or especially allusive, as are, for example, those of Degas. Courbet is rarely interested in the way the interior life of the subject may be expressed and conveyed in the portrait. "Reverie" is here signified only by the hand supporting the head and the vague, unspecific landscape in the background. Recent X-rays reveal a portrait of a man, turned sidewise, beneath the upper design of the painting.

Courbet displayed the painting in his 1863 exhibition in Saintes. Its first owner was Théodore Duret, a cousin of Baudry, who later credited his interest in art to his meetings with Courbet during the stay in Saintonge (Bonniot 1973, p. 48). A.S.-G.

40. Portrait of Mme. Laure Borreau, Woman in a Black Hat 1863

Portrait de Mme. Laure Borreau, La dame au chapeau noir

Oil on canvas, 32 x 23 1/4 in. (81 x 59 cm)
Signed and dated, lower right: *63 Gustave Courbet*
Literature: Fernier 1977, I, no. 358; Riat 1906, pp. 206, 214; Leger 1929, p. 95; Philadelphia 1959, no. 40; Ann Tzeutscher Lurie, "Mme. Laure Borreau," *Cleveland Museum of Art Bulletin* 49:4 (April 1962): 66–71; Bonniot 1973, p. 124; Paris 1977, no. 68.

The Cleveland Museum of Art, Purchase, Leonard C. Hanna, Jr., Bequest

Of the three portraits Courbet painted of Mme. Laure Borreau, this one was submitted and exhibited in the Salon of 1863. As with the portrait of Mme. Borreau's daughter Gabrielle, the painting follows a prototype developed in the Renaissance, consisting of a pyramidal composition formed by sitter in the foreground and a vista into a distant landscape in the background. The great beauty of this portrait has much to do with its rich and opulent contrasts of color: the shimmering black of Mme. Borreau's gown, the creamy tint of her skin, and the Venetian-like hues of the sunset sky—yellow

40

41. The Trellis, *or* Young Woman Arranging Flowers 1862

Le Trellis, ou *Jeune fille arrangeant des fleurs*

Oil on canvas, 43 1/4 x 53 1/4 in. (110 x 135 cm)
Signed, lower left: *G. Courbet*
Literature: Fernier 1977, I, no. 357; Riat 1906, pp. 200, 336;
Philadelphia 1959, no. 39; Bonniot 1973, pp. 86–87, no. 18; *The Toledo
Museum of Art, European Paintings,* Toledo 1976, p. 42; Paris 1977, no. 70.

The Toledo Museum of Art, Gift of Edward Drummond Libbey

Courbet initially went to the Saintonge at the invitation of Etienne Baudry, a young collector and man of letters who had been introduced to Courbet's work by his friend, also from Saintonge, the critic Jules Castagnary. Baudry's estate, Rochement, was filled with gardens; Courbet responded to the enthusiasm of his new patron for flowers, as well as to the flowers themselves, by painting a series of flower compositions. This opulent and brilliantly colored canvas is generally considered to be the masterpiece among them.

Characteristically, in choosing a genre ranked low in the conventional hierarchy of subjects, Courbet effected his own formal transformation. Most strikingly, in combining the spilling effusion of flowers with a female figure, he reversed the order of prominence one would typically expect. Thus, almost three-quarters of the canvas is given to the mass of summer flowers, while the young girl is posed on the side, formally overwhelmed by the floral profusion. (The relationship of this asymmetrical composition to that of Degas's *Woman with Chrysanthemums* at the Metropolitan Museum has frequently been noted.) Although it is true that two of the flower paintings done in Saintonge—*Poppies in a Skull* and *Soucis in a Vase*—were specifically made as "moral allegories" for one of Baudry's friends with an interest in mysticism (Bonniot 1973, p. 85), there is no reason to assume that all of Courbet's flower paintings had this origin (for one thing, the two paintings cited are unique in having inscriptions on the reverse). It is evident in the *Trellis* that the artist is responding visually and sensually to his subject, with the kind of appetite for the actual that was shared by his younger colleagues of this decade—Manet, Monet, and Bazille. The painting was exhibited in Saintes in 1863 with the title *Femme aux fleurs* (Toledo 1976). S.F. and A.S.-G.

ochres, mauves, and a gray violet. The golden strip of sky at the horizon is echoed by Mme. Borreau's yellow glove; the bouquet of flowers in tones of white, coral, blue, and lavender either complements or reiterates colored areas elsewhere in the canvas. The presence of the bouquet reminds us of Courbet's intense involvement with the painting of flowers during his time in Saintonge (see cats. 41–43).

The somewhat distorted placement of Mme. Borreau's left eye provided grist for caricature, as in one by Cham, who depicted the model as wall-eyed. The caption reads: "This is what M. Courbet knows to do with a pretty woman, for we can bet that the woman who posed for this portrait is very pretty" (cited in Cleveland 1962, p. 69). A.S.-G.

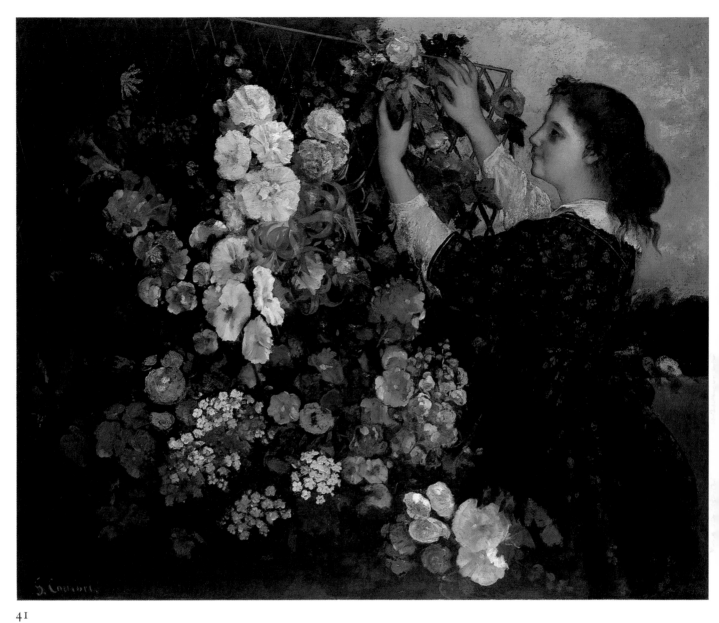

41

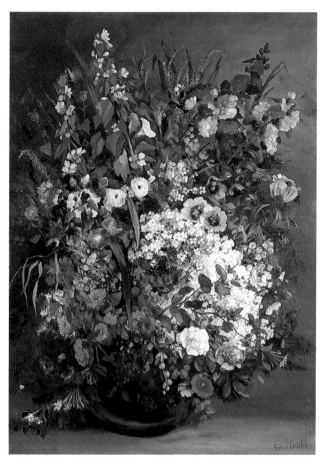

42

42. Bouquet of Flowers in a Vase 1862

Bouquet de fleurs dans un vase

Oil on canvas, 39 1/2 x 28 3/4 in. (100.5 x 73 cm)
Signed and dated, lower right: *'62 Gustave Courbet*
Literature: Fernier I, 1977, no. 302; Bonniot, "Un Tableau de fleurs inédit de Gustave Courbet," *Bulletin de la Société de l'Histoire de l'Art Français*, 2 March, 1957, pp. 77–87; Bonniot 1973, p. 230, pl. 13.

Malibu, The J. Paul Getty Museum

Included in Courbet's series of floral still lifes painted in the Saintonge region in 1862–63 is this beautiful and luxuriant display of mixed blossoms in a round, shallow, and luminous dark vase. As in almost all of these coloristically and plastically rich compositions, the subject's natural beauty, with its recollection of the out-of-doors and its association with pleasurable physical sensations, is immediately appealing. Courbet's formal decisions are calculated to reinforce and expand these aspects of the motif: the sensory delight of colors, fragrances, and textures available in nature are evoked in a faithful description of the forms and material qualities of the bou-

quet, and they are transcribed in painterly equivalents that are independently sensuous, stimulating, and consciously designed to conjoin nature and art.

The choice of a vertical, as opposed to the more usual horizontal, format encourages the upward and outward stretch of organic forms in a simulation of natural growth; nature's multiplicity, spontaneity, and predominance have their analogues in the casual, asymmetrical, and seemingly accidental arrangement of leaves and flowers that overflow their smooth, geometric, and manufactured container. Moreover, the ambiguous character of the gray-green background sets the bouquet in an oddly undefined context, midway between the indoors and the outdoors, and between nature and art: on the right the surroundings register as an atmospheric space illuminated by a light source in the upper corner, and, as the eye moves laterally leftward, they deepen in tone and take on the character of the dark interiors of Dutch and other traditional still lifes. Nor is there the slightest hint of a break in the longitudinal axis of the spatial plane to distinguish the foreground support for the vase from the areas behind it.

This composition, along with at least one other floral piece of 1862, *Flowers on a Bench* (Fernier 1977, I, no. 304), was painted for Frédric Mestreau, a landowner and member of the circle of liberal and left-wing Republicans around Saintes, who became the prefect of Charente-Inférieure after the defeat of Napoleon III (Bonniot 1973, p. 46, pl. 13). The work appeared in the exhibition of paintings and sculptures organized in Saintes in January 1863 for the benefit of the needy. R.B.

43. Flowers in a Basket 1863

Fleurs dans un panier

Oil on canvas, 29 1/2 x 39 3/8 in. (75 x 100 cm)
Signed and dated, lower left: . . . *63 Gustave Courbet*
Literature: Fernier 1977, I, no. 366; Philadelphia 1959, no. 41; Bonniot 1973, passim; Paris 1977, no. 69.

Glasgow Art Gallery and Museum

The graceful design and lively interplay of shapes and colors in *Flowers in a Basket* have earned it a reputation as one of Courbet's most beautiful floral pieces of the Saintonge period (Paris 1977; Hamburg 1978, p. 257). The still life was the often chosen gift of friendship and expression of communality among nineteenth-century painters. It admitted into the pictorial field recollections of tastes, smells, sights, and textures available in abun-

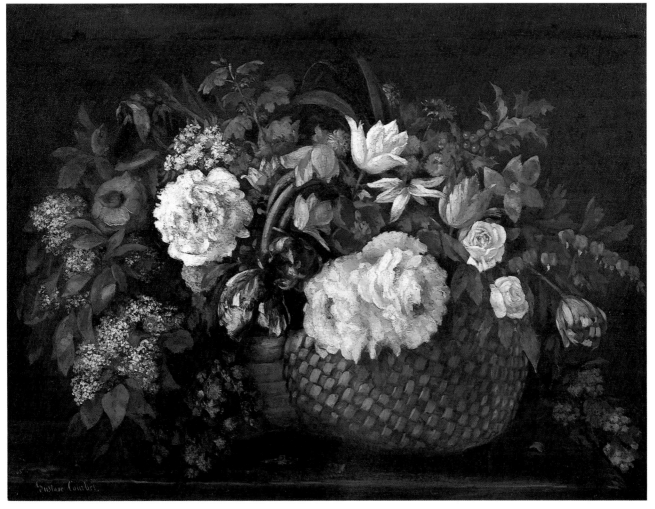

43

dance in nature and usually shared during moments of conviviality and celebration; it also offered opportunities to indulge the painter's affinities for, and professional concerns with, the abstract arrangement of color, pattern, and ornament. This picture, along with a number of similar compositions, was executed in that same spirit of confraternity and appreciation.

It was undoubtedly Etienne Baudry's love of gardens and the hospitality that he extended to his guest that prompted the artist to address himself more regularly to flower compositions now than at any other time in his career. The sumptuousness and unusual number of floral compositions during this period suggest a playful appreciation of sensuous pleasures and an easy engagement with traditional prototypes. The close focus of *Flowers in a Basket*, its multiplicity of forms and brilliant color intensified against a simple dark ground and sup-

porting surface, correspond to seventeenth-century Dutch precedents with which Courbet would have been familiar.

Effulgent, evenly lit, and captivating in their individuality, immediacy, and plastic definition, the blossoms are gathered loosely into a rhythmic arabesque across the breadth and height of the canvas. Particularly striking are the strong textural contrasts: the subtle opposition of the woven and smooth sides of what may be two separate baskets; the creamy softness of peonies relieved against the sharp edges of leaves and branches; the hardness of the light reflecting table surface set off from the matte void of the background. The individual parts and textures are markedly distinct and evocative, serving as both substance and ornament and combining nature with artifice. R.B.

44. The Oak at Flagey, *known as* The Oak of Vercingetorix 1864

La Chêne de Flagey, appelé *chêne de Vercingétorix*

Oil on canvas, 35 x 43 3/8 in. (89 x 110 cm)
Signed and dated, lower left: . . . *64 G. Courbet*
Literature: Fernier 1977, I, no. 417; Riat 1906, p. 253; Léger 1929, p. 126; Philadelphia 1959, no. 44; Nochlin 1963, p. 24; Nochlin 1967, p. 213; Lindsay 1973, p. 200; Herding 1975, p. 176; Paris 1977, no. 76; Hamburg 1978, no. 271; New York, "Nineteenth Century French Paintings," Whitney-Wheelock 1986, no. 21.

Tokyo, Murauchi Art Museum

The Oak at Flagey is a remarkable portrait of a remarkable tree. In no other tree painting of the nineteenth century does the indomitable quality of the oak, its sense of firm rootedness in the earth, its expansive upward and outward branching, receive such forceful treatment. The oak's massive permanence is further emphasized by the motif of the dog pursuing a hare, one on each side of the tree. Tiny harbingers of instantaneity, they emphasize the oak's endurance by suggesting its opposite: ephemeral passage.

The oak tree is deeply rooted in European religious and political practice. It was the sacred tree of the Druids as well as the tree associated with Zeus or Jupiter in classical mythology; it was also the tree that commemorated the civic rights and political self-determination of specific countries, regions, or provinces, for example, the famous oak of Guernica, venerated as the emblem of the independent government of the Basque people. In addition, Courbet may have associated his oak painting with a more recent political referent: the image of the Tree of Liberty, which had been a prominent icon of the ideals of the 1848 Revolution, as well as a vivid reminiscence of the first French Revolution.

The title *Oak at Flagey*, however, indicates a more specific regional reference, affirming local values and a kind of provincial pride. Illustrated articles dedicated to the promotion of well-known regional trees had appeared in popular journals of the period, and it is certainly possible that Courbet was aware of illustrations like that of the *Chêne gigantesque de Montravail* that had appeared in the *Magasin pittoresque* in 1850 (Nochlin 1967, p. 213). Indeed, the complete subtitle of the work, ". . . known as the oak of Vercingétorix, Caesar's Camp near Alesia, Franche-Comté," suggests that the oak played a role in a heated archaeological dispute of the mid-nineteenth century over the precise location of the historic plateau that had served as the battleground for Caesar's defeat of the Gallic chieftain, Vercingétorix, in

the Battle of Alesia in B.C. 52. The choice was between Alaise, near Flagey, where Courbet's family owned property, or the Mont Auxois, near Alise-Ste.-Reine in the Côte d'Or. The latter location finally won out, owing in part to the influence of the emperor himself, who, in the second volume of his *Histoire de Jules César*, published in May 1866, fully substantiated the authenticity of the site in the Côte d'Or with overwhelming archaeological evidence and documentation.

The oak tree seems to have had deep personal meaning for Courbet. A dominating oak had appeared at least four times in Courbet's oeuvre before reaching its apotheosis in the *Oak at Flagey*, at least once, in *Le Gros Chêne* of 1843–44, in a context suggesting romance and emotional attachment. In many of Courbet's early representations of himself, he had shown himself embedded in nature. In these youthful works, the landscape setting functions as a kind of natural foil for the narcissism of the young artist. In a mature work like the *Painter's Studio*, however, it is landscape as the object of the artist that is at issue: the artist identifies his mission with the painting of landscape, just as he identifies himself with the terrain of his native province.

In the *Oak at Flagey* he has gone one step farther. There is a sense in which this tree is a kind of self-portrait, a portrait of the artist as an old oak tree, rooted firmly in the ground: energetic, powerful, if twisted in his body, outreaching and expansive in his creation. Nature and artist, landscape and art, seem to have assumed a single identity here. Later, pathetically, they separate, after the ordeal following Courbet's participation in the Commune. Then, when he painted himself in prison (see cat. 87), it is a tree, poised wistfully between two window bars, outside in the courtyard of Ste.-Pélagie, that offers an alternative to, rather than identity with, the figure of the incarcerated artist. As a reminder of nature and liberty, the little tree offers a poignant contrast with the artist in his dark reclusion. But here, in the *Oak at Flagey*, in 1864, tree and artist, identity and creation, art and politics are, however briefly, united. L.N.

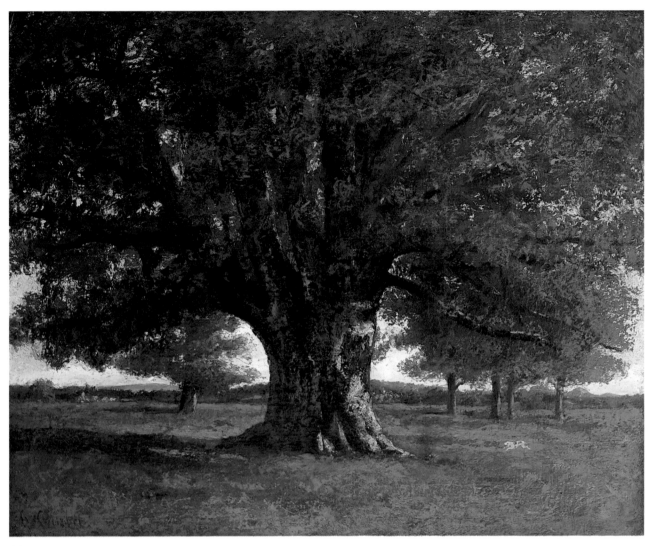

44

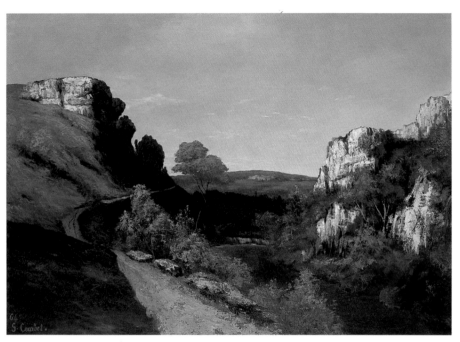

45

45. Landscape near Ornans 1864

Paysage des environs d'Ornans

Oil on canvas, 35 x 50 1/2 in. (88.8 x 127.2 cm)
Signed and dated, lower left: *64/G. Courbet*
Literature: Fernier, 1977, I, no. 412; *The Toledo Museum of Art, European Paintings*, Toledo, 1976, p. 43.

The Toledo Museum of Art, Gift of Edward Drummond Libbey

This is one of the many landscapes Courbet painted in 1864, a year spent mostly in his native Franche-Comté. Courbet often painted directly from the motif, but he sometimes amalgamated in a single composition different features of his native region, which, in reality, are not adjacent—in this case, the Loue River and the Roche du Mont, the cliff whose distinctive profile is visible in the distant right in *A Burial at Ornans*. Though the composition may be contrived, the sharp autumnal sky and crisp air have a freshness that suggests that the rendering of the light and atmosphere are the result of direct observation. The path winding along the base of the hill on the left pulls the spectator forcibly into the landscape, and the relationship between this assertive foreground and the distant hills establishes the spatial dynamic of the composition. The device of a steeply receding path was adopted by Pissarro, for example in the *Tow Path* (1864; Glasgow Art Gallery and Museum), and it is one that recurs frequently in his subsequent

landscapes, for instance in the *Climbing Path, L'Hermitage, Pontoise* (1875; The Brooklyn Museum, New York).

Related landscapes in which the left-hand part of the composition closely resembles *Landscape near Ornans* are in the Neue Pinakothek, Munich (Fernier 1977, I, no. 456) and in the Des Moines Art Center, Iowa (Fernier 1977, I, no. 459). A.D.

46. The Gour de Conche 1864

Le Gour de Conche

Oil on canvas, 27 5/8 x 23 5/8 in. (70 x 60 cm)
Signed and dated, lower left: *Gustave Courbet, 1864*
Literature: Fernier, 1977, I, no. 416; Riat, 1906, p. 219; Léger, 1929, pp. 103–04; Philadelphia 1959, no. 45; Paris 1977, no. 77; Montpellier 1985, no. 30.

Besançon, Musée des Beaux-Arts et d'Archéologie

Courbet spent most of 1864 in the Franche-Comté, staying for an extended time with his friend Max Buchon at Salins. The area abounds in natural curiosities and unusual rock formations of Jurassic origin, and these rocks, grottoes, and waterfalls provided the subjects for a number of the landscapes Courbet painted during this productive year. Some of these paintings were commissioned, including this view of the

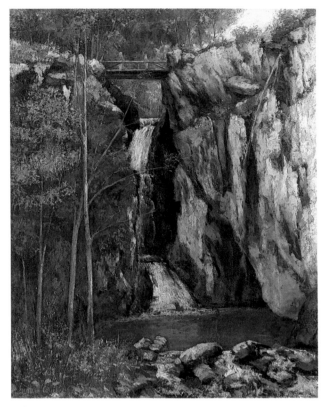

46

have been eroded by the weather and rain, which have formed long seams from top to bottom" ("Faîtes donc avec un pinceau des rochers comme cela que le temps et la pluie ont rouillés par de grandes veines du haut en bas"; Courthion 1948–50, I, p. 200). A.D.

47. The Source of the Loue 1864

La Source de la Loue

Oil on canvas, 42 1/4 x 54 1/8 in. (107.3 x 137.5 cm)
Signed, lower left: *G. Courbet*
Literature: Fernier 1977, I, no. 109; Riat 1906, p. 85; Philadelphia 1959, no. 14; Adrian Bury, "Source of the Loue by Gustave Courbet," *The Buffalo Fine Arts Academy Albright Art Gallery Notes*, 23:2 (Summer 1960): 2–5; *Albright-Knox Art Gallery: Paintings and Sculptue from Antiquity to 1942*, 1979, p. 203.

Buffalo, New York: The Albright-Knox Art Gallery, George B. and Jenny R. Mathews Fund, 1959

Gour de Conche, a small stream that forms a spectacular waterfall as it cascades over three rock basins in a high, narrow gorge a few miles from Salins. Courbet painted it for Alfred Bouvet, a wealthy industrialist and onetime mayor of Salins. Bouvet admired Courbet's work and commissioned three other paintings from him: a portrait of his wife (Fernier 1977, I, no. 427), a portrait of his daughter Béatrice (Fernier 1977, I, no. 425), and another landscape, *Fort de Joux* (Fernier 1977, I, no. 419).

In order to heighten the picturesque aspects of the scene it seems that Courbet allowed himself considerable pictorial license. His friend Charles Toubin, who watched him at work on this painting, recounted in his *Souvenirs* how Courbet adjusted the position of the bridge and exaggerated the height and volume of the waterfall. When Toubin asked Courbet about the "realism" of the painting, he is reputed to have replied: "Oh that's nothing, just beauty spots. It doesn't happen often" ("Oh! . . . des riens, des grains de beauté; Cela n'arrive pas souvent"; Léger 1929, p. 104).

Despite the small scale of the *Gour de Conche*, Courbet has manipulated the palette knife with considerable energy, especially in building up the weathered and striated face of the rock. He once remarked on this technique: "Try a brush to do rocks like that, rocks that

Among the finest works that Courbet painted in 1864, a year he spent mostly in the Franche-Comté, are a number of paintings of a famous natural curiosity of the region, the source of the Loue. From his youth he had taken an interest in the geological formations of his native province. Several early sketchbooks, now in the Louvre, contain studies of grottoes and other places of geological interest in the region of Salins (see chapter 4, above), so it is not surprising that he should be especially drawn to this spectacular site where the Loue emerges as an abundant stream from its point of origin in the depths of an immense cave.

In a letter to his Paris dealer, Luquet, written in the spring of 1864, Courbet mentioned that he had completed four paintings of the source of the Loue, each about 1.40 m wide (Riat 1906, p. 217). In addition to the present work, the three versions that are approximately this size are in the National Gallery, Washington, D.C. (cat. 48), the Kunsthalle, Hamburg, and the Metropolitan Museum, New York. (The last version is painted from farther back and encompasses a wider view that includes water mills on the left.) Fernier's dating of the Buffalo painting to 1850 is thus incorrect. That Courbet should inform his dealer of these paintings suggests that he painted them with the market in mind. Yet, unlike his other, repeated renderings of well-known scenic views—the *Black Well* or *Chillon Castle*, for example—where he often seems to follow a formula, most of the paintings of the source of the Loue exude Courbet's deeply personal feeling for his native landscape. The sheer physical presence conveyed by this compelling image derives from the very close viewpoint

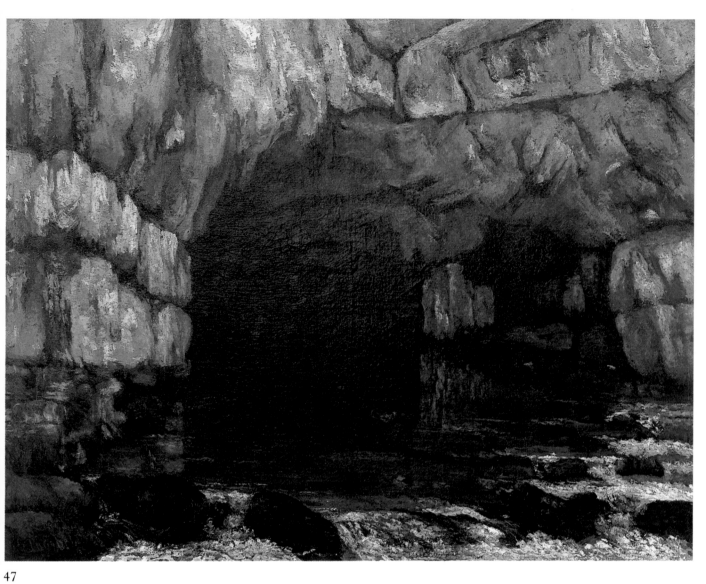

47

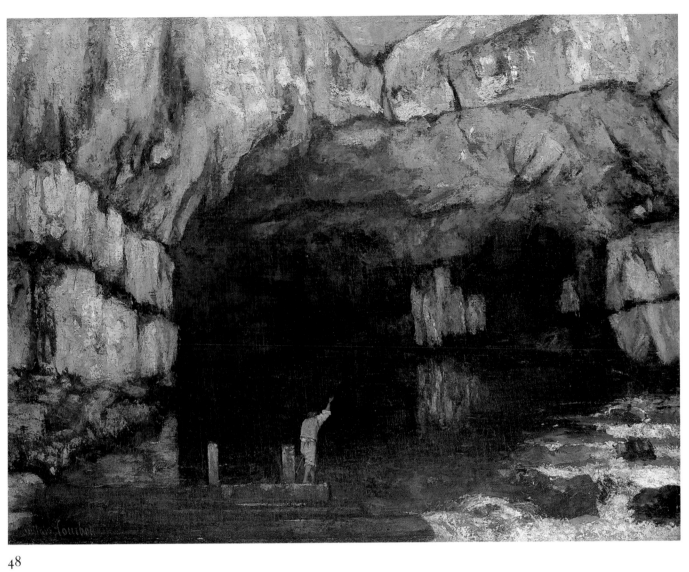

48

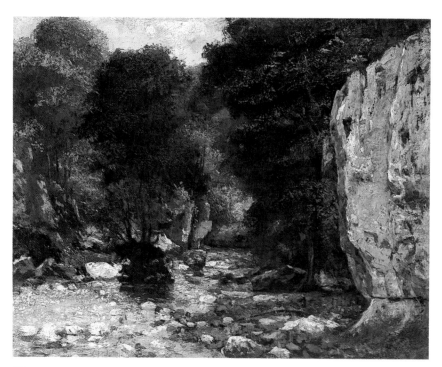

49

that Courbet has adopted; he must have set up his easel on the river bank as close as he could get to the yawning mouth of the cave. By excluding the sky and any suggestion of a landscape setting he allows the cave itself entirely to fill the painted surface, making the viewer feel that he could be sucked into its inky depths. The extraordinary materiality of these paintings, described by Linda Nochlin as "probably the most striking affirmation of the primacy of matter ever achieved by an artist" (Nochlin 1976, pp. 162–63), is heightened by the rich impasto and vigorous knife technique. Throughout the composition Courbet employs the palette knife to create a variety of textures: the glassy, smooth surface of the greenish water, or scumbled white paint for the foam that breaks over the facade of the cave. Yet, though the paint appears to have been rapidly applied with the knife, it has been done with considerable elegance, creating almost abstract formations within the paint surface.

Courbet's obsession with dark, enclosed places, evident in his many forest scenes, culminates in these paintings of the source of the Loue. Traditionally, the image of the cave suggests refuge and security, but here the dark, vaginalike opening also carries powerful sexual connotations. Werner Hofmann has speculated on the erotic associations evoked by caves in Courbet's art, comparing them to his most erotic painting, the *Origin of the World* (cat. 66). The conjunction of women and water is found frequently in Courbet's work—as early as 1844 in the *Sculptor* (New York, private collection), where the figure carved in the rock is a traditional allegorical image of the source of a river—and in the many paintings of bathers. It has been suggested that Courbet's earthy bather, called *La Source* (1868; Paris, Musée d'Orsay)—the only one, apart from another bather in the Metropolitan Museum of Art, New York, with the same title, to be graced with an allegorical title—was intended as an answer to the idealized water nymph in Ingres's *La Source* (1856; Paris, Musée du Louvre; see Paris 1977, p. 198). And, perhaps, in these assertively "real" views of an actual source, the source of the Loue, Courbet subverts in a subtle way the whole debased tradition of allegorizing, exemplified by Ingres's painting, and so prevalent in the official art of the Salon (verbal communication with Tom Wolf, Bard College).

This painting belonged to Matisse, who acquired it from the Georges Bernheim Gallery, Paris, in 1916. Matisse was a great admirer of Courbet's work and owned two other paintings by him, the *Blonde Woman Sleeping* and a large sketch for the *Young Ladies on the Banks of the Seine* (see Pierre Schneider, *Matisse* [New York, 1984], p. 503). A.D.

48. The Source of the Loue 1864

La Source de la Loue

Oil on canvas, 38 3/4 x 51 3/8 in. (98.4 x 130.4 cm)
Signed, lower left: *G. Courbet*
Literature: Fernier 1977, I, no. 393; Riat 1906, p. 330–31.

Washington, D.C., National Gallery of Art, Gift of Charles L. Lindemann

Among Courbet's documented paintings of the source of the Loue, this is one of the most imposing of his treatments of the subject. The viewpoint is the same as in the Buffalo painting (cat. 47), but in contrast to the somber browns and greens employed there, here Courbet uses a soft palette of grays, blue-grays, browns, and pinks that are enlivened by the sunlight that plays over the surface of the rocks.

The Washington *Source of the Loue* is the only one that contains a human presence, a solitary fisherman who stands on a pier projecting out into the water, his tiny figure dwarfed by the awesome magnitude of the cave. Though he seems to be spearing fish, the man's gesture also suggests a boatman ferrying his way across the water into the fathomless depths of the cave. Illuminated against the mysterious blackness of the cave interior, this figure resonates with a romantic, even a symbolist, suggestiveness that brings to mind later images such as Böcklin's *Island of the Dead* (1880; New York, Metropolitan Museum of Art), reminding us that Courbet's realism, expressed in his landscapes as the most concrete rendering of physical matter, can often coexist with a romantic sensibility. A.D.

49. The Stream of the Black Well 1865

Le Ruisseau du puits noir

Oil on canvas, 28 3/4 x 36 1/4 in. (73 x 92 cm)
Signed, lower right: *Gustave Courbet*
Literature: Fernier 1977, I, no. 467; Bern, Kunstmuseum, *Gustave Courbet*, 1962, no. 41; London, David Carritt Limited, *Corot and Courbet*, 1979, no. 21.

Zurich, Private Collection

This is one of the most beautiful of the many variants Courbet painted of this site near his native town of Ornans. Courbet's frequent portrayal of such places certainly contributed to the reputation of the Franche-Comté as a scenic part of France, and it can be seen in the context of the interest in regional topography that flourished in the nineteenth century. More luminous

and open than the Washington view of the subject (cat. 23), this work nevertheless displays Courbet's predilection for dark, enclosed places that is found, for instance, in his various paintings of the source of the Loue (cat. 47, 48). The vigorous facture is evidence of Courbet's increased use of the palette knife in the mid-1860s and is used here to great effect in emphasizing the physical substances of rocks and boulders. A.D.

50. Low Tide at Trouville 1865

Marée basse à Trouville

Oil on canvas, 23 1/2 x 28 5/8 in. (59.6 x 72.6 cm)
Signed, lower left: *G. Courbet*
Literature: Fernier 1977, I, no. 519; Paris 1977, no. 88.

Liverpool, The Walker Art Gallery
Exhibited in Brooklyn only

Low Tide at Trouville is one of a large group of seascapes that Courbet painted at Trouville on the Normandy coast in the summer and fall of 1865. Courbet had first seen the ocean when he visited Le Havre in 1841, and he wrote to his parents of the expansiveness of spirit that the experience produced in him: "We have at last seen the horizonless sea; how strange it is for a valley dweller. You feel as if you are carried away; you want to take and see the whole world" (Lindsay 1973, pp. 21–22). The Mediterranean had also made a tremendous impact on Courbet when he was staying with Alfred Bruyas in 1854, and in 1859 he had visited Honfleur. But it was at Trouville in 1865 that he painted his most sustained series of paintings of this relatively unusual motif in his work.

Courbet was exhilarated by the light and the ocean at Trouville. In a letter to Alfred Bruyas dated January 1866 he mentions that he had bathed eighty times the previous summer, and he refers to "twenty-five autumn skies—each one more extraordinary and free than the last" that he had painted (Montpellier 1985, p. 134). In response to this new subject, Courbet broke away from the academic method of working from dark to light that had characterized his earlier work and evolved a new manner of working in paler, more luminous colors, as Zola noted in his review of the 1868 Salon, although he found the seascapes too slight for Courbet's rigorous talent (Emile Zola, "Quelques Bonnes Toiles," *L'Evénement illustré*, June 9, 1868, in *Mon Salon, Manet, Ecrits sur Art* [Paris, 1970], p. 164). Where Courbet's Palavas paintings are filled with the brilliant, crystalline

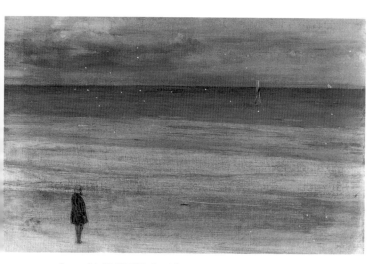

G. Randon. *Marine*, "Exposition Courbet," in *Le Journal amusant*, 1867.

James McNeill Whistler (1834–1903). *Harmony in Blue and Silver: Trouville*, 1865. Oil on canvas. Boston, Isabella Stewart Gardner Museum.

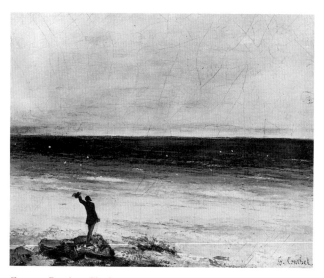

Gustave Courbet. *The Seaside at Palavas*, 1854. Oil on canvas. Montpellier, Musée Fabre.

light of the Mediterranean, the works painted at Trouville have the subtlest nuances of tone and a serenely poetic mood, which he distilled from the misty northern light of the Channel.

Low Tide at Trouville is a splendid example of the extraordinarily beautiful and delicate coloristic effects Courbet achieved in these "sea landscapes" (*paysages de mer*), as he often called them. Taking his key from a streak of salmon pink just above the horizon, he modulated his palette through soft pinks, blues and grays, sand tones and browns, applying his paint with broad strokes of the palette knife. His ability to conjure an image from the most minimal of means drew forth the following, satirical praise from one contemporary caricaturist: "As God has created the sky and the earth from nothing, so has M. Courbet drawn his seascapes from nothing or almost nothing: with three colors from his palette, three brushstrokes—as he knows how to do it—and there is an infinite sea and sky! Stupendous! Stupendous! Stupendous!" ("De meme que Dieu a tiré le ciel et la terre du néant, de même M. Courbet tire ses marines de rien ou à peu près rien: trois tons sur sa palette, trois coups de de brosse—comme il les sait donner—et voilà une mer et un ciel infinis! Prodigieux! prodigieux! prodigieux!" G. Randon, "Exposition Courbet," *Le Journal amusant*, 1867, in Léger 1920, p. 72; top left).

There seem to be few precedents for these radically reductive seascapes. Courbet may have seen some seventeenth-century Dutch seascapes when he visited Holland in 1847, but at this date, as Alan Bowness has pointed out, he probably would not have been aware of late eighteenth- and early nineteenth-century English watercolors that show a similar concern with water, light, and atmosphere (Bowness, "Courbet, Whistler and the Seascape," unpublished lecture, 1977). Be that as it may, his meeting at Le Havre in 1859 with his contemporary Boudin, whom he called "the king of skies," was of great importance in developing his sensibility to the continually changing effects of clouds above the Channel. Courbet's seascapes are, for the most part, empty of the small figures that animate Boudin's views of these fashionable Normandy resorts. Their silence and emptiness, their muted tonal harmonies and atmospheric effects, owe more to his close association with Whistler at Trouville in 1865—to a work such as Whistler's *Crepuscule in Opal: Trouville* (1865; Toledo Museum of Art), for example. Whistler's *Harmony in Blue and Silver: Trouville* (1865; Boston, Isabella Stewart Gardner Museum; left center) in fact shows the

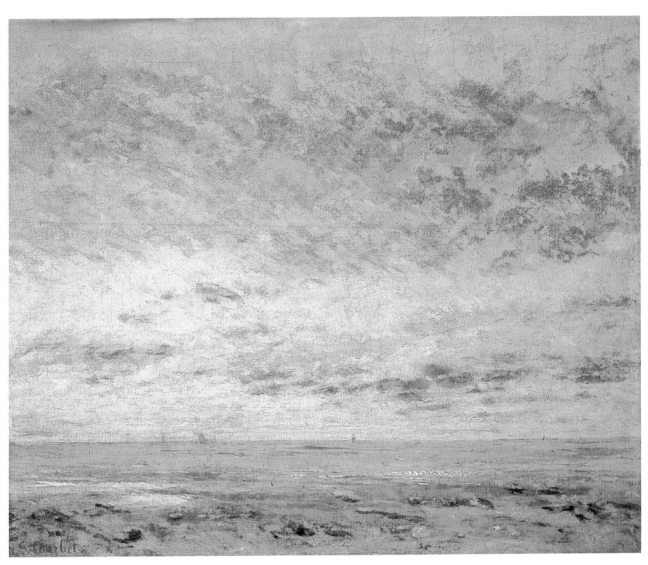

50

lone figure of Courbet contemplating the ocean, which surely is an allusion to Courbet's own painting of himself saluting the sea at Palavas in 1854 (Montpellier, Musée Fabre, opposite, bottom). Courbet's evocations of the elements, however, are never as ethereal as Whistler's: his paint retains a palpability that has evaporated from Whistler's residues of translucent color. Yet, although the palpability of Courbet's paint creates an assertively material surface, it does not deny the atmospheric panorama of the beach at low tide. This ambivalent relationship between surface and depth was later to be explored by Monet. The density of Courbet's paint, broadly applied with the palette knife, gives an equal visual weight to water, beach, and atmosphere,

creating an overall unity in which distinctions among the different substances are suppressed. As Klaus Herding has observed, this equalizing of matter led critics like Maxime Du Camp to interpret these paintings as metaphorical embodiments of an anarchic view of society in which social hierarchies are leveled (Herding 1975, p. 182).

In his 1867 exhibition, Courbet grouped ten of these seascapes under the heading of *Marines diverses*, but it is impossible to distinguish among them. A.D.

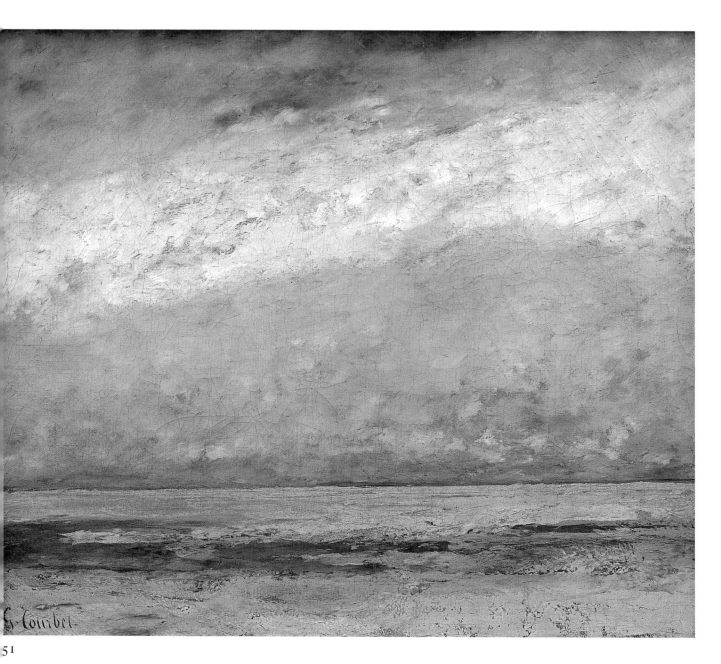

51

51. Seacoast 1865

Marine

Oil on canvas, 21 1/8 x 25 1/4 in. (53.5 x 64 cm)
Signed, lower left: *G. Courbet*
Literature: Fernier 1977, I, no. 498; Hamburg 1978, no. 280.

Cologne, Wallraf-Richartz Museum

This painting is another in the series of seascapes that
Courbet painted at Trouville in 1865. Here, every trace
of human activity, even the tiny boats visible on the
horizon in the Liverpool painting, has been eradicated.
Light, water, and atmosphere are the subjects of the
painting. The basic color scheme is a beautiful blue-
violet, deeper in tone than the more luminous Liverpool
painting. Courbet's exploration of more or less the same
empty view of sea and sky in different conditions of light
and atmosphere suggests a serial approach to the motif
that was later taken up by Monet. A.D.

52. Marine (Waterspout) 1866

La Trombe

Oil on canvas mounted on cardboard, 16 1/2 x 25 in. (42 x 63.5 cm)
Signed and dated, lower left: *Gustave Courbet . . . 66*
Literature: Fernier 1977, II, no. 595; Léger 1929, pl. 117; Philadelphia
1959, no. 58.

Philadelphia Museum of Art, John G. Johnson Collection

The *Marine* is a depiction of a waterspout, a natural
phenomenon that occurs when temperature differences
in the air create a spiral causing water to rise out of the
sea and fall back as rain. Courbet probably witnessed
this spectacle when he was working at Trouville in 1865
or 1866. It may be the painting that is listed as "no. 52:
La Trombe (Trouville, 1865)" in the catalogue of his
1867 exhibition at the Rond-Point de l'Alma, although
there is no way of being certain.

In this painting Courbet adopts the frontal, horizontal
composition of the other, more benign seascapes
painted at Trouville. A cold, bluish gray tonality per-
vades the scene, its bleak emptiness broken only by the
presence of a few sailing boats in the foreground and
along the distant horizon. A leaden gray horizon divides
the sea from the sky; a few broad strokes of the palette
knife make up the foreground strand of beach and the
white edges of the waves, and the alternating bands of
light and dark in the ocean find a counterpart in the
veils of rain that hang in the sky.

The subject of a waterspout seems to have been pop-
ular with Courbet's patrons, and he painted several ren-

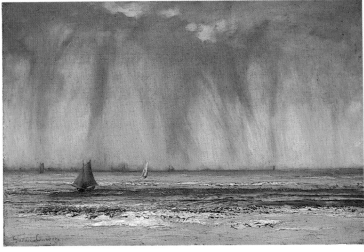

52

G. Randon. *Une Trombe,* "Exposition Courbet,"
Le Journal amusant, 1867.

derings of it. His other treatments of the subject are,
however, more overtly Romantic. In a work similar to
the Philadelphia painting (Fernier 1977, II, no. 604),
Courbet introduces the small figure of a woman who
stands on a foreground rock gesturing for help, thus
placing the work in the context of the Romantic view in
which nature can overpower a fragile human presence.
In a later group of paintings of waterspouts dated to
1870 (Fernier 1977, II, nos. 753, 756, 757) Courbet
heightens the drama by adopting a Romantic convention
of waves pounding against craggy rocks placed to one
side of the composition. In the present work, however, as
in the empty seascapes also painted at Trouville in 1865–
66, such conventions are stripped away to leave an image
radical in its directness and simplicity. The unadorned
reductiveness of Courbet's composition was lampooned
in a cartoon by G. Randon in *Le Journal amusant* of 1867
in which nature's elemental force is reduced to a few
lines of the caricaturist's pen (above). A.D.

53. Portrait of Jo, the Beautiful Irish Girl
1865(?)

Portrait de Jo, La Belle Irlandaise

Oil on canvas, 21 1/4 x 25 5/8 in. (54 x 65 cm)
Signed, dated lower left: . . . *66 Gustave Courbet*
Literature: Fernier 1977, II, no. 537; Riat 1906, pp. 228, repr. 229; Léger 1929, pp. 120, 128, and pl. 45; Hamburg 1978, no. 44.

Stockholm, Nationalmuseum

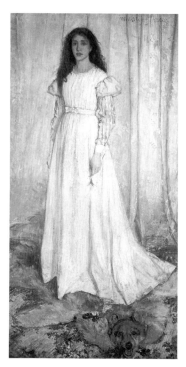

James McNeill Whistler (1834–1903). *Symphony in White, No. 1: The White Girl,* 1862. Oil on canvas. Washington, D. C., National Gallery of Art, Harris Whittemore Collection.

The subject of this portrait is Joanna Heffernan, a beautiful Irish woman who was Whistler's mistress in the early 1860s. Courbet probably painted this portrait during the summer of 1865 when he and Whistler were working together at Trouville, although it is likely that he had met Jo a few years before when she posed for Whistler's famous portrait of her called *The White Girl* (right; 1862; Washington, D.C., National Gallery).

During the productive sojourn at Trouville in the summer and autumn of 1865, Courbet enjoyed considerable success as a portraitist. But despite the many fashionable society women who came to sit for him, it was Jo's more earthy beauty that appealed to him the most, as he explained in a letter to his friend and patron Alfred Bruyas: "Among the two thousand ladies who have come to my studio, I admired more than Princess Karoly and Mlle. Aubé the beauty of a superb redhead whose portrait I have begun" (Borel 1951, p. 116, n. 1).

Courbet has responded above all to his model's spectacular auburn hair, which falls abundantly around her shoulders and onto the table in front of her. Whistler, too, was enamored of Jo's hair, which he had described in a letter to Fantin-Latour in 1860 as the "most beautiful hair you have seen! not a golden red, but copper-colored—like everything Venetian one had dreamed of!" (Quoted in *From Realism to Symbolism, Whistler and His World* [New York: Columbia University, 1971], p. 69.)

In contrast to the commissioned portraits painted at Trouville, the informality of Jo's pose conveys a feeling of intimacy. She is shown in three-quarter profile, holding up a tress of her hair and gazing at her reflection in the mirror, which she holds in the other hand. Courbet, who claimed that he painted Jo's portrait in a single sitting, has varied his brushstroke to capture the contrasting textures of her thick, tousled hair, her luminous creamy skin, and the delicate white lace around her throat. By pulling his subject right up to the picture plane so that she almost fills the space around her, Courbet has created an image of intense physical immediacy. Indeed, in this portrait of Jo it is hard to recognize the remote and virginal young woman who is the subject of Whistler's *White Girl.* There is no doubt that Courbet was very fond of Jo, and it is possible that she briefly became his mistress when Whistler departed for Chile in 1866. In that year Courbet portrayed her as the frankly erotic redheaded nude in the *Sleepers* (Paris, Petit Palais; cat. 65).

The motif of a woman studying her reflection in a mirror had appeared in Courbet's work before. His *Femme au Miroir* of 1859 (Fernier 1977, I, no. 269) met with such success that Courbet painted several versions of it (Paris 1977, no. 90). His decision to take up the motif again may have been inspired by Whistler's *Symphony in White No. 2: The Little White Girl* of 1864 (London, Tate Gallery; opposite, left), which, although different in composition, shows Jo looking at her reflection in a mirror. A closer parallel, however, is to be found in Rossetti's *Lady Lilith,* begun in 1864, but not finished until 1868 (Wilmington, Delaware Art Museum; opposite, right), which shows Rossetti's companion, Fanny Cornforth, admiring her outspread hair in the mirror that she holds in her hand (*From Realism to Symbolism,* p. 123). Whether Courbet had actually seen Rossetti's painting is not known, but he would have talked to Whistler of Rossetti's work and may even have been familiar with one of the many preliminary drawings if not with the painting itself (Alastair Grieve, "Whistler and the Pre-Raphaelites," *Art Quarterly* 34:2 [Summer, 1971]: 22).

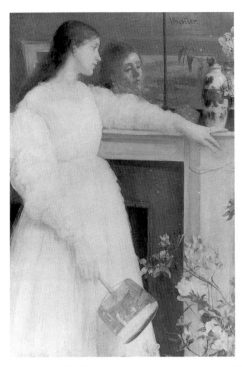

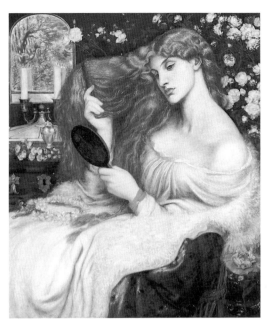

James McNeill Whistler (1834–1903). *Symphony in White, No. 2: The Little White Girl*, 1864. Oil on canvas. London, Tate Gallery.

Dante Gabriel Rossetti (1828–82). *Lady Lilith*, 1868. Oil on canvas. Delaware Art Museum, Samuel and Mary R. Bancroft Memorial.

Although there is an evident similarity between *Jo, La Belle Irlandaise* and Rossetti's composition, Courbet seems to have remained immune to the allegorical meanings that were so prevalent in Pre-Raphaelite painting. A poem by Rossetti inscribed on the frame of *Lady Lilith* dwells on the dangerous beauty of women's hair and its power to entwine men's hearts in a fatal web, a theme that was to achieve even greater potency with the image of the femme fatale found so frequently in Symbolist painting at the end of the nineteenth century. Despite Courbet's fascination with flowing hair (cats. 21, 58), these works carry little suggestion of the femme fatale, and one feels that Courbet was most interested in the purely sensous qualities of his sitters' hair. It has been suggested that in the *Portrait of Jo* Courbet was also drawing on the type of the penitent Magdalen with long, loose hair, for whom the image in the mirror denotes self-perception (Hamburg 1978, p. 237, no. 4), and he might have been familiar with this kind of imagery from works in the Musée Espagnol. But, in general, symbolic meaning, if present at all, plays a secondary role in this work. Rather, Courbet's aim seems to be to express his pleasure in Jo's physical beauty in which the spectator, as an unobserved voyeur, is implicitly invited to share.

Courbet seems to have had a particularly sentimental attachment to this painting and the memories it evoked. In a letter to Whistler written in the last year of his life, dated February 4, 1877, he wrote, "I still have Jo's por-

trait that I will never sell and which everyone admires," and he fondly reminisced about the good times they had had with Jo at Trouville when she would entertain them with Irish songs (quoted in Margaret M. Macdonald and Joy Newton, eds., "Letters from the Whistler Collection," *Gazette des Beaux-Arts* 108 [December 1986]: 203).

This is one of four versions of the subject. The others are in The Metropolitan Museum of Art, New York (cat. 54), the Nelson-Atkins Museum of Art, Kansas City (cat. 56), and a Swiss private collection (cat. 55). The latter work has always been privately owned and was not known to Fernier. Traditionally, the Stockholm version has been accepted as the first, based on two assumptions: one, that it is the version sold in the estate sale of 1881; and two, that the version that Courbet kept till his death was the original version. As Toussaint notes (Paris 1977, no. 90), the early history of the four versions is uncertain and very difficult to sort out. There are more or less significant variations among them. The exhibition of the four together and the opportunity to compare them may provide further evidence.

When one version of this painting was shown at Courbet's one-man exhibition in 1867, he added "Trouville 1866" to the title in the catalogue, *La Jo, femme d'Irlande.* Courbet was, however, notoriously unreliable in the matter of dating, and his letter to Bruyas, quoted above, would suggest that the original was painted in Trouville in 1865. A.D.

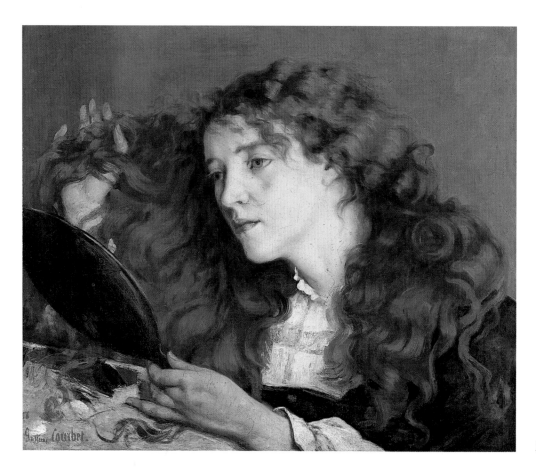

53

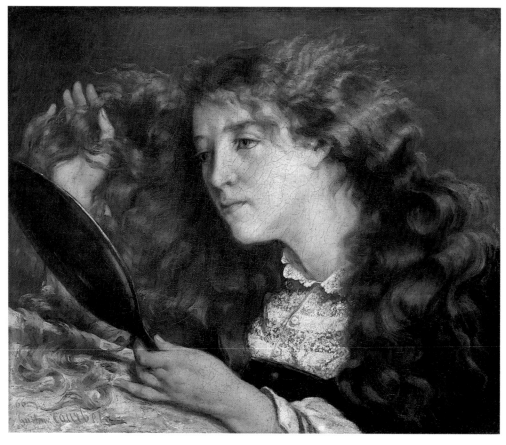

54

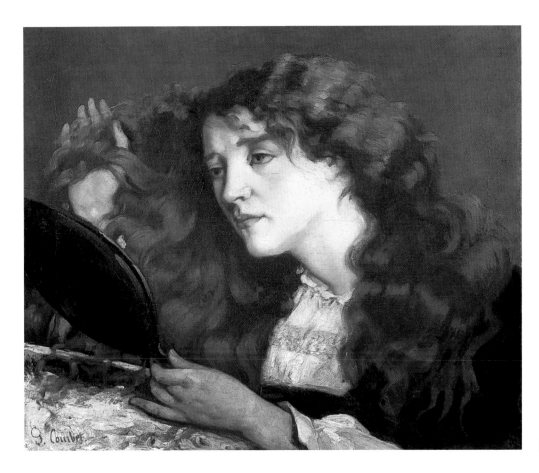

55

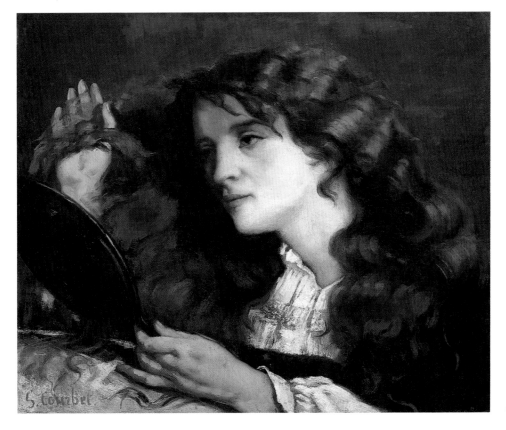

56

54. Portrait of Jo, the Beautiful Irish Girl
1865(?)

Portrait de Jo, la belle irlandaise

Oil on canvas, 22 x 26 in. (55.9 x 66 cm)
Signed and dated, lower left: *66 Gustave Courbet*
Literature: Fernier 1977, II, no. 538; Philadephia 1959, no. 55; Paris
1977, no. 90.

New York, The Metropolitan Museum of Art, Bequest of Mrs. H. O.
Havemeyer, 1929, H. O. Havemeyer Collection
See cat. 53

55. Portrait of Jo, the Beautiful Irish Girl
1865

Portrait de Jo, la belle irlandaise

Oil on canvas, 21 1/4 x 25 1/8 in. (54 x 64 cm)
Signed, lower left: *G. Courbet*
Literature (provenance): Galerie Royale, Brussels, 1911; M. E. Girard;
H. Girard; Mme Cazenave, Paris.

Zurich, Collection Rolf and Margit Weinberg
Exhibited in Brooklyn only

56. Portrait of Jo, the Beautiful Irish Girl
1865(?)

Portrait de Jo, la belle irlandaise

Oil on canvas, 20 3/4 x 25 in. (52.7 x 63.5 cm)
Signed, lower left: *G. Courbet*
Literature: Fernier 1977, II, p. 12, no. 539.

Kansas City, The Nelson-Atkins Museum of Art, Nelson Fund
See cat. 53

57. Portrait of Jo 1865

Portrait de Jo

Oil on panel, 10 5/8 x 8 1/2 in. (27 x 21.5 cm)
Signed, lower left: *G. Courbet*
Dated, lower right: *65 Jo*
Literature: Fernier 1977, I, no. 447.

New York, Private Collection

This small, freely painted oil sketch of Whistler's mis-
tress, Joanna Heffernan, was painted when Courbet and
Whistler were working together at Trouville in the sum-
mer of 1865. The casual immediacy of this sketch sug-
gests that it preceded the group of more formal portraits
of Jo (cat. 53–56). Courbet's portrayal of Jo as a fresh-
faced, ordinary girl in this sketch contrasts with her
more glamorous and seductive appearance in the
portraits. A.D.

57

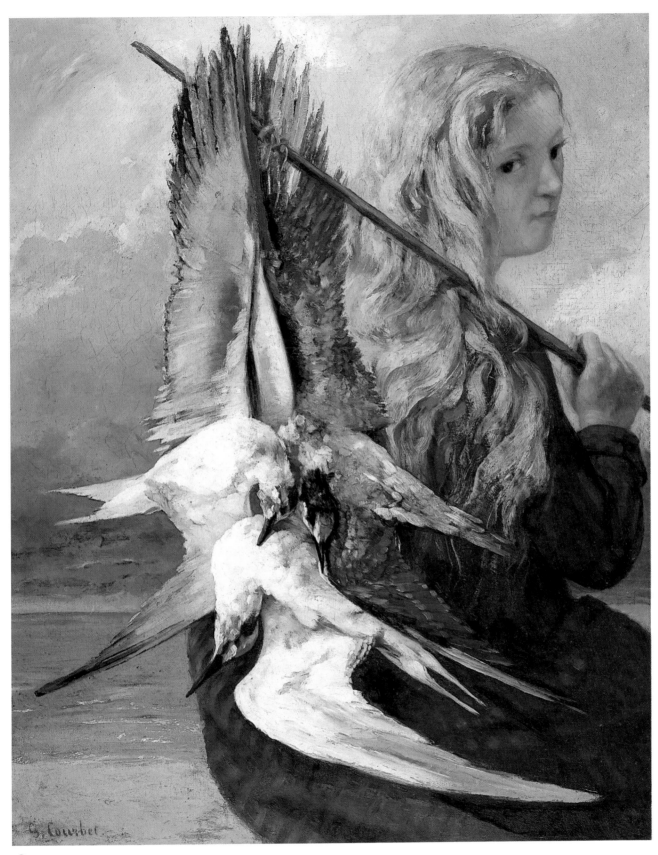

G. Courbet

58

58. The Girl with Seagulls, Trouville 1865

La Fille aux mouettes, Trouville

Oil on canvas, 31 7/8 x 25 5/8 in. (81 x 65 cm)
Signed, lower left: *G. Courbet*
Literature: Fernier 1977, I, no. 435; Riat 1906, p. 230; Léger 1929, pp. 117, 129, repr. p. 39; Philadelphia 1959, no. 48; Paris 1977, no. 87.

New York, Private Collection

This is another of the uncommissioned "portraits" Courbet painted at Trouville in the summer of 1865. The subject is an unknown girl with long, fair hair who carries three dead seagulls suspended from a pole that rests across her shoulder. The pole cuts a diagonal across the composition, detaching the girl's face with its enigmatic expression and establishing the axis for the sweep of alternating bands of light and dark formed by the girl's hair, the birds' outstretched wings, and the basket fastened around her waist. Behind her are visible the beach and a luminous sea and sky. By placing the figure close to, and to one side of, the picture plane, Courbet heightens the viewer's sense of physical involvement with the subject and creates a sense of informality. We feel as if we share Courbet's experience of momentarily glancing at this striking girl, who gazes back at us over her shoulder as she walks along the beach.

Again, Courbet returns to the subject of long, female hair that obsessed him at this period. Here, the luxuriant tangle of the girl's flowing hair and the birds' feathers are the dominant motifs of the painting. Despite the freshness and innocence of the subject, the mingling of the hair with the dead birds strikes a disturbingly strange, even macabre, note. Yet, like other depictions of dead creatures in Courbet's art—for instance, in the hunting scenes or in a painting like the *Trout* (cat. 86) where the image of death is made more poignant by the tactile beauty of the animal's pelt or the fish's scales—here the inert forms of the dead birds are ennobled by the grace of their extended wings and their exquisitely painted plumage. A.D.

59. Three English Girls at a Window 1865

Les Trois Anglaises à la fenêtre

Oil on canvas, 36 3/8 x 25 3/8 in. (92.5 x 72.5 cm)
Signed, lower right: *G. Courbet*
Literature: Fernier 1977, I, no. 437; Léger 1929, p. 117, pl. 41; Haavard Rostrup, "Trois Tableaux de Courbet," *From the Collections of the Ny Carlsberg Glyptotek* (Copenhagen, 1931), pp. 122–44; *Bulletin*, 1949, no. 5, pp. 17–21; Haarvard Rostrup, *Franske malerier og tegninger* (Copenhagen: Ny Carlsberg Glyptotek, 1977), no. 877.

Copenhagen, Ny Carlsberg Glyptotek

The *Three English Girls at a Window*, one of a powerful group of female portraits that Courbet painted during the summer of 1865 at Trouville, exudes the energy and confidence that this invigorating seaside experience produced in his work. The three girls who are the subject of the painting were apparently Lilly, Mary, and Julia Potter (Rostrup 1977). They are said to have come from England to be painted by Alfred Stevens, the noted portraitist, and when Courbet encountered them in Stevens's studio, he was so struck by their appearance that he asked Stevens if he, too, could paint them (Lindsay 1973, p. 209).

Once again Courbet uses the motif of female hair, which obsessed him at this period and which is a prominent feature of other portraits painted at Trouville, for example, *Portrait of Jo* (cat. 53), the *Girl with the Seagulls* (cat. 58), or the *Woman in a Podoscaphe* (cat. 61). The central girl's beautiful, red-gold hair dominates the painting. It is swept to the side of her head and caught in a clasp, whence it spreads luxuriantly over her shoulders, its warm tones enriched by the light that streams in from the right. According to the painting's first owner, Etienne Baudry, the collector and connoisseur with whom Courbet had stayed at Saintes in 1862 and 1863, Courbet was particularly attached to this work (*Bulletin* 1949, p. 18). (The painting was acquired by the Durand-Ruel Gallery directly from Courbet in 1872 and sold to Baudry in 1877.) He repeats exactly the same head of hair in *Les Trois Baigneuses* of 1868 (Paris, Musée du Petit Palais; Fernier 1977, II, p. 56, no. 630).

No doubt it was Courbet's desire to display his sitter's magnificent hair to full advantage that prompted him to adopt the unusual viewpoint showing his figures from behind and in profile. As is so often the case with Courbet, he pulls his figures up close to the picture surface, all but eliminating a foreground plane. As a result, the viewer has the sensation of just having stepped into this room and unexpectedly encountered the three girls gazing out to sea. The air of casual informality that this

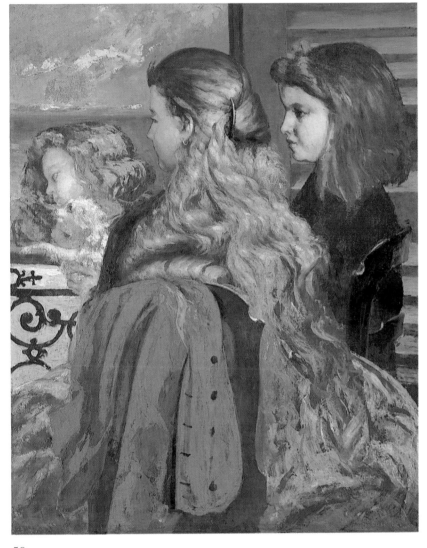

59

generates—the feeling that the painting is not a self-contained "composition" in a traditional sense, but rather a fragment of experience randomly perceived—anticipates the innovative approach to figure painting that Degas was to pursue in the 1870s and 1880s.

Courbet's close focus gives an almost hypnotic palpability to the forms and colors within the composition, but it also results in some unsettling spatial relationships. He fails to situate his figures in a convincing three-dimensional space. There is insufficient room, for example, between the two main figures and the balcony to accommodate them, and even more cramped is the figure of the small, blond girl holding a white dog, who seems to float, disembodied, above the balcony rail, since there is no believable space in which the lower part of her body could fit. This figure evidently troubled one of the painting's former owners, for at some stage in its history she was painted out and the area blended into the ocean.

It may have been Baudry who was responsible for the overpainting, but one of the work's subsequent owners, Prince de Wagram or Marczell de Nemes of Budapest, is far more likely. At any rate, when the painting appeared at the sale of the Nemes Collection at the Manzi-Joyant Gallery in Paris on June 18, 1913, it was described in the catalogue as *Deux Jeunes Filles devant la mer,* and the reproduction showed only two figures (Léger [1948, pp. 108–09] believed that Marczell de Nemes, who had a reputation for adjusting his new acquisitions, was the most likely culprit). In 1931, on the advice of Charles Léger, who knew the painting in its original state from an album of photographs of the 1882 Courbet exhibition at the Ecole des Beaux-Arts, Haavard Rostrup, the curator at the Ny Carlsberg Glyptotek, which had acquired the painting in 1914, had it restored and the third figure reappeared (Rostrup 1931, p. 132). A.D.

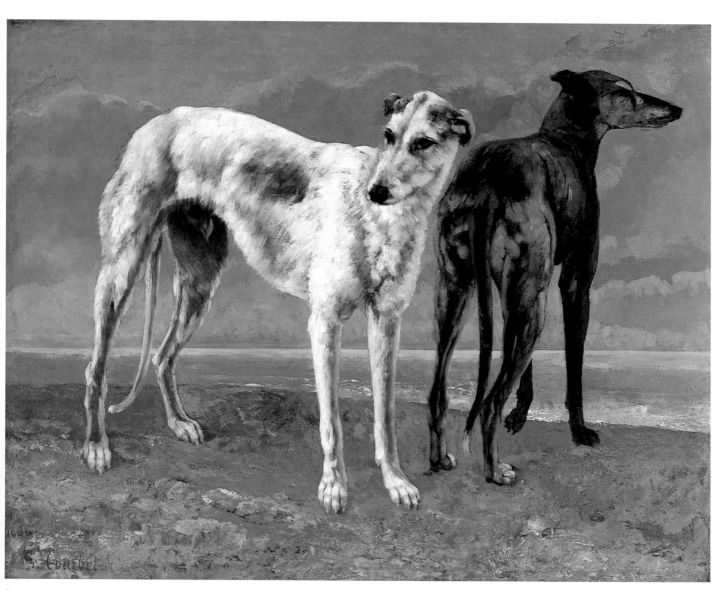

60

60. Count de Choiseul's Greyhounds 1866

Les Lévriers de M. de Choiseul

Oil on canvas, 35 x 45 3/4 in. (89 x 116.2 cm)
Signed and dated, lower left: *66 G. Courbet*
Literature: Fernier 1977, II, no. 545; Riat 1906, pp. 244–45; Léger 1929, pp. 120, 130; Philadelphia 1959, no. 57; Lindsay 1973, pp. 218–19; Paris 1977, no. 98.

The Saint Louis Art Museum, Gift of Mark C. Steinberg

During Courbet's second summer trip to the Normandy coast in 1866, he stayed in Deauville as the guest of the young comte de Choiseul, a connoisseur sympathetic to his work. As at Trouville during the previous summer, he painted a number of commissioned portraits of visitors to the coastal resort, and while staying with the count he was commissioned to make this portrait of his host's two aristocratic greyhounds. Courbet's acutely specific feeling for animals made him an ideal choice to paint such a portrait. The highly bred character of the two dogs with their long slender legs, graceful bodies, and proud heads is emphasized by the way in which they are seen from below, looking down upon the viewer (Paris 1977). The dogs are wonderfully posed, as if indeed sitting for their portraits: it is characteristic of Courbet to make one of the dogs face into the space and to have the other seen from the rear (see Fried, 1978). It is worth noting that the appearance of posing has to have been constructed by the artist: no dog ever "stood" for a portrait. Courbet's capacity for observation, his identification with his subject, and his ability to hold this visual awareness in his mind when removed from the model, are vividly apparent in this and other equally intractable animal subjects. S.F.

61. Woman in a Podoscaphe 1865

La Dame au podoscaphe

Oil on canvas, 67 1/4 x 82 1/8 in. (170.5 x 208 cm)
Literature: Fernier 1977, I, no. 449; Riat 1906, p. 230; Léger 1929, p. 117; Rome 1970, no. 27.

Tokyo, Murauchi Art Museum

In a letter to his friend Urbain Cuenot dated November 17, 1865, Courbet wrote: "I have begun at Trouville a new painting of a lady who goes to sea in a boat called a 'podoscaphe.' It consists of two long, narrow boxes which are fastened together" (Riat 1906, p. 230). This "*amphitrite moderne*" (Lindsay 1973, p. 208), as Courbet called her elsewhere, also elicited a classical analogy

from Théophile Thoré, who, in his critique of the Salon of 1866, rather fancifully described her as "a young bather from Parisian high society, famous at Trouville for her beauty and her daring. . . . This beautiful young girl on her almond shell is just as interesting to paint as Venus on her sea conch" (Théophile Thoré, *Les Salons* [Paris, 1870], vol. 2, p. 282). This painting was never actually included in the Salon, so presumably Thoré must have seen it in Courbet's studio. One wonders, though, whether this imposing, modern-life Venus may not have been conceived as a Salon piece, perhaps as a challenge to the kind of banal mythologizing exemplified by Cabanel's *Birth of Venus*, which was shown at the Salon of 1863.

During the Second Empire sea bathing had become a popular pastime at such elegant resorts along the Normandy coast as Deauville and Trouville. This athletic young woman clad in her chic, dark blue bathing suit, her long chestnut hair flying behind her in the wind, evidently caused something of a stir among the fashionable society at Trouville as she plied her way along the coast. It was rumored that she could even go as far as Le Havre in her unusual craft. No doubt it was the striking spectacle she made, as well as her physical élan, that inspired Courbet to make her the subject of this large painting.

La Dame au podoscaphe has the fresh yet unconventional, even bizarre, feeling found in other uncommissioned "portraits" painted at Trouville, such as the *Girl with Seagulls* (cat. 58) and the *Three English Girls at a Window* (cat. 59). Its sense of immediacy suggests it could have been painted on the spot, but a contemporary witness, Lemercier de Neuville, a marionnette performer, noted in his *Souvenirs* that Courbet had posed his model in her podoscaphe, holding her paddle, in the house of some people named Seillier (Léger 1929, p. 117). Perhaps this rather artificial situation accounts for the figure's somewhat stiff and naive appearance. The painting is unfinished and there is visual evidence that treatment of the surface was undertaken between 1966, when the painting was shown at the Galérie Claude Aubry in Paris, and 1969, when it was included in the Courbet exhibitions in Rome and Milan.

According to Riat, the painting was to have been acquired by Count Nieuwerkerke, Superintendent of Fine Arts, but he never claimed it, perhaps owing to a lingering ill feeling between him and Courbet (Riat 1906, p. 230). In 1853 Courbet had been angered by Nieuwerkerke's suggestion that he should paint a picture for the 1855 Exhibition Universelle but that it should be first vetted by a government committee. In

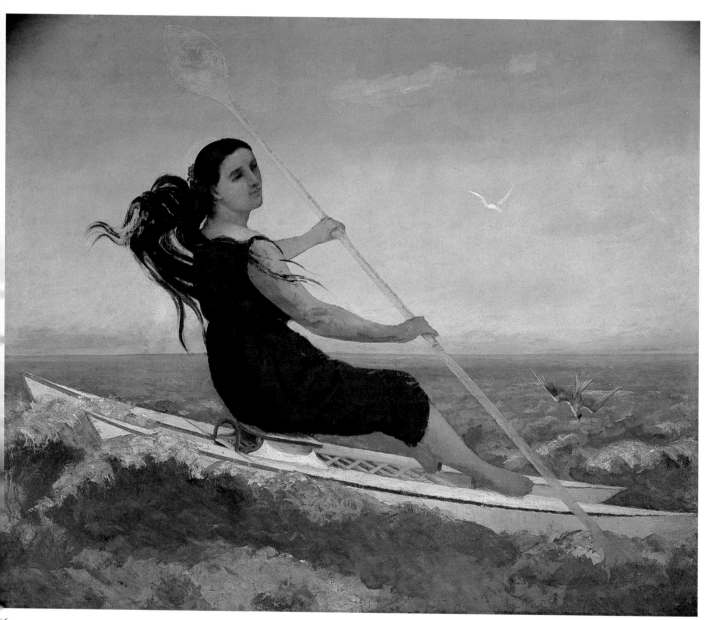

1856 a further altercation occurred between the two when Nieuwerkerke gave Courbet the impression that the government would purchase the *Woman with a Parrot* after it was shown at the 1866 Salon, but later denied having made the offer. A.D.

62. Portrait of M. Nodler the Elder 1865

Portrait de M. Nodler, aîné

Oil on canvas, 36 1/4 x 28 3/4 in. (93 x 73 cm)
Signed and dated, lower left: *66, G. Courbet*
Literature: Fernier 1977, II, no. 541; Riat 1906, p. 244; Léger 1929,
pp. 117–18; *Smith College Museum Bulletin*, 1935, pp. 11–12;
Philadelphia 1959, no. 49; Paris 1977, no. 85.

Northampton, Massachusetts, Smith College Museum of Art. Purchased,
Winthrop Hillyer Fund, 1935

Late in the summer of 1865, Courbet traveled to Trouville, the seaside resort on the English Channel made fashionable by the duc de Morny and Empress Eugénie. Always on the lookout for clients, Courbet shrewdly recognized Trouville, and its more tranquil neighbor, Deauville, as a potentially rich source for

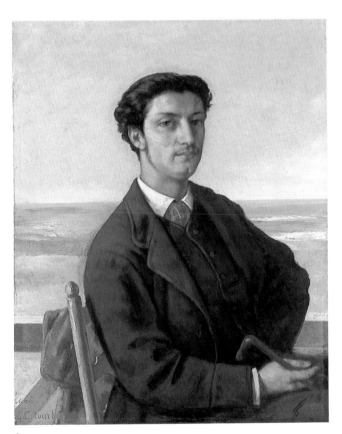

62

buyers of his paintings. He was not disappointed; the large number of commissions that he received for portraits, seascapes, and paintings of the dunes obliged him to extend his stay from an intended several weeks to three months, and to return the following summer. Despite his exaggerated country manners and patois, Courbet had no difficulty in captivating Second Empire high society. He moved comfortably among the aristocracy, relished the vigors of the sea, and painted between thirty-five and forty pictures (Mack 1951, p. 202); particularly successful was the portrait of a Hungarian aristocrat known as Karoly (her title, either princess or countess, is uncertain) that was much admired and brought large numbers of visitors to his studio.

In a letter to Urbain Cuenot dated September 16, 1865, Courbet wrote that he had completed a portrait of M. Nodler and had yet to do one of Nodler's brother or of his father (Paris 1977). In November he sent a boastful letter to his parents saying:

My fame has doubled and I have become acquainted with everybody who might be of use to me. I have received more than two thousand ladies in my studio, all of whom wish me to paint their portraits . . . Besides the portraits of women I have done two of men and many seascapes . . . (quoted in Riat 1906, p. 228)

The two men were the Nodler brothers, and this picture is that of the elder M. Nodler, a young man of obvious good fortune, represented in a moment of leisure. Attired in casual riding or strolling dress, his head and torso turned outward in three-quarter view, he sits alertly upright in a simple, ladder-back chair before a calm and sketchily rendered blue sea. The near arm and shoulder are thrust downward to converge with the overlapping shapes at lower right and thus form a solid compositional mass. The features are youthful and the expression is frank. There is a certain stiffness and naïveté to the image that recalls Courbet's stylistic sources in popular imagery and the unresolved awkwardnesses of his early professional years (as, for example, in the *Portrait of Paul Ansout*, cat. 1). It is this quality of simplicity, coupled with a bright, luminous palette, that conveys the atmosphere of summer days at the beach, that lends freshness and charm to the portrait.

In the same years—the mid-1860s—much of Courbet's imagery was painted with a baroque indulgence in sensuosity and an undisguised pleasure in the material richness of the medium. The portraits of Whistler's Irish mistress, Jo, executed at Trouville, probably

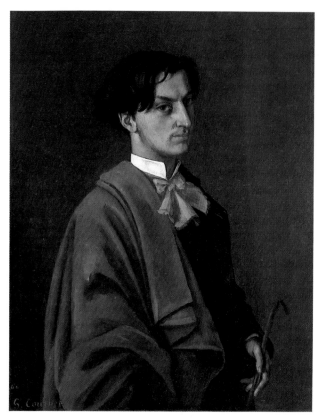

63

in the summer of 1865 (cat. 53–57) are examples of such an approach to portraiture and are markedly different from the somewhat severe images of the Nodler brothers.

The 1866 date in the left-hand corner of this picture, as well as its pendant, was set in place at the time of Courbet's one-man exhibition at the Rond-Point de l'Alma in 1867 (Paris 1977). R.B.

63. Portrait of M. Nodler the Younger 1865

Portrait de M. Nodler, cadet

Oil on canvas, 36 x 28 1/2 in. (91.4 x 72.3 cm)
Signed and dated, lower left: . . . *66 G. Courbet*
Literature: Fernier 1977, II, no. 541; Riat 1906, p. 244; Léger 1929, pp. 117–18; *Bulletin of the Springfield Museum of Fine Arts,* February/March 1954; Philadelphia 1959, no. 56; Paris 1977, no. 86.

Springfield, Massachusetts, Museum of Fine Arts, The James Philip Gray Collection

Like its pendant, this portrait shows a distinct personality, defined by apparent tastes and individualized details, but joined formally, as by the accident of birth, to the image of his brother. The line of connection resides in the similarity of style: for both portraits, a compact,

three-quarter-length figure is composed from thickly painted, individualized forms that are drawn together and contained by clearly outlined contours and a somewhat rigidly held pose. The formal similarities emphasize physiognomic resemblances, which, in this case, are unusually close. The features and build of the younger M. Nodler are remarkably like his brother's: the shape of his nose and eyes, the arch of his brows, and the less prominent, but clearly discernible, cleft in his chin testify to the biological relationship. Indeed, he does not seem much the younger of the two at all.

It is in the more conspicuous areas of personal attitudes and preferences, as well as in the descriptive details that the artist chooses to include, that the brothers and their images achieve both attractiveness and individuality. This young man's penchant for romance is manifested in the clothes that he wears, in his somewhat veiled, self-conscious glance, and in his artfully coiffed hair. With his union of perception and form, Courbet has placed his subject in an unspecified and tonally dark setting, removed from the Trouville seaside, but easily disposed in his immediate space. Moreover, he has carefully attended to the conscious neatness of the folds of the cape, the precise casualness of the ascot bow, and such other details as the impeccably starched, carefully aligned collar, and the delicate, graceful grip on the cane. For all of its sense of artificiality, the portrait is a solidly and accurately painted image of an actual young bourgeois with romantic yearnings.

Like its pendant, this picture was executed in 1865 but given an 1866 dating at the time of Courbet's 1867 one-man exhibition at the Rond-Point de l'Alma (Paris 1977). R.B.

64. Woman with a Cat 1864

La Femme au chat

Oil on canvas, 28 3/4 x 22 1/2 in. (73 x 57 cm)
Signed, lower left: *G. Courbet*
Literature: Fernier 1977, I, no. 431; Riat 1906, p. 376; Léger 1929, p. 102; Paris 1977, no. 75.

Worcester Art Museum

Amidst a froth of gauzy peignoir fabric and fluffy cat fur, the model, her shadowed head crowned with a lace morning cap, looks coquettishly at the implied spectator. In paintings such as this, which Courbet produced only after 1858, the programmatic realism of the artist appears to be eclipsed by a style that Toussaint has de-

scribed as "simplement celui du Second Empire" (Toussaint 1980, p. 93). Although nowhere as blatantly erotic as the nude *Femme au chien* (Paris, Musée d'Orsay), the ecstatic abandon of the cat, the dishabille of the sitter, and her ambiguous glance all conjoin to link the painting with the contemporary vogue for rococo-influenced, small-scale works with more or less obvious erotic implications. According to Courbet's friend the poet Max Buchon, the artist was working on this painting after the Salon jury of 1864 refused his *Venus Jealously Pursuing Psyche* (now destroyed) on the grounds of indecency (Paris 1977). The rejection prompted Courbet to remark that if *Venus and Psyche* were immoral, then all the museums of Italy, France, and Spain would have to be closed (Paris 1977, p. 184). It is possible, in the light of this situation, to read the *Woman with a Cat* as an ironical reference to, rather than a straightforward expression of, Second Empire tastes in eroticism and propriety. A.S.-G.

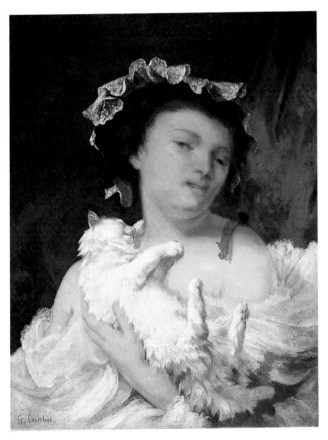

64

65. The Sleepers, *or* Sleep 1866

Le Sommeil, ou Paresse et luxure

Oil on canvas, 53 1/8 x 78 3/4 in. (135 x 200 cm)
Signed and dated, lower right: *G. Courbet 66*
Literature: Fernier 1977, II, no. 532; Riat 1906, pp. 238, 241; Léger 1929, p. 118; Philadelphia 1959, no. 59; Rome 1969, no. 31; Nochlin 1972; Farwell 1972, pp. 67–79; Paris 1977, no. 95.

Paris, Musée du Petit Palais

Courbet's production of what Champfleury contemptuously referred to as "nudités élégantes à la Parisienne" (Introduction to the 1882 Beaux-Arts exhibition, cited in Fermigier 1971, p. 82) was inaugurated in the 1860s by paintings such as the *Woman with White Stockings* (Barnes Collection). As Champfleury's locution implies, there is some distinction to be made between paintings of the female nude that more or less conform to the norms and strictures of academic tradition (or aggressively subvert them, as in the Montpellier *Bathers*) and those that are geared to the somewhat different conventions of the unambiguously erotic. *The Sleepers*, quite clearly, belongs to the latter category. Together with the earlier *Venus Pursuing Psyche* of 1864 (destroyed) and the *Awakening* (Bern), also painted in 1866, this work represents Courbet's exploitation of the theme of lesbianism. In its nineteenth-century pictorial incarnations, however, the term *lesbian* should perhaps be provided with quotation marks, insofar as we are dealing with images made by men, for men, and in which the very disposition of the women's bodies declares that they are arranged more for the eyes of the viewer than for those of one another.

The Sleepers was commissioned by Khalil Bey, a wealthy, cultivated, and profligate Turkish diplomat, who was probably of Egyptian origin (Haskell 1982). By the time he was bankrupted by his gambling debts in 1868 and compelled to sell his art collection, he had acquired more than one hundred paintings, including Ingres's *Turkish Bath*, as well as works by Delacroix, Chassériau, Daubigny, Rousseau, and Corot (Durand-Ruel was his principal supplier). He also acquired Courbet's *Les Braconniers*. It was for Bey, moreover, that Courbet painted the notorious *Origin of the World* (pl. 66), a frank and unadorned study of a supine woman's pubes.

Both in subject matter and form, the *Sleepers* draws on an array of established visual conventions, some deriving from high art, some from popular prints and lithographs, particularly those produced during the July Monarchy and Second Empire under the rubric of

scènes de la vie galante. Thus Nochlin (1971b, p. 34) has proposed the widely known and popular print by James Northcote, depicting the two young imprisoned princes in the Tower, locked in each other's arms asleep, as a formal source for the *Sleepers.* As Farwell has noted (1972), it would have been by no means uncharacteristic of Courbet to have so transformed a sentimental historical print into a monumental and flamboyantly erotic image of sexual transgression. Additionally, Nochlin has pointed out that the pairing of the fair woman with the brunette is a venerable trope in the representation of two women together, ranging from the white mistress/black maid pairings in both rococo and orientalist painting, through the spectrum of various differentiations of hair and complexion color. Farwell has proposed certain other sources that are even more striking in their resemblance to the *Sleepers:* Oliver Tassaert's *Nude on a Bed* in the Louvre, which depicts a sleeping woman suggestively embracing her pillow in a pose almost identical to that of Courbet's brunette (Farwell 1972); and a lithograph from a Scott novel by Achille Deveria entitled *Minna and Brenda,* which portrays a comparable coupling of a fair and a dark woman in bed together, lightly draped but similarly posed (opposite).

In drawing upon prototypes such as these, Courbet in every way surpassed his sources. In part, this is a function of scale itself. Taking an erotic subject normally rendered in small-scale lithographs or engravings and enlarging it to such an extent imputes an importance and grandiosity to the subject that is wholly unprecedented. Further, Courbet has here lavished his great painting skills on the glowing olive and rose-ivory flesh of the women, the white linen of the bedclothes highlighted with blues and yellow, the deep blue of the background, the luminous colors of the bouquet, and the still-life elements on the bedside table. Details such as these, as well as the discarded pearl necklace and comb, doubtless suggested the painting's other title—*Luxury and Idleness.* In keeping with the presence of an implied spectator, Courbet has contradicted the perspective structure indicated by the bed by tipping the bodies of the entwined women up and toward the picture plane—an imperative no less obeyed in the complex pose, which, despite the embrace, allows the spectator an unencumbered view of breasts and buttocks.

The "scandal" of the *Sleepers* was such that, six years later when it was exhibited in the window of a picture dealer, it was specifically noted in a police report, part of Courbet's police dossier that began in 1868. By 1872, with Courbet identified as the communard responsible

for the destruction of the Vendôme column, the existence of paintings such as the *Sleepers* was used both by the press and the police as an index of Courbet's reprobate status. A.S.-G.

66. The Origin of the World 1866

L'Origine du monde

Oil on canvas, 18 1/8 x 21 5/8 in. (46 x 55 cm)
Literature: Fernier 1977, II, no. 530; Léger 1948, pp. 115–16; Haskell 1982, pp. 40–47; Nochlin 1986, pp. 76–86

Private Collection

Courbet's *Origin of the World* was commissioned in 1866 by Khalil Bey, a Turkish diplomat, bon vivant, and art collector, who also commissioned his lesbian painting *Sleep* (cat. 65). The painting, a small but richly detailed one, representing a woman's torso, her thighs, and a single breast in extreme foreshortening, certainly falls under the rubric of pornography, as that term is generally understood, and was intended as such: a little masterpiece of overt sexuality meant for the private delectation of a sophisticated connoisseur. In Freudian terms, it represents the classical site of castration anxiety, as well as the ultimate object of male desire.

The Origin of the World has had a long history in literary description, right down to the present day (Nochlin 1986); but the work itself has actually been seen in the original by relatively few observers. It was described in the nineteenth century by such literary figures as Edmond de Goncourt, who praised it by comparing it to the work of Correggio (*Journal: Mémoires de la vie littéraire* [Paris, 1956] 3, p. 996, entry of June 1889). It was damned by Maxime du Camp, who sarcastically implied that Courbet, in catering to the whims of a rich Moslem, had neglected to represent his model's feet, legs, thighs, stomach, hips, chest, hands, arms, shoulders, neck, and head (Maxime du Camp, *Les Convulsions de Paris* [Paris, 1889], 2, p. 189–90). Evidently the *Origin* was hidden behind a green veil while in the possession of its original owner, and was later concealed by a panel representing a castle in the snow, according to Léger. The *Origin* apparently disappeared from the Hatvany Collection in Budapest during World War II, and, according to Robert Fernier, returned to Paris, where it was sold to an unspecified buyer. The painting then hung, after the war, in the famous psychoanalyst Jacques Lacan's country house, "la Prévôté," in Guitrancourt near Mantes-la-Jolie. In the section of a

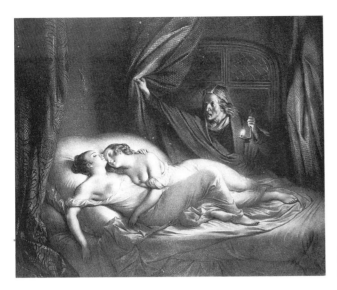

Achille Deveria (1800–57). *Minna et Brenda (Minna and Brenda)*, 1837. One of two pendants based on scenes from novels by Sir Walter Scott, 1837. Lithograph. Paris, Bibliotèque Nationale, Cabinet des Estampes.

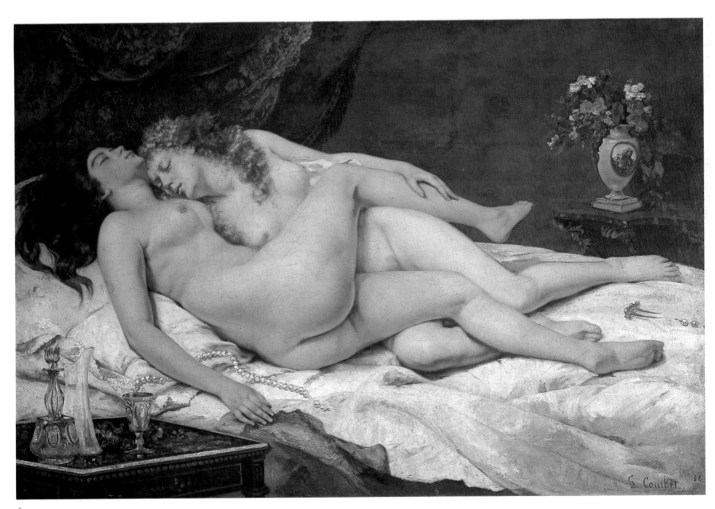

65

66

recent history of French psychoanalysis dealing with Lacan's life and work, it is described as half of a "strange diptych," a "double" painting, consisting, on the bottom, of Courbet's canvas—representing the splayed-out lower section of a woman's body—and, on the top, or visible portion, of a wooden "hiding device" constructed by the artist André Masson, representing in abstract form the elements of the first painting. A secret system allowed the viewer to slide off this wooden protective covering and reveal Courbet's painting beneath (see Elisabeth Roudinesco, *La Bataille de cent ans: Histoire de la psychanalyse en France. 2: 1925–1985* [Paris, 1986], p. 305). The analogy between this "strange diptych" and Marcel Duchamp's final work, *Etant donnés* ("Given that . . .") of c. 1946–66, now in the Philadelphia Museum of Art, is striking. *Etant donnés* consists of a large wooden door with holes bored in it through which the viewer is forced to peep like a voyeur at the realistically constructed simulacrum of a nude woman's lower body and sex organs. In both cases, the crucial relation between looking and desire is vividly established by means of a realist strategy that foregrounds the role of voyeurism in artistic experience. L.N.

67. Woman with Jewels 1867

La Dame aux bijoux

Oil on canvas, 31 7/8 x 25 1/4 in. (81 x 64 cm)
Signed and dated, lower right: *Gustave Courbet 67*
Literature: Fernier 1977, II, no. 626; Riat 1906, p. 246; Forges 1976.

Caen, Musée des Beaux-Arts

Included in Courbet's exhibition at the Rond-Point de l'Alma in 1867, and sent the following year to Courbet's exhibition in Ghent, *Woman with Jewels* was identified by Riat as being a portrait of Castagnary's mistress. Be that as it may, the painting is notable for the distinctively sensual and carnal sensibility Courbet brought to·his depictions of young women. These qualities are manifest in the painting of the heavy, glossy red hair of the model and her pearly pink flesh tones. A lithographed version of the painting executed by Méaulle appeared in Jean Bruno's *Les Misères des gueux* in 1872. A.S.-G.

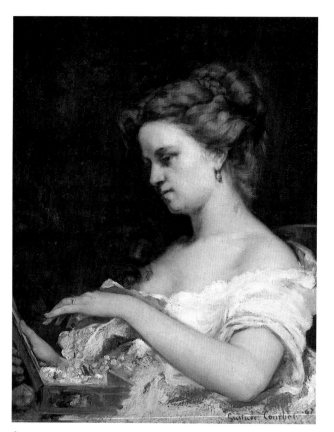

67

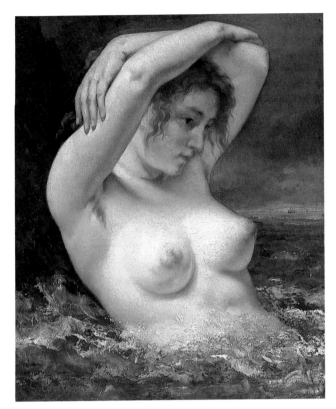

68

68. The Woman in the Waves 1866

La Femme à la vague

Oil on canvas, 25 3/4 x 21 1/4 in. (65 x 54 cm)
Signed and dated, lower left: *68 G. Courbet*
Literature: Fernier 1977, II, no. 628; Riat 1906, p. 264; Léger 1929, p.
138; Philadelphia 1959, no. 67; Paris, 1977, no. 109.

New York, The Metropolitan Museum of Art, Bequest of Mrs. H. O.
Havemeyer, 1929. H. O. Havemeyer Collection

By the time Courbet adopted the theme, the icon-
ographic convention that associated the female nude
with water—be it ocean, spring, or bath—was a venera-
ble staple of academic practice. Treated by such fash-
ionable and institutionally lauded painters as Alexandre
Cabanel and Paul Baudry, the nude-with-water motif
skirted, and occasionally transgressed, the delicate line
between the overtly salacious and the decorously aca-
demic. The underlying prurience of many of these rep-
resentations was, however, duly noted by several of the
more candid or perceptive art critics and commentators.
In the Second Empire, it was Ingres's *La Source* that was
widely reckoned as the summa of the motif, with its
skillful balance between the erotic and the abstract. It is
thus a measure of Courbet's artistic radicality that in ap-
propriating this convention, he managed to transform it
for his own, realist ends.

The nude woman and water were, in any case,
themes with a powerful hold on Courbet's imagination;
they appeared in his work as early as 1845 (see, for ex-
ample, *Nude Sleeping by a Stream*), and he returned to
them again and again. But beginning with the great
Bathers of 1853, Courbet attempted something both
more ambitious and intellectually subtle than merely sit-
uating a female nude in a natural setting and thereby
"realistically" justifying the co-presence of nude and
water. For what the physical pose of the model suggests
in the *Woman in the Waves*, and what—somewhat more
ambiguously—is implied by the posturing nude in the
Bathers, are the conventions of the academic nude itself:
a body that is posed in conformity with *aesthetic* conven-
tions and, indeed, has no meaning or significance out-
side of them. Thus, the depiction of a manifestly
naturalistic nude (the underarm hair makes this quite
explicit) is counterpointed by the position of the model's
arms—a pose with a recognizably academic pedigree.
By obliquely evoking his own painting's academic pro-
totypes (as Manet, even more programatically, had done
earlier with the *Olympia* and the *Déjeuner sur l'herbe*),
Courbet's transformations are given their polemical
charge. Neither Venus nor Andromeda, Courbet's
nude, her hair disheveled, stands in an ocean likewise
demythologized by the presence of a far-off boat. Un-
like Manet, however, Courbet was quite capable of
equivocating in his subversion of academic *doxa*. In the
related *Nude* of the same year (now in the Philadelphia
Museum of Art), Courbet used the same model, in an
identical pose from the waist up, but placed her within
the more conventional trappings of a billowing tent, with
draperies to recline upon. A.S.-G.

69. Hunter on Horseback, Recovering the Trail 1867?

Chasseur à cheval, retrouvant la piste

Oil on canvas, 47 x 37 1/2 in. (119.4 x 95.3 cm)
Literature: Fernier 1977, I, no. 375; Riat 1906, pp. 246, 254; Léger 1929,
pp. 122, 128, 216–17; Kane, 1960; F. Forster-Hahn, *French and School of
Paris Paintings in the Yale University Art Gallery*, New Haven 1968 (with full
bibliography and provenance); *Bulletin* no. 48, 1972; Forges 1973, no. 56.

New Haven, Yale University Art Gallery, Gift of J. Watson Webb and
Electra Havemeyer Webb.

As William Kane quite rightly remarked in his essay on
this painting, "this particular scene is disturbing to
those who think of the painter only as an objective natu-
ralist" (Kane 1960, p. 31). In fact, no study of Courbet's

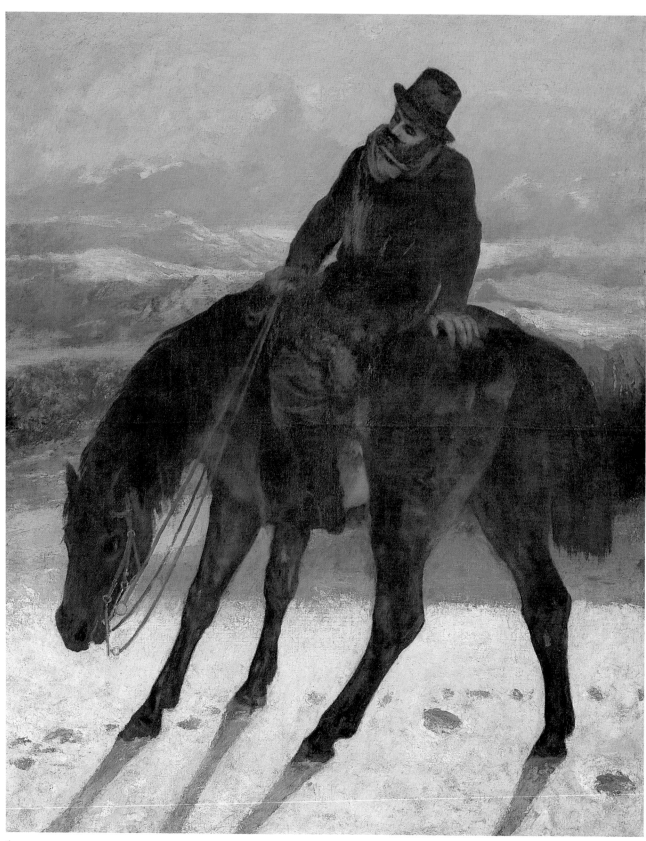

69

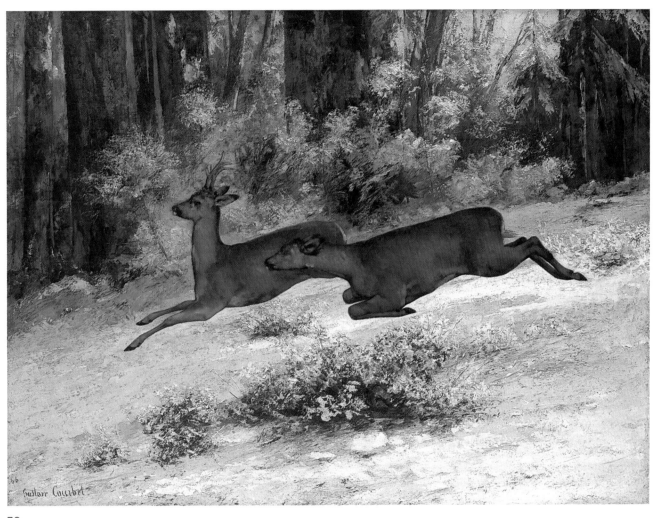

70

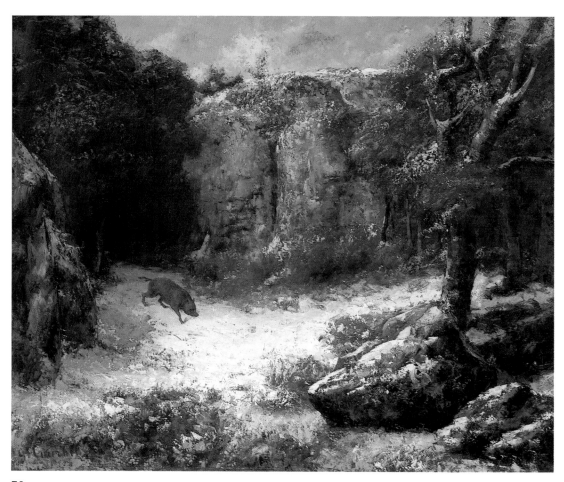

71

hunt paintings could ever conclude with the notion of "an objective naturalist." There is a powerful subjectivity at work in all of Courbet's art and nowhere more than in his paintings of the hunt, a theme that enabled him to assert an indentification both with the solitary, independent hunter and with the proud animals on both sides of the contest—the horse and the dog, the deer and the fox. The Yale painting is an image of isolation and uncertainty, quite at odds with any conventional notion of the triumph of the chase. The massive dark silhouette against the white snow, in which the figure of the man projects beyond the horse's body only in a simple, almost unbroken triangle, creates the idea of man and horse as one unified being. (This unity is arbitrarily reinforced by the fact that over time the dark pigments have sunk into the canvas, obscuring details of the rider's lower body; but the unified silhouette is part of the original conception, regardless of surface detail.) Kane makes a good case for the rider as self-portrait; Marie-Thérèse de Forges leaves the question open, but includes the picture in her study of the artist's self-portraits (Forges 1973, no. 56). A convincing comparison that Kane did not make is with the dark-bearded hunter in the *Quarry* (pl. VI); the resemblance is close enough to make the identification likely, though both must remain conjectural. The sense of melancholy is common to both images.

Hunter on Horseback was shown at the exhibition of his own work that Courbet organized at the Rond-Point de l'Alma in 1867; in the catalogue it was listed among the "studies and sketches" (études et esquisses). Thus despite its size the artist evidently considered it to be something of a first thought, not fully worked out. In part because of the date in the catalogue, it has always been assumed that the painting was made in the winter of 1866–67, when a number of other paintings with snow settings were made (see cats. 70, 71). However Fernier cites a photograph taken by a visitor to Courbet's Ornans studio in 1864 that shows this painting on the wall. S.F.

70. Deer Hunting in the Franche-Comté: The Ruse 1866

Le Change, épisode de chasse au chevreuil, Franche-Comté

Oil on canvas, 38 3/8 x 51 1/8 in. (97.5 x 130 cm)
Signed and dated, lower left: *66 Gustave Courbet*
Literature: Fernier 1977, II, no. 558; Léger 1929, p. 121; Paris 1977, no. 100; Hamburg 1978, no. 253.

Copenhagen, The Ordrupgaard Collection

Few artists have painted snow with the almost palpable pleasure of Courbet. Its various textures and tints—the crystalline crunchiness of packed snow on the ground, the powdery texture of snow on winter foliage, its blue and green coloration when shadowed (as in cat. 72)—all these effects are powerfuly evoked in Courbet's winter landscapes. This tactile illusionism is achieved through both Courbet's brilliant color sense and his immensely physical relation to the material quality of the paint itself, which was applied with brush, palette knife, rags—even fingers. The importance of the snow theme to Courbet is shown by the fact that in the catalogue of his exhibition at the Rond-Point de l'Alma in 1867, this painting and others were listed separately as "Paysages de Neige."

The tension and dynamism of Courbet's hunt pictures are here exemplified in the sense of speed and urgency of the fleeing stag and roe. Although the depiction of the animal's four legs as all in midair is anatomically incorrect, this was an artistic convention that Courbet had inherited from representation of galloping horses. The title refers to a traditional belief among hunters that when two deer are fleeing, one will follow in the tracks of the other to create the impression that only one animal is being chased. A.S.-G.

71. Snowy Landscape with Boar c. 1866–67

Sanglier dans la neige

Oil on canvas, 31 7/8 x 39 3/8 in. (81 x 100 cm)
Signed, lower left: *G. Courbet*
Literature: Fernier 1977, II, no. 551; Rome 1969, no. 28.

Copenhagen, Ny Carlsberg Glyptotek

"Painting," wrote Courbet in his open letter to prospective students, "is essentially a *concrete* art and can only consist of the representation of *real* and *existing* things. It is a completely physical language, which is made up not by words, but of all physical objects. An *abstract* object, being invisible and nonexistent, does not form part of

the domain of painting" (published in the *Courrier du dimanche*, December 25, 1861). Courbet might equally well have said, thereby anticipating modern critical formalism, that a painting is in fact made up of paint itself, which then comes to stand for the physical objects in the material world. But if such a formulation was unavailable to Courbet in 1861, it is nonetheless a perceptible element of his art and one of the reasons he was so profoundly esteemed by later, purely abstract painters.

Snowy Landscape with Boar is in this respect an exemplary painting. The density and complexity of its heavily painted surface extends across the entire pictorial field, a stippled, scumbled, impastoed mesh of whites, rusts, browns, and grays. The fissured rock and foliage, which encloses the clearing and from which the boar emerges, function equally to emphasize and reiterate those aspects of the painting's facture. The relatively small scale of the boar, painted with a brush in thinner paint, is intended less as the landscape's subject than as an animating event within it. There is a kind of porcine wit in the slight exaggeration of the snout and the animal's delicate, probing legs. A.S.-G.

72. Huntsmen Training Hounds near Ornans 1867

Les Braconniers, Ornans

Oil on canvas, 40 1/4 x 48 in. (102 x 122 cm)
Signed and dated, lower left: *Gustave Courbet 67*
Literature: Fernier 1977, II, no. 613; Riat 1906, pp. 217, 246; Léger 1929, p. 122; Rome 1969, no. 32; Paris 1977, no. 102.

Rome, Galleria Nazionale d'Arte Moderna

During the winter of 1866–67, spent largely in Ornans, Courbet made a number of paintings set in a landscape of snow (see cats. 69–70). Of these, the culminating work was the large and very carefully composed *L'Hallali du cerf* (in Besançon), the subject of which is the death of the great stag surrounded by hunting dogs who are dominated by their trainer. Hélène Toussaint maintains that the term *braconnier,* used in modern times only to refer to poachers, in Courbet's time still had the meaning of the men who train the hunting dogs (Paris 1977). There is, nevertheless, a certain ambiguity here: the men carry guns, and the one on the right carries a recently killed fox. It is nonetheless possible that training is involved, since one of the major things the dogs are taught is to keep away from attractive prey until the signal is given.

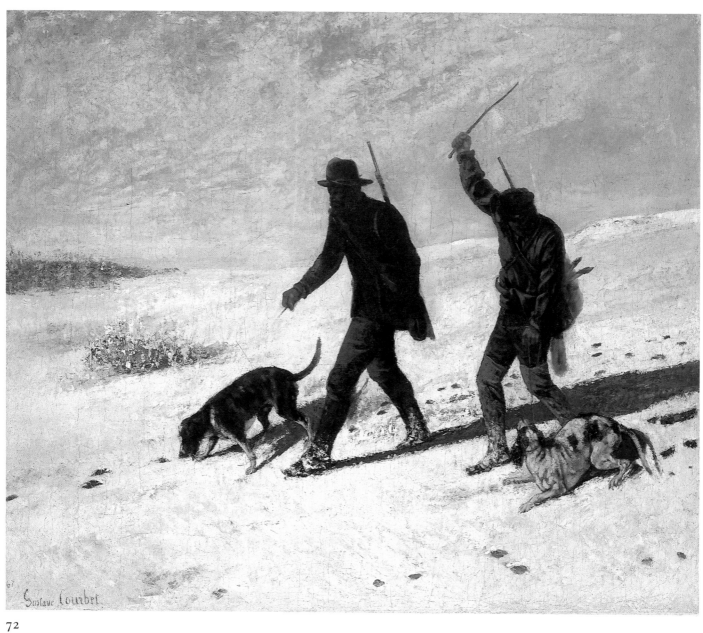

72

The figures are set in a landscape free of everything except sunlit snow and sky: they are silhouetted in light, creating a strong formal pattern together with the emphatic blue shadows. Another version of the theme, at the Musée des Beaux-Arts et d'Archéologie in Besançon, sets the figures in a larger and more diffuse landscape. Though called a replica of the Rome painting by Fernier (1977, I, no. 381), it is incorrectly dated 1864, and there is some question as to its attribution (Paris 1977). S.F.

73. Stag and Doe in the Forest 1868

Chevreuil et chevrette dans la forêt

Oil on canvas, 51 1/2 x 38 1/4 in. (130 x 97 cm)
Signed and dated, lower left: *68 Gustave Courbet*
Literature: Fernier 1977, II, no. 646; Léger 1929, p. 142; Philadelphia 1959, no. 64; Paris 1977, no. 110.

The Minneapolis Institute of Arts, Gift of James J. Hill

The kind of sharp observation and unsentimental tenderness apparent in Courbet's painting of the cattle in the *Rest During the Harvest Season* (cat. 74) is present here in his treatment of forest deer. While refusing to anthropomorphize the animals, Courbet nonetheless conceives the painting in a manner akin to his paintings of nude women in a forest setting (*The Source*, fig. 3.3): both the presence of the stream flowing out of the bottom of the painting and the position of the stag facing into the pictorial space make the painting immediate and directly accessible to the viewer.

There is a somewhat smaller, undated version of this subject, which is published in Fernier (I, no. 487) as dating from 1865, and the Minneapolis painting is called a replica of the latter work. Its recent appearance on the market (Sotheby New York, May 14, 1985, Lot no. 9) made possible an examination, which revealed that the painting dated 1865 by Fernier had instead the characteristics of a later version of an original conception: that is, that it had harder contours, less richness of paint handling in the animals' pelts, and a generally more summary quality of execution. Thus the Minneapolis work, with its masterful combination of solid form and delicate paint handling, should be considered the original version of this particular theme. S.F.

74. The Rest During the Harvest Season (Mountains of the Doubs) 1867

La Sieste pendant la saison des foins [Montagnes du Doubs]

Oil on canvas, 83 1/2 x 97 1/2 in. (212 x 273 cm)
Signed and dated, lower right: *G. Courbet 68*
Literature: Fernier 1977, II, no. 643; Riat 1906, pp. 246, 371; Léger 1929, p. 124; Paris 1977, no. 105.

Paris, Musée du Petit Palais

This is Courbet's last monumental painting on the kind of native rural theme that had inspired his radical paintings of the early 1850s. It is noteworthy that in this late work the chief role is played not by human beings but by animals. He conceived the painting as the equal of the *Remise des chevreuils* (Musée d'Orsay), which had been a success in the Salon of 1866. It is, of course, its equal, if not its superior, but the critics at the time responded cooly to it. As Toussaint remarks (Paris 1977), by this time the theme of cattle in a landscape was so common in conventional French painting that its origins in Dutch painting were forgotten. But Courbet's treatment of the theme is not a conventional one. These cattle—they are oxen, beasts of burden who haul the haywagons—are painted with a knowledge, a sensibility, and a lack of formula entirely unique in the genre. While never other than their bovine selves, never dramatized, they are uncannily endowed with the force of individual beings.

Although the foreground figure of a sleeping woman was later replaced by the mound of hay with still-life objects, the painting remains a part of that large family of Courbet's works on the theme of sleep. Usually confined to female subjects, the theme is here expanded to include male workers and the animals themselves, who share the deep passivity of rest and lassitude. The treatment of the theme in this painting suggests that Courbet's response to the stasis and the vulnerability of sleeping creatures goes well beyond the confines of sexual voyeurism. S.F.

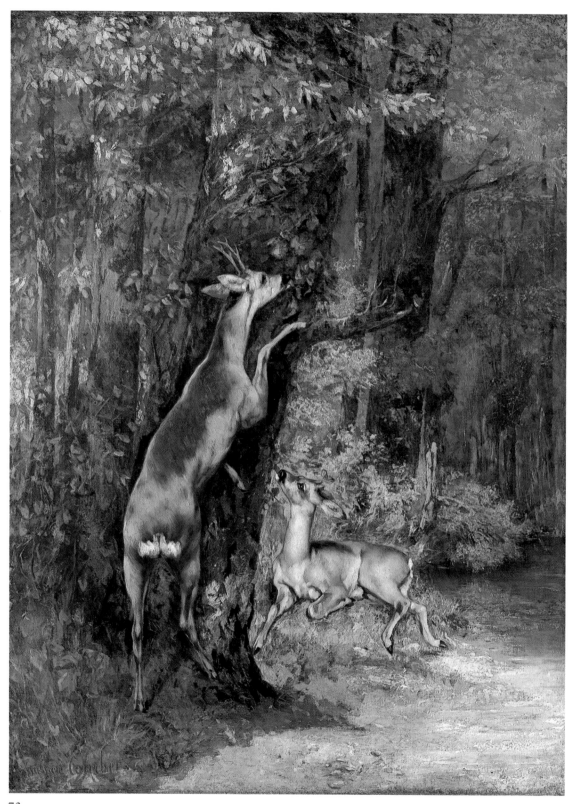

73

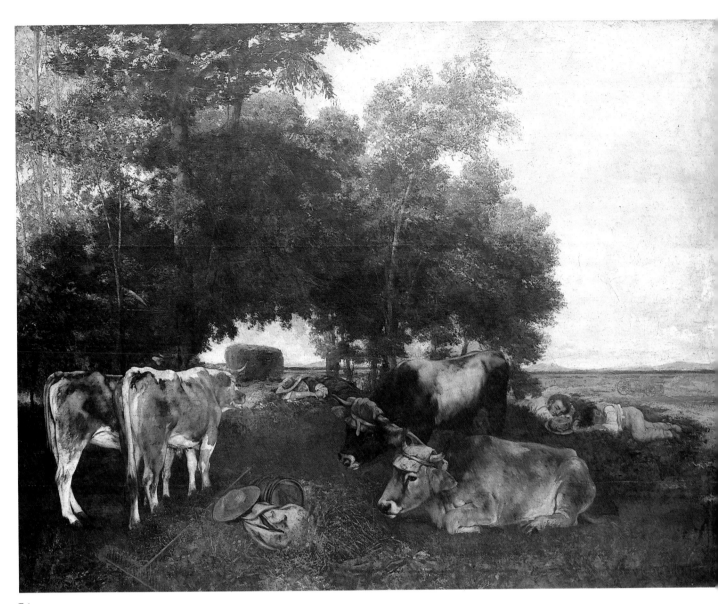

74

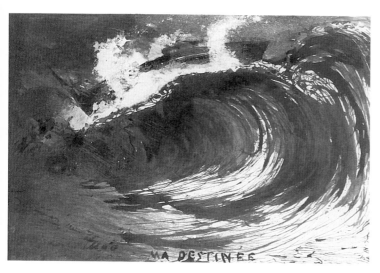

Victor Hugo (1802–85). *Ma Destinée*, 1857. Pen, ink, and gouache. Paris, Maison Victor Hugo.

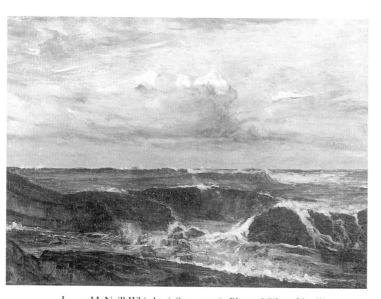

James McNeill Whistler (1834–1903). *Blue and Silver: Blue Wave Biarritz*, 1862. Oil on canvas. Farmington, Connecticut, Hill-Stead Museum.

75. The Wave c. 1869

La Vague

Oil on canvas, 26 5/8 x 42 1/8 in. (67.5 x 107 cm)
Signed, lower left: *G. Courbet*
Literature: Fernier 1977, II, no. 679; Hamburg 1978, no. 287.

Bremen, Kunsthalle

While at Etretat in 1869, Courbet produced a group of paintings of stormy seas in which a breaking wave is the central motif. Among the most remarkable of these is the *Wave,* from Bremen, in which he has created an image of extraordinary immediacy and power. In contrast to the serene seascapes painted at Trouville four years earlier, Courbet was now drawn to the sea in its violent and unbridled aspect. "The sea! The sea! . . . in her fury which growls, she reminds me of the caged monster who can devour me" ("La mer! La mer! . . . elle me rapelle dans sa fureur qui gronde le monstre en cage qui peut m'avaler"), he wrote to Victor Hugo on November 28, 1864 (Roger Bonniot, "Victor Hugo et Courbet," *Gazette des Beaux-Arts* 80 [October 1972]:242). Water was an element to which Courbet was particularly responsive and, as an avid swimmer, one that he could not only paint but immerse himself in totally. Here, he faces his subject head on, identifying with the force of nature to a remarkable degree, indeed almost making the roar of the sea stand as a metaphor for personal freedom.

The great, billowing wave rises up two-thirds of the canvas and is echoed in the threatening clouds that lower above the horizon. By eliminating any kind of mediating foreground space, Courbet brings us into direct physical confrontation with the surge of the ocean. Standing in front of this painting, one has the sense of actually being in the water about to be engulfed by the huge wave, a sensation experienced by Cézanne who described the *Wave* (now in the Nationalgalerie, Berlin) as "a tangle of flying spray, a tide drawn from the depths of eternity, a ragged sky, the livid sharpness of the whole scene. It seems to hit you full in the chest, you stagger back, the whole room reeks of spray" (Fermigier 1971, pp. 112–14).

The Wave is an image of radical simplification for which there is little precedent in Western seascapes, as contemporary critics recognized. Zola (referring to the Louvre *Wave*) praised the work's power and the way it challenged the picturesque conventions and trite symbolism employed by Cabanel or Baudry: "Do not expect a symbolic work in the manner of Cabanel or Baudry—

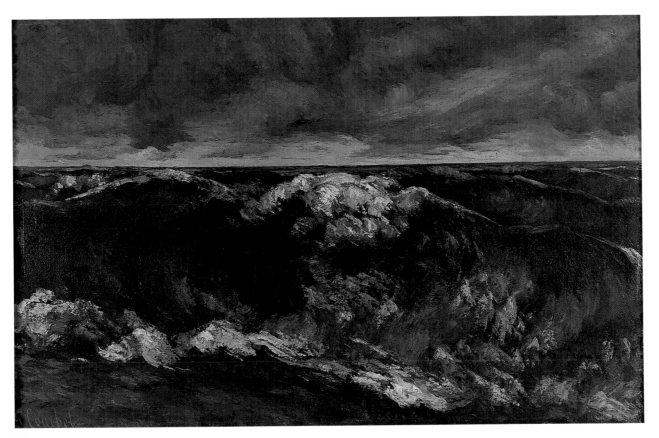

75

some nude woman, with skin as pearly as a shell, who bathes in a sea of agate. Courbet has simply painted a wave . . ." (Emile Zola, "L'Ecole Française de Peinture à l'Exposition de 1878," in *Emile Zola, Salons,* eds. F. W. J. Hemmings and Robert J. Niess [Geneva and Paris, 1959], p. 201). Stormy seas were a popular subject with Romantic painters. Such compositions as Huet's *Grande Marée d'équinoxe aux environs de Honfleur* of 1834 (Paris, Louvre) and his *Brisants à la pointe de Granville* of 1853 (Paris, Louvre), for example, show rough seas crashing against rocks, and in a remarkable drawing by Victor Hugo entitled *Ma Destinée* (1857; Paris, Maison Victor Hugo; opposite, above), a tiny ship is about to be swallowed up by a huge vortexlike wave. But Courbet's *Waves* are exceptional for their dramatically close focus on the wave itself and for the lack of human incident. A significant precedent is to be found in Whistler's *Blue and Silver: Blue Wave, Biarritz* of 1862 (Hill-Stead Museum, Farmington, Connecticut; opposite, below), a work Courbet may have seen, which shows an expansive view of an empty, stormy sea. It lacks, however, the close-up impact of Courbet's powerful wave.

Courbet's paint has an extraordinary material presence. He uses a sonorous blue-green to convey the deep and changing color of the swelling surge of water. Given the relatively modest size of the canvas, his stroke is remarkably gestural. With broad and vigorous handling of the palette knife he has recreated the white curl of foam at the crest of the wave and invested the fluid medium of water with the weight and solidity of his landscape forms. In the *Wave* the wall of water rises up like one of the craggy limestone escarpments of his native Franche-Comté, and the cavelike formation made by the curl of the wave brings to mind the caves and grottoes that appear in Courbet's several renderings of the *Source of the Loue.* A.D.

Katsushika Hokusai (1760–1849). *The Wave*, from *One Hundred Views of Mount Fuji*, vol. 2, 1835. Woodcut. Dartmouth College, Hood Museum of Art, Hanover, New Hampshire, purchased through the Julia L. Whittier Fund.

Claude Monet (1840–1926). *The Green Wave*, 1865. Oil on canvas. New York, The Metropolitan Museum of Art, The H. O. Havemeyer Collection.

76. The Wave 1869

La Vague

Oil on canvas, 29 1/4 x 35 3/4 in. (74.3 x 90.8 cm)
Signed, lower right: *G. Courbet*
Literature: Fernier 1977, II, no. 685; Sotheby's *Important Nineteenth Century European Paintings, Drawings and Watercolors*, May 21, 1987, no. 38.

Tokyo, Gallery Art Point

This is a fine example of a group of *Wave* paintings that Courbet painted at Etretat in 1869 in which the motif is a single wave as it curls over on the point of breaking. Unlike the Bremen *Wave* (cat. 75), which has the appearance of two waves converging, here the reductive simplification results in an almost abstract form. Possibly, the concept of depicting a wave in this way was suggested to Courbet by Japanese prints in which formalized renderings of single waves are frequently found—for instance, by an image such as Hokusai's *Wave* from his 1835 album *One Hundred Views of Mount Fuji* (left above). (Hokusai's albums of prints were more disseminated and collected in Paris than works such as his now more famous single print, *The Great Wave*.*) Courbet's interest in Japanese prints is not documented, but given their wide circulation in artistic circles in Paris in the 1860s, as well as his friendship with such japonistes as Fantin-Latour, Whistler, and Champfleury, who had an impressive collection of works by Hokusai, he can hardly have failed to have seen them. Moreover, his taste for popular prints (Epinal woodcuts for example) would surely have made him receptive to these vigorous and boldly designed Japanese images.

Courbet probably knew Monet's *The Green Wave* (New York, The Metropolitan Museum of Art, left), which was painted when Monet was at Trouville with Courbet, Daubigny, and Boudin in 1865, and in which the stylized treatment of the wave, the flattened space, and high viewpoint are clearly Japanese in inspiration. Courbet's painting, however—despite its simplified motif—conveys a characteristic depth and texture and a sense of the material substance of water that is entirely remote from the linearity and decorative flatness of Japanese prints. A.D.

*I am grateful to Phyllis Floyd for supplying me with this information and for suggesting this example.

76

77

77. The Cliff at Etretat after the Storm 1869

La Falaise d'Etretat après l'orage

Oil on canvas, 52 3/8 x 63 3/4 in. (133 x 162 cm)
Signed and dated, lower left: *70 Gustave Courbet*
Literature: Fernier 1977, II, no. 745; Riat 1906, p. 268; Léger 1929, p.
152; Philadelphia 1959, no. 69; Paris 1977, no. 113.

Paris, Musée d'Orsay

In the summer of 1869 Courbet visited Etretat, a fishing
village near Le Havre on the Normandy coast, which by
the 1860s was rapidly emerging as a tourist resort. The
charm of the place and its celebrated cliff formations—
three huge archways known as La Porte d'Avale, La
Porte d'Amont, and La Manneporte—had attracted
artists since the beginning of the nineteenth century:
Vernet, Isabey, Delacroix, and Boudin had all painted
there. The unusual site inspired Courbet to paint a
whole series of paintings portraying the cliffs from dif-
ferent viewpoints and in varying conditions of light and
weather (Fernier 1977, II, nos. 718–27), and in 1885
and 1886 Monet, partly inspired by Courbet's example,
was to paint a spectacular series of paintings of the
Manneporte.

Delighted by Etretat, Courbet wrote to Castagnary on
September 6: "The country is charming . . . it is very
hot, the bathing is delightful. I have already done nine
seascapes, with which I'm satisfied; tomorrow I'll start
one 1 x .60 meters for the Exhibition. I've never shown
one of this kind" (Lindsay 1973, p. 237). Courbet en-
tered two Etretat paintings, both approximately 160 cm
wide, in the 1870 Salon. The date of 1870 reflects
Courbet's practice of dating a work when he entered it
in an exhibition—in this case, the present work and *The
Wave (The Stormy Sea)*, also in the Louvre. As Hélène
Toussaint has pointed out (Paris 1977), Courbet had
never before painted such large paintings that contained
no animal or human life. In a sense the two paintings
can be seen as pendants, each encapsulating a dominant
mode—the serene and the stormy—of his earlier sea-
scapes. Like the seascapes painted at Trouville, the
Etretat paintings give no hint of the place as a popular
resort. All trace of social existence is banished, leaving
only the beached boats with their suggestion of a de-
parted human presence—a motif that was later to be
taken up by both Monet and van Gogh. In these boats,
the craggy cliffs, and the emptiness of the scene,
Courbet retains the conventions of Romantic landscape
painting, yet, at the same time, he breaks with the Ro-
mantic tradition by excluding any hint of rhetoric from
his composition. The limpid clarity of the rain-washed

light and the harmonious balance of the composition
create an effect of striking simplicity and candor.
Among the many critics who admired the work Castag-
nary especially praised its truth and lack of pictorial ar-
tifice, its "truthful rendering which makes the work of
art disappear, letting us see only nature" ("cette vérité
de rendu qui fait disparaître l'oeuvre d'art pour ne
laisser voir que la nature"; *Salon de 1870*, vol. 1, p. 396.)

In the *Cliff at Etretat*, two poles in Courbet's art—en-
closed forms and limitless space, densely material sur-
face and atmospheric depth—are reconciled. The
stalwart cliff immediately brings to mind the rocky es-
carpments that feature so frequently in the views of his
native Franche-Comté, and, in a sense, the work is as
much a recapitulation of his Ornans landscapes as of his
sea paintings. Among the last landscapes Courbet
painted in France, this work exudes a majestic grandeur
that gives it an air of culmination in his art. A.D.

78. Copy of a Self-Portrait by Rembrandt 1869

Copie d'un autoportrait de Rembrandt

Oil on canvas, 34 1/4 x 28 3/4 in. (87 x 73 cm)
Signed and dated, lower left: *69 G. Courbet*
Inscribed, lower right: *Copie Mée Munich*
Literature: Fernier 1977, II, no. 668; Léger 1929, pp. 148–49; Nochlin
1976, p. 210; Paris 1977, no. 115.

Besançon, Musée des Beaux-Arts et d'Archéologie

In the summer of 1869 Courbet traveled to Munich,
where seven of his paintings, among them the *Stone-
breakers* and *Woman with a Parrot*, were exhibited to en-
thusiastic audiences. The artist was given a triumphant
welcome by local artists and named a chevalier first class
of the Order of Merit of St. Michael by Ludwig II of Ba-
varia. Munich's first International Exhibition was orga-
nized to offer an overview of contemporary currents in
art as well as to present the most significant works by
Old Masters available in south Germany and
Switzerland (Hamburg 1978, p. 305). Courbet's early
and continued regard for the work of seventeenth-
century Dutch and Spanish masters prompted him to
copy three of the exhibited paintings: the *Malle Babbe* of
Frans Hals (fig., p. 194), a *Portrait of a Man* by Murillo,
which has not been identified, and a *Self-Portrait* by
Rembrandt that is still in the collection of the Alte
Pinakothek in Munich, but is no longer recognized as
an original.

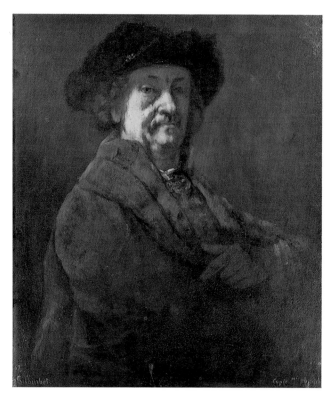

78

Gustave Courbet. *La Sorcière, Copy after Frans Hals*, 1869. Oil on canvas. Hamburg, Kunsthalle.

This portrait of an aging Rembrandt, shown in three-quarter view with features and bearing marked by the pressures and sorrows of time, is the work of a mature Courbet who, as Hélène Toussaint remarks (Paris 1977), still took pleasure in copying the Old Masters, here returning to a practice of the early stages of his artistic development, but now with a certainty of hand and in the full confidence of his own genius.

It is thought that the picture was intended both to simulate the Rembrandt and to exist as a competing, independent work, and indeed, the strong lights and deep shadows of the countenance, painted in thick layers of pigment, register as the materials of Courbet's own personal style. An unconfirmed anecdote would have it that Courbet, in a playful mood, wagered that for a short time the picture could replace the original painting without attracting the attention of museum officials (Hamburg 1978, p. 376). It was, nonetheless, clearly signed *G. Courbet*, and the inscription *copy Munich Museum* establishes it as the work of a proud modern master. R.B.

79. Still Life with Apples 1871–72

Nature morte aux pommes

Oil on canvas, 23 1/4 x 28 3/4 in. (59 x 73 cm)
Signed and dated, lower left: *G. Courbet, 71*
Inscribed, lower right: *Ste. Pélagie*
Literature: Fernier 1977, II, no. 770; Riat 1906, p. 332; Rome 1969, no. 39; Paris 1977, no. 119.

The Hague, Mesdag Museum

Courbet painted a series of fruits and flowers in the winter and spring of 1871–72, when he was serving a six-month prison term for his participation in the Paris Commune. Apart from the large number of floral compositions executed in the Saintonge region in 1862–63, he rarely addressed himself to the still life as an independent composition; nevertheless, as Hélène Toussaint has pointed out, it is a genre in which he excelled (Paris 1977, p. 208). It exists in his oeuvre as an important segment of more extensive figural compositions and is a necessary component of his inclusive and additive vision. It was, however, the circumstances of confinement that generated Courbet's second large cycle of still lifes.

Courbet was arrested in June 1871, for his alleged role in pulling down the Vendôme column during the Paris Commune. After a summer of imprisonment and trial, he was sentenced to a term in Ste.-Pélagie prison, where he had visited Proudhon twenty years earlier. Here he, like the other communards, was treated not as a political prisoner but as a common criminal. At first denied painting materials, he was later allowed them; his subjects were the fruits brought to him by his sister. But it is generally agreed that the fully realized fruit still lifes of this period were most probably made early the following year, when the artist's physical condition made it necessary to complete his prison term in a nursing home at Neuilly, or possibly even after his return to Ornans. The inscription *Ste.-Pélagie* found on many of the works in this series is Courbet's way of directly linking them to the painful and degrading experience of prison. As powerful images of organic life, they affirm the artist's vindication and triumph over the despair he was forced to undergo.

Still Life with Apples is composed of sixteen, vigorously painted fruits and a few fallen leaves sprawled across the lower half of the canvas in a loose, double-tiered pile; they lie beneath a large, cropped tree that is rooted in an enigmatic middle ground and silhouetted against a sketchy expanse of land and sky. The landscape background is unusual for a still life; it provides the apples with a natural setting while its ambiguous space and broadly brushed, muted tones press the coloristically rich fruits to the surface of the canvas.

Werner Hofmann notes the fact that the apple tree served Max Buchon as an analogue for Courbet's naturalness and productivity as a painter, and he proposes that the artist's recurring selection of apples as still-life subjects may spring from the erotic appeal of their rounded forms or from the related idea of fecundity and the bounties of life (Hamburg 1978, p. 313). Although the image is firmly anchored in an empirically observed truth, the blemished condition of these apples, the possibility that they stand in for figures in a landscape, and Courbet's direct reference to his imprisonment in the inscription broadly reflect the painter's own circumstances during this period. R.B.

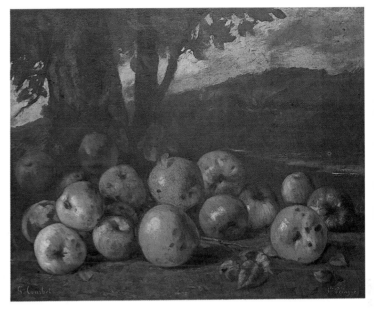

79

80. Still Life: Fruit 1871–72

Nature morte: Fruits

Oil on canvas, 23 1/4 x 28 3/8 in. (59 x 72 cm)
Signed, dated, and inscribed, lower left: *71 Ste. Pélagie/G. Courbet*
Literature: Fernier 1977, II, 776; Riat 1906, p. 330; Léger 1929, p. 167; Philadelphia 1959, no. 79.

Vermont, Shelburne Museum

The clear atmosphere, overall light tones, and cheerful, domestic setting of this painting suggest a date of spring 1872, after Courbet was transferred from the prison at Ste.-Pélagie to the nursing home at Neuilly. "I have never been so comfortable in my life," he wrote to his family on January 4. "I have a large garden to walk in, a pleasant room. I eat extremely well at the family table and there are guests almost every day, good friends" (Mack 1951, pp. 293–94).

The joy of return to normalcy is everywhere evident in this presentation of a table laden with fruits that sits before a large window, unmarred by prison bars, and looks out on a view of bushes, trees, a small house, and a wide, open expanse of sky. A straw basket brimming with garden-fresh apples and pears—some with leaves

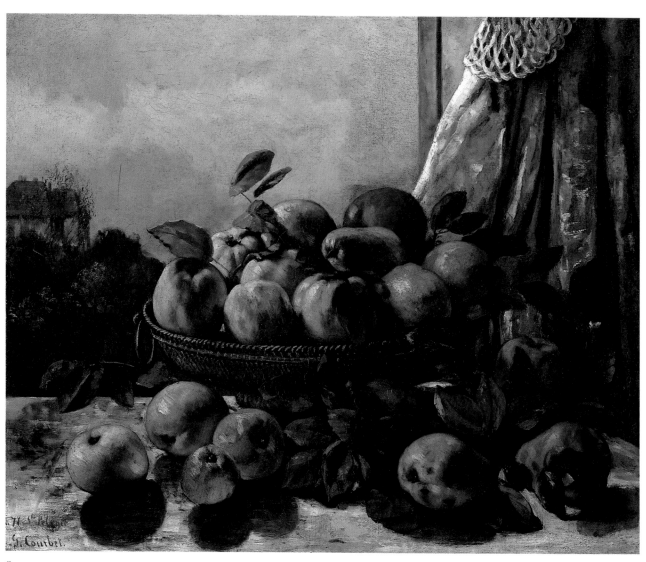

80

and stems still attached—is at the center of the composition; companion fruits and foliage are strewn casually across the upwardly tilted, light-reflecting tabletop: four apples, distinct in size and shape, are displayed in a cluster on the left; a thick bed of green leaves is gathered at center; two pears and one apple lie nestled among the foliage on the right. Solidly modeled, rich in color, and enhanced with a lyrical pattern of dark, cast shadows, the fruits appeal directly to natural sensations of taste, touch, sight, and smell; a background drape, heavy with folds and held by a cropped lace flounce, adds a note of intimacy and protection to the scene.

Two of Courbet's formal modes for fruit still lifes are combined into the structure of this composition: the broad, horizontal display, often set in the outdoors, is the method of arrangement in the foreground (*Still Life with Apples*, cat. 79), and the more concentrated gather-

ing in a dish or platter, usually placed in a dimly lit interior, marks the middle-ground image (*Still Life with Apples and Pomegranate*, cat. 81). The two are complementary images, each an independent compositional unit with its own assortment of individualized forms and grouped configurations. Here they are linked to the background drapery, with which they form a cohesive indoor scene; their relationship to the vista beyond the window pane is spatially ambiguous and may stem from the fact that Courbet was not yet fully freed from the burden of his prison sentence. More likely, it is the natural outgrowth of a vision that sees and transcribes the materials of his subject specifically and cumulatively. R.B.

81. Still Life with Apples and Pomegranate 1871–72

Nature morte, pommes et grenade

Oil on canvas, 17 3/8 x 24 in. (44 x 61 cm)
Signed and dated, lower right: *G. Courbet 71*
Literature: Fernier 1977, II, no. 764; Léger 1929, p. 168; Paris 1977, no. 120; Hamburg 1978, no. 294.

London, The Trustees of the National Gallery
Exhibited in Brooklyn only

This painting, one of the most classic in format of the series, offers a serene arrangement of fruit and simple objects that, as Hélène Toussaint has noted, recalls the tradition of Chardin (Paris 1977). Although it exhibits a greater concern for formal relationships and abstract design than is usually associated with Courbet, it is also anchored in the artist's customarily strong feeling for the physical character of his material and his subject matter. The ripe, red fruits that comprise the composition's central motif are each precisely described, supply contoured, gravitationally weighted, and thick in painterly facture. Set against a dark, neutral background, their brightly illuminated, globular forms function as space creating agents and as subtly varied surface patterns.

An X-ray of this canvas reveals that it was used for an earlier still-life composition with apples and a platter that is unrelated to this image (Paris 1977). R.B.

82. Still Life 1871–72

Nature morte

Oil on canvas, 15 1/8 x 22 1/8 in. (38.5 x 56 cm)
Signed, lower left: *G. Courbet*
Literature: Fernier 1977, II, no. 796; London, The Lefevre Gallery. *Important XIX and XX Century Works of Art*, June 20–July 27, 1985, no. 5.

London, The Lefevre Gallery

This composition is characterized by a clarity of individual forms, a consolidated central image, three, laterally extended planes aligned to serve as a supporting fore- and background structure, and a division of the canvas into dramatically opposing dark and light zones. An illusion of shallow space and an affirmation of the material nature of the subject are conveyed by the rendering of the fruits as firmly rounded volumes stationed on top of a plain white cloth; each is arresting, distinct, and painted with an openly thick and fluid facture. Especially compelling are the open halves of a pomegran-

ate that lie at the base of the mound of fruits at an angle that reveals juice-filled, burgundy kernels in densely packed interiors, the hue and texture of thick membranes, red-brown skins, and light-reflecting, painted surfaces. R.B.

83. Apples and a Pear 1871–72

Pommes et poire

Oil on canvas, 9 1/2 x 12 7/8 in. (24 x 32.5 cm)
Signed and dated, lower left: *G. Courbet 71*
Literature: Fernier 1977, II, no. 778; Philadelphia 1959, no. 79.

Philadelphia Museum of Art, The Louis E. Stern Collection

This rapidly painted display of nine apples, one pear, and a few accompanying green leaves resembles others of the artist's fruit still lifes, and while it records the material nature of the subject, it also moves between the artist's characteristic concentration on individual forms and an impulse toward integration and abstraction. It may have been motivated by a wish to explore the recent procedures and preoccupations of Cézanne and the Impressionist generation. R.B.

84. Head of a Woman with Flowers 1871

Tête de femme et fleurs

Oil on canvas, 21 3/4 x 18 1/4 in. (55.3 x 46.3 cm)
Signed and dated, lower right: *71 Ste.-Pélagie G. Courbet*
Literature: Fernier 1977, II, no. 783; Riat 1906, pp. 332 and 376; Léger 1929, p. 169; Philadelphia 1959, no. 78; Foucart 1977, p. 80.

Philadelphia Museum of Art, The Louis E. Stern Collection

Painted during Courbet's incarceration in the prison of Ste.-Pélagie, *Head of a Woman with Flowers*, like the earlier work entitled *The Trellis*, which was executed in happier days, effects the same audacious reversal in which the flowers dominate the human subject. Foucart, however, has remarked on the somewhat nightmarish and fantastic quality of the painting, in which the flowers—dense, substantial, rendered in a rich impasto—appear virtually to explode from the head of the loosely painted and shadowed model. Thus despite the brightly colored blooms, the fair, reddish hair, a palette described as "a dazzle of clear, transparent, and delicate tonalities" (Riat 1906, p. 332), there is at the same time a distinctly claustral and disturbing quality to the work that is quite unusual in Courbet's oeuvre. A.S.-G.

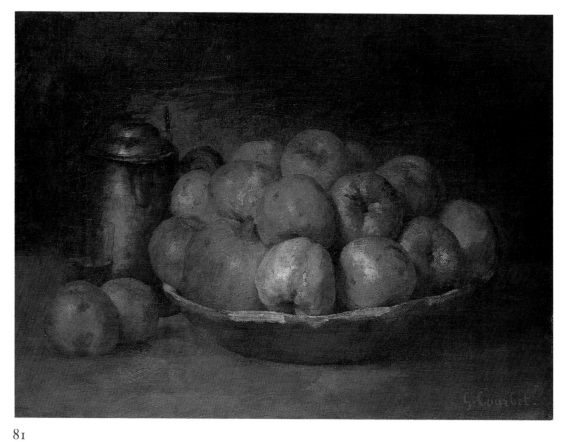

81

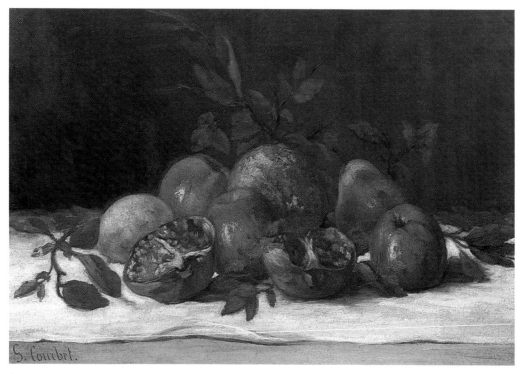

82

83

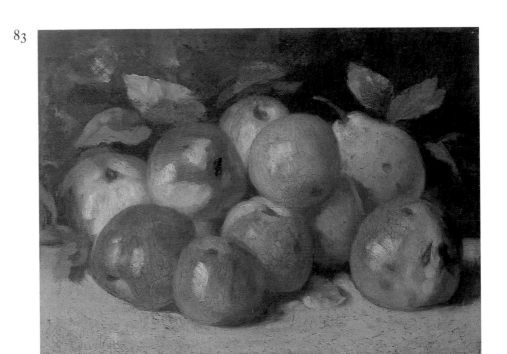

84

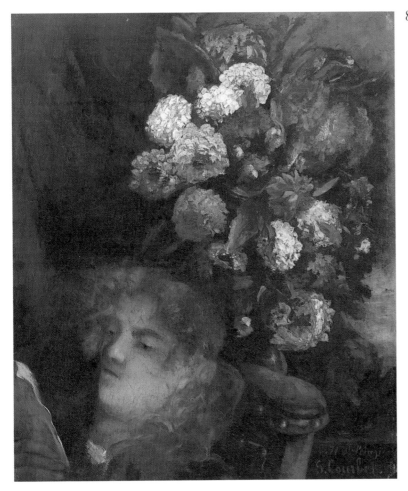

85. The Trout 1872

La Truite

Oil on canvas, 21 5/8 × 35 in. (55 x 89 cm)
Signed and dated, lower left, with inscription: *71 G. Courbet. In vinculis faciebat*
Literature: Fernier 1977, II, no. 786; Riat 1906, p. 330; Léger 1929, p. 178; Philadelphia 1959, no. 82; Paris 1977, no. 123; Hamburg 1978, no. 293.

Zurich, Kunsthaus

86. The Trout 1873

La Truite

Oil on canvas, 25 1/2 x 39 in. (65 x 99 cm)
Signed and dated, lower right: *G. Courbet 1973*
Literature: Fernier 1977, II, no. 883; Rome 1969, no. 42; Paris 1977, no. 125.

Paris, Musée d'Orsay

Paintings of fish, usually as elements of a still life, have a distinguished legacy that flowered in the seventeenth century, when they had figured in Dutch painting, in the Spanish genre known as the *bodegone*, and closer to Courbet's own time, in the work of such still-life masters as Chardin. The appeal of such a subject lay in the sensual qualities it offered as a technical challenge to the painter: the subtle, silvery colors of fish skin, its sheen or opacity, the range of textures from scaly to smooth, and so forth. The rediscovery of these earlier artists and schools, as is well known, was an important tributary to nineteenth-century French Realism, and Courbet was surely familiar with many examples of the motif. Nevertheless, Courbet's own rendering of the still-living and struggling trout, in both the Zurich and Paris versions, is unprecedented for the drama and intensity with which he has depicted the subject. Exceeding a merely aesthetic or purely naturalistic transcription of a river trout caught on a line, Courbet has grippingly conveyed the "sensation of dying rather than the meaning of death" (Nochlin 1971b, p. 72).

The Zurich version of the trout was dated by the artist 1871 and bears the inscription *in vinculis faciebat* (made in bondage). In fact, the painting seems to have been executed in Ornans in late 1872 or early 1873, just before Courbet's final exile in Switzerland. This is suggested by a letter Courbet wrote to Edouard Pasteur, uncle of Max Buchon, the purchaser of the painting, on February 20, 1873. But that Courbet so pointedly in-

scribed and predated the painting signals his profound identification with this image of mortal struggle and entrapment.

In part, the power of the image—particularly in the Zurich version—derives from its constricted, tightly framed space. This claustral and oppressive spatial frame is further emphasized by the dark and agitated paint of the background rocks and the almost equally dark area of the sky. The diagonal formed by the trout's body, bisecting the canvas from upper left to lower right, is stressed by the taut line leading directly to the canvas's edge. This diagonal thus constitutes both the formal axis of the painting and the psychological and dramatic locus of its meaning. Using dense paint and a copious palette knife application, Courbet has worked with a limited, but rich and subtle range of color: umbers, ochres, silvery beiges, and—most movingly—dabs of red blood at the gills and mouth.

The Orsay trout, by contrast, lacks somewhat the intensity and drama of the Zurich version. By composing the trout's body more on a horizontal axis than a diagonal one, and by apportioning more space above it, Courbet has lessened the tension and immediacy of the subject. On the other hand, the range of colors and the virtuoso array of different types of paint application (especially brushstrokes that vary from the delicate, dry brush stipples on the trout's gray sides to an impasto inky green over the trout's spine) are, if anything, even greater than in the Zurich version. A.S.-G.

87. Self-Portrait at Ste.-Pélagie c. 1872

Portrait de l'artiste à Ste.-Pélagie

Oil on canvas, 36 1/4 x 28 3/8 in. (92 x 72 cm)
Literature: Fernier 1977, II, no. 760; Riat 1906, p. 326; Léger 1929, pp. 167, 218; Philadelphia 1959, no. 77; Rome 1969, no. 38; Paris 1977, no. 128; Hamburg 1978, no. 292; Montpellier 1985, no. 33.

Ornans, Musée Gustave Courbet

This late self-portrait represents Courbet in his prison cell at Ste.-Pélagie, where he spent the period between September 22 and the end of December 1871. His letters to friends and family reveal a man embittered by the injustice of his imprisonment and the wretched, humiliating conditions of prison life, but one with his convictions intact. He presents himself here in three-quarter view, at nearly full length, partly reclined against a table before the barred window of his cell; he is *not* attired in

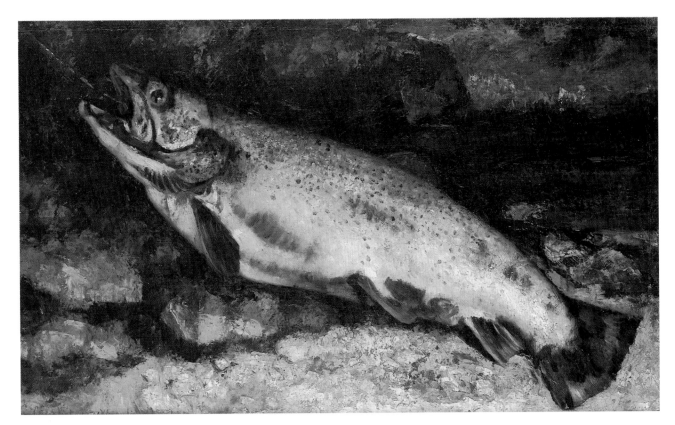

85

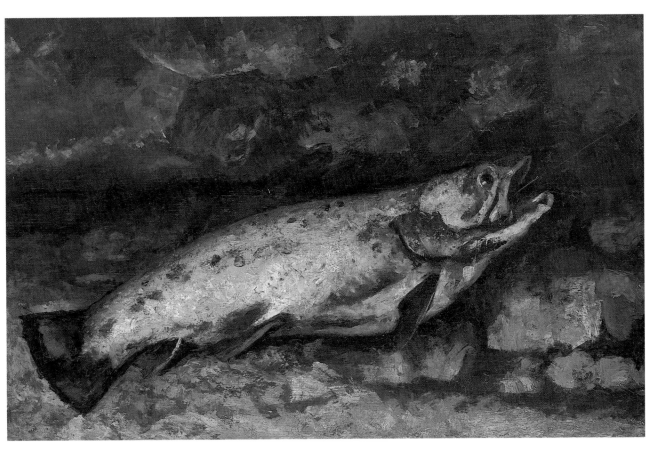

86

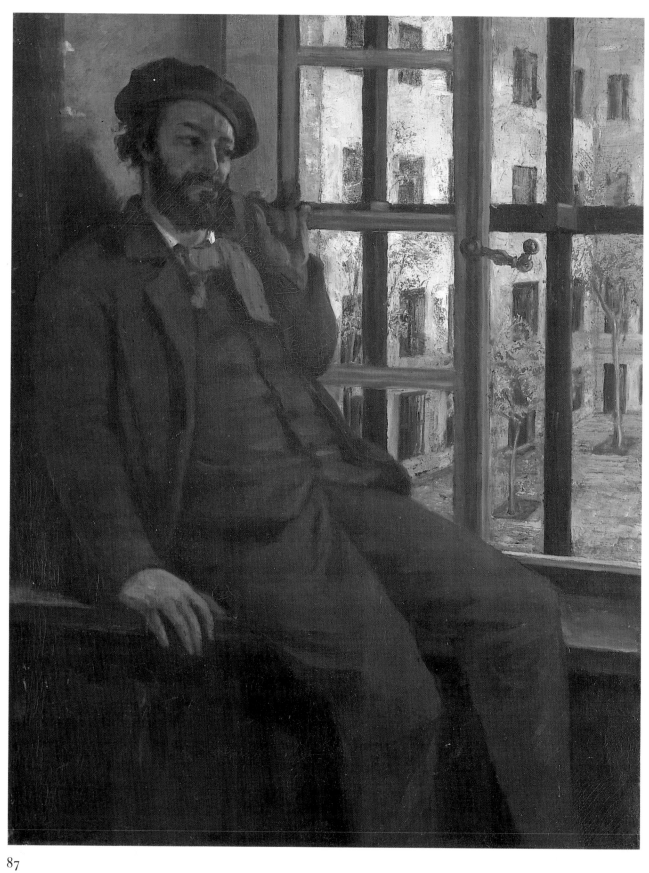

87

the prison garb that he was obliged to wear, but clothed in a brown civilian suit, a gray beret that circles his head like a tiara and is illuminated from behind, and with a bright red cravat that clearly affirms his political sympathies (Montpellier 1985, p. 64). With the pipe that rarely left his mouth and a thoughtful expression on his face, he is an alert and dignified figure who exhibits the handsome, and barely changed, features familiar from self-portraits of two decades earlier, as well as the slim, supple mien of a still agile, but mature man. The view outside the window is of an enclosed courtyard, shut off from the outside world by a stony, seemingly endless wall that prevents even a glimpse of the sky and is punctuated with a series of rectangular apertures that mark the cells of other prisoners. Two wiry and feeble trees rooted in small, unpromising squares of earth are the sole signs of the nature that nurtured the artist's spirit and work for all of his life.

The figure in this painting is remote from the sad truth of Courbet's condition and surroundings at the time, and from the state of mental anguish in which he existed and that he attempted to quell with work—when it was finally permitted him—but it also lacks an optimistic outlook. A comparison with photographs taken in the 1860s when Courbet was at the height of his acclaim (Hamburg 1978, nos. 443–46), or with a *Self-Portrait* drawing of 1871 (cat. 101) that is consonant with his fifty-two years, confirms the deliberate youthfulness of this representation.

Although Courbet's letters openly express nostalgia for a happier time in youth (letter to Julie Joliclenc; Hamburg 1978, p. 310) that may have been a partial determinant for his self-portrait, the image is, in fact, Courbet as he had been and continued to be: an independent, if isolated, figure, anchored in the realities of the moment, yet dominating his environment. This picture springs from the same impulse for myth making that served Courbet in building and manipulating his public image as artist, Bohemian, and peasant in the early years of his career, and it reveals its intention by a sensitive choice of formal language.

Peter-Klaus Schuster notes the presence of a similar grid of prison bars behind the figure of the collector of popular poetry and songs, Pierre-Jean de Beranger, in the frontispiece to his *Collected Works* (Hamburg 1978, fig. 292a), and he cites relationships to sources in Romantic and Christian imagery. Whether Courbet drew upon these sources cannot be determined, but it is quite clear that even though the portrait bypasses the usual conventions of idealization, it is a free interpretation of reality. A more accurate rendering of prison life can be found in Courbet's small sketchbook drawings made while he actually was in prison (Paris, Louvre, Département des Arts Graphiques).

It is generally agreed that this picture postdates Courbet's confinement at Ste.-Pélagie and that it was painted either when he was transferred to Neuilly or when he returned to Ornans late in the spring of 1872. Marie-Thérèse de Forges proposes an even later date: during Courbet's exile at La Tour-de-Peilz (Paris 1977). A letter of 1882 from Juliette Courbet to the Mayor of Ornans, offering to the town this painting and *Chillon Castle,* refers to "two paintings that were made by my brother at my request" (ibid.). R.B.

88. Château de Chillon 1874

Le Château de Chillon

Oil on canvas, 33 7/8 x 39 3/8 in. (86 x 100 cm)
Signed, lower right: *G. Courbet*
Literature: Fernier 1977, II, no. 937; Riat 1906, p. 356; Léger 1929, pp. 191 and 125; *Bulletin,* no. 5, 1949, pp. 16–21; Paris 1977, no. 130; Chessex 1982, no. 112; Montpellier 1985, no. 34.

Ornans, Musée Gustave Courbet

This view of the medieval castle of Chillon, once the stronghold of the dukes of Savoy, was painted during the last years of Courbet's life when he was exiled in Switzerland and living at La Tour-de-Peilz, a few miles away from this site. The castle's history and its dramatic setting on a promontory overlooking Lake Geneva had, by Courbet's day, made it a popular tourist spot and one that already had an established pictorial tradition in illustrated travel books and topographical prints and postcards.

The pressure of Courbet's financial situation in exile and his urgent need to repay the debts that he had incurred following his implication in the destruction of the Vendôme column encouraged him to turn out numerous variations of this popular subject (Fernier includes twenty in his catalogue raisonné of the artist)— as well as other picturesque scenes such as sunsets over Lake Geneva—to satisfy the large demand from collectors and tourists (Chessex 1982, p. 61). Several of these variations are forgeries, and others Courbet painted in collaboration with his assistants in order to speed up production. Not surprisingly, many of them are uneven in quality, but the present work stands out for its fine handling and the unique simplicity of its composition, devoid of such incidental details as sailing boats and foliage found in other renderings of the subject.

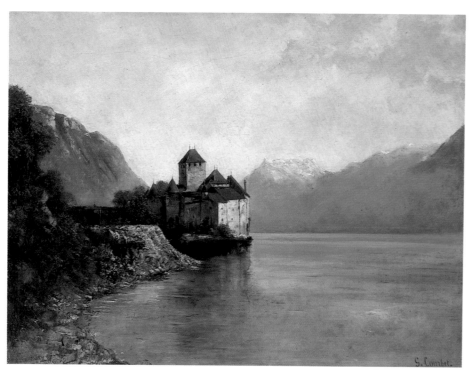

88

In choosing to paint this famous site, however, Courbet was portraying not merely a picturesque view but a place with a particularly rich cultural and historical context. During its long history the castle had housed many political prisoners, of whom the most celebrated was Bonivard, who in 1532 spent four years chained to a column in the dungeons. By the early nineteenth century the vicinity of Chillon, which is the setting for Jean-Jacques Rousseau's *La Nouvelle Héloïse* (1761), became a pilgrimage site for devotees of the book. The castle held a particularly strong appeal for the Romantic imagination, with its penchant for medieval history: Turner included it in watercolors, drawings, and oil paintings after his first visit to Switzerland in 1802, and, with Byron's famous poem *The Prisoner of Chillon* (1819), itself inspired by Bonivard's captivity, the castle acquired a new fame throughout Europe. Visitors flocked to see it, and numerous editions of the poem appeared, many of them illustrated with scenes of Bonivard in prison. The most famous illustration of Bonivard is, however, Delacroix's painting *The Prisoner of Chillon* (1835; Paris, Musée du Louvre). Courbet would surely have been conscious of the cultural resonance of the place and, in view of his own recent imprisonment and exile, its associations with political martyrdom must have held a personal meaning for him (unpublished manuscript, Tom Wolf, Bard College).

Yet in depicting the castle, Courbet eschews a narrative or overtly Romantic approach, presenting instead a peaceful exterior view that is more in the tradition of topographical prints and contemporary photographs produced for the tourist trade. This painting was in fact based on a photograph by Adolphe Braun taken in 1867 (see Scharf 1968, pp. 101–02, and Chessex 1982, p. 62). A.D.

89. Grand Panorama of the Alps with the Dents du Midi 1877

Grand Panorama des Alpes, Les Dents du Midi

Oil on canvas, 59 1/2 x 82 3/4 in. (151 x 210 cm)
Literature: Fernier 1977, II, no. 955; Ann Tzeutschler Lurie, "Gustave Courbet: Grand Panorama of the Alps with the Dents du Midi," *Bulletin of the Cleveland Museum of Art* 53 (March 1966):74–80; Paris 1977, no. 132.

The Cleveland Museum of Art, John L. Severance Fund

This magnificent painting, the last major work of Courbet's life and one that he had intended to show in the Salon of 1877, was incomplete when he died in December 1877. The subject is the alpine range of the Dents du Midi seen across Lake Geneva from its northern shore, a view Courbet would have looked at daily for

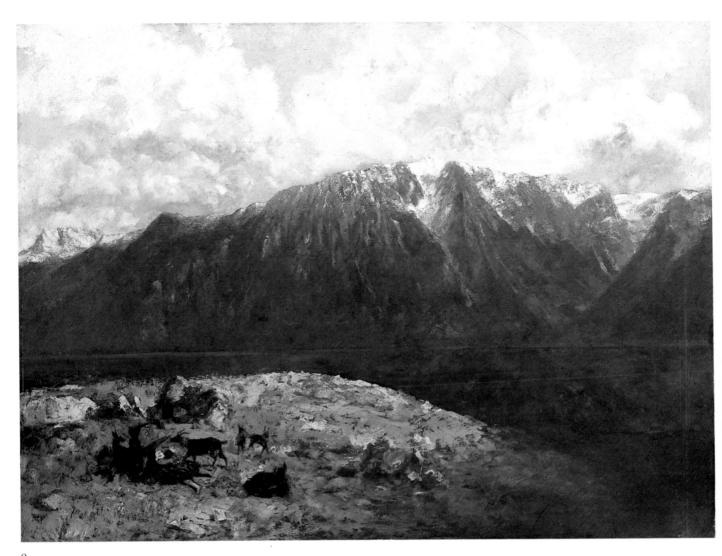

89

the last few years of his life, when he was living in exile
in Switzerland. Despite many visits from friends,
Courbet was unhappy in exile and longed to return to
France. But, according to Castagnary, all such hopes
were dashed when, following a political crisis on May
16, 1877, President MacMahon dismissed the left-wing
premier, Jules Simon, an event that signified the end of
any chance of a pardon for Courbet. A further crushing
blow was the final pronouncement on May 24 of the
penalty fees for the reconstruction of the column:
Courbet was asked to pay the French state the enor-
mous sum of 323 thousand francs. Moreover, by this
time Courbet's health was declining and he had begun
to suffer from the dropsy that would eventually kill him.
The sight of these mountains across the lake must have
been all the more poignant to him when he realized that
he would never be able to return to his homeland. Com-
pletely broken by the events that had befallen him,
Courbet abandoned work on the *Grand Panorama of
the Alps.*

Courbet had intended to send this work to the World
Exhibition of 1878 and had begun by making a large
preparatory study, now in a private collection in Paris.
Although he had made substantial progress with the
finished painting, it remains incomplete. A reddish-
brown area in the right foreground corner reveals the
work's unfinished state and demonstrates Courbet's
typical technique of priming his canvas with dark pig-
ment and then adding the highlights, in this case, crisp
white paint applied with the palette knife that is particu-
larly effective in evoking the thin atmosphere in the
snowy mountain peaks. The emptiness of the scene is
relieved only by the figure of a small girl and the goats
she is tending in the immediate foreground, and these
may have been invented or painted from memory.

The range of mountains stretching across the horizon
share the physical presence and elemental force of
Courbet's *Wave* (cat. 76). Considering Courbet's des-
perate circumstances and the weakened state of his
health when he painted *Grand Panorama of the Alps*, it is
remarkable that he could still summon the reserves to
paint a work of such majesty and power. A.D.

90

90. Portrait of Juliette Courbet 1840–41

Portrait de Juliette Courbet

Lead pencil on paper, 7 1/2 x 8 5/8 in. (19 x 22 cm)
Literature: Fernier 1977, II, no. 15; Paris 1977, no. 133; Hamburg 1978, p. 333, no. 304.

Paris, Musée du Louvre, Département des Arts Graphiques
Exhibited in Brooklyn only

Juliette Courbet (1831–1915), the youngest and the favorite of the artist's three sisters, is the subject of this pencil drawing. Based on physical resemblances to the *Portrait of Juliette at Age Ten,* painted in 1841 (Fernier 1977, I, no 16), and on stylistic correspondences with an early sketchbook now in the Louvre (R.F. 29234; Hamburg 1978, p. 333), this picture is dated 1840–41. It is a youthful work with a degree of figural stiffness that was, by way of an affinity for popular imagery, later to become a significant and much caricatured aspect of the Realist enterprise. The planiform and linear character of the design, the preciseness and continuity of contours, and the clarity of compositional elements indicate a debt to prevailing academic conventions; the integration of figure and surrounding space by means of even hatching and coterminous tones on the left is handled somewhat awkwardly and points to a still fledgling uncertainty.

Clearly evident is the sympathy and affection that were to endure between Juliette and her brother throughout their lives. She was the subject of numerous portraits both as a child and as an adult (see cat. 1) and the sister to whom he most often turned for a model for a variety of compositions. Here her innocence and childlike qualities are captured in a natural and offguard moment, dozing off at the normal schoolgirl task of reading or study. Margret Stuffmann has noted that Courbet's lifelong interest in describing sleep as a state of unconscious being is already apparent in this image (Hamburg 1978). The theme of the figure overcome by sleep while engaged in labor is one with seventeenth-century Dutch precedents, a tradition that directly affected Courbet's development as a painter. R.B.

91

91. Country Nap 1840s

La Sieste champêtre

Charcoal and black crayon on paper, 10 1/4 x 12 1/4 in. (26 x 31 cm)
Literature: Fernier 1977, II, no. 13; Paris 1977, no. 136.

Besançon, Musée des Beaux-Arts et d'Archéologie
Exhibited in Minneapolis only

This softly modeled drawing, with its romantic setting
and poeticized figures, is in the style of Courbet's pre-
Realist self-portraits of the middle and late 1840s. In
choice of materials and method of handling, it reflects
the gradual shift in the artist's graphic technique from
the hard line and precise detailing of earlier images in
pencil (for example, the *Portrait of Juliette Courbet*), to
more fluid, plastic formulations in charcoal and chalk
(Hamburg 1978, pp. 328–29). The muted contours of
the figures and the replacement of linear cross-hatch-
ings for shadowed areas with broadly wiped surfaces ef-
fectively simulate the character of the painter's brush
and indicate a turn from contemporary conventions of
draftsmanship. As in *Lovers in the Country* (cat. 94), a
drawing with similar subject matter, strong dark-light
contrasts contribute to the intensity of mood and corre-
spond to the dramatic content of Courbet's paintings in
this period. It was, possibly, the graphic work of Fran-

çois Bonvin—a close and supportive friend in the
1840s—and the new techniques of lithography that en-
couraged Courbet to explore the painterly potential of
the medium (Hamburg 1978, p. 329).

Country Nap is the underlying motif for the beautiful
self-portrait called *The Wounded Man* (see cat. 9). R.B.

92. Seated Model Reading in the Studio
c. 1845–47

Jeune Modèle au repos

Conté crayon on paper, 22 1/8 x 15 3/8 in. (56.2 x 39 cm)
Signed, lower left: *G. Courbet*
Literature: Fernier 1977, II, no. 32; Hamburg 1978, no. 317; *Great
Drawings from The Art Institute of Chicago*, exhibition catalogue, 1985,
p. 139, no. 92.

The Art Institute of Chicago, Simeon B. Williams Fund

This drawing dates from the mid-1840s, when there
was a discernible shift in Courbet's graphic style from a
generalized and linear handling of form to a softening of
contours and surfaces and an increased use of dramatic
chiaroscuro contrasts (cats. 93 and 95). *Model Reading in
the Studio* utilizes both aspects of style, displaying a
masterly control of the draftsman's medium and a quali-

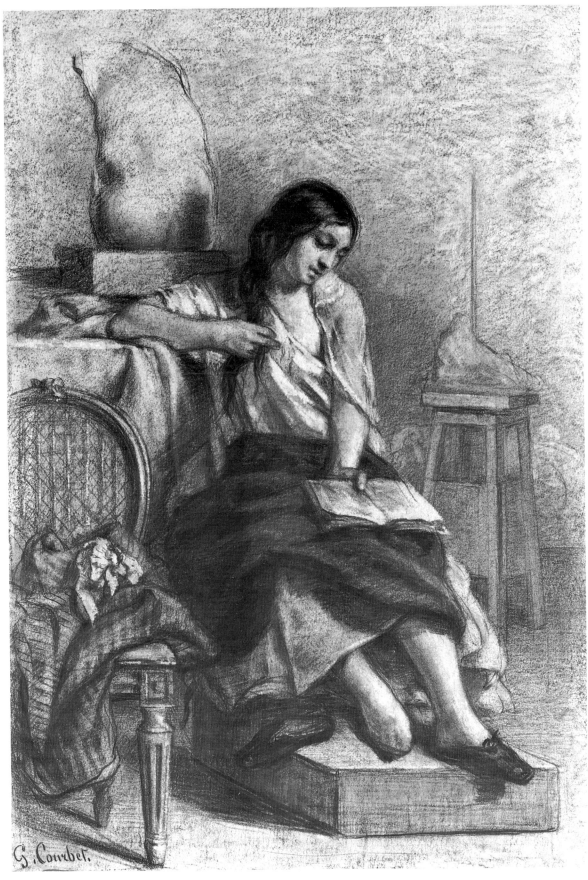

G. Courbet.

92

ty of painterliness achieved by the malleability of charcoal and chalk. It is an image of absolute clarity and precision, related to the artist's earlier pencil and pen drawings by a similarly firm, continuous, and varied use of line, but with more deliberately massed areas of darkness—as for example, the model's hair, lap cover, and shoes—and the replacement of parallel- and cross-hatch marks with a more fluid and rubbed technique for the rendering of shadows (see cat. 90). The picture's surface is animated by a simultaneous juxtaposing and contiguity of subtly graded and sharply opposing tones, which are demonstrated in the even transitions within the striped cloth and chair caning immediately to the left of the dark and white extremes in the model's form. A relatively capacious space is rendered by gradually receding planes and volumes that describe complementary and contrasting objects: the angularity and hard texture of the model's platform and the leg of the chair, followed by the soft, crumpled drapery, the rounded shape of the chair back, and the alternating forms behind.

Although it has been proposed that the content of the drawing may reside in the antipodal concept of nature and art (Hamburg 1978), the theme inverts the traditional image of the studio as the work space and domain of the painter and the materials of his work. The concentration here is on the model, the tiring effects of her labor, and her artless posture and preoccupation between sittings. The completeness and casualness of her figure set in front of a fragment of classical sculpture addresses the issues of endurance and the relationship between life and art. R.B.

93. Self-Portrait with Pipe 1846–48

L'Homme à la pipe

Conté crayon on bluish paper, 11 x 8 1/8 in. (27.9 x 20.6 cm)
Signed, lower left: *G.C.*
Literature: Fernier 1977, II, no. 30; Nochlin 1976, pp. 46–48; Clark 1973a, p. 45; Forges 1973, no. 45; Hamburg 1978, no. 309.

Hartford, Wadsworth Atheneum, J. J. Goodwin Fund

With this beautiful drawing, composed as if planned as a finished work (Nochlin 1976, p. 48), the disparate ingredients with which Courbet forged his mature Realist style stand ready for final shaping: candor, directness, and informality combine with a subtle measure of ambiguity and with a deliberate striving for concreteness. Courbet no longer chooses to represent himself in one of many artificially imposed, popularized Romantic

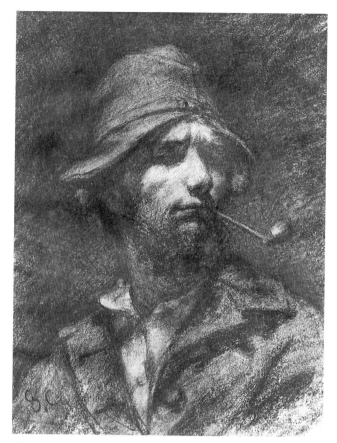

93

guises—in costume, or as sculptor, lover, martyr, musician, or even as the beautiful, sensitive Bohemian compellingly on display, as he is in the oil painting *Man with a Pipe* (cat. 8). Even though the residue of these tested pathways is, to some extent, still present in this image, it is primarily a portrayal of Courbet as he appeared to himself and to his inner circle of friends as he began to integrate the materials and experiences of the provincial world of his birth with a sophistication gained in the literary and artistic circles of cosmopolitan Paris and in his exploration of traditional and popular sources.

Dressed in casual and informal attire, his pipe clenched firmly between his lips, a huntsman's cap pulled down just far enough partly to reveal and partly to shade the structure of the head, he offers himself as a handsome young countryman, comfortable with his origins and proudly independent in his personal identity, but still straining to make an impression. It is, in certain respects, a rendering of the Courbet who, in Castagnary's words, "held court" at the Brasserie Andler, carefully calculating his effect on the people who came there to see him, a young man whose character and imminent emergence as an original artist reveal themselves here in what Clark terms the "contrary readings" that the image fosters (1973a, p. 45): a continued affectation

in pose, now partly dispelled by the simplicity and concrete details of country attire; a self-consciousness of stance; firm contouring and solidly plastic forms that result in a figure clearly detached from its surroundings, but also joined to the darkened background by a similar combination of energetic charcoal markings, painterly surfaces, and a more varied but analogous scale of values.

At issue in this lively and carefully organized portrait is the degree to which Courbet permits the viewer to penetrate the single and combined aspects of a multifaceted personality. The figure's distant air affirms the separate spheres of observer and observed, yet it is also made accessible by a closeness to the picture plane and, despite the heavy overlay of shadow, by the solidity of its physical parts. It is this tangibility that points in the direction of an emanating Realist style.

It is probable that this drawing follows at least three other self-portraits with a pipe: a sketch in a notebook now in the Louvre (RF 29234 fol. 23 recto; Paris 1977, no. 19); an image executed in crayon using the blurred and softer techniques of earlier drawings (Cambridge, Mass., Fogg Art Museum; see Hamburg 1978, p. 339, fig. 309a); and the oil painting in Montpellier (see cat. 8). It is of some interest that Courbet used the pipe as a personal signature: on his departure from Munich in 1869 he left a memento of himself in the form of a sketch of his pipe with the inscription, *Courbet sans idéal et sans religion*. Given the fact that the pipe is also included in the last of the self-images, *Self-Portrait at Ste.-Pélagie*, it is safe to assume that these paintings and drawings constitute a body of work of a particularly strong personal and revelatory character. R.B.

94. Lovers in the Country 1847

Les Amants dans la campagne

Charcoal on paper, 16 5/8 x 12 1/4 in. (42 x 31 cm)
Signed and dated, lower left: *G. Courbet/1847*
Literature: Fernier 1977, II, no. 23; Hamburg 1978, no. 307.

Zurich, Dr. Peter Nathan

This drawing, with some minor changes, reproduces the design of two oil paintings, one of 1844 now in the Musée des Beaux-Arts in Lyons (opposite), and one in the Petit Palais in Paris, dated by Hélène Toussaint "after 1844" (Paris 1977, p. 89). It is probably, but not certainly, an intermediary work, with compositional links—such as the retention of the hand and forearm of the young man—to the Lyons picture, and with the dis-

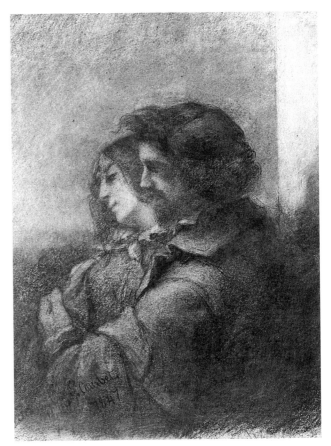

94

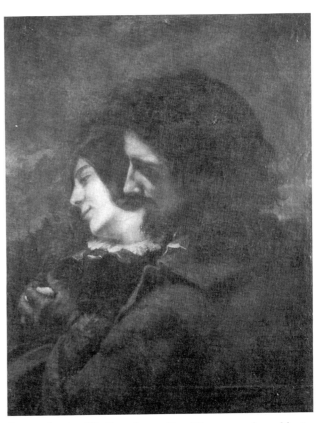

Gustave Courbet. *The Happy Lovers*, 1844. Oil on canvas. Lyon, Musée des Beaux-Arts.

95

95. Portrait of a Man (Urbain Cuenot?)
c. 1847

Portrait d'homme (Urbain Cuenot?)

Charcoal and chalk, heightened with white, on blue-gray paper,
16 1/8 x 11 in. (41 x 28 cm)
Literature: Fernier 1977, II, no. 58; 1974, p. 391; Hamburg 1978, no.
310; George Goldner, *Master Drawings from the Woodner Collection*,
Malibu, J. Paul Getty Museum, 1983, no. 63.

New York, Ian Woodner Collection

According to Fernier, this is a portrait from the 1860s
and represents either the engraver Félix Bracquemond
or the artist's friend Félix Gaudy (Fernier 1977, II,
p. 306), a wealthy landowner and enthusiastic hunts-
man who was a senator for the Département du Doubs.
But Margaret Stuffman (Hamburg 1978) has argued
convincingly that the subject of the drawing closely re-
sembles that of the portrait of Urbain Cuenot in the
Pennsylvania Academy of Fine Art. Also the tenebrist
style of the work puts it closer to the 1847 date of the
Hartford drawing (cat. 93; Goldner 1983).

In both images there is an unconventional handling of
the medium that declares itself as an effort to find paral-
lels for the viscous facture of paint; the choice of a rela-
tively thick blue-gray paper for this and other drawings is
thought to have been intended as a correspondent for the
coarser texture of canvas (see Hamburg 1978, p. 329).

The deep and enduring attachment between Courb-
et and Cuénot stems from their formative years at
Ornans. In 1841 they made a trip together to Le Havre
for a first glimpse of the sea; they were part of a
Bohemian circle that included Marc Trapadoux, Al-
phonse Promayet, and Max Buchon; and they were
labeled politically dangerous following the coup d'état
of 1851 (Clark 1973a, p. 100). Cuenot was Courbet's
model for the figure of the saint in *St. Nicholas Raising
the Children from the Dead* (1847; Doubs, Eglise de
Saules); and it is his house that was the locus for the
After Dinner at Ornans (1848–49; Lille, Musée des
Beaux-Arts), the artist's first major Realist work. In the
Painter's Studio he stands on the right between P.-J.
Proudhon and Max Buchon.

The pose of the figure approximates that of the
Philadelphia portrait. The handsome face, the
thoughtful gaze, the angle of the shoulders, and the
somewhat stiff posture recall the ceremonial pose and
absorbed expression of St. Nicholas, although that
figure is seen from the left, rather than from the right
profile, and with a lower incline of the head; a short
haircut and a similarly well-shaped, exposed ear are
details that correspond in both images. R.B.

solving contours and the closer massing of male and
female figures of the Paris version. Aspects of style and
the 1847 date on the drawing reinforce a closer connec-
tion to the Paris image.

The choice of charcoal and chalk, which permit a
ready transition of tones and a softening of surfaces, is
part of an effort to achieve painterly effects in the
graphic medium, and is a feature of Courbet's develop-
ment as a draftsman. Here these materials serve as
equivalents for the mellifluous flow of paint, and are
used to produce a gentle, tonal image consonant with
the romantic spirit of the paintings.

The figures represented in *Lovers in the Country* are
the artist himself and Virginie Binet, a woman with
whom he had a long liaison and who bore him a son in
1847. The two are locked in an embrace that originally
may have been a dance to an accompanying waltz melo-
dy (Paris 1977, p. 89). It is, in any case, an image that
captures a moment of youthful abandon to the ideas of
romantic love. R.B.

6

96. A Burial at Ornans 1848

Un Enterrement à Ornans

Charcoal on bluish paper, 14 5/8 x 37 3/8 in. (37 x 95 cm)
Literature: Fernier 1977, II, no. 31; Schapiro 1941; Clark 1973, p. 81;
Paris 1977, no. 139; Hamburg 1978, no. 313; Mainzer 1981; Mayaud
1981; Mainzer 1982, pp. 75–77.

Besançon, Musée des Beaux-Arts et d'Archéologie
Exhibited in Brooklyn only

In this drawing we have what is rare in Courbet's oeuvre, a preliminary sketch for a painting—in this case a large, complex, and highly significant work (see pl. 1 and chapter 1). Although the drawing differs in many important respects from the painting (see Clark 1973a, p. 81), the essential elements are present: the additive, friezelike composition, deliberately lacking in hierarchical or dramatic focus; the sense of the massed, black-clad figures of the rural bourgeoisie in their top hats, frock coats, full skirts, and shawls; the separate grouping of men and women and the substantial group of clerical figures; the central presence of the two "men of '93," the older Revolutionary generation; the kneeling gravedigger; the young acolytes; and even the dog; the sense of specific place indicated by the line of cliffs and the steep slope of the Château d'Ornans at the left background. Comparison of the drawing and painting makes plain the extent to which Courbet was a *painter* who composed and created form directly on canvas, as well as the very un-Academic character of his drawing style.

The drawing is usually dated to 1849, since the first evidence of Courbet's beginning to paint the *Burial* is from late in that year (Riat 1906, p. 76). Recent archival research by Claudette Mainzer has suggested reasons for dating the drawing to the fall of 1848 (see chapter 6). Mainzer's identification of the burial as that of Courbet's great-uncle Claude-Étienne Teste adds significantly to our understanding of the work. The event had a multiple meaning for Courbet. The dead man was part of his family, and many of the mourners can be identified as family members or friends of the artist (see Mayaud 1981). The ceremony, which inaugurated the new town burial site (see chapter 6), represents the victory, in the revolutionary year of 1848, of the secular, progressive forces in this particular corner of the Franche-Comté. And, the relationship of Teste was to Grandfather Oudot, who was for the young Courbet a model of republican virtue; both older men were members of the heroic generation of the Revolution. In the painting—though not in the drawing, where the figures are not identifiable—Courbet emphasizes this connection in a way that sheds light on the complexity of his realism: the figure at the far left of the painting is none other than Grandfather Oudot, taking his place among his brother-in-law's mourners in spite of the fact of his own death a month prior to the ceremony.

These discoveries illuminate the question of the origins of the *Burial* and its meaning for Courbet. Mainzer's suggestion, however, that the drawing was made at the funeral itself is most unlikely, since the artist was one of the mourners. The drawing may very well have

been made sometime during the the autumn of 1848, and have remained the concept of a painting that Courbet could only realize on the ambitious scale he desired when he acquired a larger studio in Ornans in the autumn of 1849. S.F.

97. Portrait of Zélie c. 1850

Portrait de Zélie

Crayon and wash on paper, 12 3/4 x 8 in. (32.4 x 20.3 cm)
Signed, lower right: *G. Courbet*
Literature: Atlanta, High Museum of Art, *The Henry P. McIlhenny Collection: Nineteenth Century, French and English Masterpieces*, 1984, no. 15.

Philadelphia Museum of Art, The Henry P. McIlhenny Collection in Memory of Frances P. McIlhenny

Zélie Courbet (1828–75), the artist's middle sister, was the most gentle and pious of the three women. Her fragile health was unusual in the family and may be the reason that she never married and died at a relatively early age. Like her sisters, Zoë and Juliette, she appeared in several of her brother's compositions, notably

97

the *Young Ladies of the Village* (cat. 14), and she may have been the model for the *Sleeping Spinner* (cat. 16). In the Musée Courbet in Ornans, a drawing of Zélie seated, half-length (Fernier 1977, II, no. 39) shares similar features, though the face is given a somewhat different shape by a different and more flattering way of dressing the hair. R.B.

98. Pierrot and the Black Arm 1856

Le Bras noir

Conté crayon on paper, heightened with white, 18 5/8 x 20 3/8 in. (47.3 x 51.8 cm)
Signed, lower right: *G.C.*
Literature: Fernier 1977, II, no. 42; Léger 1929, p. 68; Clark 1973a, pp. 54ff; Hamburg 1978, no. 318; Chu 1980b, p. 80.

Ottawa, The National Gallery of Canada/Musée des Beaux-Arts du Canada

The drawing *Pierrot and the Black Arm*, originally in the collection of Champfleury, was made for the premiere, on February 8, 1856, at the Théâtre des Folies-Nouvelles, of *Le Bras Noir*, a verse-pantomime play by Courbet's friend, Fernand Desnoyers. A wood engraving, smaller and different in detail from the original, was made as the title page to a text distributed to the audience to explain the pantomime; a later, and better reproduction from the drawing appeared in *L'Illustration* (Hamburg 1978) and in several subsequent publications (Mimi C. Taylor, unpublished essay in the National Gallery [Ottawa] files, p. 2). This drawing, which was lost for decades before recently reappearing in a private collection, is one of the finest works in Courbet's relatively small and uneven corpus of graphics.

Little is known about the commission of the drawing, but the interest in popular theater in advanced intellectual circles in France during the 1840s and 1850s, as well as Courbet's friendship and close association with Champfleury—who was an ardent promoter and author of pantomime plays—coupled with the painter's use of popular imagery as a source for his own work, establish him as a logical candidate for such an assignment. That he responded to the request by producing a full-scale drawing rather than a simple woodcut design suggests either a greater interest in the medium's potential than is usually thought and/or a strong interest in the play, the character, and the view—which he shared with Champfleury—of the popular theater as an effective arena for artistic freedom and social criticism. More-

98

over, it was fairly common among photographers in the 1850s to present acclaimed performers in the roles for which they were famous. Here the lead part is played by the actor Paul Legrand, the foremost Pierrot of the day. Courbet's portrait of the opera singer Louis Gueymard in the role of Robert le Diable is a work in a similar vein executed in the following year (New York, The Metropolitan Museum of Art).

The commedia dell'arte is the source for Pierrot, the adored hero of nineteenth-century theatergoers and the subject of numerous paintings by distinguished artists. Briefly summarized, the plot of *Le Bras Noir* involves Pierrot's battle with Scapin, his evil rival, for the unrequited love of the flirtatious Nina, over a stolen bag of gold. In the course of the struggle each loses an arm, Scapin is killed, and Scapin's black arm is attached to Pierrot's shoulder by the stock character, Dr. Roidamos. Pierrot, trapped by a farcical tension between the good and honest white arm and its brutal and thieving counterpart, finds himself embroiled in a series of unwilled, mischievous deeds until, in an escapade with the police, the black arm is disconnected. While it now becomes a symbol for evil and continues to haunt him for the duration of the play, it is at this point that

Nina returns with the stolen bag of gold, flees, and Pierrot's goodness and virtue are restored.

Courbet has chosen the high point of the drama as his subject, and as Margaret Stuffmann points out, he seems to have taken the play's moral significance "quite seriously in that he reduced all the scenic anecdotal elements and concentrated entirely on the dualism in Pierrot and the appearance of the black arm" (Hamburg 1978, p. 348). R.B.

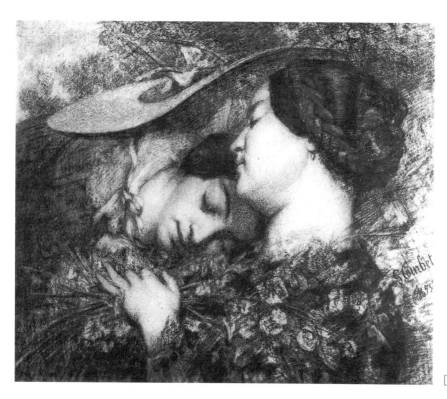

☐ 99

99. Young Women in a Wheatfield 1855

Les Femmes dans les blés

Conte crayon on paper, 18 1/8 x 22 in. (46 x 56 cm)
Signed, lower right: *G. Courbet 1855*
Literature: Fernier 1977, II, no. 40; Riat 1906, p. 150; Forges 1973,
p. 12; Hamburg 1978, p. 327.

Lyon, Musée des Beaux Arts

This drawing has often been called a study for the *Young Ladies on the Banks of the Seine.* However, it was exhibited in Courbet's 1867 exhibition at the Rond-Point de l'Alma with the title *Les Femmes dans les blés.* In the same catalogue, an oil study for the *Young Ladies on the Banks of the Seine* was listed with that specific title. This would seem to indicate that in the artist's mind the drawing was not closely linked to the painting. Of course the theme of two women drowsing together in an outdoor setting is common to both works, but there are a number of features that distinguish the drawing from the painting. The pose of the drawing is more intimate, recalling that of the pair in the *Country Nap* (cat. 91), but paradoxically the figures project an innocence far removed from the atmosphere of the Parisian demimon-daines. The figures in the drawing appear to be country women, of the type of Courbet's sisters, very different from the kind of women to be found on a Sunday outing in Aisnières or Courbevoie. The sheaf of wild flowers in the arm of the right-hand figure in the drawing creates quite a different effect from that of the blossoms in the lap of the gloved figure in the *Demoiselles.* The painting is unique in Courbet's work for the number of known oil studies: six of them, some of both figures and some of single figures or parts of figures, but all close to the final work in a way that the drawing is not. That said, it remains true that the pictorial idea, a variation of one of Courbet's most persistent themes—that of the sleeping woman—links the two works. As far as we know, the drawing, with its atmosphere of rural innocence, is the first statement of this particular variation of the theme. Another version of the subject, squared off as if prepared for engraving, is in an American private collection. S.F.

100. Portrait of François Sabatier 1857

Portrait de François Sabatier

Conté crayon on paper, 13 3/8 x 10 1/4 in. (34 x 26 cm)
Monogrammed (twice), left: *G.C.*
Literature: Fernier 1977, II; no. 39; Paris 1977, no. 140; *French Drawings From the Collection of the Musée Fabre,* The Trust for Museum Exhibitions, Washington, D.C., 1986, no. 53; Montpellier 1985, p. 30, fig. 8.

Montpellier, Musée Fabre

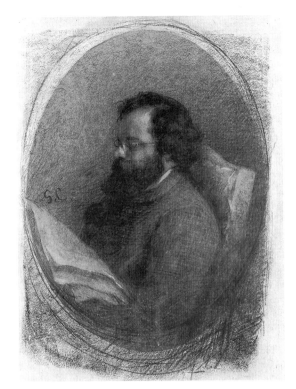

100

Among the friends whom Courbet met during his stay with Alfred Bruyas at Montpellier in the summer of 1854 was François Sabatier (1818–91), a critic, poet, patron of the arts, and a dedicated Fourierist. It was Sabatier, writing under the name of Sabatier-Ungher (his wife was the celebrated opera singer Caroline Ungher), who had been the only critic outside Courbet's circle in 1851 to grasp the true importance of his work (see chapter 1, above).

Although the date for this small drawing of Sabatier is usually given as either 1854 or 1857, both years when Courbet made extended visits to Montpellier, Philippe Bordes argues persuasively for the later date. A letter from the artist to his sister Juliette, written just before the end of his 1854 visit, reports that during these months he had given Bruyas the pleasure of painting only for him (Montpellier 1985, p. 30). Thus the two landscapes of Sabatier's own property, *La Tour de Farges* and *The Bridge at Ambrussum* (Musée Fabre, Montpellier), are also dated to 1857, when Courbet was Sabatier's guest.

Sabatier's Republican politics and Fourierist principles—ideals that he shared with Courbet—obliged him, following the coup d'état in 1851, to abandon his Paris residence and divide his time between the Hérault and a villa in Florence. In Courbet's momental *Painter's Studio* of 1855 the couple who appear at the extreme right, just after Baudelaire, and who are designated "a woman of the world and her husband" are usually assumed to be François and Caroline Sabatier-Ungher. Hélène Toussaint argues that the two more closely resemble Mme. Apollonie Sabatier, well known for her intellectual and artistic salon, and her lover, Alfred Mosselmann, a Belgian aristocrat (Paris 1977, pp. 258–60). However, given the social, political, and aesthetic ideals that Sabatier and Courbet shared, the Sabatier-Unghers are more likely candidates for a place among the "lovers of art" than the other pair, whose intimate circle included Gautier and other *literati* hostile to Courbet.

For many years this drawing was thought to represent P.-J. Proudhon, the philosopher and friend whose posthumous portrait Courbet painted in 1865, and whose bespectacled countenance and rounded proportions bear a resemblance to this figure. It was not until 1943 that Jean Claparède, curator of the Musée Fabre in Montpellier, recognized the sitter as François Sabatier, whose bequest had entered the museum's collection following his death in 1891.

This image is a casual portrayal of Sabatier reading a newspaper, with an oval framing device executed in chalk lines that gives it the character of a vignette. The initials "G. C." appear both below and above the newspaper; the upper monogram may not be authentic (Paris 1977). R.B.

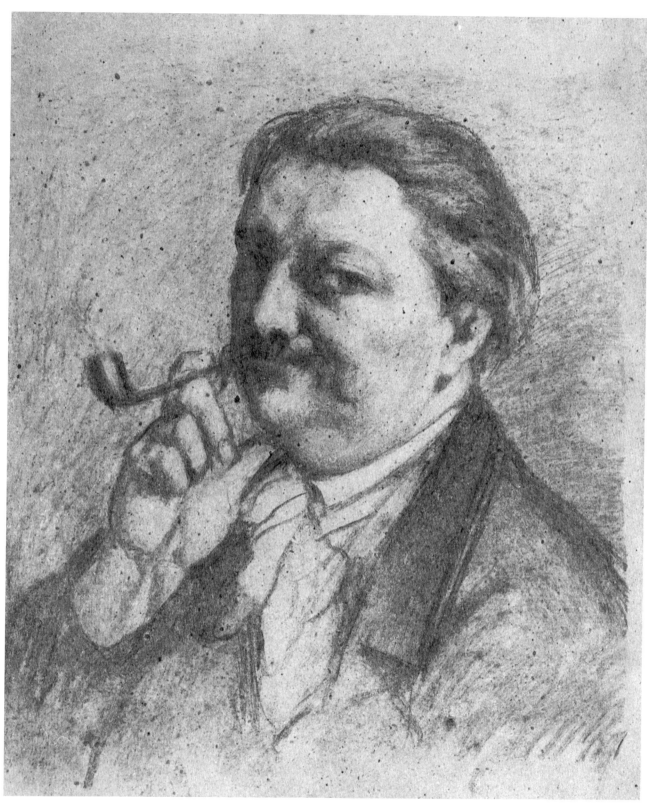

101

101. Self-Portrait 1871

Portrait de l'artiste

Charcoal on brown paper, 32 1/8 x 25 5/8 in. (81.5 x 65 cm)
Inscription on the back side of the cardboard (translated from the
German, Hamburg 1978, p. 357): "Courbet's portrait, drawn by his own
hand while he was hiding from the police, who were pursuing him as a
member of the Commune. He is shaven so as not to be recognized should
he be discovered."
Literature: Riat 1906, p. 311; Hamburg 1978, no. 325.

Paris, Musée du Louvre, Département des Arts Graphiques
Exhibited in Brooklyn only

This recently discovered self-portrait was executed just
before Courbet's arrest in June 1871. The novelty of a
clean-shaven Courbet is explained by the circumstances
of the moment (see inscription above). While the sitter's
identity is affirmed by physiognomic resemblances to a
portrait of the artist by his disciple Cherubino Pata and
a photograph of 1873 (Hamburg 1978), this image is al-
most certainly that mentioned by Courbet's attorney, M.
Lachaud, in the Castagnary papers on Courbet.

*8. June, 1871. Examination by the forementioned police
commissioner, Henry Dorville, at the home of A. Lecomte, a
maker of musical instruments, rue St.-Gilles 12, where
Courbet was apprehended the previous evening. Since then,
the house of M. Lecomte has been under surveillance by two
policemen. Since the evening of the 25th of May Courbet had
requested sanctuary. Lecomte explained that he was never
troubled about politics, but he did not believe he could deny
this service to one whom he had known for twenty years. He
adapted himself so that Courbet passed the time with him
drawing his portrait in charcoal and reading. I place this por-
trait at the disposal of justice. (Hamburg 1978)*

In this drawing, much larger than earlier bust por-
traits, Courbet represents himself in a familiar pose with
his pipe in his mouth, his face somewhat puffy and de-
cidedly unidealized. The familiar sidelong glance be-
trays an added dimension of poignancy. R.B.

Notes

Chapter One. Reconsidering Courbet

All translations from the French are by the author unless otherwise noted.

1. See Clark 1973a and Clark 1980. It is not my intention, in suggesting the limitations of Clark's view, to "de-politicize" the interpretation of Courbet. Rather, I would argue that the radical character of Courbet's art was in itself a political stance at a time when the Second Empire was fighting a rearguard battle on behalf of an authoritarian culture.

2. It is not possible to document with certainty the identification of Courbet in this painting. It is however accepted by the Musée d'Orsay and by Marie Thérèse de Forges (1973, p. 49).

3. Courbet Papers, Box 2, letters from Courbet to Francis Wey.

4. Mayaud 1979b.

5. Montpellier 1985, p. 120.

6. "Nous n'eussions pas peut-être parlé de ces productions affligeantes de M. Courbet, si l'on ne nous avait annoncé qu'il se destinait à faire école, et si nous n'avions deviné nous-mêmes en lui, à travers tant d'excentricités, un artiste de talent fourvoyé dans une fausse route . . ." *Salon de 1851*, Paris 1851, p. 81. Claude Vignon was the nom de plume of Mme. Noémie Constant.

7. "Cet ouvrage renferme des qualités trop solides, et certaines parties sont trop bien peintes, pour que l'on croie à la sauvagerie et a l'ignorance affectés de cet artiste." *Journal des débats*, January 7, 1851.

8. Gaillard 1980. In this excellent article the author deconstructs the texts of the 1851 Salon critics in a method akin to that of Clark but from a more epistemological point of view. Her conclusions about the "autonomy of painting" are less convincing than her analysis.

9. Clark 1973a, p. 142ff.

10. Gautier in *La Presse*, February 15, 1851.

11. ". . . l'art n'est pas la réproduction indifférente de l'objet le premier passant, mais le choix délicat d'une intelligence raffiné par l'étude." Louis de Geofroy, in *Revue des deux mondes*, March 1, 1851, p. 930.

12. "Le résultat d'une impression de daguérreotype mal venue," *Journal des débats*, January 7, 1851.

13. Quoted in Chartres [1984], p. 61. The article by Patrick Le Noeune, "Première Reception des tableaux exposés au Salon de 1850–51 et re-

groupés par les historiens de l'art sous l'etiquette 'réaliste,'" is highly polemical but very informative about the Salon and its critics of every political persuasion.

14. *La Mode*, January 26, 1851, "Salon de 1850," pp. 206–11.

15. *L'Evénement*, February 15, 1851.

16. *Revue de Paris*, 18 (July 1, 1853): 88.

17. "M. Courbet s'est fait une place dans l'école actuelle française à la manière d'un boulet de canon qui vient se loger dans un mur." Sabatier-Ungher 1851, p. 36.

18. "Malgré les récriminations, les dédains et les injures dont il est assailli, malgré ses défauts même, *l'Enterrement à Ornans* sera classé, je n'en doute point, parmi les oeuvres les plus remarquables de ce temps. Je cherche en vain dans le Salon qui puissent lui être comparées. Depuis le naufrage de la *Méduse*, rien d'aussi fort de substance et de résultat, rien d'aussi original surtout, n'avait été fait chez nous." Ibid., p. 60.

19. The military police report of a Radical Republican electoral meeting on May 8, 1949, in the Hérault cites a M. Sabatier as one of the local candidates. *1848 in France*, ed. Roger Price (London, 1975), p. 134.

20. Francois Xavier Amprimoz, "Un Décor 'Fourierist' à Florence," *Revue de l'Art*, 48 (1980):57–67.

21. "L'art est l'expression la plus haute et la plus complète du microsome humaine, la plus sublime création de l'homme social. . . . le beau est la splendeur du vrai." Sabatier-Ungher 1851, p. v.

22. Ibid., pp. v–viii.

23. "Le beau style a tort, non qu'il ne soit fort beau, mais parce qu'il est grec, et qu'en France, au 19ième siècle, les français sont plus vivants que les grecs qui sont morts." Ibid., pp. 3–6.

24. "Les habits, les têtes ont une solidité d'aspect, une variété de ton et un fermeté de dessin semi-venitienne, semi-espagnole; cela tient de Zurbaran et du Titien . . . Ce n'était pas chose facile que de donner de la dignité et du style à tous ces costumes modernes . . . Je soutiens . . . que loin d'être tombé dans la vulgarité et le matérialisme, M. Courbet a idealisé et stylisé son sujet autant qu'il était possible, en voulant rester émouvant et vrai." Ibid., pp. 62–63.

25. Translated in Nochlin 1966, pp. 33–34.

26. Montpellier 1985, p. 120.

27. "Décidemment les qualités du savoir vivre, du bon ton, de la politesse française me manquent toujours." "Oui, cher ami, dans notre société si bien civilisé il faut que je mène une vie de sauvage. Il faut que je m'affranchise même des gouvernements, le peuple jouit de mes sympathies, il faut que je m'adresse à lui directement . . . c'est un devoir sérieux, d'abord pour donner l'exemple de la liberté et de la personnalité en art, puis après pour donner de la publicité à l'art que j'entreprends." Courbet Papers, Box 2, letters from Courbet to Francis Wey.

28. 1861, Open letter to prospective students, translated in Nochlin 1966, p. 35.

29. Théophile Silvestre, for example, ostensibly a supporter: "If the word REALISM had a meaning . . . it must be: Negation of the Imagination!" (quoted in Courthion 1948, I, p. 61).

30. Theodore Cogniard et Clairville, "Le Royaume du Calembour, Revue de l'année 1855," performed at the Théâtre des Variétés, December 8, 1855, published in *Magazin Théâtral Illustré* (Paris, n.d.). The Realist painter Dutoupet, a parody of Courbet in the year of his one-man show, engages in such dialogue as the following:

Lady: *So, you refuse to paint my portrait?*
Dutoupet: *Excuse me, madame, but that would be to take me out of my speciality . . . Ah! if you were pockmarked, one-eyed or a little bit hunchbacked . . .*

I am grateful to Hélène Toussaint for directing me to this publication.

31. Courthion 1948, I, p. 98.

32. "Le rustique d'Ornans est un paysan du Doubs, comme Metternich etait un paysan du Danube. Sa naiveté se compose de tous les secrets, de toutes les malices et de toutes les délicatesses de l'art." Edmond About, *Salon de 1866* (Paris 1867), p. 45.

33. "Il proclama qu'il n'avait point de maître, et qu'il était issu de lui-même, comme le phénix. Le phénix est de tous les oiseaux celui qui s'aime le plus: comme fils, il révère en soi un père vénérable; comme père, il chérit en soi le plus tendre des fils." E. About, *Voyage à travers l'Exposition des Beaux-arts* (Paris 1855), p. 203.

34. "Courbet drawn from Life," *Histoire des Artistes Vivants* (Paris 1856), trans. in Chu 1977, p. 24.

35. See the chapter entitled "Narcisse Paysan," in Courthion 1931, pp. 21–29, and Rubin 1980, p. 28.

36. Nicolson 1973, p. 73.

37. Courbet Papers, Box 3, Castagnary notes.

38. "Comment voulez-vous que j'aille, parce que M. Picot a été sot envers moi, exercer des représailles sur les malheureux qui entrent dans les arts? Ce qu'on m'a fait souffrir de désespoir dans ma jeunesse, il faut que je le fasse souffrir à d'autres? Cette idée est insensée . . . Non, il faut enfin que quelqu'un ait le courage d'être honnête homme et de dire que l'Académie est un corps nuisible, absorbant, incapable de remplir l'objet de sa prétendue mission." Courbet Papers, Box 3, letter of October 17, 1868.

39. Montpellier 1985, p. 124.

40. Ibid., p. 52.

41. Ibid., p. 124. "Ce n'est pas nous qui nous sommes rencontrés, ce sont nos solutions."

42. The article is reproduced in Montpellier 1985, Appendix, pp. 141–53. Clark (1973a, p. 157), apparently unaware of this trip and careless of the date, assumes that Champfleury got all his material from Courbet—an unnecessary slur.

43. Montpellier 1985, p. 35.

44. Courbet Papers, Box 2, letters to Francis Wey, April 20, 1861.

45. Paris 1977, p. 144.

46. This argument is made by Albert Boime in his article, "Le Réalisme Officiel du Second Empire," in Chartres [1984].

47. Courbet Papers, Box 2, letter of March 14, 1868, from Olin to Courbet. For a study of Courbet's landscapes in relation to the market, see Wagner 1981.

48. Paris 1977, p. 35.

49. Francis Haskell, "A Turk and his Pictures," *Oxford Art Journal* 5 (1982): 40–47.

50. Bonniot 1973, p. 86, makes this suggestion of series arising from specific locations, in which he includes the *marines* of Trouville.

51. Courbet Papers, Box 3, undated letter (1870).

52. Courbet Papers, Box 3, letter of September 27, 1866.

53. Published sources include Castagnary, *Gustave Courbet et la Colonne Vendôme: Plaidoyer pour un ami mort* (Paris, 1883), and, in modern times, the study by Rodolphe Walter, "Un Dossier délicat: Courbet et la Colonne Vendôme," *Gazette des Beaux-Arts* (March 1973): 173–84, and the article by Linda Nochlin, "Courbet, The Commune and The Visual Arts," in *Realismus als Widerspruch: Wirklichkeit in Courbets Malerei* (Frankfurt, 1978).

54. See Walter 1973, p. 176.

55. See especially Courbet's letters and reports of September 1870 to Minister Jules Simon, Archives Nationales, Paris.

56. Castagnary, *Plaidoyer*, 1883, pp. 13ff.

57. *A l'armée allemande et aux artistes allemands*, Paris, October 29, 1870 (pamphlet, Bibliothèque Nationale, Cabinet des Estampes).

58. Walter 1973, p. 175. See also Barbet de Jouy, *Son Journal pendant la Commune*, edited with commentary by le Comte d'Ussel (Paris, 1898). Again, I am grateful to Hélène Toussaint for this publication.

Chapter Two, Part One. Courbet's Real Allegory

The research for these essays was supported by the Guggenheim Foundation and the Institute for Advanced Study in Princeton, New Jersey. EPIGRAPHS: Cited in Champfleury 1973, p. 190. Walter Benjamin, *The Origin of German Tragic Drama*, tr. J. Osborne (London, 1977), p. 178. Jane Gallop, *Reading Lacan* (Ithaca, 1985), p. 21.

1. The letter, cited by Hélène Toussaint in Paris 1977, pp. 260–61, was written to his friend Français to ask the latter to persuade the Universelle Exhibition jury to extend the time limit for the submission of his pictures.

2. For more specific information about the cast of characters, see the complete text of the letter, which is available in English translation in London 1978, pp. 254–55. All of my English translations of material from Paris 1977 are taken from this source.

3. Emile Littré, *Dictionnaire de la langue française*, ed. J. Pauvert (Paris, 1936), 2:317: "Sorte de métaphore continuée, espèce de discours qui est d'abord présenté sous un sense propre et qui ne sert que de comparaison pour donner l'intelligence d'un autre sense qu'on n'exprime point."

4. Angus Fletcher, *Allegory: The Theory of a Symbolic Mode* (Ithaca, 1964), p. 2. He continues: "It [allegory] destroys the normal expectation we have about language, that our words 'mean what they say.' When we predicate quality *x* of a person Y, Y really is what our predication says he is (or we assume so); but allegory would turn Y into something other (*allos*) than what the open and direct statement tells the reader."

5. Paris 1977, pp. 246–47.

6. See, for example, the opinions of critics and men of letters from 1855 and after—A.-H. du Pays, Champfleury, Charles Perier, Paul Mantz, Jules Buisson, and many others—gathered together as "Appréciations," in Huyghe, et al. 1944, pp. 24–28. Delacroix, who greatly admired the *Painter's Studio* when he saw it in Courbet's exhibition in 1855, referring to it as "one of the most singular works of our time," simply refused to deal with its meaning at all. *Journal,* August 3, 1855, cited in Huyghe, et al. 1944, pp. 24–25.

7. For interpretations of the *Painter's Studio* see: Hoffmann 1961, pp. 11–49; Georgel 1975, pp. 69–72; Bowness 1972; Nicolson 1973; Nochlin 1968, pp. 13–16; Seltzer 1977, pp. 44–50; Rubin 1980, especially pp. 38–63; Seibert 1983, pp. 311–16, and Moffitt 1987, pp. 183–93. This list is by no means exhaustive. See Paris 1977, p. 243, for further references.

8. This opposition between the side of the shareholders and friends on the right and the masses, "wretchedness, poverty, wealth, the exploited and the exploiters, people who live on death" (Paris 1977, p. 246), to the left, perhaps—not merely coincidentally—repeats the opposition between the blessed to the right of the Judging Christ and the damned to his left in the Christian iconography of the Last Judgment.

9. Courbet's description of this character in the letter is as follows: "A weather-beaten old man, a diehard republican (that Minister of the Interior, for instance who was in the Assembly when Louis XVI was condemned to death, the one who was still following courses at the Sorbonne last year) a man 90 years old with a begging-bag in his hand, dressed in old patched white linen and wearing a broad-brimmed hat." Paris 1977, p. 246.

10. Toussaint supported each of her specific identifications with a contemporary photograph or print of the public figure in question (Paris 1977, pp. 252–58).

11. Toussaint maintains, in considerable detail, that the crucial letter to Champfleury actually contains many hints about these hidden identities, hints available only to those who have a really idiomatic knowledge of the meaning of certain French turns-of-phrase of the period. For example, she explains, in support of her contention that the scytheman is a portrait of Kościuszko, representing insurgent Poland, that in 1855 the French term *faucheur* signified "above all, a Polish patriot." She convincingly explains the double meaning of many other phrases used by Courbet in his letter of explanation. These hints were, she feels, certainly understood by Courbet's friend and champion Castagnary, when he declared in 1881 that the *Painter's Studio* "contains a whole side of topical reference which is escaping from us through the death of almost all its audience." See Hélène Toussaint, "A propos d'une Critique," Les Amis de Gustave Courbet *Bulletin* 61 (1979): 10–13.

12. See Paris 1977, p. 253.

13. Paris 1977, pp. 253–54.

14. Paris 1977, pp. 254–55.

15. Paris 1977, pp. 256–57. Toussaint originally identified the laborer representing Russian socialism as Alexander Herzen, who had worked with Proudhon in Paris until 1851. She later admitted to me, in conversation, that this figure was more likely based on a portrait of the anarchist Bakunin.

16. Paris 1977, pp. 257–58. Toussaint's identification of this *braconnier* or poacher-figure with Napoleon III, based on similarity of appearance and meaningful hints in accouterments—the seated figure is wearing the jackboots that often "stood for" the forbidden image of the emperor in cartoons—is extremely convincing.

17. Paris 1977, p. 264.

18. Herding 1978, pp. 223–47.

19. It is, of course, impossible to summarize Herding's whole article in a few sentences. I have, however, attempted to draw out the main points of his piece. I am grateful to Benjamin Buchloh for his translation of Herding's article.

20. Fletcher, *Allegory,* pp. 304–05 and 322–23. The author cites Northrop Frye, *The Anatomy of Criticism: Four Essays* (Princeton, 1957), p. 90, to prove his case.

21. See above, the sources for the epigraphs to this chapter.

22. Fredric Jameson, *Marxism and Form* (Princeton, 1971), p. 71.

23. Angus Fletcher refers to I. A. Richards's introduction of these terms in the latter's lectures, *The Philosophy of Rhetoric,* in 1936. See Fletcher, *Allegory,* p. 11 and n. 19.

24. Terry Eagleton, *Walter Benjamin or Towards a Revolutionary Criticism* (London, 1981), p. 19.

25. Jameson, *Marxism and Form,* p. 72.

26. For the distinction between the work and the text, see Roland Barthes, *Le Plaisir du texte* (Paris, 1973) and "De l'oeuvre au texte", *Revue de l'esthétique* 24:3 (1971), esp. 230–31: "L'oeuvre est ordinairement l'objet d'une consommation; . . . le texte demande qu'on essaye d'abolir . . . la distance entre l'écriture et la lecture . . . Le lecteur joue, lui, deux fois: il *joue au Texte* (sense ludique), il *joue le Texte;* . . . Le Texte est à peu près une partition; . . . il sollicite au lecteur une collaboration pratique.
"Ceci amène à poser . . . une dernière approche du Texte: celle du plaisir."

27. Hoffman 1961, pp. 11–49, is a rare exception. Hoffman does not, however, discuss the sketchy quality of the work in relation to allegory. For a passing reference to the fact that the painting is incomplete, see Nicolson 1973, pp. 18–20. For a first-rate analysis of the role of sketchiness, color, and brushwork in Courbet's oeuvre as a whole, see Klaus Herding, "Farbe und Weltbild: Thesen zu Courbets Malerei" in Hamburg 1978, pp. 478–92.

28. He did, however, have ample time to finish it after it was shown in Paris. The work was not sold and it was shown in its present form twice during Courbet's lifetime: in Bordeaux in 1865 and in Vienna in 1873 (Paris 1977, p. 243).

29. Charles Baudelaire, "The Salon of 1845," in *The Mirror of Art,* tr. J. Mayne (London, 1955), p. 29.

30. I have considered the implications of the sketch and sketchiness in both modernist and more traditional practice, as well as the issue of the privileging of the personal touch of the artist over the illusionistic representation of subject or narrative, in a lecture entitled "The Sketch, Sketchiness, and the Effect of the Aesthetic in Nineteenth-Century French Art," presented at the National Academy of Design in New York in 1987.

31. Paris 1977, p. 247. This group is presided over by the tortured and lifeless nude form of the lay figure behind it, which in turn creates further meanings, and extends the dark, "pessimistic" implications of this section as a whole.

32. Herding 1978, p. 241 and n. 81.

33. Not, it must be emphasized, within the context of art historical "influence." I am not trying to posit a specific formal or iconographic "influence" relating Dürer's *Melancolia I* to Courbet's beggar woman. Courbet scholars have, however, attempted to point out such a relationship between the figure of Proudhon, in the *Portrait of P.-J. Proudhon in 1853* and that of the Dürer engraving. See Hamburg 1978, p. 266 and fig. 262e.

34. Benjamin, *Origin*, p. 152.

35. Norman Bryson, *Word and Image: French Painting of the Ancien Regime* (Cambridge, 1981), p. 71.

36. Eagleton, *Benjamin*, p. 20, and Benjamin, *Origin*, p. 202.

37. Eagleton, *Benjamin*, p. 20 and nn. 35, 36, 37, which give his references to Benjamin's work.

38. Northrop Frye, *Anatomy of Criticism: Four Essays,* (Princeton, 1957), p. 89. Joel Fineman cites Frye in his discussion of this dimension of allegory in "The Structure of Allegorical Desire," *October* 12 (Spring, 1980):49. Also see Fredric Jameson, who, in the preface to *The Political Unconscious* (Ithaca, 1981), p. 10, declares that "interpretation is here construed as an essentially allegorical act, which consists in rewriting a given text in terms of a particular interpretive master code." Probably no critic has done more to reinstate allegory as the primary figure of interpretation than the late Paul de Man, in whose seminal essay, "The Rhetoric of Temporality," originally published in 1969 (republished in *Blindness and Insight: Essays in the Rhetoric of Contemporary Criticism* [Minneapolis, 1983], pp. 187–228), symbol is disparaged as a mystification and allegory associated with an "authentic understanding of language and temporality" (Jonathan Culler, *On Deconstruction* [Ithaca, 1985], p. 185). Indeed, de Man's study of the nature of figural language in the work of Rousseau, Nietzsche, Rilke, and Proust is entitled *Allegories of Reading* (New Haven, 1979).

39. A Barthean *punctum?* Perhaps. But even a *punctum* can be unraveled. See Victor Burgin's piece, "Diderot, Barthes, *Vertigo*," in *Formations of Fantasy*, ed. V. Burgin, J. Donald, and C. Kaplan (London and New York, 1986), esp. pp. 86–101, for an interesting attempt. Virginia Woolf has commented most appositely on the male display (what Lacan calls *parade*) embodied by Courbet in his striped trousers: "Your clothes in the first place make us gape with astonishment . . . every button, rosette and stripe seems to have some symbolical meaning." V. Woolf, *Three Guineas*, cited by V. Burgin, "Diderot, Barthes," p. 56.

40. Charles Baudelaire, "Puisque réalisme il y a" (1855), in *Oeuvres complètes*, ed. Y.-G. Le Dantec and C. Pichois (Paris, 1961), p. 637.

41. For the political implications of Courbet's image of Baudelaire in this painting, see the end of T. J. Clark's complex analysis locating the revolutionary context of Courbet's c. 1848 *Portrait of Baudelaire*, the image upon which the one in the *Painter's Studio* is based. Of the portrait Clark says: "This is an image of privacy and self-absorption, a space where one man excludes the world of public statement." T. J. Clark, *Image of the People* (Princeton, 1982 [orig. publ. 1973]), p. 75.

42. Charles Baudelaire, "Les Petites Vieilles," from *Tableaux Parisiens* in *Oeuvres complètes*, pp. 85–86: "Ces yeux mystérieux ont d'invincibles charmes / Pour celui que l'austère Infortune allaita!"

Chapter Two, Part Two. *Courbet's Real Allegory*

1. See Nochlin 1986.

2. Or of ambiguously placed branches or "bisexual spindles", which Michael Fried, in his essay, "Courbet's 'Femininity'" (see chap. 3), posits as signifiers of Courbet's feminine, or even protofeminist, identification with his female subjects (more accurately, perhaps, defined as "objects").

3. The phrase "representing representation" of course refers to Michael Fried's article entitled "Representing Representation: The Central Group in Courbet's 'Studio'," *Art in America* 69 (September 1981):127–33, also published in Fried 1981.

4. For the relation of the ephebe, or youthful artist, to the master poet, see Harold Bloom, *The Anxiety of Influence: A Theory of Poetry* (London and New York, 1973), pp. 77–92.

5. Hélène Toussaint, and Klaus Herding following her, claim to see the portrait of Courbet's mother in the features of the nude model. See Herding 1978, p. 309, no. 13.

6. The female nude has been interpreted as an allegorical representation of Truth, Beauty, and/or Liberty by Margaret Ambrust Seibert (Seibert 1983). For a complex and suggestive iconographic reading of the nude, and the central group as a whole, in relation to an eighteenth-century allegorical print of The Rights of Man, see the recent article by John Moffitt (Moffitt 1987).

7. Klaus Theweleit, *Male Fantasies* (Minneapolis, 1987), vol. 1, p. 294.

8. This youthful male figure can also, of course, be read as the Bloomean ephebe. See n. 4 above.

9. See chap. 3.

10. See chap. 3, passim.

11. Originally, he seems to have depicted himself as the postcoital lover in this painting, in the 1844 version of which he had represented himself with his current mistress.

12. For a good summary of the history of *The Wounded Man*, see Paris 1977, no. 35.

13. By the same token, one might postulate that Courbet was being protovegetarian in identifying, as I once suggested, with the dying trout in his poignant closeup painting of the fish. What seems important to me is not whether the artist identifies with this or that figure or element in his painting, but what such identification means, how it is to be interpreted—and by whom.

14. See chap. 3.

15. Ibid., p. 47.

16. See Arthur Munby, *Munby: Man of Two Worlds* (London, 1972) and Liz Stanley, ed., *The Diaries of Hannah Culwick, Victorian Maid-servant* (New Brunswick, New Jersey, 1984) for illustrations of the powerful working-class woman. A truly androgynous—and transgressive—imagery embodying muscular masculine arms and seductive feminine face—had to wait for the twentieth century, most notably in the work of the woman collagist and member of Berlin Dada, Hannah Höch, in her provocative *Tamer* of 1930.

17. For an important discussion of the theme of sleep in Courbet's work, viewed in the context of scientific and literary investigations of the theme during the mid-nineteenth century, see Sheon 1981.

18. Nor is the figure either fully awake or fully asleep, but rather in some intermediary state of languor, associated with sexual availability or postcoital repleteness—again, a scandalous "intermediary" state.

19. Flora Tristan [Flore Célestine Thérèse Henriette Tristan y Moscozo], *Flora Tristan's London Journal: A Survey of London Life in the 1830s* (a translation of *Promenades dans Londres*), trans. D. Palmer and G. Pincetl (London, 1980), p. 78.

20. Tristan, *London Journal*, p. 78 and n. 1. Horrifying as this image of transgression and degradation is, it becomes even more so if we think of the "tossing of the liquids" as a euphemism for even worse—more basic acts of gendered desecration: men vomiting, urinating, or even defecating on the helpless bodies of women as a sign of ultimate contempt. Surely it is this ultimate transgressive befouling that the act—and Tristan's obsessive visual recounting of it—encodes. At the same time, the Tristan passages are interesting in the way they seem to anticipate hostile critical reaction to the bold use of pigment characteristic of Manet and the Im-

pressionists. This critical vocabulary constantly equates synoptic brush-work with "dirt," unmodulated passages of light and dark tones as "filthy," et cetera.

21. The presence of the male hat and gloves in the boat in the background of the painting also signals a certain attempt at moral narrative here. Holman Hunt's repentant fallen woman in the *Awakening Conscience*, painted in 1852, is also wearing white lingerie—a nightdress—as a token of her moral lapse.

22. This tract was published after its author's death in 1865. See P.-J. Proudhon, *La Pornocratie ou les femmes dans les temps modernes*, ed. C. Bouglé and H. Moysset in *Oeuvres complètes* (Paris, 1939), pp. 303–412.

23. P.-J. Proudhon, *Du principe de l'art et de sa destination sociale* in *Oeuvres complètes*, pp. 1–301.

24. Proudhon, *Du principe*, p. 199.

25. Proudhon, *Du principe*, p. 201.

26. Susan Sontag, "The Pornographic Imagination," in *Styles of Radical Will* (New York, 1981), p. 45.

27. Of course such practices within the realm of art need to be examined within the context of the nineteenth-century production of sexual discourses analyzed by Michel Foucault in the *History of Sexuality* (New York, 1980). For the classic article on the differences constituted by reading vanguard practices in twentieth-century representation from a feminist perspective, see Carol Duncan, "Virility and Domination in Early Twentieth-Century Vanguard Painting," in *Feminism and Art History: Questioning the Litany*, ed. Norma Broude and Mary D. Garrard (New York, 1982), pp. 293–313.

28. Susan Rubin Suleiman, "Pornography, Transgression, and the Avant-Garde: Bataille's *Story of the Eye*," in *The Poetics of Gender*, ed. Nancy K. Miller (New York, 1986), pp. 117–36.

29. I have attempted to stay as close to Suleiman's original text as possible in my transposition. Here is Suleiman, discussing Bataille as a prime example of the notion of discursive transgression in pornographic texts: "What we see here is the transfer . . . of the notion of transgression from the realm of experience—whose equivalent, in fiction, is representation—to the realm of words, with a corresponding shift in the roles and importance accorded to the signifier and the signified. The signified becomes the vehicle of the metaphor, whose tenor . . . is the signifier: the sexually scandalous scenes of *Histoire de l'oeil* are there to 'signify' Bataille's linguistically scandalous verbal combinations, not vice versa." Suleiman, "Pornography, Transgression, and the Avant-Garde: Bataille's *Story of the Eye*," p. 120.

30. For the complex issue of women's viewing positions as set forth in recent feminist film theory, see: Laura Mulvey, "Visual Pleasure and Narrative Cinema," *Screen* 16:3 (Autumn 1975):6–18; Mary Ann Doane, "Film and Masquerade—Theorizing the Female Spectator," *Screen* 23:3–4(September–October 1982):74–88; Teresa de Lauretis, "Desire in Narrative," in *Alice Doesn't: Feminism, Semiotics, Cinema* (Bloomington, 1984), pp. 103–57; E. Ann Kaplan, "Is the Gaze Male?" in *Women and Film: Both Sides of the Cinema* (New York, 1983), chap. 1; Annette Kuhn, *Women's Pictures: Feminism and Cinema*, (London, 1982), passim; and especially Mary Ann Doane, "The Desire to Desire," in *The Desire to Desire: The Woman's Film of the 1940s* (Bloomington, 1987), pp. 1–37.

31. This shifty and ambiguous viewing position must be differentiated from what has been termed "oscillation" and constitutes a pleasurable subject position for women constituted in relation to an androgynous object of the gaze. I am grateful to Maud Lavin for bringing this distinction to my attention in her dissertation in progress, "Hannah Höch, Photomontage, and the Representation of the New Woman in Weimar Germany, 1918–1933," The Graduate School and University Center of the

City University of New York. But this pleasurable oscillation is not possible in relation to representations that position women as closed, replete, finished, perfect natural objects; only in relation to viewing those that position "her" as a construct of disparate fragments, as in the Dada photomontages of Höch, the present-day work of Barbara Kruger, or certain vanguard feminist filmmakers.

32. Suleiman, "Pornography, Transgression," p. 132. The author continues: "What does appear to me certain is that there will be no renewal, either in a poetics or in a politics of gender, as long as every drama, whether textual or sexual, continues to be envisaged—as in Bataille's pornography and in Harold Bloom's theory of poetry—in terms of a confrontation between an all-powerful father and a traumatized son, a confrontation staged across and over the body of the mother."

33. Heterosexual of course—and middle-aged, and above all, used to wearing clothes, having names, being in authority.

34. P.-J. Proudhon, *La Pornocratie ou les femmes dans les temps modernes*, pp. 309–412. Proudhon firmly believed that women had the choice of being either housewives or harlots: nothing else. His book is the most consistent antifeminist tract of its time, or perhaps, any other, and as such is worthy of careful study. Certainly, it raises all the main issues about woman's position in society and her sexuality with a paranoid intensity unmatched in any other text.

35. I have borrowed the words, which seem appropriate to the occasion, of Julia Kristeva in "Motherhood According to Bellini," evoking the experience of *jouissance*. Julia Kristeva, "Motherhood According to Bellini," *Desire in Language*, ed. Leon Roudiez, tr. T. Gora, et al. (New York, 1980), p. 248. The women's laughter I have borrowed from the courtroom scene in Marlene Goris's film, *A Question of Silence*. Elaine Showalter, more briefly, imagines such role reversal in her dream of a feminist literary conference at the end of "Critical Cross-Dressing: Male Feminists and the Woman of the Year," in *Men in Feminism*, ed. A. Jardine and P. Smith (New York and London, 1987), p. 132. (Showalter's article was originally published in *Raritan* [Fall], 1983).

36. Nevertheless, my Utopian vision belongs to a well-established tradition going back to the Middle Ages, that of the "World Upside-Down." For a discussion of such role-reversing practices in early modern Europe and their relation to gender, see Natalie Zemon Davis, "Woman on Top," chap. 5 in *Society and Culture in Early Modern France: Eight Essays* (Stanford, California, 1975), pp. 124–51. The classic investigation of carnivalesque practices, including that of role reversal, is Mikhail Bakhtin's *Rabelais and His World*, tr. H. Iswolsky (Bloomington, 1984). For the theme of Utopian inversion in relation to Marxism, see Gerard Raulet, "Critique of Religion and Religion as Critique: The Secularized Hope of Ernst Bloch," tr. D. Parent, ed. T. Luke, *New German Critique* 9(Fall 1976):76–77.

37. Carnival, as Michael Holquist points out in his prologue to Bakhtin's *Rabelais and His World*, must not, of course, be "confused . . . with self-serving festivals fostered by governments, secular or theocratic" (p. xviii). My analogy between the traditional carnival and the Universelle Exposition can only go so far. Nevertheless, Courbet made of it what he could: in a sense, he transformed, for his own productive purposes, a "self-serving festival" into an irreverent carnival. See note 36 above. The theme of the ruler paying homage to the artist had a certain vogue in the earlier nineteenth century, in works like Ingres's *Death of Leonardo da Vinci*, in which the artist expires in the arms of François I; or Robert-Fleury's *Charles V Picking Up Titian's Paint Brush*. See Nochlin 1967, pp. 218–19, and Francis Haskell, "The Old Masters in Nineteenth-Century French Painting," *Art Quarterly* 24:1 (1971):55–80.

38. For a detailed examination of hidden political references, often of a rather "basic" or "popular" nature, in two of Courbet's paintings of the 1850s—*La Mère Grégoire* and *Le Départ des pompiers*—see Toussaint 1982.

39. Fletcher, *Allegory*, p. 328. Fletcher further defines the political grounding of allegory as follows: "The art of subterfuge par excellence, it needs to be justified as an art proper to those moments when nothing but subterfuge will work, as in a political state where dictatorial censorship prevails" (p. 345). Also see Joel Fineman: ". . . We can note that allegory seems regularly to surface in critical or polemical atmospheres, when for political or metaphysical reasons there is something that cannot be said." "The Structure of Allegorical Desire," *October* 12(Spring, 1980):48.

40. See, especially, Thomas Crow, "Modernism and Mass Culture in the Visual Arts," in *Modernism and Modernity: The Vancouver Conference Papers* (Halifax, Nova Scotia, 1983), pp. 215–64.

41. Crow, "Modernism and Mass Culture," p. 224. For T. J. Clark on the *Burial at Ornans*, see Clark 1982, pp. 140–49 and 153–56.

42. For information about the emperor's involvement in the Universal Exposition Universelle, see Herding 1978, p. 238. For the most recent detailed examination of the art-politics of the 1855 Exposition, see Mainardi 1987, pp. 32–120.

43. Toussaint, in Paris 1977, p. 262.

44. See especially the letter from Courbet to his patron, Alfred Bruyas, describing his fateful luncheon with Nieuwerkerke, during the course of which the latter asked Courbet to do a painting for the Exhibition of 1855 which would have to be submitted to two committees for approval. Courbet proudly rejected the offer, the artist declaring to the superintendent that: "I also was a Government and that I defied his to do anything for mine that I could accept." Borel 1951, p. 68.

45. Herding 1978, p. 22.

46. Of course, it is important to remember that Courbet by no means renounced official acceptance. He did, after all, show eleven paintings—no small number for a relatively young man of thirty-six—at the government-sponsored exhibition in the Palais des Beaux-Arts.

47. For information about the fate of the painting between the time that Courbet exhibited it in 1855 and that of its purchase for the Louvre, see "En 1920, 'L'Atelier' de Courbet entrait au Louvre," Les Amis de Gustave Courbet *Bulletin* 29(1961):1–13, and p. 2, n. 1.

48. For a discussion of the depoliticization of Courbet and his work in the early years of the Third Republic, see Nochlin 1982. Although there were always a few people, like Jules Vallès, who saw Courbet's life and his painting as primarily political in their meaning, the repoliticization of the artist's work was not achieved until 1941, when Meyer Schapiro published his remarkable article "Courbet and Popular Imagery: An Essay on Realism and Naiveté," *Journal of the Warburg and Courtauld Institutes* (April-June 1941):164–91, in which the author insisted on the social and political meaning of Courbet's choice of language and the impact of 1848 on the formation of his style. This reading of Courbet was the springboard for the author's own investigation of Courbet, in both her doctoral dissertation—*Gustave Courbet: A Study of Style and Society* (New York, 1976), originally Ph.D. diss., New York University, 1963—and articles like "Gustave Courbet's *Meeting*: A Portrait of the Artist as a Wandering Jew," *The Art Bulletin* 49(November 1967):209–22. A full-scale revisionist reading of Courbet from the vantage point of a social history of art had to wait until 1973 and T. J. Clark's *Image of the People: Gustave Courbet and the 1848 Revolution*.

49. For a differentiation among the *Painter's Studio*, Courbet's work in general, and the project of modernism, see Nochlin 1968.

50. The compulsive syndrome is, as Angus Fletcher astutely points out, the proper psychoanalytic analogue to allegory. See Fletcher, *Allegory*, p. 286. Compulsive behavior is, as Fletcher also points out, like allegory, highly orderly and above all, supersystematic (p. 291); such compulsive systematization also marks to a high degree the Utopian theories of Charles Fourier as well as the theories and practices of his followers: the

Utopian vegetarian, Jupille, for instance, who proselytized for socialist salvation through a noncarnivorous diet; or the Fourierist dramatist Sardat, author of a bizarre didactic drama entitled "La Loi d'union ou nouvelle organisation sociale," in sixteen acts and a prologue, with a cast of 296 ranging in age from four to seventy, set in a "Temple de Bonheur" and setting forth the hopes, duties, pleasures and daily life in a phalanstery of eighty families in a rhetorical structure that might well be called, for lack of a better term, a "real allegory." Courbet's allegory must, of course, be distinguished from the wilder excesses of these Utopian eccentrics described by Champfleury (*Les Excentriques*, 2nd ed. [Paris: 1877, 1st pub. 1852], pp. 77–82, 149–51, and 155) but there is enough of that tradition of eccentric extremism remaining in the *Painter's Studio* to remove it from the realm of the simple, down-to-earth critique and elevate it to that of eschatological transformation. For the impact of Fourierist ideas on the iconography of *The Studio*, see Nochlin 1968, esp. pp. 18–19.

51. Ernst Bloch, cited in Gerard Raulet, "Critique of Religion and Religion as Critique: The Secularized Hope of Ernst Bloch," in *New German Critique* 9(Fall 1976):82.

Chapter Three. Courbet's "Femininity"

EPIGRAPH: A jeer shouted at feminists meeting at Vincennes in 1970 (Elaine Marks and Isabelle de Courtivron, "Introduction III: Contexts of the New French Feminisms," in *New French Feminisms: An Anthology*, ed. Elaine Marks and Isabelle de Courtivron [New York, 1981], p. 31).

1. My understanding of these issues is based on the (often mutually conflicting) work of numerous writers, including Parveen Adams, Beverley Brown, Hélène Cixous, Mary Ann Doane, Stephen Heath, Neil Hertz, Jane Gallup, Sarah Kofman, Luce Irigaray, Teresa de Lauretis, Juliet Mitchell, Michèle Montrelay, Laura Mulvey, and Jacqueline Rose. For useful overviews of Freud and Lacan on sexual difference, see the introductory essays by Juliet Mitchell and Jacqueline Rose in *Feminine Sexuality: Jacques Lacan and the école freudienne*, trans. Jacqueline Rose, ed. Juliet Mitchell and Jacqueline Rose (New York and London, 1982). A central concern of feminist theorists of film has come to be "how to reconstruct or organize vision from the 'impossible' place of female desire, the historical place of the female spectator between the look of the camera and the image on the screen" (Teresa de Lauretis, *Alice Doesn't: Feminism, Semiotics, Cinema* [Bloomington, 1984], p. 69). As will become plain, the present essay doesn't speak directly to the issue of female spectatorship; at the same time, its insistence on the necessity of *reading* Courbet's paintings, often against the grain of their ostensible content, means that we shall be far from regarding the visible as a realm of (phallogocentric) self-evidence. Throughout this essay quotation marks have been placed around the words "masculine" and "feminine" so as to emphasize the status of both concepts as cultural constructions rather than biological givens.

2. The claim that an impulse—unrecognized as such by the artist—to transport himself (more precisely, himself as painter-beholder) into his paintings lies at the heart of Courbet's enterprise has been put forward by me in a series of essays (see bibliography). See also my forthcoming book, *The Beholder in Courbet*.

3. (Berkeley and London, 1980).

4. Traditionally, of course, scholars have assumed that reading the "real allegory" of the *Painter's Studio* is largely a matter of deciphering the iconographical significance both of individual figures in the painting and of the composition as a whole. Recent attempts along these lines include Hélène Toussaint in Paris 1977, and in London 1978; Herding 1978; and Rubin 1980.

5. See, for example, Mary Ann Doane, "Film and the Masquerade: Theorising the Female Spectator," *Screen* 23(September–October 1982):74–87, in which it is argued that "it is precisely [the] opposition between proximity and distance, control of the image and its loss, which locates the possibilities of spectatorship within the problematic of sexual difference. For the female spectator there is a certain over-presence of the image— she *is* the image" (p. 78). Doane goes on to note "the constant recurrence of the motif of proximity in feminist theories (especially those labeled 'new French feminisms') that purport to describe a feminine specificity" (ibid.), citing relevant passages from Irigaray, Cixous, Kofman, and Montrelay. Against the essentialism implicit in much recent French work, however, Doane insists that "the entire elaboration of femininity as a closeness, a nearness, as present-to-itself is not the definition of an essence but the delineation of a *place* culturally assigned to the woman" (p. 87; emphasis hers). This is surely correct. At the same time, without endorsing Irigaray's essentialism, I am struck by the relevance to my reading of Courbet of her speculation that in "a feminine syntax . . . there would no longer be proper meanings, proper names, 'proper' attributes . . . Instead, that 'syntax' would involve nearness, proximity, but in such an extreme form that it would preclude any distinction of identities, any establishment of ownership, thus any form of appropriation" (*This Sex Which Is Not One,* trans. Catherine Porter with Caroline Burke [Ithaca, 1985], p. 134). As Irigaray also puts it, "We would thus escape from a dominant *scopic* economy, we would be to a greater extent in an economy of *flow*" (p. 148; emphasis hers), a remark pertinent not only to Courbet's paintings of river landscapes but to an entire metaphorics of flow in his art.

6. Nochlin 1980. Thus for example Nochlin remarks that "the only figures [in previous art] which suggest the kind of confident muscular expansiveness characteristic of Courbet's grain sifter are male ones, like Tintoretto's marvelously energetic back-to iron-worker from his *Forge of Vulcan.* This is not, of course, to suggest a specific influence, but merely to point out that the kind of pose chosen by Courbet here is rare in the ranks of representations of 19th-century women workers" (p. 61).

7. "Philosophy has never spoken—I do not say of *passivity*: we are not effects—but I would say of the passivity of our activity . . ." (Maurice Merleau-Ponty, *The Visible and the Invisible,* tr. Alphonso Lingis, ed. Claude Lefort [Evanston, Illinois, 1968], p. 221; emphasis his). But precisely this is the focus of the French philosopher Félix Ravaisson's *De l'habitude* (1838), a text I relate to Courbet's paintings in Fried 1986.

8. Cf. Jane Gallop, "Annie Leclerc Writing a Letter, with Vermeer," *October* 33(Summer 1985):103–18. Gallop's article is largely a discussion of Leclerc's "La Lettre d'amour"; what chiefly interests Gallop is Leclerc's notion that the woman writer is split between "masculinity" and "femininity" by the act of writing and that the split is embodied in the difference between the writer's two arms: "The right arm, the writing arm, is for Leclerc 'virile.' [Thus] she says: 'If you only look at my . . . right hand, you'll see it at a distance from my body, you'll see it independent, abstract, male' " (p. 114). But the writer herself isn't thereby simply "masculinized": "Leclerc wants her right hand to copy down what the left hand knows" (p. 116). The association of maleness with the (superior) right side of the body and of femaleness with the (inferior) left side is a myth that goes back as far as the Greeks (see, for example, James Hillman, "First Adam, Then Eve: Fantasies of Female Inferiority in Changing Consciousness," *Art International* 14[September 1970]:33).

9. Also contributing to a destabilizing of fixed gender identities in the central group is the pairing just the other side of the picture on the easel of an Irishwoman seated on the studio floor and nursing an infant and a partly draped male manikin standing behind her, a pairing I view as chiasmatically equivalent to that of the painter-beholder and model. See also n. 12 below.

10. The exact status of the concepts of the phallus and of castration in Freud's and Lacan's accounts of sexual difference has been a matter of dispute among feminist theorists (and others). Stephen Heath, for exam-
ple, in a well-known article criticizes both Lacan and Freud for the emphasis on vision inherent in their respective appeals to the concept of castration, or rather for what he takes to be the essentialist implications of that emphasis, their failure to recognize that the production of sexuality must be thought in relation to the larger question of the historical constitution of the subject ("Difference," *Screen* 19[Autumn 1978]:54 and passim). (Similar critiques are developed by de Lauretis in *Alice Doesn't* and Doane in "Film and the Masquerade," and of course a large French feminist literature contests Lacan's privileging of the phallus.) Jacqueline Rose, however, argues that Lacan at any rate is often misrepresented by his critics. "When Lacan is reproached with phallocentrism at the level of his theory," she writes, "what is most often missed is that the subject's entry into the symbolic order is equally an exposure of the value of the phallus itself. The subject has to recognise that there is desire, or lack in the place of the Other, that there is no ultimate certainty or truth, and that the status of the phallus is a fraud (this is, for Lacan, the meaning of castration). The phallus can only take up its place by indicating the precariousness of any identity assumed by the subject on the basis of its token" ("Introduction II," *Feminine Sexuality,* p. 40). Rose doesn't deny "that Lacan was implicated in the phallocentrism he described" (he could not not have been, she seems to suggest), and she acknowledges that it is far from clear *why* the phallus should play so crucial a role "in the structuring and securing (never secure) of human subjectivity" (p. 56). But she is critical of recent attempts by feminist theorists to counter the primacy of the phallus by appealing either "to a concept of the feminine as pregiven" [for example, as a function of more comprehensive differences between men's and women's bodies] or "to an androcentrism in the symbolic which the phallus would simply reflect. The former relegates women outside language and history, the latter simply subordinates them to both" (p. 57). See also Jane Gallop, *The Daughter's Seduction: Feminism and Psychoanalysis* (Ithaca, 1982), pp. 43–55 (on Heath on Lacan), 92–112, and passim.

11. On the phallic significance of distaffs in European painting, see, for example, Donald Posner, "An Aspect of Watteau 'peintre de la réalité,' " *Etudes d'art français offertes à Charles Sterling,* ed. Albert Châtelet and Nicole Reynaud (Paris, 1975), pp. 279–86. See also Hofmann 1978.

12. Cf. Courbet's intimate friend Max Buchon's claim that watching Courbet paint "one would say that he produced his works . . . as simply as an apple tree produces apples" (quoted in Charles Léger, *Courbet* [Paris, 1929], p. 66, translation mine). A related fantasy is perhaps implied by the presence in the central group in the *Painter's Studio* of the small peasant boy watching Courbet paint (the one element in the group that stands apart from the movement toward merger). On the one hand, we inevitably associate the boy both with the figure of Courbet at his easel and with that of a second, apparently somewhat older boy who is shown drawing on a piece of paper on the floor to the right of the model's dress, with the result that the value of "masculinity" is enhanced even as it is thus represented in a "diminished" form. On the other hand, the peasant boy makes the central group into an image of what today would be called a nuclear family; and to the extent that, as I have tried to show, no absolute distinction between the terms of the "parental couple" is finally possible, the suggestion is conveyed that the painter-beholder has in effect given birth to a younger version of himself, as if in accord with a desire for autochthony. Something of the sort may also be implied by the relationship in the *Grain Sifters* between peasant boy and "pregnant" *tarare,* the latter an image of biological productivity that more than offsets the equivocalness in this regard of the image of menstrual blood.

13. This isn't the only instance in Courbet's art where the verbal connotations of a word or image are required to be taken into account; see Fried 1982, pp. 642–43; Fried 1983, p. 672, n. 49; and the discussion of the double significance of the French word *quenouille,* meaning both distaff and bedpost, later in this essay.

14. A bloody scalpel plays an analogous role in another masterwork of nineteenth-century realism, Thomas Eakins's *The Gross Clinic* (1875); see Michael Fried, *Realism, Writing, Disfiguration: On Thomas Eakins and Stephen Crane* (Chicago and London, 1987), pp. 2–89.

15. Recent studies that demonstrate the multiplicity and fluidity of distinctions within the world of prostitution in nineteenth-century France are Alain Corbin, *Les Filles de noce: Misère sexuelle et prostitution au XIXe et XXe siècles* (Paris, 1978); and Jill Harsin, *Policing Prostitution in Nineteenth-Century Paris* (Princeton, 1985).

16. The notion of resistance is taken from Jack Lindsay, who writes that the motif of a return to nature, "expressed in other works by a girl, clothed or naked, asleep among trees, has here the effect of showing up remorselessly all that is artificial, soiled, dehumanised in the [*Young Ladies*]. Their rich clothes resist the flowers and foliage, and obliterate the humanity of their bodies. And yet the penetration into their being, ruthless as it is, is made with entire sympathy" (Lindsay 1973], p. 148). Obviously I think this is wrong, or at best far too simple. I should add, however, that to emphasize as I have done the pervasiveness and so to speak the consistency of the floral imagery in the *Young Ladies on the Banks of the Seine* is not to concur in a mythological reading of the two women: they are no symbols of fertility even if some of their accoutrements—the blonde's bouquet, the brunette's garland—ultimately derive from traditional images of that type (see Peter-Klaus Schuster on the *Young Ladies* and related works in Hamburg 1978, pp. 230–32). Nor, I think, is it likely that they were intended to be seen as modern versions of the traditional figure of Flora-as-prostitute (see Julius Held, "Flora, Goddess and Courtesan," in Millard Meiss, ed., *De Artibus Opuscula* XL: *Essays in Honor of Erwin Panofsky* [New York, 1961], pp. 201–18).

Werner Hofmann's essay "Courbets Wirklichkeiten," in the same catalogue interprets a number of Courbet's paintings of women, including the *Sleeping Spinner, Grain Sifters, Young Ladies on the Banks of the Seine,* and *Sleep,* as modern reworkings of traditional mythological themes (pp. 590–613). The most intriguing of his comparisons is between the falling grain in the *Grain Sifters* and the shower of gold in traditional representations of Danae (p. 600).

17. Cf. Charles Baudelaire's prose poem "The Thyrsus" ("*Le Thyrse*"), dedicated to Franz Liszt, the first paragraph of which reads:

"What is a thyrsus? In its religious and poetic sense it is the sacerdotal emblem of priests and priestesses when celebrating the deity whose interpreters they are. But physically it is just a stick, a simple stick, a staff to hold up hops, a prop for training vines, straight, hard and dry. Around this stick in capricious convolutions, stems and flowers play and gambol, some sinuous and wayward, others hanging like bells, or like goblets up-side-down. And an amazing resplendence surges from this complexity of lines and of delicate or brilliant colors. Does it not seem as though all those delicate corollas, all those calyxes, in an explosion of scents and colors, were executing a mysterious fandango around the hieratic rod? But what imprudent mortal would dare to say whether the flowers and the vines have been made for the stick, or whether the stick is not a pretext for displaying the beauty of the vines and the flowers? The thyrsus is an image of your astonishing quality, great and venerated Master, dear Bacchante of mysterious and passionate Beauty. Never did a Nymph, driven to frenzy by the invincible Bacchus, shake her thyrsus over the heads of her maddened companions with such energy and wantonness as you your genius over the hearts of your brothers. The rod is your will, steady, straight, and firm, and the flowers, the wanderings of your fancy around your will, the feminine element executing its bewitching pirouettes around the male. Straight line and arabesque, intention and expression, inflexibility of the will, sinuosity of the word, unity of the goal, variety of the means, all-powerful and indivisible amalgam of genius, what analyst would have the detestable courage to divide and separate you?" (*Paris Spleen,* trans. Louise Varèse [New York, 1970], pp. 72–73)

On the one hand, Baudelaire's characterization of Liszt as embodying both a "masculine" and a "feminine" principle suggests that this was a topos of (masculinist) encomiastic discourse in the arts. On the other, the rigorously oppositional language of Baudelaire's text, with its elaborate contrast between a phallic stick or rod and a "feminine" imagery of flowers, points up the far more radical amalgam of "masculine" and "feminine" elements in the *Young Ladies on the Banks of the Seine.*

18. See also in this connection the impressive drawing in the Chicago Art Institute known as the *Seated Model* (c. 1854), a work that bears a suggestive relation to both the *Grain Sifters* and the *Painter's Studio.*

19. A phallic element is perhaps also introduced by the illusionistic erectness of Courbet's signature immediately below the nearer of the two tresses. I should note too that the version of the *Portrait of Jo* I have been discussing is considered a replica after the original version in Stockholm, and that in the latter, as in a second replica in Kansas City, a single tress emerges from beneath (within?) the sitter's left hand, very much as if it were affixed to the handle of the mirror as to the shaft of a brush.

20. The following, much too brief account of Manet's enterprise is based on Fried, "Manet's Sources: Aspects of His Art, 1859–65," *Artforum* 7(March 1969):28–82. See also Theodore Reff, "'Manet's Sources': A Critical Evaluation," *Artforum* 8(September 1969):40–48; and Fried, "Painting Memories: On the Containment of the Past in Baudelaire and Manet," *Critical Inquiry* 10(March 1984):510–42. On the relationship between Courbet's *Young Ladies on the Banks of the Seine* and Manet's *Déjeuner sur l'herbe,* see Fried, "Manet's Sources," p. 46. Other connections between works by the two painters are discussed by Reff, "Courbet and Manet," *Arts* 54(March 1980):98–103.

21. In Manet's last ambitious painting, *A Bar at the Folies-Bergère* (1882), this state of affairs is made explicit by the reflection in the mirror behind the barmaid of a customer standing in the "place" of the beholder. For a reading of the *Bar* based on the hypothesis "that inconsistencies so carefully contrived must have been felt to be somehow appropriate to the social forms the painter had chosen to show," see T. J. Clark, *The Painting of Modern Life: Paris in the Art of Manet and His Followers* (New York, 1985), pp. 239–55.

22. In his chapter on the *Olympia,* Clark provides a persuasive analysis of the crisis of the genre of the traditional erotic nude in the 1860s (*The Painting of Modern Life,* pp. 119–31). On the highly problematic relation of the traditional nude to contemporaneous pornographic photography, a topic not dealt with by Clark, see Gerald Needham, "Manet, 'Olympia' and Pornographic Photography," in Thomas B. Hess and Linda Nochlin, eds., *Woman as Sex Object: Studies in Erotic Art, 1730–1970* (London, 1973), pp. 80–89; and Abigail Solomon-Godeau, "The Legs of the Countess," *October* 39(Winter 1986):65–108, esp. 98–99.

23. Two paintings of 1863 in which a naked woman is depicted lying on her back, Paul Baudry's *The Pearl and the Wave* and Alexandre Cabanel's *Birth of Venus,* make interesting comparisons with the *Woman with a Parrot;* both are illustrated in Clark, *The Painting of Modern Life,* figs. 43 and 45.

24. Disquieting because the combination of the woman's open mouth and snakelike hair invites being read as a displaced representation of her concealed genitals. What remains unclear, given the context of my argument, is the relation of that representation, and more broadly of Courbet's imagery of women's hair, to the Freudian problematic of castration; the key text here would be Freud's "Medusa's Head," *The Standard Edition of the Complete Psychological Works of Sigmund Freud,* ed. James Strachey, vol. 18 (London, 1955), pp. 273–74. In general I would argue that Courbet's art avoids the petrifying consequences of castration anxiety, a point on which I take myself to be in agreement with Neil Hertz, *The End of the Line: Essays on Psychoanalysis and the Sublime* (New York, 1985), pp. 209–14.

25. A similar duplex structure, of implied flow outward from the painting conjoined with implied penetration into the picture-space, characterizes Courbet's depictions of "Le Puits noir" (a stream near Ornans), the sources of the Loue and the Lison, and other favorite landscape sites (see Fried 1981, pp. 120–22). The same structure is evident in another picture juxtaposing flowers and a woman, *The Trellis* (1863). Notice, by the

way, how in the *Hammock* the disposition of the woman's body leaves no doubt that her head and upper body are nearer the beholder than are her legs and feet.

26. Hélène Toussaint, for example, cites an early pencil sketch of two clothed women embracing in a bed, the *Women in a Wheatfield* (1855), and several versions of *Venus and Psyche* (1864, 1866; Paris 1977, p. 186). To this list Alan Bowness would add *The Bathers* (1853; ibid., p. 16). The possibility that *Sleep* reflects an awareness of J.-A.-D. Ingres's *Le Bain Turc*, acquired by Khalil Bey in 1865, is raised by Francis Haskell in an article on Khalil Bey, "A Turk and his Pictures in Nineteenth-Century Paris," *Oxford Art Review* 5:1(1982):40–47. "It is . . . extremely tempting to suggest (but quite impossible to substantiate) that Khalil Bey told Courbet about the purchase," Haskell writes, "perhaps showed him the picture, and then suggested that the great 'realist' should paint a modern counterpart to this Oriental fantasy—in the light of our current knowledge, it seems chronologically this hypothesis is just tenable . . ." (p. 45). Haskell goes on to note the lesbian undertones of certain figures in Ingres's tondo, and to remark that, although the two works are compositionally unlike, "[*Sleep*] explores one of [the *Bain Turc*'s] underlying themes with a blatancy, a vulgarity even, that would have horrified Ingres, but which could nevertheless have been suggested by his picture" (ibid.). In addition Beatrice Farwell has associated *Sleep* with lesbian imagery in popular lithographs of the 1830s and after, citing in particular Achille Devéria's *The Girl Friends Discovered* (c. 1830) (Farwell 1972, p. 71).

27. See Toussaint on Courbet's *Venus and Psyche* (1866), Paris 1977, pp. 182–84.

28. In an unpublished essay, "Courbet, Bronzino, and Blasphemy." Castagnary's remarks are taken from his unfinished manuscript on Courbet (see Courthion 1948, pp. 188–89).

29. Cf. Leo Steinberg's discussion of Picasso's attempts to represent "the form of a woman who possesses both front and back, as though the fullness of her were on display" ("The Algerian Women and Picasso at Large," *Other Criteria: Confrontations with Twentieth-Century Art* [New York, 1972], p. 154). An altogether different sort of merging of a pair of male figures takes place in Courbet's *Wrestlers* (1853), a painting usefully considered in relation to his *Bathers* of the same year.

30. In a number of Courbet's still lifes painted during and after his imprisonment in Ste.-Pélagie in 1871 there can be discerned an implicit and no doubt unintended analogy with the general configuration of a reclining female nude (or for that matter pair of nudes). Indeed it is tempting to compare both the *Woman with a Parrot* and *Sleep* with one of the most elaborate of the still lifes, *Apples, Pears, and Primroses on a Table* (1871), in the Norton Simon Museum of Art in Pasadena. Cf. Meyer Schapiro's essay, "The Apples of Cézanne: An Essay on the Meaning of Still-life," in which he suggests that "in Cézanne's habitual representation of the apple as theme by itself there is a latent erotic sense, an unconscious symbolizing of a repressed desire" (*Modern Art, 19th and 20th Centuries: Selected Papers* [New York, 1978], p. 12).

31. Toussaint in her discussion of *Sleep* sees in this a modern version of a religious allegory: "[Courbet] offers us the expressive symbol of remorse or absolution in this broken string of pearls that trails from the crystal goblet in the same way that evil, incarnated by a snake, emerges from the 'poisoned chalice' in old pictures of the legend of St. John the Evangelist" (Paris 1977, p. 186; translation mine). I regard it as unlikely that Courbet actually intended anything of the sort, but Toussaint's remarks are valuable for focusing attention on the relationship between pearls and goblet. My reading of that relationship is indebted to conversations with Neil Hertz.

One further point that should at least be mentioned is that Jo Heffernan was the painter James McNeill Whistler's mistress. The recent work of Eve Kosofsky Sedgwick on the exploitation of women in the interests of what she calls male homosocial desire raises the possibility that, in addition to its other significances, lesbianism in *Sleep* might be a figure for a

homosocial relationship, at once of friendship and of rivalry, between the two male painters. See Sedgwick, *Between Men: English Literature and Male Homosocial Desire* (New York, 1985).

32. Still another subgroup of Courbet's paintings of women, the most notorious of which is the canvas known as *The Origin of the World* (1866; also painted for Khalil Bey; cat. 66), evokes the notion of an act of sexual possession of the woman, and by implication of the painting, by the painter-beholder. In terms of the concerns of this essay, the result of such an act would be a complete undoing of distance and hence of vision, which is why the act itself cannot be represented but can only be suggested (the sexual embrace is "blind," as Steinberg remarks ["The Algerian Women and Picasso at Large," p. 130]). More broadly, to the extent that a metaphor of penetration has been implicit throughout my account of the painter-beholder seeking to transport himself quasi-corporeally into his pictures in the course of painting them, Courbet's antitheatrical project itself may be understood as figuratively "masculine." But just as the "masculine" phallus/paintbrush in Courbet turns out to possess "feminine" attributes, so penetration itself has unexpected consequences (for example, the painter-beholder all but "becomes" his female surrogates).

For their help in bringing this essay to its final form I want to thank Neil Hertz, Lynn Hunt, Ruth Leys, Sheila McTighe, Walter Benn Michaels, and Eve Kosofsky Sedgwick.

Chapter Four. "It Took Millions of Years to Compose That Picture"

The title of this essay is borrowed from *In Suspect Terrain* (New York, 1983), by John McPhee, who wrote this line with reference to George Inness's painting of the *Delaware Watergap*.

The essay grew out of a paper delivered at the College Art Association meeting in Toronto in 1985. I am grateful to Louis Hawes for giving me the opportunity to test my ideas at that occasion. For their comments and suggestions I thank Miriam Levin, Virginia Wageman, Gabriel Weisberg, and Lisa Wolf.

1. Schapiro 1941.

2. Herding 1975.

3. Wagner 1981.

4. Brötje 1978.

5. The study of the relationship between landscape painting and landscape experience has received less attention from art historians than from geographers. See, for example, J. Appleton, *The Experience of Landscape* (London, 1975) and Denis E. Cosgrove, *Social Formation and Symbolic Landscape* (Totowa, N.J., 1985).

6. Information about the Département du Doubs may be found in G. Gazier, *La Franche-Comté* (1924) and E. Préclin, *Histoire de la Franche-Comté* (Paris, 1947).

7. This closeness to the landscape is beautifully evoked in Riat 1906, chap. 1, passim.

8. Mayaud 1979b.

9. The wife of Régis, Sylvie Oudot (Courbet's mother), belonged to a family of landowning vintners (*vignerons propriétaires*), who were both well-to-do and respected in the community. Sylvie's father, Jean-Antoine Oudot, was the tax collector for Ornans township. Though he gave his daughter a relatively modest dowry, in 1842 he presented her with a vineyard and a house in the Iles Basses quarter of Ornans. See Mayaud 1979b, p. 18. In 1850 the attic of this house was turned into a studio for Courbet. It was here that he painted the *Stonebreakers* and the *Burial at Ornans*. See Léger 1948, p. 37.

10. Mayaud 1979b, pp. 19–20. Courbet's painting *The Return from the Fair* (Fernier 107) exemplifies his father's active participation in the farming process.

11. On Régis's inventions, see Riat 1906, p. 2. Riat's description of Régis Courbet as an impractical idealist is not confirmed by the archival data uncovered by Mayaud.

12. Mayaud 1979b, pp. 16–18.

13. Unpublished letter to Urbain Cuenot, no date [1866]. Author's translation.

14. Letter to Juliette, Frankfurt, no date [Feb. 1859]. Published in the *Archives de l'art français*, 1987.

15. Mayaud 1979b, p. 16.

16. The membership of the sociétés d'émulation was listed regularly in the *Bulletins* or *Mémoires* published by these organizations.

17. See Courthion 1950, p. 25.

18. The main article on Alesia was written by one of the founders of the society, the architect A. Delacroix. Entitled "Alesia," it appeared in the *Mémoires de la Société d'émulation du Doubs*, 2d series, 7(1855):113–60. Several short notices about excursions to Alesia and reports by committees studying aspects of the Alesia question are found in subsequent volumes of the *Mémoires*. The Alesia question was hotly debated in the mid-nineteenth century. Of the two factions that controlled the debate, one, led by Napoleon III, believed it to have been the ancestor of Alise-Ste.-Reine in the Côte d'Or; the other, led by Delacroix, claimed Alesia to have been near the small hamlet Alaise, south of Besançon, close to the Source de Lison. On this debate, which continued into the twentieth century, see J. Bruley, *L'Identification de la 'vraie' Alésia* (Paris, n.d.).

19. *Mémoires de la Société d'émulation du Doubs*, 3rd series, vol. 1 (1856): entire issue.

20. The title of an article by the geologist H. Coquand, "Traité des rochers, considérées au point de vue de leur origine, de leur composition, de leur gisement et de leurs applications à la géologie et à l'industrie," eminently evokes this dynamic idea of landscape, as in one broad sweep it connects the origins of certain rock formations with their current morphology and physical composition (and even with their potential for future industrial use). C. G. Collingwood, *The Idea of Nature* (Oxford, 1957), pp. 13ff.

21. Collingwood, *The Idea of Nature*, p. 10.

22. See Jules Michelet, *La Montagne* (Paris, 1861), p. 123. Michelet compares the importance of the French Revolution for mankind with the effects of volcanic action for the shape of the earth, and, similarly, the fall of Napoleon with the results of an earthquake.

23. ". . . vous verrez Salins, vous verrez Poupet et Alaise, ou Alaisia, selon les Druides, Nans et la source du Lison." Unpublished letter to Jules Castagnary, no date [Dec. 14, 1864]. For Courbet's father's interest in the Alesia question, see Zahar 1950, p. 13.

24. Riat 1906, p. 4.

25. Ibid., p. 217.

26. Ibid., pp. 159 and 179.

27. See the *Dictionnaire de biographie française* (Paris, 1933–), vol. 8, p. 820.

28. In Courbet's private exhibition at the Rond-Point de l'Alma. On Courbet's relaxed attitude about payment for this work, see Jean-Jacques Fernier, ed., *15 Lettres de Courbet* (Ornans, 1987), n.p. (letter no. 10).

29. Max Buchon, *Jules Marcou* (Salins, 1865), p. 16.

30. See ibid.

31. *Mémoires de la Société géologique de France*, 2d series, 3(1847):1–151.

32. See Jules Marcou, *Lettres sur les roches du Jura et leur distribution géographique dans les deux hémisphères* (Paris, 1857–60), pp. 29–30.

33. Unfortunately little of substance is known about the precise relationship between Courbet and Marcou. It appears, however, that their acquaintance was more than casual. When the sculptor Max Claudet visited Courbet's studio on the route de Besançon in 1864, he reported that the walls were covered with the arms of savages given to Courbet by Marcou. See Riat 1906, p. 217.

34. In Klaus Herding and Katharina Schmidt, eds., *Les Voyages secrets de Monsieur Courbet: Unbekannte Reiseskizzen aus Baden, Spa, und Biarritz* (Baden-Baden/Zürich, 1984), pp. 60–62.

35. While the representation of Caesar's camp as a field of trees in a general way denotes the progressive course of history, the large oak tree dominating the field may refine the meaning of the picture. In the nineteenth century the oak tree was popularly associated with the Druidic religion of the Gauls, whose heroic leader Vercingetorix was defeated by Caesar at Alesia. Courbet's painting seems to suggest that in spite of the Gauls' defeat their freedom spirit outlasted foreign repression: while the vestiges of the mighty Caesar are forever buried underground, the mighty oak stands as a symbol to Gallic strength and endurance.

36. First exhibited under this title at the Exposition Universelle of 1855, no. 2811.

37. On Cuenot's ownership of one of the houses of the Château d'Ornans, see Adolphe Marlet, "Notice sur une aiguille de pierre existant au territoire d'Ornans," *Mémoires de la Société d'émulation du Doubs*, 2d series, 8(1856):14. On Cuenot's social and economic background, see Mayaud 1981, p. 59.

38. Quoted in Stuckey 1971–73, pp. 27–28.

39. On this illustration and its preliminary drawing see Chu 1980b, pp. 81–82.

40. "J'y voyais nombre de barques abandonnés, inutiles. La pêche est devenue stérile. Le poisson a fui. Etretat languit, périt, près de Dieppe languissante. De plus en plus, il est réduit à la ressource des bains; il attend la vie des baigneurs, du hasard des logements, qui tantôt loués, tantôt vides, rapportent un jour et l'autre l'appauvrissement. Ce mélange avec Paris, le Paris mondain, quelque cher que celui-ci paye, est un fléau pour le pays." Michelet, *La Mer*, pp. 406–07.

41. For numerous examples of such illustrations, see Barbara Stafford, *Voyage into Substance* (Cambridge and London, 1984).

42. Courthion 1948, p. 129.

43. See Anthea Callen, *Techniques of the Impressionists* (Secaucus, 1982), p. 36.

44. "Faites donc avec un pinceau des rochers comme cela que le temps et la pluie ont rouillés par de grandes veines du haut en bas." Quoted in Courthion 1948, p. 200.

45. Quoted in ibid., 1948, p. 199.

46. Ibid., 1948, p. 54.

47. In a letter to an editor dated May 8, 1852, he objects to being called a student of Auguste Hesse and demands instead to be listed in official publications as an apprentice of nature. N.D.L.R., "Lettres autographes," *Amour de l'Art* 12(1931):393.

48. Miriam Levin, *Republican Art and Ideology in Late Nineteenth-Century France* (Ann Arbor, 1986), p. 168.

49. Hippolyte Taine, *Philosophie de l'art* (Paris, 1909), vol. 2, pp. 342–43, "la vie est la même dans les oeuvres du génie et dans les oeuvres de la nature."

50. For a different discussion of Courbet's painting technique, see Klaus Herding, "Farbe und Weltbild: Thesen zu Courbets Malerei," in Hamburg 1978, pp. 478–92.

51. Courbet despised finish and detail in landscape painting. On being shown a meticulously painted landscape by Louis Français, he is quoted as having said, "Qu'en dis tu? On ne peut pas ch . . . là dedans." Quoted in Léger 1948, p. 125.

52. In such recent works as Gabriel P. Weisberg, *Millet and His Barbizon Contemporaries* (Tokyo, 1985); Hans-Peter Bühler, *Die Schule von Barbizon* (Munich, 1979); and J. Bouret, *L'École de Barbizon* (Neuchâtel, 1972).

53. His official success during the Second Empire is measured by the fact that he was invited to stay at the imperial palace in Compiègne for a week in the winter of 1865. See Paris, Musée du Louvre, *Théodore Rousseau* (1968), "Biographie" (n. p.). See also Alfred Sensier, *Souvenirs sur Théodore Rousseau* (Paris, 1872), pp. 336ff.

54. Paris, *Rousseau*, p. 71.

55. Sensier, *Souvenirs,* passim.

56. Compare a remark by Jules Breton, quoted in Paris, *Rousseau*, introduction (n.p.): "En forêt, il restait des heures sur son pliant, couvert d'un manteau feuille-morte, le cou obstinément ployé par une attention qui ne relevait que ses yeux . . . , si immobile qu'il avait l'air d'une ruche."

57. "J'entends par composition ce qui est en nous, entrant le plus possible dans la réalité extérieure des choses.

"Si c'était autrement, le maçon armé de sa latte en aurait fini bien vite avec la composition d'un tableau représentant la mer. Il suffirait d'une ligne tracée à n'importe quelle hauteur sur la toile. Maintenant, qui composera la mer, si ce n'est l'âme de l'artiste. . . .

"Il y a composition quand les objets représentés ne le sont pas pour eux-mêmes, mais en vue de contenir, sous une apparence naturelle, les echos qu'ils ont placés dans notre âme. Si l'on peut constater s'ils pensent [les arbres], à coup sur ils nous donnent à penser, et en retour de toute la modestie dont ils font usage pour élever nos pensées, nous leur devons, pour prix de leur spectacle, non arrogante maîtrise, ou le style pédant et classique, mais toute la sincérité d'une attention reconnaissante dans la réproduction de leurs êtres, pour la puissante action qu'ils éveillent en nous. Ils ne nous demandent, pour tout ce qu'ils nous donnent à penser, que de ne pas les défigurer, de ne pas les priver de cet air dont ils ont tant besoin. . . .

"Pour Dieu et en récompense de la vie qu'il nous a donnée, faisons que dans nos oeuvres la manifestation de la vie soit la première de nos pensées; faisons qu'un homme respire, qu'un arbre puisse réellement végéter." Sensier, *Souvenirs,* pp. 278–79.

58. Paris, *Rousseau*, introduction (n.p.).

59. Sensier, *Souvenirs,* passim.

60. See Cosgrove, *Social Formation and Symbolic Landscape,* p. 245.

61. Paris, *Rousseau*, introduction (n.p.).

62. Sensier, *Souvenirs,* p. 14.

63. On Wolf, see especially Willi Raeber, *Caspar Wolf (1735–1783). Sein Leben und sein Werk* (Aarau and Zürich, 1979).

64. Reproduced in ibid., p. 71.

65. Ibid., p. 63.

66. For an insightful analysis of Courbet's *Source of the Loue River* in the Kunsthaus in Zürich, see Emil Maurer, "'Die Quelle der Loue.' Zu einem Gemälde im Kunsthaus Zürich," in *15 Aufsätze zur Geschichte der Malerei* (Basel, Boston, and Stuttgart, 1982), pp. 161–68. For an alternative, psychoanalytical interpretation of Courbet's caves, see Werner Hofmann, "Courbets Wirklichkeiten," in Hamburg 1978, p. 610. On the subject of caves in art in general, see also Appleton, *The Experience of Landscape,* pp. 103ff.

67. On the scientific approach to landscape of Swiss eighteenth- and nineteenth-century painters, see E. W. Bredt, *Die Alpen und ihre Maler* (Leipzig, 1911), passim; on Hodler's interest in the natural sciences, see Oskar Bätschmann, "The Landscape Oeuvre of Ferdinand Hodler," in Los Angeles, Wight Art Gallery; The Art Institute of Chicago; and New York, National Academy of Design, *Ferdinand Hodler: Landscapes* (1987), pp. 24–48.

68. On the relation between Courbet and Hodler, see Bätschmann, "The Landscape Oeuvre of Ferdinand Hodler," pp. 30–31 and passim.

Chapter Five. Courbet's Reception in America

The research for this essay was conducted concurrently with that for my master's essay, "Patronage and Criticism of Courbet and Manet in Nineteenth-Century America" (Queens College, CUNY, 1988), which was completed under the direction of H. Barbara Weinberg and Linda Nochlin. Their support and guidance was invaluable. I am grateful to Professor Nochlin for recommending me for this project, and to Sarah Faunce of The Brooklyn Museum for being gracious enough to provide the opportunity to publish my work alongside that of some very distinguished scholars. My research was funded by a generous assistantship provided by Dean Helen Cairns and the Office of the Dean of Graduate Studies and Research at Queens College. Many others generously provided time and information: William Gerdts, Lois Marie Fink, Joseph Rishel, Carl Strehlke, Theresa D. Cederholm, Caroline Durand-Ruel Godfroy, Henry-Claude Cousseau, Anne Coffin Hanson, Maygene Frost Daniels, Arleen Pancza-Graham, Pam Delaney, Theresa Rosinsky, Nancy Fresella-Lee, Michael Goodison, Lea R. Schein, and Margaret Heller.

This essay is dedicated to my family, and to the memory of Andrew Salman—a cherished friend and dedicated student of art history.

1. Lois Marie Fink, "French Art in the United States, 1850–1870: Three Dealers and Collectors," *Gazette des Beaux-Arts,* ser. 6, 92(September 1978):87–100.

2. See H. Barbara Weinberg, "The Lure of Paris: Late-Nineteenth-Century American Painters and Their French Training," *A New World: Masterpieces of American Painting, 1760–1910,* ed. Janet Silver (Boston, Washington, D.C., and Paris, 1983–84), pp. 16–32; and Lois Fink, "American Artists in France, 1850–1870," *American Art Journal* 5:2(November 1973):32–49.

3. "The French and English Gallery," *New-York Daily Tribune,* September 24, 1859, 3:1.

4. Fink, "French Art," pp. 88ff.

5. *Second Exhibition in New York of Paintings, The Contributions of Artists of the French and English Schools* (New York, 1859), p. 5, cat. no. 38.

6. The identification of this work was made in consultation with Linda Nochlin. In a letter to the author dated April 10, 1986, Henry-Claude Cousseau, director of the Musée des Beaux-Arts in Nantes, stated that, although he doubted the possibility of such a trip, there was no information in the museum's files that would definitively preclude the work's exhibition in New York. The work entered the museum's permanent collection in 1861.

7. Only a few of the reviews mention Courbet's painting; none of them discuss it. See: *New-York Times,* September 10, 1859, 4:5; *New York Her-*

ald, September 25, 1859, 1:3; *New-York Daily Tribune*, September 12, 1859, 7:1–2; *Gazette des Beaux-Arts* 1:5(March 1, 1859):320; and, "Domestic Art Gossip," *The Crayon* (New York) 6:10(October 1859):320.

8. Fink, "French Art," p. 89. *La Société des Aquafortistes* had been founded by Alfred Cadart in 1863.

9. "The Exhibition of the French Etching Club at the Derby Gallery," *New-York Times*, April 8, 1866, 5:4. (The Fine Arts Gallery was also known as the Derby Gallery.)

10. Ibid.

11. Ibid.

12. *1866[.] First Exh[i]bition in New York of Pictures[,] The Contributions of Artists of the French Etching Club . . .* , ed. Cadart and Luquet, intro. Jules-Antoine Castagnary (New York, 1866), pp. 8–10, cat. nos. 53–56.

13. Ibid., "Gustave Courbet: The Art of Painting in the XIX Century," pp. 4–5.

14. "The French Etching Club," *The Round Table* 3:30(March 31, 1866):199.

15. Ibid.

16. Ibid.

17. On these men, and the development of private collections in Boston, see: Peter Bermingham, *American Art in the Barbizon Mood* (Washington, D.C., 1975); Alexandra R. Murphy, "French Paintings in Boston: 1800–1900," *Corot to Braque: French Paintings from the Museum of Fine Arts, Boston* (Boston, 1979), pp. xvii–xlvi; Susan Fleming, "The Boston Patrons of Jean-François Millet," *Jean-François Millet* (Boston, 1984), pp. ix–xviii; Robert C. Vose, Jr., "Boston's Vose Galleries: A Family Affair," *Archives of American Art Journal* 21:1(1981):8–20; and, "An American Expert," *The Collector* 2:5(January 1, 1891):54.

18. William Howe Downes, "Boston Painters and Paintings," pt. 6, *Atlantic Monthly* 62(December 1888):781. Murphy, "French Paintings in Boston," p. xxxviii, says that the New York dealer to whom Downes refers was Samuel Putnam Avery, and that the Boston dealer Seth Vose was the one who managed to find buyers for them.

19. Downes, "Boston Painters and Paintings," pt. 3, *Atlantic Monthly* 62(September 1888):389, called it "the only [club in Boston] worthy of the name."

20. A full account of the purchase and subsequent exhibition of the *Quarry* is provided by Downes, "Boston Painters and Paintings," pt. 4, *Atlantic Monthly* 62(October 1888):503–06.

21. Ibid., p. 504. Downes is here quoting Amand Gautier.

22. *Catalogue. Allston Club, First Exhibition* ([Boston], 1866), p. 3, cat. no. 1.

23. E. S., "Notes on 'La Curée' at the Allston Club's Exhibition," *Boston Daily Evening Transcript*, May 12, 1866 [4:3].

24. Ibid.

25. See Laura Meixner, "Popular Criticism of Jean-François Millet in Nineteenth-Century America," *Art Bulletin* 65(1983):94–105, and Madeleine Fidell-Beaufort, "Jules Breton in America: Collecting in the 19th Century," *Jules Breton and the French Rural Tradition*, ed. Hollister Sturges (Omaha, Nebraska, and New York, 1982), pp. 51–61.

26. Robert F. Perkins, Jr., and William J. Gavin III, comp. and ed., *Boston Athenaeum Art Exhibition Index: 1827–1874* (Boston, 1980), pp. 5, 42.

27. The provenance of the work is given by Bruce K. MacDonald, in "The Quarry by Gustave Courbet," *Bulletin: Museum of Fine Arts, Boston* 67(1969):67n1.

28. Weinberg, "The Lure of Paris," 16.

29. E. S. [Edward Strahan, pseud. for Earl Shinn], "The International Exhibition," *The Nation* 23(September 28, 1876):193.

30. *United States Centennial Commission. International Exhibition. 1876. Official Catalogue. Part II. Art Gallery and Annexes. Dept. IV. Art.*, 10th and rev. ed. ([Cambridge, Mass.], 1876), cat. nos. 807–10.

31. E. S., "The International Exhibition," *The Nation* 23(October 12, 1876):225.

32. The painting was acquired by the Metropolitan Museum of Art in 1940. For the full provenance and exhibition history of this painting, see Charles Sterling and Margaretta M. Salinger, *French Paintings: A Catalogue of The Collection of The Metropolitan Museum of Art*, 3 vols. (New York, 1966), vol. 2, p. 109.

33. *Massachusetts Charitable Mechanic Association. Catalogue of the Department of Fine Arts. Fourteenth Exhibition.* (Boston, 1881), p. 14, cat. no. 156. The work is further identified as a *Swiss Landscape* by Edward Strahan in *Art Treasures of America*, 3 vols. (Philadelphia, 1880), vol. 2, p. 99. On these pages Strahan also discusses and illustrates *Demoiselles* and *Quarry* (vol. 2, pp. 87–100). Among the Courbets not discussed here, he lists the *Great Oak of Ornans*, owned by Henry C. Gibson of Philadelphia; *Evening in the Jura*, owned by S. A. Coale, Jr., of St. Louis; and two works owned by Judge George Hoadly of Cincinnati.

34. These are discussed in greater detail in my unpublished master's thesis, "Patronage and Criticism of Courbet and Manet in Nineteenth-Century America" (Queens College, CUNY, 1988).

35. *Catalogue of an Extraordinary Collection of First Class Original Pictures Being The Entire Collection Known As The "French and Flemish Exhibition," At "Goupil's," . . .* (New York, 1861), p. 9, cat. no. 102.

36. *Catalogue of the Art Collection. Cincinnati Industrial Exposition. 1873.* ([Cincinnati], 1873), p. 33, cat. no. 256. The work was imported from London by the attorney M. D. Conway.

37. Catalogue not located. The work is discussed in "Mr. Schenck's Art Gallery—Sale of Paintings," *New-York Times*, January 27, 1875, 5:3.

38. *Chicago Academy of Design. 1876. Catalogue.* ([Chicago] 1876), p. 11, cat. no. 213.

39. *1866. Second Exhibition in New York, of Pictures, The Contributions of Artists of the French Etching Club.* (Brooklyn, New York, 1866), p. 6, cat. no. 59.

40. *Catalogue. Allston Club, Second Annual Exhibition, 1867.* ([Boston], 1867), pp. 3–4, cat. nos. 1, 2.

41. "Gustave Courbet," *Temple Bar* 42(November 1874):535–46; pages 543–44 were reprinted in "Art Notes . . . Courbet's Works . . . ," *New-York Times*, January 17, 1875, 10:7.

42. Ibid.

43. See "Painter Courbet's Troubles," *New-York Times*, August 29, 1875, 5:6 (reprinted from the London *Daily Telegraph*); and "M. Courbet and the Commune," *New-York Times*, September 30, 1876, 3:6 (reprinted from the London *Standard*).

44. "M. Courbet and the Commune," *New-York Times*, September 30, 1876, 3:6.

45. *New-York Times*, January 27, 1875, 5:3.

46. "Current French Topics. . . . Courbet the Painter," *New-York Times*, January 17, 1878, 2:5–6.

47. Charlotte Adams, "A Memory of Gustave Courbet," *Lippincott's Magazine* 21(May 1878):632.

48. Titus Munson Coan, "Gustave Courbet, Artist and Communist," *Century Magazine* 27:4(February 1884):483–95.

49. Ibid.

50. Ibid.

51. M[ariana] G[riswold] van Rensselaer, "Courbet, the Artist," *Century Magazine* 29:5(March 1885):792–94.

52. Ibid., p. 793.

53. C[lara] H[arrison] Stranahan, *A History of French Painting: From Its Earliest to Its Latest Practice . . .* (New York, 1888), pp. 376–82.

54. Ibid., p. 377.

55. John C. Van Dyke, ed., *Modern French Masters. A Series of Biographical and Critical Reviews by American Artists* (New York, 1896).

56. Samuel Isham, "Gustave Courbet," in Van Dyke, pp. 199–212.

57. Isham, p. 199.

58. Ibid., p. 207.

59. "Foreign Art in Boston. A Disappointing Exhibition," *New-York Daily Tribune,* September 11, 1883, 5:3.

60. "Art at the Boston Exhibitions," *Art Amateur* 9:5(October 1883):90. Another scathing review was delivered in "Art Notes," *Boston Evening Transcript,* September 6, 1883, 5:1.

61. *Catalogue of the Art Department. Foreign Exhibition. Illustrated.* (Boston, 1883), cat. nos. 8, 109, 116.

62. *New-York Daily Tribune,* September 11, 1883, 5:3.

63. For a revised look at the exhibition, see Maureen C. O'Brien, *In Support of Liberty: European Paintings at the 1883 Pedestal Fund Art Loan Exhibition* (New York, 1986).

64. "The Pedestal Art Loan" [Pt. 1], *New-York Times,* December 2, 1883, 2:5.

65. Ronald G. Pisano, "William Merritt Chase: Innovator and Reformer," in O'Brien, *In Support of Liberty,* pp. 63ff.

66. *Catalogue of the Pedestal Fund Art Loan Exhibition, at the National Academy of Design . . . December, 1883* (New York, 1883), cat. nos. 67, 68, 94, 144, 163, 166, and 181.

67. "The Paintings at the Loan Exhibition," *New-York Daily Tribune,* December 26, 1883, 6:2.

68. John C. Van Dyke, "The Bartholdi Loan Collection," *Studio* 2:49 (December 8, 1883):263.

69. *New-York Times,* December 2, 1883, 2:5.

70. "To Be Open on Sunday," *New-York Times,* December 20, 1883, 5:2. See also Lois Dinnerstein, "When Liberty was Controversial," in O'Brien, *In Support of Liberty,* pp. 73ff.

71. "The Exhibition of Paintings," *Art Amateur* 10:2 (January 1884):42.

72. E. Durand-Gréville, "La Peinture aux Etats-Unis," *Gazette des Beaux-Arts,* ser. 2, 36(1887):65–66.

73. See, for example, Thomas E. Norton, *100 Years of Collecting in America: The Story of Sotheby Parke Bernet* (New York, 1984).

74. Murphy, "French Paintings in Boston," p. xxxviii.

75. A typical example would be the Wall-Brown sale. Prices of selected works were listed by the *New-York Times.* See: "Auction Sale of Paintings," March 31, 1886, 5:2; "'The Little Mendicant,'" April 1, 1886, 4:7; and "Valuable Paintings Sold," April 2, 1886, 1:6.

76. *Catalogue of Modern Paintings Belonging to Erwin Davis, Esq.* ([New York], [1889]), cat. nos. 26, 61, 100, and 135.

77. Downes, "Boston Painters," pt. 6, p. 781 (quoted in n. 18).

78. Dorothy Weir Young, *The Life and Letters of J. Alden Weir* (New Haven, Connecticut, 1960), pp. 144–46.

79. Frances Weitzenhoffer, "First Manet Paintings to Enter an American Museum," *Gazette des Beaux-Arts* ser. 6, 97(March 1981):127.

80. Ibid. See also: "A Quarter of a Million," *New-York Times,* March 21, 1889, 2:5; "Big Prices for Pictures," *New-York Daily Tribune,* March 21, 1889, 7:1; "Wild Bidding for Pictures," *New York Herald,* March 21, 1889, 7:5.

81. Weitzenhoffer, "First Manet Paintings," pp. 127–28. See also: "Fictitious Prices," *New-York Times,* March 22, 1889, 2:7; "Buying His Own to Give Away," *New York Herald,* March 22, 1889, 7:5.

82. "Very Light Bidding," *New-York Times,* March 20, 1889, 5:4; "Pictures at Auction," *New-York Daily Tribune,* March 20, 1889, 6:6; "The Erwin Davis Sale," *New York Herald,* March 20, 1889, 6:6 (where Courbet is misspelled "Coubert"). See also the press reviews listed in n. 80, where the *Herald* gives the buyer's name as "Barnay," rather than "Barnum" (as in the *Tribune*).

83. *Catalogue of a Collection of Fine Paintings Belonging to John G. Johnson* (Philadelphia, 1892), pp. 21–23, cat. nos. 58–64.

84. The provenance is given in Fernier 1977, no. 321. See also: *Catalogue of the Collection of Mr. Thomas Robinson of Providence, R.I. . . .* (Providence, 1886), p. 53, cat. no. 129.

85. Archive Files, European Paintings Dept. (W. P. Wilstach Collection), Philadelphia Museum of Art. Johnson acquired the work from a Philadelphia art dealer named Haseltine sometime between 1888 and 1890.

86. *Loan Exhibition. February, 1893. Catalogue.* ([New York], 1893), p. 42, cat. no. 63. See also: "Modern Pictures at the Loan," *New-York Times,* March 10, 1893, 4:5.

87. *Loan Exhibition Catalogue,* 1893, p. 44, cat. no. 85. For the review, see: *New-York Times,* March 10, 1893, 4:5.

88. *H. O. Havemeyer Collection: Catalogue of Paintings, Prints, Sculpture and Objects of Art* (New York, 1931).

89. See Louisine W. Havemeyer, *Sixteen to Sixty: Memoirs of a Collector* (New York, 1961), pp. 180–203; and Frances Weitzenhoffer, *The Havemeyers: Impressionism Comes to America* (New York, 1986).

90. Havemeyer, *Sixteen to Sixty,* p. 190; and Weitzenhoffer, *The Havemeyers,* pp. 22, 79–80.

91. Havemeyer, *Sixteen to Sixty,* p. 181.

92. Ibid., pp. 191–92; and Weitzenhoffer, *The Havemeyers,* pp. 79–80.

93. Weitzenhoffer, *The Havemeyers,* pp. 79–80.

94. Ibid., p. 89.

95. *World's Columbian Exposition Official Publications[.] Revised Catalogue[.] Department of Fine Arts[.] With Index of Exhibitors[.]* (Chicago, 1893), p. 153, cat. no. 3115.

96. William Coffin, "The Columbian Exposition.—[Pt.] V. Fine Arts: The French Pictures and the Loan Collection," *The Nation* 57(August 31, 1893):152.

97. Hubert Howe Bancroft, *The Book of the Fair,* 3 vols. (1893), vol. 3, p. 694.

98. Ibid.

99. Havemeyer, *Sixteen to Sixty,* p. 194.

100. Weitzenhoffer, *The Havemeyers*, p. 56n9.

101. Havemeyer, *Sixteen to Sixty*, p. 196. See also Weitzenhoffer, *The Havemeyers*, p. 193.

102. Letter to the author, dated May 27, 1986, from Caroline Durand-Ruel Godfroy. I have been unable to locate the catalogue through the usual sources. An invitation to the exhibition may be found on microfilm at the Archives of American Art, Smithsonian Institution, New York Branch, Reel No. N100, frame 121.

103. "The Week in Art," *Saturday Review of Books and Art* (supp.), *New York Times*, May 6, 1899, 290:2.

104. "Art Exhibitions," *New-York Daily Tribune*, April 29, 1899, 8:6.

105. Quoted above in n. 57.

Chapter Six. Who Is Buried at Ornans?

1. The Franche-Comté has had a tumultuous and unique history. It existed as an island, never a contiguous part of any nation, yet claimed by many groups occupying this eastern border region of France since ancient Roman times. Its complicated history began with the Séquanes, a Gallic tribe that established itself in the Jura during the first millennium B.C. Later, the Franche-Comté enlisted the help of Julius Caesar in repressing constant invasions by the Swedes and Germanic tribes. A Roman fortress was erected at Besançon, and Roman occupation of the *Provincia Maxima Sequanorum* lasted until the fifth century. In 1032, the region passed into the hands of the Salian emperor Conrad II. Briefly under French control in 1295, the region passed to Flemish hands following the Hundred Years War. Between 1477 and 1601, the Franche-Comté became a possession of the Hapsburg empire. The early seventeenth century marked the beginning of the period of French invasions to annex the Franche-Comté, which culminated in the final conquest of 1674 under Louis XIV. It was not until 1678 and the Treaty of Nimeguen that the province officially became part of France.

2. Borel 1951, p. 71.

3. For a discussion of burial practices prior to the Napoleonic decrees, see Eugen Weber, *Peasants into Frenchmen. The Modernization of Rural France, 1870–1914* (Stanford, 1976).

4. Much of this documentary evidence is found in series *O* and *M* of the Archives Départementales du Doubs, Besançon (hereafter referred to as A.D.D.). For detailed discussion of the Ornans cemetery controversy, see Mainzer 1982, pp. 49–66.

5. Mainzer 1981, p. 22n8.

6. "Si j'avais été consulté dans cette translation, j'aurais fait remarquer les inconvénients qui se trouvent dans un cimetière ainsi placé, par rapport à la solemnité religieuse." Letter dated September 20, 1847, Archives Diocesaines de Besançon.

7. Six-page letter dated 1828 (before April 13), A.D.D. 0/444/0(4).

8. Prosper's father was Ferréol-Hilaire François Teste (1765–1825), and his maternal grandfather was Jean-Hermand François Xavier, vicomte de Sagey (1755–1831).

9. Guyot de Vercia remained a relentless advocate of the cemetery's relocation from his letter of July 28, 1813, which is the earliest local evidence of the controversy, until his death in 1834. Members of the de Vercia family were large landowners, and many served as mayors of Ornans during the seventeenth and eighteenth centuries. The location of the Hôtel Guyot de Vercia, adjacent to the old churchyard cemetery, had an important bearing on his protests.

10. One short manuscript, entitled "Le conseil municipal d'Ornans," is filled with humorous and somewhat biting remarks that reflect Courbet's profound disdain for some dignitaries and council members; Courbet Papers, Box 1, "Manuscrits divers."

11. The area known as the "Roche Ougneche," made up of numbers 211–33 of Ornans's land registry, belonged to the Courbet family.

12. Clark 1973a, p. 51.

13. "Dans ce moment-ci, je compose mon tableau sur la toile"; letter dated December 12, 1849 from Courbet to M. and Mme. Wey; Riat 1906, p. 76.

14. According to Paul Grosperrin, Ornans's present-day gravedigger, this plaque was set up c. 1975 through the efforts of M. Albert Altheimer; interview, Ornans, November 1980.

15. Interviews with Abbé Emile Teste (born 1910), Cirey-les-Bellevaux (Haute-Saône), April 22, 1981, and with M. Pierre Simon, Ornans, April 6, 1981.

16. Claude-Isabelle Brelot, "Un Equilibre dans la tension: Economie et société Franc-comtoises traditionnelles (1789–1870)," in *Histoire de la Franche-Comté.* Under the direction of Roland Fietier (Univers de la France et des pays francophones) (Toulouse, 1977), pp. 351–97.

17. After the Revolution, ca. 1794, Teste was a tribunal judge for the district of Ornans, and from 1798 to 1800 he was a municipal agent and officer of the civil records for the commune of Ornans.

18. Claude-Etienne Teste was present at the following council meetings dealing with the new cemetery project: May 21 and September 17, 1820; June 24, 1821; July 9 and September 11, 1826; and, at the March 23, 1828 meeting, he voted in support of the measure to secure funds for the new cemetery; "Extraits du Registre des délibérations du conseil municipal de la ville d'Ornans," A.D.D. 0/444/0(4).

19. The original location of Claude-Etienne Teste's grave can be determined from a document of 1874, in which his grandsons, Georges Edouard Teste (1816–1903) and Jean-Augustin Teste (born 1820), procured a cemetery concession on the same site; "Concessions du Cimetière d'Ornans," A.D.D. 0/444/0(13).

20. Abbé Garneret, "L'Homme est mortel." *Barbizier* (Almanach populaire comtois, 1954), p. 208.

21. Schapiro 1941, p. 167.

22. Riat 1906, pp. 77–79.

23. Paris 1977, p. 99.

24. Mayaud 1981.

25. Yves Dornier, "Pour les successeurs des fossoyeurs de l'*Enterrement à Ornans* une fidelité vieille d'un siècle et demi," *L'Est Republicain* (November 1, 1980):11.

26. Paris 1977, p. 102.

27. Claude-Isabelle Brelot, *Besançon revolutionnaire* (Paris, 1966), pp. 122–23.

Bibliography

Adhémar, Jean. 1977. "Deux Notes sur des Tableaux de Courbet." *Gazette des Beaux-Arts*, 6th ser., 90:200–04.

Aragon, Louis. 1952. *L'Exemple de Courbet*. Paris.

Baden-Baden, Staatliche Kunsthalle. 1984. *Les Voyages secrets de Monsieur Courbet: Unbekannte Reiseskizzen aus Baden, Spa und Biarritz*. Exh. cat. by Klaus Herding and Katharina Schmidt.

Berger, Klaus. 1943. "Courbet in His Century." *Gazette des Beaux-Arts*, 6th ser., 24:19–40.

Bessis, Henriette. 1981. "Courbet en Suisse surveillé par la police française." *Gazette des Beaux-Arts* 98:115–26.

Boas, George, ed. 1938. *Courbet and the Naturalistic Movement*. Baltimore.

Bonniot, Roger. 1967. "Interventions en faveur de Courbet en exil." *Gazette des Beaux-Arts* 6, 70:227–244.

——————. 1973. *Gustave Courbet en Saintonge*. Paris.

Borel, Pierre. 1922. *Le roman de Gustave Courbet, d'après une correspondance originale du grand peintre*. Paris.

——————. 1951. *Lettres de Gustave Courbet à Alfred Bruyas*. Geneva.

Boudaille, Georges. 1969. *Gustave Courbet: Painter in Protest*. Greenwich, Connecticut.

——————. 1981. *G. Courbet*. Paris.

Bowness, Alan. 1972. *Courbet's "Atelier du Peintre."* Newcastle upon Tyne.

——————. 1977a. "New Courbet Literature." *Burlington Magazine* 119:290–91.

——————. 1977b. "Courbet and Baudelaire." *Gazette des Beaux-Arts* 119:189–99.

——————. 1978. "Courbet's Proudhon." *Burlington Magazine* 120:123–28.

Brötje, M. 1978. "Das Bild als Parabel: Sur Landschaftsmalerei Gustave Courbets." *Jahrbuch der Hamburger Kunstsammlungen* 23:75–106.

Brunius, Teddy. "Gustave Courbet, Realism and Revolution," in *Mutual Aid in the Arts from the Second Empire to Fin de Siècle*. *Figura*: Uppsala Studies in the History of Art, new series 9. Uppsala, 1972, pp. 9–57.

Bulletin. Les Amis de Gustave Courbet *Bulletin*. Vol. 1, 1947 ff.

Callen, Anthea. 1980. *Courbet*. London.

Castagnary, Jules. 1911–12. "Fragments d'un livre sur Courbet." Part 1, *Gazette des Beaux-Arts*, 5:5–20; part 2, 6:488–97; part 3, 7:19–30.

Champfleury [pseud.]. 1973. *Champfleury: Le réalisme*. Geneviève and Jean Lacambre, eds. Paris.

Chartres, Musée des Beaux-Arts. [1984]. *Exigences de réalisme dans la peinture française entre 1830 et 1870*. Exh. cat., n.d.

Chessex, Pierre. 1982. *Courbet et la Suisse*. Exh. cat. La Tour-de-Peilz, Switzerland.

Chirico, Giorgio de. 1925. *Gustave Courbet*. Paris.

Chu, Petra ten-Doesschate. 1974. *French Realism and the Dutch Masters*. Utrecht.

——————, ed. 1977. *Courbet in Perspective*. Englewood Cliffs, New Jersey.

——————. 1980a. "Courbet's Unpainted Pictures." *Arts* 55:134–41.

——————. 1980b. "Gustave Courbet: Illustrator." *Drawing* 2:78–85.

Clark, T. J. 1969a. "A Bourgeois Dance of Death: Max Buchon on Courbet–I." *Burlington Magazine* 111:208–12.

——————. 1969b. "A Bourgeois Dance of Death: Max Buchon on Courbet–II." *Burlington Magazine* 111:286–90.

——————. 1973a and 1982. *Image of the People: Gustave Courbet and the 1848 Revolution*. London and Princeton.

——————. 1973b. *The Absolute Bourgeois: Artists and Politics in France 1848–1851*. London.

——————. 1980. "Courbet the Communist and the Temple Bar Magazine." In *Malerei und Theorie: Das Courbet-Colloquium 1979*. Klaus Gallwitz and Klaus Herding, eds. Frankfurt am Main, pp. 23–36.

Cooper, Douglas. 1960. "Courbet in Philadelphia and Boston." *Burlington Magazine* 102(June): 244–45.

Courbet Papers. "Documents sur Gustave Courbet réunis par Et. Moreau-Nélaton et Georges Riat (venus de Castagnary) et La Famille Courbet." Paris, Bibliothèque Nationale: Cabinet des Estampes.

Courthion, Pierre. 1931. *Courbet*. Paris.

——————, ed. 1948 and 1950. *Courbet raconté par lui-même et par ses amis*. 2 vols. Geneva.

Delbourgo, Suzy, and Lola Faillant. 1973. "Courbet du copiste au maître." In "Contribution à l'étude de Gustave Courbet," in participation with M. Hours and M.-T. de Forges in *Laboratoire de recherche des Musées de France: Annales.*

Dittman, Lorenz. 1971. "Courbet und die Theorie des Realismus." *Beitrage zur Theorie der Künste in 19. Jahrhundert.* Frankfurt: 215–39.

Dumur, Guy. 1959. "La Galerie Bruyas." *L'Oeil* 60:87–94.

Duret, Théodore. 1918. *Courbet.* Paris.

Edelson, Douglas E. 1987. "Patronage and Criticism of Courbet and Manet in Nineteenth-Century America." Master's thesis, Queens College, CUNY.

Estignard, Alexandre. 1897. *Courbet: Sa vie et ses oeuvres.* Besançon.

Faillant-Dumas, L. 1977. "*L'Atelier* de Courbet: Etude radiographique au Laboratoire des Recherches des Musées de France." *Annales du Laboratoire des Recherches des Musées de France,* pp. 30–41.

Farwell, Beatrice. 1972. "Courbet's *Baigneuses* and the Rhetorical Feminine Image." In *Woman as Sex Object: Studies in Erotic Art, 1730–1970.* Thomas Hess and Linda Nochlin, eds. New York, pp. 65–79.

————. 1977. *The Cult of Images: Baudelaire and the Nineteenth-Century Media Explosion.* Exh. cat. Santa Barbara, University of California Santa Barbara Art Museum.

Fermigier, André. 1971. *Courbet.* Geneva.

Fernier, J-J. 1987. "C'est l'histoire physique de mon atelier." In *L'Atelier du peintre . . . une étude du tableau de Courbet.* Ornans, Musée Gustave Courbet.

Fernier, Robert. 1961. "En 1920, 'L'Atelier' de Courbet entrait au Louvre." Les Amis de Gustave Courbet *Bulletin* 29:1–13.

————. 1969. *Gustave Courbet.* Paris.

————. 1977. *La Vie et l'oeuvre de Gustave Courbet: Catalogue raisonné.* 2 vols. Lausanne and Paris.

Ferrier, Jean-Louis. 1980. *Courbet: Un enterrement à Ornans. Anatomie d'un chef d'oeuvre.* Paris.

Fontainas, André. 1921. *Courbet.* Paris.

Forges, Marie-Thérèse de. 1973. *Autoportraits de Courbet.* Exh. cat. Les Dossiers du Département des Peintures, no. 6, Musée du Louvre. Paris.

————. 1976. "Un nouveau tableau de Courbet au Musée des Beaux-Arts de Caen." *La Revue du Louvre* 5–6:408–10.

Foucart, Bruno. 1977. *G. Courbet.* Paris.

Fried, Michael. 1978. "The Beholder in Courbet: His Early Self-Portraits and Their Place in His Art." *Glyph* 8:85–129.

————. 1981. "Representing Representation: On the Central Group in Courbet's *Studio.*" In *Allegory and Representation,* Stephen J. Greenblatt, ed. Selected Papers from the English Institute, 1979–80. Baltimore, pp. 94–127.

————. 1982. "Painter into Painting: On Courbet's *After Dinner at Ornans* and *Stonebreakers.*" *Critical Inquiry* 8:619–49.

————. 1983. "The Structure of Beholding in Courbet's *Burial at Ornans.*" *Critical Inquiry* 9:635–83.

————. 1986. "Courbet's Metaphysics: A Reading of *The Quarry.*" In *Reconstructing Individualism: Autonomy, Individuality, and the Self in Western Thought,* T. C. Heller, et al., eds. Stanford, California, pp. 75–105.

Gaillard, Fr. 1980. "Gustave Courbet et le réalisme: Anatomie de la réception critique d'une oeuvre: 'un enterrement.' " *Revue d'histoire littéraire de la France* 6:978–98.

Gallwitz, Klaus, and Klaus Herding, eds. 1980. *Malerei und Theorie: Das Courbet-Colloquium 1979.* Frankfurt am Main.

Georgel, Pierre. 1975. "Les transformations de la peinture vers 1848, 1855, 1863." *Revue de l'Art* 27:69–72.

Gros-Kost, Emile. 1880. *Gustave Courbet: Souvenirs intimes.* Paris.

Guichard, Marie. 1862. *Les doctrines de M. Gustave Courbet, maître peintre.* Paris.

Haedeke, Marion. 1980. *Alfred Bruyas: Kunstgeschichtliche Studie zum Mazenatentum im 19. Jahrhundert.* Europäische Hochschulschriften: Kunstgeschichte, series 28, no. 14. Frankfurt am Main.

Hamburg, Kunsthalle. 1978. *Courbet und Deutschland.* Exh. cat. by Werner Hofmann, Klaus Herding, Margaret Stuffmann, et al.

Haskell, Francis. 1982. "A Turk and His Pictures in Nineteenth-Century Paris." *Oxford Art Review* 5(1):40–47.

Herbert, Robert. 1980. "Courbet's 'Mère Grégoire' and Béranger." In *Malerei und Theorie: Das Courbet-Colloquium 1979.* Klaus Gallwitz and Klaus Herding, eds. Frankfurt am Main, pp. 75–89.

Herding, Klaus. 1975. "Egalität und Autorität in Courbets Lanschaftsmalerei." *Stadel-Jahrbuch* 5:159–87.

————. 1977. "Les Lutteurs détestables: Stil- und Gesellschaftskritik in Courbets Ringerbild." *Jahrbuch der Hamburger Kunstsammlungen* 22:137ff.

————. 1978. "Das *Atelier des Malers*—Treffpunkt der Welt und Ort der Versohnung." In *Realismus als Widerspruch: Die Wirklichkeit in Courbets Malerei.* Klaus Herding, ed. Frankfurt am Main, pp. 223–47.

Hofmann, Werner. 1961. *The Earthly Paradise.* New York.

————. 1978. "Uber die 'Schlaffende Spinnerin'." In *Realismus als Widerspruch: Die Wirklichkeit in Courbets Malerei.* Klaus Herding, ed. Frankfurt am Main, pp. 212–22.

Humbert, C. 1987. "C'est l'histoire morale de mon atelier." In *L'Atelier du peintre . . . une étude du tableau de Courbet.* Ornans, Musée Gustave Courbet.

Huyghe, René, Germain Bazain, et al. 1944. *Courbet: L'atelier du peintre: Allégorie Réelle, 1855.* Monographies des peintres du Musée du Louvre, no. 3. Paris.

Ideveille, Henri d'. 1878. *Gustave Courbet: Notes et documents sur sa vie et son oeuvre.* Paris.

Kane, William M. 1960. "Courbet's 'Chasseur' of 1866–67." *Yale University Art Gallery Bulletin* 25(3):31–38.

Kozloff, Max. 1964. "An Interpretation of Courbet's 'L'Atelier.'" *Art and Literature* 3:162–83.

Larkin, Oliver. 1939. "Courbet and His Contemporaries: 1848–1867." *Science and Society* 3:42–63.

Lazar, Bela. 1911. *Courbet et son influence à l'étranger.* Paris.

Léger, Charles. 1920. *Courbet selon les caricatures et les images.* Paris.

————. 1925. *Courbet.* Paris.

————. 1929. *Courbet.* Paris.

————. 1948. *Courbet et son temps.* Paris.

Lemonnier, Camille. 1878. *G. Courbet et son oeuvre.* Paris.

Lesko, Diane. 1979. "From Genre to Allegory in Gustave Courbet's *Les Demoiselles du Village.*" *Art Journal* 38:171–77.

Levine, Stephen Z. 1980. "Gustave Courbet in His Landscape." *Arts* 54:67–69.

Lindsay, Jack. 1973. *Gustave Courbet: His Life and Art.* New York.

London, Royal Academy. 1978. *Gustave Courbet: 1819–1877.* Exh. cat. by Hélène Toussaint, et al. (cf. Paris 1977)

MacCarthy, James. 1975. "Courbet's Ideological Contradictions and *The Burial at Ornans.*" *Art Journal* 35:12–16.

MacOrlan, Pierre. 1951. *Courbet.* Paris.

Mack, Gerstle. 1951. *Gustave Courbet.* New York.

Mainardi, Patricia. 1979. "Gustave Courbet's Second Scandal: *Les Demoiselles du Village.*" *Arts Magazine* 53:95–103.

———. 1987. *Art and Politics of the Second Empire.* London and New Haven.

Mainzer, Claudette. 1981. "Une histoire de cimetière." In *Ornans à l'enterrement—Tableau historique de figures humaines.* Ornans: Musée Departmental—Maison Natale Gustave Courbet, pp. 40–76.

———. 1982. "Gustave Courbet, Franc-Comtois: The Early Personal History Paintings, 1848–1850." Ph.D. diss. The Ohio State University.

Malvano, Laura. 1966. *Courbet.* Milan.

Mantz, Paul. 1878a. "Gustave Courbet–I." *Gazette des Beaux-Arts* 17:514–27.

———. 1878b. "Gustave Courbet–II." *Gazette des Beaux-Arts* 18:17–29.

———. 1878c. "Gustave Courbet–III." *Gazette des Beaux-Arts* 18:371–84.

Mayaud, Jean-Luc. 1979a. *Les Paysans du Doubs au temps de Courbet.* Cahiers d'études comtoises, no. 25. Paris.

———. 1979b. "Des notables ruraux du XVIIIe au XIXe siècle en Franche-Comté: La Famille de Gustave Courbet." *Mémoires de la Société d'Emulation du Doubs,* n. s., 21:15–28.

———. 1981. "Courbet, peintre de notables à l'enterrement . . . de la République." In *Ornans à l'Enterrement—Tableau historique de figures humaines.* Ornans: Musée Departemental—Maison Natale Gustave Courbet, pp. 40–76.

McWilliam, Neil. 1983. "'Un Enterrement à Paris': Courbet's Political Contacts in 1845." *Burlington Magazine* 125:155–56.

Meier-Graefe, Julius. 1921. *Courbet.* Munich.

Moffitt, John F. 1987. "Art and Politics and Underlying Pictorial-Political Topos in Courbet's *Real Allegory.*" *Artibus et Historiae* 8(15).

Montpellier, Musée Fabre. 1977. *Exposition Courbet.* Exh. cat.

———. 1985. *Courbet à Montpellier.* Exh. cat. by Philippe Bordes.

Nicolson, Benedict. 1973. *Courbet: The Studio of the Painter.* New York.

Nochlin, Linda, ed. 1966. *Realism and Tradition in Art 1848–1900.* Englewood Cliffs, New Jersey.

———. 1967. "Gustave Courbet's *Meeting:* A Portrait of the Artist as a Wandering Jew." *Art Bulletin* 49:209–22.

———. 1968. "The Invention of the Avant-Garde: France, 1830–80." *Art News Annual* 24:13–16.

———. 1971a. "Gustave Courbet's *Toilette de la Mariée.*" *Art Quarterly* 34(1):31–54.

———. 1971b. *Realism.* Harmondsworth.

———. 1976. *Gustave Courbet: A Study in Style and Society.* Ph.D. diss., New York University, 1963. New York.

———. 1978. "Courbet, die Commune und de bildenden Künste." In *Realismus als Widerspruch: Die Wirklichkeit in Courbets Malerei.* Klaus Herding, ed. Frankfurt am Main, pp. 248–62.

———. 1980. "The *Cribleuses de Blé*: Courbet, Millet, Breton and Kollwitz and the Image of the Working Woman." In *Malerei und Theorie: Das Courbet-Colloquium 1979.* Klaus Gallwitz and Klaus Herding, eds. Frankfurt am Main, pp. 49–73.

———. 1982. "The De-Politicization of Gustave Courbet: Transformation and Rehabilitation under the Third Republic." *October* 22:65–77.

———. 1986. "Courbet's *L'origine du monde*: The Origin without an Original." *October* 37:76–86.

Ornans, Amis de Gustave Courbet. 1981. *Ornans à l'Enterrement—Tableau historique de figures humaines.* Exh. cat.

———. 1987. *L'Atelier du peintre . . . une étude du tableau de Courbet.* Exh. cat.

Paris, Ecole des Beaux-Arts. 1882. *Exposition des oeuvres de G. Courbet.* Exh. cat.

Paris, Grand Palais. 1977. *Gustave Courbet (1819–1877).* Exh. cat. by Hélène Toussaint, et al. (cf. London 1978)

Philadelphia, Philadelphia Museum of Art. 1959. *Gustave Courbet: 1819–1877.* Exh. cat.

Proudhon, P.-J. 1939. *Du principe de l'art et de sa destination sociale.* In *Oeuvres complètes.* C. Bouglé and H. Moysset, eds. Paris, pp. 1–282.

Reff, Theodore. 1980. "Courbet and Manet." *Arts* 54:98–103.

Riat, Georges. 1906. *Gustave Courbet, peintre.* Paris.

Rich, Daniel Catton. 1930. "'Mère Grégoire' by Courbet." *Bulletin of the Art Institute of Chicago* 24(4):42–43.

Rome, Villa Medicis. 1969. *Courbet.* Exh. cat. by Marie-Thérèse de Forges, et al.

Rosenthal, Léon. 1914. *Du romantisme au réalisme.* Paris.

Rubin, James Henry. 1980. *Realism and Social Vision in Courbet and Proudhon.* Princeton.

Sabatier-Ungher, François. 1851. *Salon de 1851.* Paris.

Sanchez, Jean Pierre. 1978. "La Critique de Courbet et la critique du Réalisme entre 1880 et 1890." *Histoire et critique des arts* 4–5:76–83.

Schapiro, Meyer. 1941. "Courbet and Popular Imagery: An Essay on Realism and Naiveté." *Journal of the Warburg and Courtauld Institutes* 4:164–91.

Scharf, Aaron. 1968. *Art and Photography.* London.

Schrug, B. 1962. *Courbet: Das Atelier.* Werk Monographien zur Bildenden Kunst, no. 73. Stuttgart.

Seibert, Margaret Armbrust. 1983. "A Political and a Pictorial Tradition Used in Gustave Courbet's *Real Allegory.*" *Art Bulletin* 65:11–16.

Seltzer, Alex. 1977. "Gustave Courbet: All the World's a Studio." *Artforum* 16(Sept.):44–50.

Seznec, Jean. 1955. "La Toilette de la mariée," *Les Amis de Gustave Courbet Bulletin* 5:7–9.

Sheon, Aaron. 1981. "Courbet, French Realism and the Discovery of the Unconscious." *Arts* 55(February):114–28.

Stuckey, Charles. 1971–3. "Gustave Courbet's 'Château d'Ornans.'" The *Minneapolis Insitute of Arts Bulletin* 60: 26–37.

Toussaint, Hélène. 1980. "Deux peintures de Courbet." *La Revue du Louvre et des Musées de France* 2:91–94.

———. 1982. "Le Réalisme de Courbet au service de la satire politique et de la propagande gouvernementale." *Les Amis de Gustave Courbet Bulletin* 67:5–27.

Troubat, Jules. 1900. *Une Amitié à la d'Arthez: Champfleury, Courbet, Max Buchon.* Paris.

Vath, H. 1981. "Photographie contra Realismus. Courbets Realismusbegriff und die Photographie." *Lendemains* 6:71–88.

Wagner, Anne M. 1981. "Courbet's Landscapes and their Market." *Art History* 4:410–31.

Wakeford, E. 1979. "Courbet's *La Diligence dans la neige.*" *Leonardo* 12:151–54.

Walter, Rodolphe. 1973. "Un dossier délicat: Courbet et la Colonne Vendôme." *Gazette des Beaux-Arts* 81:173–84.

Weisberg, Gabriel P. 1980. *The Realist Tradition: French Painting and Drawing 1830–1900.* Exh. cat. Cleveland Museum.

Winner, Matthias. 1962. "Gemalte Kunsttheorie: Zu Gustave Courbets *Allégorie réelle* und der Tradition." *Jahrbuch der Berliner Museen* 4:151ff.

Zahar, Marcel. 1950. *Gustave Courbet.* Paris.

Ziegler, Jean. 1978. "Quelques précisions sur Courbet dans l'Indre (1855–56): Sea séjours, ses tableaux d'après des lettres inédites." *Gazette des Beaux-Arts* 91:172.

———. 1979. "Victor Frond et *Les Pompiers* de Courbet." *Gazette des Beaux-Arts* 93:172.

Title Index

Photographic Credits

The publishers wish to thank the owners of works reproduced in the catalogue for kindly granting permissions and for providing photographs. Unless listed below, credit is given in the catalogue entries and captions. The publishers have made every effort to contact all holders of copyrighted works. All copyright holders we have been unable to reach are invited to contact the publishers so that a full acknowledgment may be given in subsequent editions.

Photographs have been supplied by those listed below.

Cliché Ville de Nantes: Musée des Beaux Arts: pl. v
Copenhagen, Ole Woldbye: cat. 69.
Documentation photographique de la réunion des musées nationaux: fig.
 1.1, 1.4, 1.5, 1.9, 1.10, 1.11, 2.3, 2.5, 2.8, 3.1, 3.2, 3.3, 3.4, 3.5, 4.3,
 4.4, 4.8, 4.12; cat. 9, 32, 77, 85, 90, 101
Leeds, West Park Studios: cat. 13
London, Tate Gallery: fig on p.
Montpellier, Musée Fabre, Mairie de Montpellier: fig. 2.1, 4.5; cat. 7, 8,
 16, 17, 18, 19, 100; fig. on p. 158.
Musée des Beaux-Arts de Caen, Proprietaire. Photo Martine Seyve
 Christofoli: cat. 67
Musées de la ville de Paris © by SPADEM 1988: cat. 76
Photo Bulloz: fig. 1.2
Reproduced by courtesy of Sotheby's, New York: fig. 1.7
Reproduced by courtesy of the Master and Fellows of Trinity College,
 Cambridge: fig. 2.7
Reproduced by permission of the Syndics of the Fitzwilliam Museum,
 Cambridge: fig. 4.10; fig. on p. 142.
Oskar Reinhart Collection, "Am Romerholz," Winterthur: pl. 111
Stockholm, Nationalmuseum, Photograph: Statens Konstmuseer: cat. 6,
 53
Ville de Paris, Musée du Petit Palais. Photo Bulloz: pl. IX; cat. 2, 32, 65,
 73

Lenders to the Exhibition

Besançon
MUSÉE DES BEAUX-ARTS ET D'ARCHÉOLOGIE
28, 46, 78, 91, 96

Boston
MUSEUM OF FINE ARTS
37

Bremen
KUNSTHALLE
75

Brussels
MUSÉES ROYAUX DES BEAUX-ARTS DE BELGIQUE
15

Buffalo
ALBRIGHT-KNOX GALLERY
47

Caen
MUSÉE DES BEAUX-ARTS
67

Chicago
THE ART INSTITUTE OF CHICAGO
29, 39, 92

Cleveland
THE CLEVELAND MUSEUM OF ART
40, 89

Cologne
WALLRAF-RICHARTZ MUSEUM
51

Copenhagen
NY CARLSBERG GLYPTOTEK
59, 71

Copenhagen
THE ORDRUPGAARD COLLECTION
70

Dallas
DALLAS MUSEUM OF ART
34

Detroit
THE DETROIT INSTITUTE OF ARTS
4

Dieppe
CHÂTEAU-MUSÉE
2

Fort Worth
KIMBELL ART MUSEUM
5

Glasgow
GLASGOW ART GALLERY AND MUSEUM
43

Rome
GALLERIA NAZIONALE D'ARTE MODERNA DI ROMA
72

Saint Louis
THE SAINT LOUIS ART MUSEUM
60

Shelburne, Vermont
SHELBURNE MUSEUM
80

Springfield, Massachusetts
MUSEUM OF FINE ARTS
63

Stockholm
NATIONALMUSEUM
6, 53

Strasbourg
MUSÉE DES BEAUX-ARTS
10

Tokyo
GALLERY ART POINT
76

Tokyo
MURAUCHI MUSEUM
44, 61

Toledo
THE TOLEDO MUSEUM OF ART
41, 45

Washington, D.C.
NATIONAL GALLERY OF ART
23, 48

Washington, D.C.
THE PHILLIPS COLLECTION
24

Worcester, Massachusetts
WORCESTER ART MUSEUM
64

Zurich
COLLECTION ROLF AND MARGIT WEINBERG
55

Zurich
DR. PETER NATHAN
94

Zurich
GALERIE NATHAN
12

Zurich
KUNSTHAUS
85

Zurich
PRIVATE COLLECTION
49

Typeset in Ehrhardt.
Composition by The Composing Room of Michigan, Inc.,
Grand Rapids.
Printed and bound by Amilcare Pizzi S.p.A., Milan
on Cartiere Burgo R-400 paper.
Designed by John C. Gambell, New Haven.